Reviewers' Praise for This Book

"If you read only one book on astrology in your life, let this be the one....a great, comprehensive treatment of the subject."
—Ellen Lamb, Selection Dept.
King County Library System, Washington

"*Astrology: A Cosmic Science* is a comprehensive textbook that I would recommend especially to those who are interested in karmic, spiritual and evolutionary astrology....Interpretations are an interesting mix of solid traditional meanings and philosophical/metaphysical insights.

"The author was a much-loved and respected teacher whose work directly or indirectly shaped many of today's lecturers, counselors, and teachers."
—Donna Van Toen, Book Reviewer
The Mountain Astrologer

"It was only when I discovered Isabel Hickey's *A Cosmic Science* that the more essential, spiritual dimensions of astrology began to make sense for me. Her work helped immensely in my quest to understand astrology's higher purpose and deepest values. Thereafter I recommended her book to all my students over many years, and they also responded to it with great enthusiasm and appreciation."
—Stephen Arroyo, M.A.
Psychologist & Author of numerous
best-selling books on astrology

Isabel Hickey's Approach to Astrology

"When the child utters the first cry, it takes into its body the life breath charged with the vibrations manifesting that day and that hour at that particular spot on the earth.

"Astrology is *not* fatalism. The birth-chart indicates certain physical, mental, emotional, and spiritual tendencies with which the person is endowed at birth. The blueprint shows what the soul has on its spiritual ledger—the debits and credits.

"This is the right use of astrology by the student. The person who studies from this point of view draws increasingly from the higher side of the planetary forces, develops his intuition and finds himself more and more able to interpret these forces correctly in terms of life and energy. Such a study trains the student in perceiving realities behind forms.

"Astrology deals with symbols, and the soul speaks and thinks in symbols. The interpretation of symbols is a necessary faculty for every spiritual student to develop. In planes beyond the earth, everything must be understood through symbols, for language is of the material plane only. Once you transcend the earth plane, you must read by inner perception and understanding. The study of psychological astrology prepares the student for higher planes of greater glory and power."

ASTROLOGY
A Cosmic Science

Isabel M. Hickey

CRCS PUBLICATIONS
Post Office Box 1460
Sebastopol, California 95472

Library of Congress Cataloging-in-Publication Data

Hickey, Isabel M.
 Astrology : a cosmic science : the classic work on spiritual
astrology / Isabel M. Hickey.
 p. cm.
 ISBN 0-916360-52-0 : $12.95
 1. Astrology. 2. Spiritual life. I. Title.
BF1711.H47 1992
133.5--dc20 92-12492
 CIP

FIRST REVISED & COMBINED EDITION
 [Comprising *Astrology, A Cosmic Science* by Isabel M. Hickey &
 Pluto or Minerva by Isabel M. Hickey & Bruce H. Altieri]

International Standard Book Number: 0-916360-52-0

Published simultaneously in the USA, Canada & the UK by
CRCS Publications

Cover art © 1981 by Sheila Waters, entitled *Roundel of the Seasons*
and used with her kind permission

Table of Contents

PART ONE

PART TWO

PLUTO OR MINERVA: The Choice is Yours

ASTROLOGY

A Cosmic Science

Dedicated to Y.K.W., Helen Hickey and all the Astral Angels, here and there. With a special "Thank You" to Bruce Altieri and Johanne Guinoski; without them this book would not have been published.

Preface

So you have decided to study astrology. Welcome. You are starting a journey toward self-understanding as well as gaining the ability to understand how the other fellow operates. Truly it is a spiritual science. It involves the relationship between the larger universe outside you and the personal universe within. The same energies that function in your personal universe function in the larger one 'out there.' The blueprint we call the horoscope, or the birthchart, plots the energies that flow in your magnetic field. At the moment of birth you took into your body, with the first breath, the vibrations manifested on that day and time at that particular spot on earth. This basic pattern goes with you throughout life.

The birthchart shows our potentials and tendencies. One of our astrological teachers once said: "Man is not what he is because he was born when he was. He was born when he was because he was potentially what he is." It is not because you were born at a certain place or time that you react to influences, but the influences of that moment and that place in space show your potentials that can be actualized in the future. Fate is earmarked in tendencies, not in facts. All anyone can see in a birthchart are tendencies that will become facts if one does not do something to alter them. None of us comes unbound into this livingness. We do not start here, and we do not finish our livingness here. Life is eternal. If we have it in front of us, is it not logical to believe we may have it behind us too? It is as though we have a built-in bookkeeping system. We have debits, and we have credits. Some of us come into this life with a great deal of capital in our spiritual bank books. This is earned income from a past life. Others come in with a depleted bank account. This is the difference between an easy life pattern and a difficult one. However, there is nothing to stop us from using up our capital and becoming bankrupt, or going to work to make up the deficit so we will have a surplus with which to function.

The horoscope is a blueprint of our character. Character IS destiny. There is nothing static in this universe in which we dwell. We can change by changing our attitudes and patterns of behavior. In so doing, we change our destiny. Yes, the blueprint or birthchart shows your character and your personality pattern — your human nature, but you are spirit too. The stars impel but do not compel. An understanding of planetary influences allows you to take your life into your own hands and intelligently utilize the planetary influences that will help you in your evolution if you but will.

Astrology deals with symbols. The signs of the zodiac are symbols of great and potent forces. The physical planets are but the outer forms through which soul energies manifest. It is these energies that affect us, not the physical planets. When you meet a person you are not affected by his physical body. Yet you respond to his character and personality to your benefit or detriment. So it is with planetary energies.

Let us consider your horoscope to be a roadmap. It shows the conditions you are going to meet in life. Some of the roads on which you will travel will be smooth and easy if you have built them well in a past that your personality does not remember. Some of the roads will be in poor condition and need repair. If you repair them and put them into good condition your vehicle will not break down and cause you difficulties and delays.

Always the idea of rebirth raises the question: "If I have lived before why do I not remember and know?" Your personality is new but not the soul. The soul is the unit of evolution. The personality is the unit of incarnation. When you become conscious of who you truly are — a soul using a personality through which to function — you will remember.

Another thought worth pondering is this one. "How much do I consciously remember of what I have lived in this lifetime?" As you will learn later in your study of astrology, the knowledge is in your subconscious self. Your subconscious self has hidden in it the sum total of all your experiences to date. You will find as you study that you will be developing your intuitional facilities for you are dealing with powerful energies that will aid in your spiritual on-going. How much you get out of this study depends on how much you put into it. It is security invested in your spiritual bankbook upon which you can draw in any crisis or experience where understanding is needed. If you have not studied for a long time the study of astrology will be a means of removing the rust from your brain, not only in one area but others as well. New pathways or grooves in the brain are made with every new study you take up. There is an actual expansion of dormant brain cells when you make new pathways of comprehension in your gray matter. The first part of astrological study involves the use of your memory. The signs and the planets that rule them must be memorized though I would like to add the word visualized. Dwelling on the symbols, pondering their meanings, meditating on these energies, will bring you in contact with the power behind the symbols. Remember: any knowledge gained through outer study takes you as far as your conscious mind. There is a Superconscious Mind beyond that area where you can gain direct knowledge from the source of your Being. That part of you already IS Understanding — IS Wisdom — IS Knowledge NOW. Astrology is one of the means of knowing that SELF. So let's be on our way.

Godspeed.

CHAPTER 1
Signs and Symbols

The zodiac has 360 degrees in the circle, each sign having 30 degrees. The number of degrees in a sign never changes, but you can have a lesser or greater number of degrees in a house due to the angle of the rays at the time of birth. This can be confusing to a new student when he is dealing with orbs of aspects. They must be counted by signs, never by houses. When you do not have the time of day for a birthchart you will use the natural zodiac. This gives an understanding of character and shows the cycles that are operating, but it will not show the circumstances through which the energies will operate. You will need the time of day and place of birth for this information.

The natural zodiac has Aries on the first house, Taurus on the second and the other signs are shown on the other houses in succession. In the time chart any one of the 12 signs can be on the first house (Ascendant) but there will always be a hidden influence of Aries operating, as it is the underlying keynote of the first house. This will also be true for the other houses. The natural sign and ruler will be the underlying vibration.

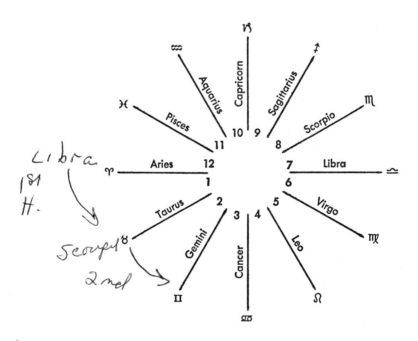

Sign	Symbol	Keyword	Time of Year — Approximate
Aries	♈	I am	March 21st to April 21st
Taurus	♉	I have	April 22nd to May 22nd
Gemini	♊	I think	May 22nd to June 22nd
Cancer	♋	I feel	June 22nd to July 22nd
Leo	♌	I will	July 22nd to August 22nd
Virgo	♍	I analyze	August 22nd to September 22nd
Libra	♎	I balance	September 22nd to October 22nd
Scorpio	♏	I desire	October 22nd to November 22nd
Sagittarius	♐	I perceive	November 22nd to December 22nd
Capricorn	♑	I use	December 22nd to January 22nd
Aquarius	♒	I know	January 22nd to February 22nd
Pisces	♓	I believe	February 22nd to March 21st

The ephemeris must be consulted for the exact day and time the signs change.

OPPOSITE SIGNS

Aries _____ opposite _____ Libra

Taurus _____ Scorpio

Gemini _____ Sagittarius

Cancer _____ Capricorn

Leo _____ Aquarius

Virgo _____ Pisces

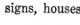

In astrology you are going to be dealing with four factors: planets, signs, houses and aspects.

Planets are the energies. "What" is operating.

Signs are "How" the energies operate. The planets in the signs indicate character — the individual pattern from other lifetimes. The signs show how the energy (the planets) is conditioned and how it operates. The planets in the signs show your capacity, ability or power to achieve what is indicated by the nature of the planets.

Houses show "Where" the energies will work; the circumstances. Houses indicate the the environmental pattern where you will work out your destiny. They indicate the opportunities offered by your environment.

Aspects (the flow of force between the planets) show your use or abuse of the energies operating in your magnetic field. They show dispositions and the predispositions to action and reaction.

The horoscope or birthchart is an X-ray of the personality. It shows how we operate within our personal magnetic fields. We are miniature universes. Every energy operating out in the larger universe is operating in our personal magnetic field for we are part of that universe. Life flows. Changes take place. Energy is released and **how** we release it is the all important factor. The birthchart shows the tendencies and conditioning. It shows what can happen, not what will happen. We have the right to choose not to respond to life negatively. The birthchart rules the personality in the world of appearance, but we are spirit too. If the real self operates we rule our stars (energies) and are not ruled by them.

Each sign has a planetary ruler. Some planets rule two signs. At the present time there are ten planets and twelve signs. When we have evolved further along the path of evolution, there will be twelve planets. The next planet to be discovered will be Vulcan. There are seven planets connected with the earth. In Revelations they are represented by the seven angels before the throne of God. Think of them as great planetary beings using the physical planets through which to pour certain types of influences. It is not the physical planets in the heavens the illuminated astrologer means when he talks about planetary influences.

There is a division of the signs into positive (masculine) and receptive (feminine) signs and this is important in understanding a birthchart.

Masculine		Feminine	
Aries	♈	Taurus	♉
Gemini	♊	Cancer	♋
Leo	♌	Virgo	♍
Libra	♎	Scorpio	♏
Sagittarius	♐	Capricorn	♑
Aquarius	♒	Pisces	♓

Count the planets in masculine and feminine signs in order to understand the basic polarity of the individual. This will tell whether he is rightly balanced or not in regard to positive and receptive (passive) forces. If there are too many planets in feminine signs in a male chart his body may be masculine but his soul will be feminine. He will lack strength and will be passive and dependent. He finds it difficult to adjust to a new polarity for probably he has had a number of lifetimes as a female. Now he is given the opportunity of developing the male qualities. This helps us to understand the over masculine woman and too feminine man. When we understand, there is no condemnation or desire to judge.

Carl Jung, the Swiss psychoanalyst, said that every female has a man (the animus) in her subconscious that she has to understand before she can relate properly to a man in the outer world. Every man has to understand the woman (the anima) in his own subconscious before he can relate rightly to a female in the outer world.

When you are told you are an Aries, Gemini, or any of the other signs, it means that you were born in that part of the year when the Sun was in that particular sign. As the Sun indicates the essence of the individuality or inner self it gives the underlying keynote of our character. Due to the influence of all the other planets there are infinite variations and combinations, but the underlying influence of your sun-sign will be operating. There are twelve signs and ten planets in every birthchart. They all play a part in making you what you are. Every four minutes the heavens change. One can make general statements when the sun-sign of an individual is known. To know that person as he really is you must have the birthdate, the time of day and the place (longitude and latitude) where the person is born. You will need an ephemeris (planets' places) for the year of birth; a Table of Houses that will give the cusps of the houses; and a Longitude and Latitude book that will give the true local time of birth and the time difference between the place of birth and Greenwich Mean Time. This is the equipment necessary to set up a correct birthchart.

After learning the twelve signs and their symbols, learn the signs that oppose each other. The signs that oppose each other have many things in common for they function on the same wave length but are opposite poles. When you set up charts only six signs are given in the Table of Houses. You have to know the opposite signs and insert them in their proper places. Look for the similarities and the differences between the signs that oppose each other. You will learn much. On the personality level opposites attract. They oppose each other or complement each other according to their level of consciousness. On the higher levels, the soul levels, similar wavelengths attract. Therefore, there is less friction and much more harmony. However, friction means growth until we evolve to the place where harmony reigns. An advanced teacher once said, "You can take the path of friction if you wish, but there is a better way." Our earth plane is a school of learning; experience is the teacher. Knowledge is power. We can be asleep in matter or choose to wake up and be aware of what the purpose and meaning of life may be. Astrology points the way.

The signs, symbols, keywords and approximate time of year should be committed to memory. Except for March 21st, which is always the beginning of the astrological year, the entrance of the Sun into the signs is not a constant. To know the exact day and time the signs change you must consult an ephemeris for the day and year.

CHAPTER 2
The Twelve Signs of the Zodiac

ARIES:

Ruled by Mars. Cardinal, fire sign. Positive and masculine sign. March 21st to April 21st. Keyword: I AM. "The uprushing fountain of Life. Fire of the head. The untamed fire of Impulse." In the physical body Aries rules the head. Aries is symbolized by the Ram.

TAURUS:

Ruled by Venus. Fixed, earth sign. Feminine and receptive sign. April 21st to May 21st. Keyword: I HAVE. "The freshly plowed earth of springtime, ready for the seed." In the physical body, Taurus rules the throat and cerebellum, the back part of the brain. Taurus is symbolizd by the Bull.

GEMINI:

Ruled by Mercury. Mutable, air sign. Neutral in expression, for it is a combination of male and female in a subtle way. It is a positive sign so it is listed as a masculine sign. May 21st to June 21st. Keyword: I THINK. "The light, changeable breeze of early summer. Here today and gone tomorrow but you are better for the contact." In the physical body it rules the nervous system, the hands, the shoulders, the arms and the lungs. Gemini is symbolized by the Twins. The Chinese call it the 'monkey' sign.

CANCER:

Ruled by the Moon. Cardinal, water sign. Feminine and receptive sign. June 21st to July 21st. Keyword: I FEEL. "The restless tides of the ocean; the surging and ebbing of emotions." In the physical body it rules the breasts, the stomach and the solar plexus. Cancer is symbolized by the Crab.

LEO:

Ruled by the Sun. Fixed, fire sign. Positive and masculine sign. July 21st to August 21st. Keyword: I WILL. "Fire of the heart; the steady controlled fire of affection." In the physical body it governs the heart and the spine. Leo is symbolized by the Lion.

VIRGO:

Ruled by Mercury. Mutable, earth sign. Feminine and receptive sign. August 21st to September 21st. Keyword: I ANALYZE. "The harvest time; the time of reaping and assimilation." Governs the intestinal tract in the body and its powers of assimilation. Virgo is symbolized by the Virgin, with a sheaf of wheat.

LIBRA:

Ruled by Venus. Cardinal, air sign. Positive, masculine sign. September 21st to October 21st. Keyword: WE BALANCE. "High wind and hurricanes, followed by calm." Rules the kidneys, purifiers of the body as relationships purify the soul. Symbolized by the Scales.

SCORPIO:

Ruled by Mars and Pluto. Fixed, water sign. Feminine, receptive sign. October 21st to November 21st. Keyword: I CREATE. "Unhealthy and stagnant marsh waters that need to be brought to the surface and cleansed." Rules the generative system and the rectum. Scorpio is symbolized by three symbols; the Scorpion on its lowest side, the Eagle, the higher symbol, and the Phoenix bird that dies in the ashes of its crucified self and is reborn anew.

SAGITTARIUS:

Ruled by Jupiter. Mutable, fire sign. Positive, masculine sign. November 21st to December 21st. Keyword: I PERCEIVE. "The fire of the Spirit. The arrow that shoots heavenward." Rules the hips and thighs and has a great deal to do with arterial blood. Symbolized by the Centaur, half man and half horse.

CAPRICORN:

Ruled by Saturn. Cardinal, earth sign. Feminine, receptive sign. December 21st to January 21st. Keyword: I USE. "The goat, solitary and alone, climbing to the highest peak." Rules the knees and the bony structure of the body. The symbol of Capricorn is the Goat.

AQUARIUS:

Ruled by Saturn and Uranus. Fixed, air sign. Positive and masculine in expression. January 21st to February 21st. Keyword: I KNOW. "The clear, crystal electric air of winter." Rules the circulation and the ankles in the body. Symbolized by the Man with the watering pot.

PISCES:

Ruled by Neptune with Jupiter as vice-regent. Mutable, water sign. Feminine, receptive sign. Keyword: I BELIEVE. "The fish, swimming below the surface, uncertain of its destination, but in ceaseless motion." It rules the feet (symbol of understanding) in the physical body. Symbolized by the two fish, tied together, but swimming in opposite directions.

In studying the signs and planets, keywords are given to aid in understanding. It is well to have a notebook and put into it every bit of knowledge you can glean on the planets and the signs. There are astrological magazines on the market that are of great aid to the student. Every sign and every planet is placed somewhere in your horoscope. The more knowledge you have of the meanings of the planets and the signs, the greater will be your ability to interpret a birthchart.

ARIES

Aries: Ruled by Mars.
A positive, masculine sign.
Cardinal, Fire

The Sun is in Aries from March 21st to April 21st. The entrance of the Sun in the various signs differs from year to year. The ephemeris will show the exact time and date the Sun changes signs. Keyword for Aries 'I am.' Represents the 'uprushing fountain of life. Fire of the head. Untamed fire of impulse.' Rules the head in the physical body.

Aries is the point of all beginnings. The person with his Sun in Aries is in the process of building a personality. All the energies are self-centered and self-directed. Before one can give one's self away, there must be something to give. So, 'I am' (me first) is the Keyword of the self-assertive Arian. What are the qualities of the Ram that are the symbol of the Aries sign? Leadership, strength, charging forth to butt their heads against any obstruction in their way; such are the qualities of the undeveloped Arians. Impatient and unwilling to wait for events to mature they are apt to rush in where angels fear to tread. Arians are the pioneers of the zodiac. They make good executives and are wonderful at getting projects started. They are the original idea people. They have initiative and never lack courage. As children they are noisy and full of energy. They must be doing something every minute. They like games and sports for they have a great deal of physical energy.

Don't try to direct the life of anyone born in Aries. They want to do what they want to do when they want to do it. Any interference brings wrath on the offender. Arians are the self-starters of the zodiac but are apt to lose interest if the pace slows down or things become complicated.

They are very self-confident on the surface but this conceals a feeling of inadequacy on the subconscious level. The negative aspects of Arians are arrogance, egotism and a tendency to dominate. The woman born in this sign has difficulties because she functions from the head instead of her heart. However, she makes a good career woman. In her emotional life she is likely to be far too positive, opinionated and masculine. She has to learn to build in her feminine side and be willing to be quiet and receptive. There are three qualities that every Arian should learn: coordination, conservation of energy and completion.

From the universal standpoint, Aries is the first impulse of the life force into activity, the descent of the Divine Spark into manifestation. Wherever Aries is placed in your horoscope (the house it rules) is where you, as Spirit, begin to operate. Aries is symbolized by the Ram on the objective level. In its highest aspect it is the Lamb of God. The Lamb, the higher symbol, is the symbol of submissiveness and non-resistance. "The Lamb of God slain from the beginning of the world" is symbolic of the Spirit (the Lamb) being forced into a subordinate position when the world (the personality) takes over. When the personality makes itself the positive pole of expression the Real Self is forced to take a back seat. God's gift to the children of men is the gift of free will. There is one catch to it. When we put our will into action we must abide by the result. Where there is action there is equal and opposite reaction. This is the Cosmic Law that Easterners call the Law of Karma.

Arians go at such a speed and are so demanding they tire other people out long before they themselves are ready to quit. They spill energy in every direction and if they do not learn to conserve it they have bad health. The headaches, so prevalent with Aries people, are due to tension that comes from failure to relax.

TAURUS

Taurus: Ruled by Venus.
A feminine, receptive sign.
Fixed, Earth.

The Sun is in Taurus from April 21st to May 22nd. Taurus represents 'the freshly plowed earth of springtime, ready for the seed.' The keyword is 'I have.' Taurus rules the throat in the physical body, also the cerebellum.

Taurus is called the sign of the Bull, but it is much more. There are four serpent signs of the zodiac that have to do with will and power. Taurus is the first serpent sign and represents coiled up serpent power, latent and not yet in full expression. The other serpent signs are Leo, Scorpio and Aquarius. Taurus people are slow, steady and stubborn. Their reflexes are slow and they cannot be pushed. You can lead a bull to water but you can't push his head in without being in trouble. In dealing with a Taurean, indirect action is best. With Aries you can be

quick and to the point. This is not so with Taurus. It takes time for them to adjust to new ideas. They get accustomed to new concepts gradually. They get flustered and upset if they are not given time to assimilate facts slowly. Taureans are long suffering, kind and gentle. It takes a great deal to anger them, but when they do get angry do not try to argue with them. Wait until they cool down.

Possessions and material things are of great significance to those born in Taurus. Taurus is the money sign of the zodiac. Money is the symbol of value, not the value in itself. The house that is ruled by Taurus in any chart will indicate your sense of values, as well as where you are apt to be locked up in the world of matter. When the Sun is in Taurus the basic lessons in life have to do with acquiring a true sense of values. "Render unto Caesar what belongs to Caesar, and unto God what belongs to God." The Master did not say "Nothing belongs to Caesar." It's knowing what belongs to Caesar and what belongs to God that is important. The negative qualities that have to be overcome in Taurus are overpossessiveness. jealousy and greediness. These qualities are based on fear of loss. He who has no desire to possess has no fear of loss. Do you remember those beautiful lines of Tagore:

"Why did the flower fade?
I clutched it to my heart in excess of feeling and crushed it.
Why did the lamp go out?
I shielded it with my cloak and it got no air."

Taurus mothers are the most possessive of all the signs except its opposite sign, Scorpio. They find it difficult to let their children go, even when they are adults. The quality most necessary for the Taurus sign to acquire is detachment.

Taurus rules the throat in the physical body. There is a reflex action from the opposite sign, Scorpio, that can give difficulties where the generative organs are concerned. There is an intimate relationship between the throat center (Taurus) and the sexual center (Scorpio). When a boy gains the power to create on the physical level his voice changes. What we may not realize is that the power to create on the higher level operates through the use of speech. We can see the results of our physical creations in the outer world. The creations we send forth through speech are equally as potent though we do not always recognize our creations when they come home to us.

GEMINI

Gemini: Ruled by Mercury.
 A dual sign, masculine and intellectual in approach.
 Mutable, air sign.

The keyword is 'I think.' May 21st to June 21st. Represented by "the light changeable breezes of early summer. Here today and gone tomorrow but you are better for the contact." Rules the shoulders, lungs, arms,

hands and the nervous system. Note the duality shown here. There are two of everything.

Gemini is called the sign of the Twins but inwardly it represents the conscious mind. In the opposite sign, Sagittarius, lies the potentiality of the superconscious faculties of illumination and wisdom. From the standpoint of the universal laws Gemini is the most important of the twelve signs for our earth. Everyone on earth comes under the influence of Gemini. It represents the dual forces; the opposition of the human and the divine in all of us. In mythology this sign is represented by the two brothers, Castor and Pollux. One is the heavenly twin and the other is his earthly brother. Until the two are harmonized the law of opposites will continue to operate.

Gemini is called the butterfly of the zodiac for he flits from one situation to another in order to gain growth through many varied experiences. It is the most versatile and adaptable of signs, but it is not noted for concentration and persistence. The Chinese speak of it as the monkey sign because of its extreme restlessness.

In dealing with those with many planets in Gemini remember that they are not basically emotional. You must appeal to them through logic and reason. The undeveloped Gemini people fuss and nag over inconsequentials and have no idea how difficult it is to cope with their temperaments. Because of their dual nature they are often considered two-faced. Sometimes they are.

The Geminis' tremendous wit and sense of humor endear them to the children of earth. They make excellent salesmen for they can sell ideas to anyone. "Don't fence me in" is the battle cry they share with their opposite sign, Sagittarius. Gemini is adverse to close and binding ties. Taurus wants to own and be owned. Not Gemini. Their psychology is entirely different. They like everyone and find it hard to love one only. The more liberty they get in marriage the happier they are, although they want the feeling of being important to someone.

Gemini people make good teachers, writers, reporters and salesmen due to their facility in communication. They need a vocation in which they can move about and mingle with people. They could not stand being at a desk for eight hours as their nerves would give them difficulties.

Gemini individuals dramatize everything that happens to them and are apt to let their imaginations carry them away. They dream 'big' schemes but have to start at the beginning, which isn't easy to do because of their restless desire to be on their way.

Gemini is the most dual of all the signs and people born in this sign are split personalities until they understand the function of the mind and learn to control it. For all of us, getting the mind under control is a very difficult task but for Gemini people it is a 'must.' The nervous system is highly geared. Because of their inability to control their thinking they are apt to be the neurotics of the zodiac. Nerves are caused by the person in the body giving the body a hard time. Gemini

people are more subject to nervous breakdowns than any of the other signs. Their preoccupation with themselves is at the root of their difficulties. Their way out is to take the emphasis off the self and lose it through service to others. Because of their tenseness they can be inveterate smokers, and if so, their lungs will pay a high price. Emphysema is apt to be the end result.

The spiritual motto of the Gemini sign should be "Let go and let God." There is magic for us all in that simple word: LET.

CANCER

Cancer: Ruled by the Moon.

A feminine, receptive sign.

Cardinal, water sign.

Keyword is "I feel." June 21st to July 21st. Cancer people are passive, receptive and emotional in nature. Cancer is represented by "the restless tides of the ocean, the surging and ebbing of emotions." In the physical body Cancer rules the breast, stomach and the solar plexus.

Cancer is the mothering, sustaining, nuturing sign of the zodiac. It is the sign of the womb, the house, the home, the interior of all things for it is the protecting or covering principle. Cancer is symbolized by the slow moving crab, identified with its dwelling place. It carries its house upon its back and retreats into it when threatened by exterior forces. It is equally at home on land (physical plane) and also in the water (emotional plane). Cancer is not a vital sign. It has a sluggishly moving energy flow. This may account for its physical laziness. Cancerians hate to exercise. As a consequence, in later life they are apt to suffer from poor circulation. Cancer people live much in their feelings and affections. They seek sympathy, and do not realize how self-centered and selfish they are. They have to be first with those they love or they are very unhappy. Like the crab, their hold on those they love is a tenacious one.

Cancer is the most subconscious of all signs; everything is latent and hidden. No issue is clear or direct. Like the crab who sidesteps any object approaching him, Cancerians are not forthright and direct in action. Unlike Gemini, who responds to life through his mind, Cancer responds to life through his feelings. You can't reason with them when they are emotionally disturbed. Wait until they quiet down and then talk to them. There is an indefiniteness and an apparently vague subtlety which proves most elusive to people dealing with Cancerians. As they are extremely psychic they find it difficult to separate what they feel from what they think. They are at the mercy of their moods, up one day and down the next. They are psychic sponges, absorbing any atmosphere around them without realizing it. If they are in the company of happy people they bloom; if depressed people are in their vicinity they droop and wilt and do not know why.

Cancer is not an easy sign for a male, for it is the most feminine of all the signs. There is a very strong attachment to the home and the mother. It is difficult to cut the umbilical cord that binds them to the past. When a man has his Sun in Cancer and the Moon, its ruler, afflicted to Saturn, there are deep psychological problems due to his lack of masculinity.

No matter how far Cancer roams — and they do love to roam — they want a home to which they can return. They may not be in it very much but they want it there. Their emotional insecurity is very great until they are centered beyond the personality aspect. The Moon rules the personality. It has no light of its own but shines by the reflected light of the Sun. Think of the personality as an unlit room. Until the light (Sun) is turned on the room is dark. The greatest need for Cancer people is to find their inner center and function from there. Then they are stabilized and not subject to the tides of their personality.

Cancer rules the public; mass consciousness. Mass consciousness is ruled by feeling, never by reason. Propagandists and advertising agencies know this fact well and make full use of it in dealing with the public. America, born on the fourth of July, is Cancer born. At the entrance to New York harbour stands a feminine statue that portrays the Cancer type so very well. The protective, yearning, sustaining power is Cancer at its best. We. as a nation, do have a very strong emotional response to the world's need. We need to add to this quality the qualities of reason and discrimination.

L E O

Leo: Ruled by the Sun.
A positive outgoing sign.
Fixed, fire.

The Sun is in Leo from July 22nd to August 22nd, approximately. It is represented by "Fire of the heart; the steady controlled fire of affection, the hearth fire." The keyword of Leo is 'I will.' It rules the heart and the spine in the physical body.

Leo is the sign of self-consciousness, as Cancer is the sign of the instinctual conscious. Whether Leo people are constructive or destructive in their approach to life depends on who drives their chariot; self or Self. Leo people have great courage, but unless they have a sense of responsibility and are willing to take discipline of their own accord they can bring great difficulties on themselves. One of Leo's keywords is DOMINION. This does not mean dominion over others (a trap Leo needs to learn to avoid) but dominion over their own unsubjugated forces. Leo is the most vital of the signs and has tremendous energy. They have a confidence and an assurance that strengthens those who are timid and angers those who are seeking the power inherent in Leo. Leo is the royal and kingly

sign of the Zodiac. In an age where Kings are a thing of the past Leos need the realization that the royalty of the Aquarian age will be the spiritual aristocrats who function through the heart and soul in real simplicity. What is simplicity but going to the inner heart of things and seeing things whole! Leo rules the inner center — the heart.

There is an ancient astrological aphorism: Leo rules by divine right and Capricorn by delegated authority. This is Leo's greatest stumbling block — authority. Leos will not delegate authority to others. They give it with one hand and take it away with the other. This is one reason so many Leo people die of heart attacks before they reach old age. They think they have to do it all themselves and in the process wear themselves out.

Leos' faith and loyalty to those they love is very strong. Being a fixed sign, once they give their affections they do not change easily. Where their opposite sign, Aquarius, is too impersonal and indifferent in relationships, Leo people are too attached where those they love are concerned. They have to learn true detachment. Can the Sun shine for itself or just one other? Only when Leo individuals become impersonal and give their warmth and affection to all do they come into their inheritance. Of all the signs they cannot live for themselves alone. All energy and power comes from the Sun which rules Leo, but Light and Power can warm or scorch, create or destroy. The solar radiation has the power to bring forth life, but Leos have to use that life wisely or pay a heavy price. That is why Leos' will must become God's will, or they are in trouble.

There is dignity, self-respect, courage and integrity in the evolved Leo individuals. They are honest, direct and fully dependable when they are evolved; arrogant, egotistical and bombastic when they enthrone their ego where their Higher Self should be.

Their virtues are big ones as well as their faults. Love should become divine compassion before their regeneration is complete. The Leo destiny is a high one. No man can be a true leader until he is willing to be servant of all. The greatest gift a Leo can bring to the world is an understanding heart.

VIRGO

Virgo: Ruled by Mercury.
A feminine, receptive sign.
Mutable, earth.

The Sun is in Virgo from August 21st to September 22nd, approximately. Virgo is represented by "the harvest time, the gleaming of the wheat and the fruits of the earth." The keyword: "I analyze." Rules the assimilative system in the physical body.

Virgo's symbol is depicted as the Virgin, holding a sheaf of wheat, This symbol indicates the gathering in of material needs, just as the

Virgo people collect, digest and correlate facts for their mental values. The Virgin denotes purity and perfection. Virgos' desire is to reach the highest possible perfection, not only for themselves but for those around them. They have a greater sense of power than they are able to express, resulting in an inferiority complex. An inferiority complex is a superiority complex turned in on itself. Virgo is constantly learning the lesson of humble service and patience. They find their fullest expression through service to others, being willing to do it quietly but thoroughly. Taking care of endless details and routine jobs is where they function best. There is a cautiousness and oftimes a selfishness in Virgo that is often unrecognized by the person born in this sign. It is difficult for the person to communicate and articulate where their inner thoughts and feelings are concerned. Their home is extremely important to them for they feel more secure there than in any other surrounding. They are not gregarious because of their shyness. Virgo people have jittery nerves and a highly geared nervous system. Their state of mind has a direct bearing on their health. They can become hypochondriacs if they become to self-centered and anxious about their health. Nervous tension is the person in the body giving the body a hard time.

The Virgo individuals greatest fault is being too critical. Their analyzing mind can cause them to degenerate into faultfinding, criticism and irritabilty. Virgos real satisfaction lies in the realm of work and service. They are one of the best workers in the zodiac. They are practical and down to earth in their approach to life. They are good in the field of accounting and bookkeeping. Virgo women make excellent nurses and there is a strong purity and fastidiousness in them. They dislike anything crude or coarse. There is a sweetness and a lack of aggresiveness in this sign that gives a great attractiveness to those born in this sign. Virgo people make few enemies and have many friends due to their quiet, gentle manner.

Because of their own inner feelings of inadequacy, they can be very demanding where their loved ones are concerned. Their need is to learn to be less critical and more loving. Venus, the love principle, is unhappy in an area where the lower mind operates. Love withers in a critical atmosphere. We relate to others through the heart, never through the head. We recognize this fact subconsciously when we use the term "Never mind."

In the universal scheme of things, Virgo stands for the 'womb of time' wherein God's plan is being worked out through pain, struggle and conflict. These are the things that set the consciousness free from being earthbound. Virgo represents the sign of the hidden Christ in every man; the seed planted in earth, that must root in the darkness, and through struggle break its sheath and struggle towards the Light. Virgo is the last of the personal or involving signs, and is the threshold of the birth of the inner man. The personality is developed from Aries to Virgo; the soul is developed from Virgo to Pisces.

LIBRA

Libra: Ruled by Venus.

A positive, masculine sign.

Cardinal, air.

The Sun is in Libra from September 21st to October 21st. Represented by "high winds and line storms, followed by calm." The keyword is "I balance." Libra rules the kidneys in the physical body.

Libra is the seventh sign of the zodiac and marks the beginning of the fall season. It is the time of year when we have the equinoctial storms. Libra is the turning point in the evolutionary process. The nadir of selfness has been reached and in this sign, relationships involving cooperation are born. This is the 'union' or marriage sign of the zodiac, and the soul can no longer function in the 'me' consciousness. It has to become the 'we' consciousness. Now the soul has to balance the world of appearance (the personality) with the inner world of reality (the soul). Venus is the ruler of this sign for only through love and cohesiveness can true union be attained. The development of relationships is the most important attainment for the Libran. One of the Libra's weaknesses is wanting to be all things to all men. So great is their desire to be liked by everyone, they will not take a stand on an issue, even when they know it to be right inwardly. "Peace at any price," is their motto, but sometimes the price is too high. When integrity is involved, it is well to be willing to pay the price. It is difficult for the Libran to be generous for there is tenacity and Saturn is exalted in this sign. Librans are very secretive about finances and personal matters and will resent any attempt to pry into their affairs. They have an executive and legal type mind. Many lawyers have planets in this sign. Librans are not the stay-at-home types like Virgo and Cancer. They like to travel and explore horizons, either mentally or physically. Librans can work up a storm where other people are concerned. On the surface there is a diplomacy and sweetness, but beneath the velvet glove is a fist of iron. It is hard for a Libran to believe they are dominating and selfwilled, but it is true. The esoteric ruler of Libra is Uranus. This explains a great deal.

There is a tendency to stay overlong in the parental nest due to a strong identification with the mother. Because of a strong sense of duty and responsibility it is difficult for the Libran to get away from "the womb of the past." This blockage causes deep seated resentment which becomes stronger because it is unexpressed.

Librans are the diplomats par excellence for they are friendly, outgoing and interested in living life to the fullest. Their desire for approbation is very strong. In group associations they shine because they are tactful and conscientious, have a strong sense of justice and the will to do good.

In the physical body Libra rules the kidneys, the purifiers of the body. In the psychological body, relationships are the purifiers of the consciousness. No man can be an island.

SCORPIO

Scorpio: Ruled by Mars and Pluto

An introverted, feminine sign.

Fixed, water.

The Sun is in Scorpio from October 21st to November 21st. Keyword: 'I create.' It is represented by 'the hidden, stagnant marsh waters that must be cleansed by the free-flowing waters of life.' Scorpio rules the generative system; the creative fount of all physical life.

Scorpio is the mystery sign of the zodiac. It is the death sign and the sign in which the battle must be fought between the soul and the personality. The personality has to die. Devil or angel — there is no in between. This is the sign personified in the poem:

> The high soul seeks the high way,
> And the low soul seeks the low,
> And in between on the misty flats
> The rest drift to and fro.

There are no Scorpios found on the misty flats. It is the only sign that is given three symbols indicative of the tests that embrace the three-fold personality. Mental, emotional and physical levels are all involved. The Scorpion is the lowest symbol of the sign who, rather than forego the pleasure of stinging, will sting himself to death; the eagle, symbol of the bird that can fly closer to the Sun (spirit) than any other; and the phoenix bird resurrected from the ashes of the dead self. Wherever Scorpio is found in the birthchart is where transfiguration and resurrection must take place.

Scorpio natives have a very strong reserve and are not easily known. Much lies hidden beneath the surface. They command respect from acquaintances due to their strong, quiet exterior, but they have to earn the respect of those in close ties. Too often that strength becomes vindictiveness, jealousy and resentment in the family circle. In this sign there is creativeness and great resourcefulness. There is a great need to guard against sarcasm for the Scorpio's tongue can be deadly if used vindictively. They are apt to run into difficulties with co-workers and employees because of a supercritical nature and the tendency to pass judgment on others. There is a need to learn stability and steadiness where partnerships are concerned. There is great stubbornness that makes for difficulties in partnerships. Relationships call for equality and a responsibility that the Scorpio individuals would rather avoid. They would rather be lone wolves They like animals as pets for they can be their masters and not have to relate on an equal basis.

Scorpio is the sex sign of the zodiac and Scorpio individuals have strong passions that need regenerating. There is a tremendous pride in this sign that will not allow any emotion to ruffle the surface of the nature. 'Don't judge a book by its cover,' is truer of Scorpio than any other sign. Their emotions do not show on the surface. They have tremendous

strength and power when they have risen above personality reactions. Scorpios are truly powerful when they do not seek power for self, but seek to be used by the power to heal and bless others. Their goals are reached by service, purity, compassion and humility. When they serve others and forget themselves they are truly dynamic and majestic. Scorpios are not likely to have a happy marriage until they have redeemed and transformed their natures. Yet marriage and relationships are extremely important for them. Their regeneration lies in learning to be cooperative and outgoing toward others.

SAGITTARIUS

Sagittarius: Ruled by Jupiter.

A positive, masculine sign.

Mutable, fire.

The Sun is in Sagittarius between November 21st and December 21st. Keyword: 'I perceive.' It is represented by 'the archer who shoots his arrow into the air though he knows not its destiny.' Rules the hips and thighs in the physical body.

Sagittarius is the natural ruler of the ninth house, which governs understanding and the superconscious mind. The symbol of the sign is represented by the centaur (half human and half animal) carrying a bow and arrow aimed heavenward. This represents his attempt to liberate himself from his lower nature and become that which he already is on the higher plane. There are two very different types of Sagittarians. Only the synthesis of the other planets will tell you which type is operating.

The average Sagittarian individuals are friendly, outgoing, optimistic and extroverted in their approach to life. They love sports and gambling and are willing to take a chance on anything. They are apt to be quite superficial in all their interests in the first half of their life. 'Don't fence me in' is their battle cry, for they are independent and freedom is the breath of life to them. The mate of a Sagittarian has to understand this quality in them, for they can't be pinned down. They are like their opposite sign, Gemini, in this respect. Half the difficulties in married life and in families would be overcome if people understood the qualities inherent in each sign. Each one of the twelve signs of the zodiac has a different temperament. Where Capricorn clings to tradition and the past, Sagittarius couldn't care less. The Sagittarians are interested in the forward thrust, moving into the future. They love to travel and are the gypsies of the zodiac. Sagittarius rules the hips in the physical body; without the hip movement we couldn't move freely.

As the Sagittarians reach the middle part of life's journey, their desire for distant horizons begins to turn inward and upward. Then the superconscious regions and spiritual philosophies begin to interest them. They will not be caught in dogma or creed, but the spiritual life begins to dominate their thinking and feeling. They have an innate under-

standing of people that makes them good counselors, ministers, personnel directors and workers in humanitarian movements. They are the salesmen par excellence and the promoter types. When unevolved they can be the confidence men. Their glib tongue and easy-going manner can be very deceiving.

Sagittarius' keyword is 'perception', another word for intuition. When we understand the meanings of the symbols much that now lies hidden in darkness will be clear to us. Jacob, in the Bible story, was lame in his hip (his understanding). He had to wrestle all night with the angel and he could not let the angel go until it blessed him. Darkness or night symbolizes the darkness of our own ignorance; the angel was his problem. We all have them. We never lose the problem until we find the reason for it. Then, when we receive our understanding, the problem dissolves and we never need face it again.

One of the Sagittarian liabilities is procrastination. They do put off until tomorrow that which they could do today. Then, because their conscience gives them a bad time, they get 'nerves.' Lack of organization and lack of discipline always takes its toll on the nervous system. Would that more of us would realize this truth!

Sagittarians are as direct as arrows and sometimes as harmful. They have an unerring ability to hit the other fellow's weak point. Tact is a needed virtue, and the lovingness of Venus can help them build it in. Females in this sign have difficulties in relationships with men because of their lack of femininity. They want to run the show and need to learn to be feminine. The masculine type that they so much admire will run when they feel their aggressiveness. The only type the opinionated females can attract is the Caspar Milquetoast types and how they dislike them. Yet the electric law is at work. Positive poles attract the negative polarity.

CAPRICORN

Capricorn: Ruled by Saturn.
A receptive, feminine sign.
Cardinal, earth.

The Sun is in Capricorn from December 21st to January 21st, approximately. It represents 'the mountain goat, climbing toward the heights, solitary and alone.' Keyword: 'I use.' Rules the bones, the skin and the knees in the physical body.

Capricorn is the natural ruler of the tenth house, the amplifier of what the person attains, or does not attain, in prestige, honor and success before the public. Capricorn is a 'testing' sign and the tenth house is of deep significance to the soul on its journey to the highlands of spirit. Capricorn is symbolized by the mountain goat, solitary and alone, who climbs to the heights with patient persistence. He faces calculated risks in that climb, but nothing is going to stop him before he attains his objectives. Is it any wonder that Capricorn rules big business?

Capricorn people can exemplify the highest or the lowest qualities of which human nature is capable. They are capable of great strength and have a strong sense of purpose. How they use that strength and what that purpose will be is of utmost importance. Expediency is a Capricorn keynote. "How can I use this?" differs from "How can this be of use to others?" These attitudes show the difference between the un-evolved and the evolved soul born in Capricorn.

Where Leo rules by the divine right of kings, Capricorn rules by delegated authority. The Capricorn's strength lies in leadership and in humility. Too often their weaknesses lead to false pride and to the as-surance that they are the only ones who know what is good for the other fellow. Materialism is very strong in the people of Capricorn. Money is extremely important to them, not for the money itself but for the power it wields in the outer world.

Respect and reward have to be earned in the sign of Capricorn. Great wealth or power entails great responsibilities. Some of the robber-barons that took advantage of the laborers at the turn of the century found this out. They tried to right the wrongs they had done and gave a great deal of their finances toward humanitarian causes, but their dues had to be paid. They were paid through the instrument that the Capri-corn values most — the body. Good health was the one thing their money could not buy. Saturn, the ruler of Capricorn, keeps a perfect set of books. We might break legal laws but we can't break cosmic laws. Everything in the universe goes back to its source. Everything we do, good or ill, re-turns to us. This is the Law. Sooner or later, everyone of us gets what he deserves, no more and no less.

The positive qualities of the Capricorn people are leadership, patience, persistence, efficiency and practicality. They are ambitious and willing to work and to work hard for what they want. There is strength and in-tegrity in the higher type Capricorns. They are dependable and confident, and give confidence to others.

Tradition, home, mother, the past (often exemplified through their love of antiques) ; these are important to the people of Capricorn. The Capricorn male clings to mother even after marriage. While mother lives she is at the hub of his life. This can lead to complications in marriage. Too often Capricorns are much nicer to people out in the world than they are to their own family. So many times they have been accused of being a "street angel and house devil." Too often this can be true. They are the disciplinarians. "Do it because I say so." This is because they do not understand the other fellow's feelings.

Capricorns are accused of being cold and insufficiently concerned about those close to them. This is true if Saturn or the Sun has afflictions in the chart. Then they are apt to want their own way regardless of the other person's feelings. They may not consider the fact that every indi-vidual has the right to his own feelings and his own freedom. The antidote for an afflicted Saturn is Venus. Love is the healing force that dissolves arrogance and selfishness.

A Q U A R I U S

Aquarius: Ruled by Saturn and Uranus.

Positive and masculine in expression.

Fixed, air.

The Sun is in Aquarius from January 22nd to February 21st. Represented by the "clear crystal electric air of winter." The keyword is 'I know.' Rules the ankles and the circulation in the physical body.

Aquarians are the mental pioneers, the forward thinking individuals who live in the future and not in the past. They are outgoing and impersonally friendly and appear to have a great deal of confidence. The fixity of the sign is not apparent on the surface, but Aquarians are inflexible in their ideas and cannot be pushed into anything they do not want to do. There is an impersonality and a detachment that is maddening to those who are completely immersed in their emotions. Aquarians approach life through their intellects and it is difficult for them to understand those who respond to life emotionally. Aquarians function exceptionally well in the scientific fields or in research work of any kind.

Aquarians are much more emotionally involved in their work then they are with people. It is important that they like the type of work they do for it occupies most of their time and they invest most of their vital force and energy in their occupation. The Aquarian's home is important as a status symbol. It has to be a home that increases their sense of pride and prestige.

Aquarians heartily dislike any restraint. They are rebels and individualists that have to go their own way, learning their own way. Independent, imaginative, creative and inventive, there is a genius about them if they are evolved. If they live on the destructive side they can be mentally cruel, sadistically so, and totally lacking in love or mercy. Because of their strong will that brooks no interference with their desires they have difficulties in marriage or in unions.

They have strong physical bodies though they would rather use their minds than do physical work. Aquarians are critical and demanding in positions of authority and it is not easy to be their employees. There is a coldness and a detachment that repels rather than attracts, especially if the Sun is afflicted. When they are evolved and their emotions are tenderized, no sign is more magnanimous or as monumental. When they 'feel' love instead of 'think' it they are great souls. No one can 'think' love; one has to 'feel' it.

The Aquarians usually have two types of friends, and never the twain do meet. They have the conservative, traditional type and the unconventional bohemian friends. One type represents the Saturnian side of their nature, the other group the Uranian side.

Aquarians work well in organizational work or in big business. They are capable of being good leaders and organizers. They are the individualists who are ready and willing to break new trails where inventive ideas

and new procedures are concerned. When Aquarians are of the higher type, they make lasting contributions to the world. Lincoln, Edison, Franklin Roosevelt, Wendell Wilkie and Evangeline Adams were Aquarians.

In a cosmic sense, the sign Aquarius is very important for it is the sign of the 'incoming age.' The Cosmic year is of 25,000 years duration. Each Cosmic year is about 2100 years in time. We are just leaving the Piscean age. Pisces is the twelfth house sign of restriction and limitation. It is an emotional sign and has more to do with faith than reason. Its keyword is 'I believe.' The keyword of Aquarius is 'I know.' We stand between two ages and to faith must be added "knowledge" and "intuition." Intuition is inner knowing.

Aquarius has two rulers: Saturn and Uranus. They must work together or chaos will be the result. Uranus is the shattering force that breaks up old forms. Saturn is the agent which crystallizes forms or structures and establishes them in an ego complex. Saturn is the oldest of the gods and represents the first law of manifestation: the law of limitation. Without the concentration of energy within a defined field of activity there would be no power or focus. Uranus represents the power or life force; Saturn represents the confining form that makes it useable on the earth plane.

If we can understand these two energies we will understand what is happening in the world today. Without the responsibility inherent in Saturn the force of Uranus can cause destruction and chaos. Without discipline (Saturn) there can be no real freedom. Freedom without responsibility is license and not liberty.

Old molds, old concepts, those things which have outgrown their usefulness in every area of life are being shattered. When the Saturn form is shattered it sets the spirit free to function in a greater expanse of consciousness if it will. On the unevolved, Uranus can act destructively, for they break out into irresponsible destructive actions and they need a strong sense of the Saturnian common sense to steady them. The unevolved of today are sweeping away old forms of control and of government without possessing the necessary inner self-control to see them safely through this time of transition. Self-control is the highest aspect of Saturn; suffering is its lower aspect. No one can cop out on responsibility without paying a steep price later in life. No one can break the cosmic laws with immunity.

Aquarius is the sign of spiritual rebirth. The desire for it is strong in the youth of today. They are riding the wave of the new age. Spiritual rebirth through drugs is an illegitimate birth and will damage the mother and the child. The drugs act like an explosion of the atoms in the mind and the atoms will be difficult to reassemble so that the individual can have focused and concentrative power.

In this age, Saturn (responsibility) and Uranus (liberation) go hand in hand. The whole problem of liberty is involved in Aquarius, the Liberator. True liberation can only come from within.

PISCES

Pisces: Ruled by Neptune with Jupiter as co-regent.
A feminine, receptive sign.
Mutable, water sign.

The Sun is in Pisces from February 21st to March 21st. Keyword: 'I believe.' Represented by two fish tied together. Rules the feet in the physical body.

Pisces is the last sign of the zodiac and the inner self is preparing to retreat from the world. It is cleaning up the odds and ends that have not been cleared in the other eleven signs. For this reason some students call it "the dustpan of the zodiac." The symbol of the sign is an interesting one to study; the two fish, tied together. In Gemini the two lines of force were connected but not tied. In Pisces, one fish swims downstream representing the personality, the other fish swimming upstream represents the soul. Either the soul captures the personaltiy and it becomes the servant, or the soul is bound and made captive by the personality. This brings deep suffering to the people born in Pisces. This is why the spiritual motto of Pisces is "serve or suffer." The choice is there and it is one or the other. There is no other way.

Pisces is the most sensitive sign of the zodiac and emotions are strong and deep in this sign. They are moody and introspective and hard to understand. The world is not their habitat and the need to escape from it is very great. Pisceans need to be alone and do need to retreat from contact with the world in order to retain their equilibrium. Everything for renewal must go back to its source. When Pisceans are connected with the inner source of their Being, they are capable of great achievements. When they are not connected their way of escape is often through alcohol or drugs. Then, because of their psychic sensitivity, they are the prey of obsessing entities from the lower psychic levels. Individuals born in Pisces have deeply hidden inner pride. Assail it at your peril.

Pisceans suffer from an inferiority complex and a sense of unworthiness. They never feel that they do enough so they often overwork, putting stress and strain on the physical body. They do not give it enough attention. It is the temple of the living Spirit. Pisces, like Scorpio, must overcome the sensual response to life. They can be self-indulgent and wallow in the senses. Then they make of the temple a tavern and great suffering ensues.

Complete resignation and submissiveness to whatever stream they are in — whether it be love or lust, work or pleasure — is indicative of the Piscean nature trying to lose the sense of separateness. The only true freedom for Pisces comes through spiritual orientation. When they are true to their real nature Pisceans have a high and holy destiny and are the true saviours and servants of mankind. They have a great sense of compassion and sacrifice themselves in utter devotion for the redemption of the world.

Pisceans have a deep love of music and are fine muscians when they pursue music as a lifework. They make wonderful doctors and in any area of the medical field do excellent work.

CHAPTER 3
The Planets and Their Meanings

Planets are the focal points through which the radiations from the Sun pour forth upon the earth, and as they revolve about the Sun the angle of that radiation changes. In the spring that angle is such that life is renewed. It surges forth. It is the most dynamic time of growth whether it be the spring of the year, or whether it be youth, the springtime of an individual. In the summer the angle changes. The Sun is higher in the heavens; it is hotter. It dries and heats, not because the Sun is nearer the earth, for it's farther from the earth at the summer solstice, but because of the angle of its radiations. In the fall the angle has again changed, and life begins to withdraw. Thus, it is the change of the angles that causes the seasons.

The earth planets are seven in number: the Sun, Moon, Mercury, Mars, Venus, Jupiter and Saturn. Think of them as great planetary beings that have charge of the evolution of the earth. They are the seven spirits before the throne of God mentioned in Revelation in the Bible. Their energies play ceaselessly and directly upon the earth. As the evolution of the earth has progressed, great beings were called from outer space to step up its progress. These beings wear the vestures of the planets we call Uranus, Neptune and Pluto. Uranus (intuition) is the higher octave of Mercury (intellect). Neptune (divine compassion) is the higher octave of Venus (personal affection). Pluto (regeneration) is the higher octave of Mars (animal energy).

Planets		Rulerships	Keywords
Sun	☉	Leo	Will, individuality, spirit
Moon	☽	Cancer	Personality, matter
Mercury	☿	Gemini, Virgo	Mind, link between spirit and matter
Venus	♀	Taurus, Libra	Personal affections, appreciation
Mars	♂	Aries, Scorpio	Energy, initiative, courage
Jupiter	♃	Sagittarius, co-ruler in Pisces	Principle of expansion
Saturn	♄	Capricorn, co-ruler in Aquarius	Principle of contraction
Uranus	♅	Aquarius	Independence, originality
Neptune	♆	Pisces	Compassion, chaos or cosmos
Pluto	♇ / ♀	Scorpio	Regeneration, coercion, or cooperation

PLANETARY SYMBOLS AND THEIR MEANINGS

The basic symbols of the planets are represented by the

O Circle

☽ Crescent

+ Cross

The circle represents that which is boundless, eternal, infinite, without beginning and without end. It is often represented by the serpent swallowing his own tail.

The crescent represents the personality, half the circle, the outer aspect of being.

The cross, wherever this is found, symbolizes earth living; the opposition of the human and the divine. It is the signature of this planet for this is called the Planet of the Sorrowful Star. We are the rebel angels that set our will against the Will of God in order to learn to be Gods in our own right. Man, when he stands upright and extends his arms is in the form of a cross. When the outer self becomes the reflector of the true self, then we can truly say "I and my Father are One" and can understand the meaning of the phrase, "No man cometh to the Father except through me." The "me" is the personality that has to become the servant of the High Self. In the Aquarian Age this will come about through the redemption and mastery of the personality rather than by crucifying it.

The symbol of the Sun is ☉

The circle represents the eternal self that did not start here and does not finish here on earth. The dot in the middle represents the divine spark at the center of every living cell; the "light" which lighteth **every** man which cometh into the world. It is the point of Light at the center of every living cell.

In the blueprint the Sun represents the main expression of the individual — the heart and core of beingness. The Sun has a different effect on individuals born at different times of the year. According to the sign and house in which the Sun is placed we are able to judge the general vitality and physique, the qualities of leadership and the individual's ability to be successful in life. Where the Sun is placed by house is where the ability to make a significant contribution to life lies.

In a personal chart the Sun represents:
 The basic drive for significance.
 A powerful Sun means very great power to do and to be.
 The will.
 Male relationships in female charts, especially the father.
 Vital energy coming from the etheric levels. Prana.
 Fuel on which the total personality operates.
 Urge for power.

Constitutional strength.

Rules the heart and spine in the physical body.

Rules the sign, Leo, and is natural ruler of the fifth house.

The symbol of the Moon is ☽ *Leo 10th*

The half circle is the symbol of the personality. It, like the Moon in the physical sky, has no light of its own but must shine by the reflected light of the Sun. The personality acts, or should, as a reflector of our true selves, the Sun. The Sun is the greater Light and the Moon is the lesser Light. The periodical ebb and flow of energy in and on the earth is produced by the combined electrical and magnetic forces of the Sun and Moon. The ebb and flow of emotional tides are shown in the blueprint by the Moon. Where the Moon is placed by house is where our emotions have full sway.

In a personal chart the Moon represents:

Personality.

Subconscious self.

Feelings and receptivity.

Mother and female influences in a male chart.

Femininity.

Memory.

The habit patterns of the past.

Mass consciousness — the public (ruled by emotion, not reason).

Functional power of the body.

Stomach and breast in the physical body.

Rules the sign Cancer and the natural ruler of the fourth house.

The symbol of Mercury is ☿ *Pisces 5th*

Here the three symbols are shown; the cross, symbol of earth manifestation; the circle, symbol of spirit; and the crescent, the cup that symbolizes the uplifted personality.

Mercury is the planet ruling intellect and intelligence; the mind, not the brain mechanism that is ruled by the Moon. Mercury is the link between heaven and earth. Both are within us. The mind is the link between the soul and the personality. Mercury has rulership over the nervous system. All communication, within and without, is possible only through Mercury. He is called the "Messenger of the Gods" for he travels ceaselessly and does not travel a one-way street. He tends to excite activity. He uses everything in the outer as well as the inner world as grist for growth and progress. Mercury is neither male nor female but a neutral planet that acts as a mirror to reflect whatever is in its vicinity. In insanity he withdraws from the magnetic field and the connection between the soul and the body is severed. Wherever Mercury is placed in the birthchart is the area where attention and awareness must be focused and techniques and skills learned.

In a personal chart Mercury represents:

Intellect and intelligence.
Logic and reasoning power.
Perception.
Communication.
Speaking and writing.
Educational capacity.
Brothers and sisters.
Techniques and skills.
Youth.
Short journeys.
In the physical body it rules nerves, lungs, shoulders, arms and hands.
Mercury rules two signs, Gemini and Virgo, and is the natural ruler of the third and sixth houses.

The symbol of Venus is ♀

The circle of spirit above the cross represents the spirit overcoming matter through love. Venus is the power of cohesion and attraction and draws things together in a synthesis.

Venus draws to itself through the magnetic attracting power of love. It is a feminine receptive force and never compels issues. Venus uses the power of persuasion in a quiet, gentle way. It rules personal affection where the higher octave of Venus, Neptune, rules divine compassion.

In a personal chart Venus represents:

Social urges.
Affection.
Beauty.
Values — what we appreciate.
Art.
Attraction and cohesion.
Melody and song.
Love of luxury.
Rules the venous blood, in the higher creative centers the throat and larnyx.
Venus rules two signs and two houses: Taurus and the second house, the earthy and materialistic Venus; Libra and the seventh house, the cultured and esthetic Venus.

The symbol of Mars is ♂

The symbol of spirit held down by matter gives an indication that Mars rules the animal self, not yet redeemed by the inner self. There was a time when the symbol was made in this fashion — ♂ — showing the complete subjection of the spirit to matter. Now the energy, like the arrow, can be magnificently used by the spirit to raise the animal energy to the level of spirit.

Mars is a positive, outgoing, outthrusting energy, masculine in expression. He tends to scatter matter for he drives from the center of the self outward. Mars has a great deal to do with the physical self for it rules the human animal. On the emotional level Mars gives the drive to our feelings. When feelings are activated Mars is as responsible for courage as he is for temper. The energy is the same. It is the USE of it that names it. Essentially Mars is fire; without the fire of life and an enthusiasm and passion for livingness there is no vitality. Where Mars is placed in the natal chart is where there is great energy that can bring strife and tension if it is not handled properly.

In a personal chart Mars represents:

Courage.
Dynamic energy.
Aggressive urges.
Strife, war.
Activity.
Combativeness,
Struggle.
Sports.
Mechanical ability.
Initiative.
Selfishness.
Passion.
Rules two signs: Aries and the first house (sign of beginnings) and Scorpio and the eighth house (sign of death, endings).

The symbol of Saturn is ♄

The symbol shows the cross of manifestation above the crescent; the Moon or personality held down by the cross. The only portion of ourselves that can be crucified is the dark self — the personality. Saturn can not touch YOU — only the mask which you wear. All restraints and limitations imposed by Saturn are really in the individual himself. The world of appearance is a mirror in which we see reflected our own nature.

Saturn is called the oldest of the gods and to this angel was given the rulership of the earth (the personality). Saturn represents the first law of manifestation; the law of limitation. Saturn focalizes or concentrates energy. Saturn is called Father Time and the Reaper, for time brings all manifestation to an end. It is also called the planet of necessity for it demands acceptance of the material world as the temporary proving ground for the spirit.

Wherever Saturn is placed by house or sign, the keynote is Conservation. Saturn is not the creator of our difficulties or successes. But as each individual sets the creative processes in motion, Saturn relentlessly brings back to the individual his own creation. Saturn shows the weaknesses and lacks in the character so they can be changed into strengths. In the birthchart Saturn is the ruler of the ego, for it collects and retains

the impression made upon the consciousness through experience. It gathers the fruit of every experience and builds it into soul power. Saturn builds in time for eternity. In understanding the mission of Saturn lies the solution to the mystery of life. Saturn builds walls around the self until it is strong enough to stand without them. It is a constricting, contracting influence until the soul is strong enough to break down the selfishness and separateness in him and go free.

Saturn rules the signs, Capricorn and Aquarius; signs that are not concerned with generation and the vital animal forces. Capricorn rules the knees and Aquarius rules the ankles; the two parts that enable the body to bend and to move forward. Capricorn rules the bony structure, the skeleton on which all the rest of the body is suspended. Rigidity and flexibility are ruled by Saturn. Kneeling, the power to bend, is a sign of humility, reverence and obedience, and these qualities are the antithesis of the Martian spirit of aggressiveness and combativeness. The movement of the joints in walking enables the person to move forward. Man's upright position is possible through the scaffold (the skeleton) that enables him to stand upright.

In the ancient mysteries Saturn (or Satan) was represented as the Tester, and tried the person's endurance until he grew strong enough, as a soul to withstand the demands of the personality. Saturn's job is to destroy the old, the outworn forms in order to build a better structure on a higher level. In Hindu astrology, Saturn is related to the God, Shiva, the destroyer. Saturn's mission is to destroy all that is outgrown in the personality. The destroyers have to break down the past before the builders can come. In this era of time it helps to remember that the old age of Pisces is outmoded and outgrown and Saturn is destroying the old forms in order that new energy (through Aquarius) can come in. Astrology gives the clue as to what is happening in the world of today. Saturn does not bind forever, due to its being the law of limitation. It builds the circle that holds us in until we are strong enough to break the wheel and go free. Saturn is the bridge between the animal self and the real Self, the spirit.

Saturn is called the Lord of Karma and, inasmuch as it shows the area (house) and qualities (signs and aspects) which we need to change and redeem, it is. The Hindus speak of Dharma as one's duty of responsibility in life. That is what Saturn represents in the birthchart. It indicates where our responsibilities lie and what our life's lessons must be. Saturn is the individual's approach to life; where he has to accept the responsibility of making his own world according to the conditions that Saturn defines. Saturn indicates the places where he must conform and accept if he would know security, within and without. Where Saturn begins (by house) in the chart is where the individual must begin. Where Saturn operates by transit is where, by necessity, the individual must submit to tests and trials. The house in which Saturn is placed at birth is where the individual must start his structure of security, responsibility and self-sufficiency.

Saturn in Fixed signs shows the stability of the ego, its power to resist pressure from without. In a Cardinal sign, Saturn shows the power to change through becoming immersed in activity. In a Mutable sign Saturn's power to be adaptable helps but too often there is too much indecisiveness and not enough strength to overcome conditions.

Saturn is directly concerned with character building and is one of the greatest angels in the universe. This angel was given the hardest job of all; to test and try man's soul until he learned to break his self-imposed bonds and go free. When man uses the Saturn force negatively he is filled with selfishness and fear. He who is selfish must know fear. These are the siamese twins of consciousness; one can not live without the other. Love, that asks nothing but to give, is the antidote for an afflicted Saturn.

In a personal chart Saturn represents:
>Time.
>Safety urges.
>Discipline.
>Principle of contraction and crystallization.
>Organization.
>Ambition.
>Limitation and delay.
>Old age.
>Wisdom gained through experience.
>Self-preservation.
>Rules bones, skin and teeth in the physical body.
>Rules Capricorn and the tenth house in its feminine aspect and Aquarius and the eleventh house in its positive expression.

The symbol for Jupiter is ♃

Here the personality is risen above the cross and is no longer confined by it. Jupiter has rulership over the superconscious Self in each and every earthchild. Nothing can confine, restrict or limit that Self. This is the Self that was supposed to be in command for that Self is eternally one with the Divine. But the personality took over and no longer was it the Will of the Father in Heaven (the positive pole — the Spirit) but "let my will not Thine be done." And so began the difficulties on this planet of the Sorrowful Star.

In a personal chart Jupiter represents:
>Principle of expansion.
>Aspiration and inspiration.
>Superconscious Self.
>Understanding.
>Prosperity and abundance.
>Faith and optimism.
>Religion and philosophy.
>Friendliness.

Judgment.

Rules cell growth, the arterial blood and the liver in the physical body. By house, the area where your fulfillment lies.

Natural ruler of Sagittarius and the ninth house, and is co-regent with Neptune in Pisces and the twelfth house.

The symbol for Uranus is ♅

The symbol of Uranus is composed of two moons or pillars, one human and one divine, back to back. These two are joined together by the four-armed cross of matter, with the circle of spirit (the Sun) pushing them to higher levels.

Uranus is the symbol of the highest energy of all. It symbolizes the Sun behind the Sun. The American Indians called the Sun a hole in the sky. They knew intuitively that there was a greater Sun behind our physical Sun. In mythology Uranus was given rulership over heaven while Saturn was given rulership of the earth. Uranus is the planet of destiny and is the **only** planetary energy you cannot control. The only thing you can control is your reaction to it.

Uranus, higher octave of Mercury, represents intuition that comes like lightning in a flash of knowingness. It is the planet that rules astrology for it gives insight into the cosmic laws that concern the relationship of man and the solar system. Only those who have an angular Uranus (1st, 4th, 7th or 10th houses) or have Uranus configurated with the Sun, Moon or Mercury are true Uranians. Most Aquarians are more Saturnian than Uranian and this will puzzle you unless you understand that the New Age egos will have Uranus, not Aquarius, prominently located. The test of Saturn (discipline and responsibility) must be passed before we know the freedom inherent in Uranus. Otherwise liberty means license, not freedom.

In the birthchart Uranus represents:

Freedom.

Independence.

Originality and genius.

Individualism.

Unexpected, sudden and unpredictable changes.

Rebelliousness.

Electricity.

Cosmic consciousness.

Transformation.

The Divine will.

Inventions.

Co-ruler with Saturn in Aquarius and natural ruler of the eleventh house.

The symbol for Neptune is Ψ

The symbol for Neptune shows the cross piercing the cup of personality in order to set it free to manifest on a level above selfish pursuits. Neptune's keyword is 'Serve or Suffer.' The choice is yours but choose you must. It was the Neptunian Master of the Piscean Age that said, "He who loses himself (his personality) shall find himself (the soul)."

Neptune's vibration is not of the earth, earthy. It rules the next dimension and is an elusive, mysterious and subtle emanation. It is a pervading energy that seeps into the consciousness. Neptune is the mystic where Uranus is the occulist. Neptune works through feeling and the imagination. It gives mediumistic ability and psychic powers. In some charts it gives a strong dislike of facing reality. It prefers to dream rather than to act. Where Uranus is too positive in insisting that his ideas be put into action (often prematurely), Neptune is too negative and procrastinating to put his ideas into operation. It is a feminine vibration where Uranus is a masculine one.

In a personal chart Neptune represents:

Obligation — in whatever area it is placed in the blueprint, one must serve the universal whole.

Sensitivity.

Psychic and mystical- capacity.

Cosmic consciousness that comes through devotion and feelings.

Chaos or Cosmos.

Dreams, night or dav.

Material bondage.

Illusion and disillusion.

Deception.

Alcohol, drugs, anesthesia.

Suffering.

Divine compassion.

Ed. note: For the discussion of Pluto, see Chapters 32–39. For the meaning of the symbol of Pluto, see pp. 284 and 287.

CHAPTER 4
Keywords of the Planets

The Sun is the significator of the Spirit in Man; the BEINGNESS or ISNESS of life; the immortal part of man's complex manifestation. It rules the basic drive for significance — the will-to-be.

Physically the Sun is the sustainer of life, giver of light, heat and energy.

More than anything else in the chart, it shows the WILL, Man's highest expression.

Its aspects show deep character traits, the chief ambitions. It needs aspects to the planets for strength of expression in the horoscope.

As the Sun moves through the signs, its return to the sign of its exaltation, Aries, the Eastern horizon, marks the beginning of the astrological year. Springtime brings the release of a new cycle of life.

As the Sun moves through the houses, its return to the Eastern horizon is the beginning of the astrological day — sunrise.

Basic	Positive	Negative
Will	Self-consciousness	Self-will
Determination	Strength	Cruelty
Dignity	Authoritativeness	Austerity
Confidence	Positivity	Arrogance
Reliance	Individualism	Willfulness
Vitality	Power	Aggressiveness
Loyalty	Leadership	Dictatorialness
Poise	Confidence	Egocentricness
Fortitude	Courage	Overbearingness
Optimism	Faith	Pessimism

THE MOON — BUILDER OF FORM
The Moon is the significator of the personality, and the subconscious and instinctive patterns therein. The Moon rules the form side of life and the functional activity of the body. Birth and death are under the dominion of the Moon. The tides and rhythms of the body, as well as the tides in the ocean, are under the influence of the Moon.

The Moon rules the emotional and feeling side of man's nature. It rules the public (mass consciousness) which does not reason but responds to life through emotions. The demagogues know this fact well. They are able to influence public opinion by playing on the emotions and feelings of the people.

The Moon in the physical universe has no light of its own. It shines by the reflected light of the Sun. The personality has no light of its own. It is like an unlit room. Only when the light of the Real Self (the Sun) shines through is it truly illumined.

The masculine, positive Sun rules the Spirit and is electrical in nature; the feminine Moon rules Form, the receptive and magnetic pole of life.

Basic	Positive	Negative
Matter	Growth	Materialism
Maternalness	Protectiveness	Smother love
Flexibility	Plasticity	Emotional Instability
Sensitivity	Positive Psychism	Negative Mediumship
Receptivity	Magnetism	Passivity
Feeling	Peacefulness	Moodiness
Imagination	Creativity	Visionary
Domesticity	Kindness	Worry
Sympathy	Impressionability	Changeability

MERCURY — THE LINK OF MIND

The masculine Sun rules Spirit, the positive polarity. The feminine Moon rules Form, the negative polarity. Androgynous Mercury rules the reasoning Mind, the link between Spirit and Form, and is the "Messenger of the Gods."

With the reasoning mind we are self-conscious; aware of the activities in the world about us. We are able to perceive and evaluate through thought and action, to observe cause and effect, action and reaction.

Mercury is the link of communication. Inwardly, the link of reason between spirit and form; externally, the senses permit communication between ourself and others.

Through reason man has freedom of choice and is responsible for his own acts. He has the opportunity for self-conscious advancement and growth and can become aware of his divine origin and potentiality.

Mercury, being reflective, needs aspects for its expansion. The closest aspect is very important.

Basic	Positive	Negative
Reason	Brilliance	Skepticism
Agility	Alertness	Irresponsibility
Expressiveness	Articulateness	Verbosity
Adaptability	Versatility	Mental Instability
Duality	Discrimination	Indecisiveness
Analyticalness	Preciseness	Criticalness
Senses	Awareness	Diffusiveness
Changeability	Efficiency	Restlessness
Activity	Dexterity	Imitativeness

VENUS — BEAUTY AND LOVE

The masculine Sun rules Spirit, the Life Principle.

The feminine Moon is the Builder of Form.

Androgynous Mercury is the reasoning mind, the vehicle of self-consciousness — separateness. Through reason we become conscious of ourselves as separate, evolving beings.

Feminine Venus is the Goddess of Love and Beauty. Through love we are conscious of others and can understand the principle of union and achieve unity.

Life, form and reason are necessities of human existence. Venus changes existence to 'living' through the addition of love, art and beauty in all the departments of physical life. Venus is also the planet of harmony, cooperation and refinement. Through Venus we beautify ourselves, our appearance, expression and environments, and the lives of others.

We can exist without love and beauty, but we can not truly 'live' without love, beauty, cooperation, harmony and unity.

Basic	Positive	Negative
Beauty	Harmony	Indolence
Love	Devotion	Sentimentality
Art	Refinement	Ostentation
Sociability	Affection	Superficiality
Femininity	Attractiveness	Flirtatiousness
Impressionability	Responsiveness	Oversensitiveness
Gentleness	Courtesy	Indifference
Cooperativeness	Considerateness	Evasiveness
Originality	Constructiveness	Vacillation

MARS — DESIRE, ENERGY AND ACTION

Mars is the planet of Desire and dynamic energy — the planet of Action. It shows the urge and energy to accomplish, build and progress.

One way to realize our desires is to work and earn. Through this we develop the ability to hold our own against economic competition, gain self-confidence, and learn self-discipline.

Mars is also the planet of War. Through war we can experience hatred or heroism, killing or self-sacrifice, and we can find courage and endurance we did not know we had.

Besides the war with others, there is the struggle within for self-mastery. From the desire and action of Mars we gain valuable experience, experience which will ultimately teach us to use our energies constructively and transmute desire into Will and healing power. It is the use or misuse of this energy that makes one man a saint and another man a devil.

Basic	Positive	Negative
Energy	Enthusiasm	Domination
Dynamicness	Forcefulness	Defiance
Impulsiveness	Spontaneity	Violence
Leadership	Assertiveness	Combativeness
Courage	Heroicness	Foolhardiness
Expression	Frankness	Sarcasm
Independence	Self-reliance	Separateness
Generative force	Transmutation	Passion
Forcefulness	Fearlessness	Cruelty
Practicality	Constructive	Destructiveness

Scorpio 2nd (handwritten)

JUPITER — THE EXPANDER

Jupiter is the Greater Benefic. It is the largest planet in our system. Jupiter does things on a large scale. He is the Promoter, expansive, optimistic, popular, successful and generous.

Jupiter afflicted is overconfident, exaggerates, is extravagant, conceited, fond of display, and goes to excess in many things.

Jupiter is also the Preserver. We preserve food in tin cans; tin is Jupiter's metal. He is active and conservative in religious and philosophical activities, favoring the more orthodox and established religions. Ritual and ceremony are correlated with the Jupiterian energy.

Jupiter is the planet of the Higher Mind. He lifts man's eyes up; takes man out of himself and stimulates aspiration, idealism, tolerance, understanding and vision.

Jupiter also likes to live to the utmost, many times dissipating time, opportunity, money and energy.

Basic	Positive	Negative
Aspiration	Idealism	Impracticality
Generosity	Philanthropy	Extravagance
Benevolence	Understanding	Indulgence
Religion	Devoutness	Fanaticism
Orthodoxy	Reverence	Bigotry
Confidence	Faithfulness	Cynicism
Optimism	Radiance	Pompousness
Humane	Charitableness	Guillibility
Mercy	Kindness	Indolence
Dignity	Poise	Formality

Leo 10 (handwritten)

SATURN -- THE TESTER

Saturn's goal is **perfection.** Through the chastening process of testing, sorrow, delay, disappointment, limitation and privation, man learns the purpose of life is not pleasure but to gain experience, patience, humility, wisdom and compassion.

Through disintegration, old, worn out, useless and crystallized forms are destroyed so better, more beautiful, useful and adaptable forms may replace them.

Through experience, patience, persistence, and self-discipline we can change the negative Saturn qualities of skepticism, fear, suppression, materialism and self-preservation into confidence, dependability, reverence, wisdom and compassion.

In Saturn's silence, in retrospection, meditation, concentration, looking within for guidance, and be willing to wait, Saturn helps us to bear our karma and pass the tests of life and finally enables us to reach the perfection we must all attain in the process of evolution.

Basic	Positive	Negative
Caution	Patience	Fearfulness
Restraint	Self-discipline	Suppression
Seriousness	Humility	Sensitivity
Sincerity	Responsibility	Severity
Acquisitiveness	Thriftiness	Miserliness
Defensiveness	Diplomacy	Pessimism
Justice	Forebearance	Exacting sternness
Law	Respect	Rigidity
Stability	Endurance	Obstructiveness

URANUS — THE AWAKENER

As the discovery of Uranus changed the old planetary pattern and concepts, so Uranus brings changes into our lives today. The unexpected, sudden, erratic and unpredictable events are Uranus in action.

People with Uranus angular (especially in the first or tenth house), are highly individualized people living in the future and are interested in "now" things and developments. Science, astrology, metaphysics, and occultism are in the domain of Uranus. Uranians are creative and often need a hobby to express their creativity and use their energies constructively.

Being a slow moving planet, Uranus' house position is very important as it stays in a sign seven years. The conjunction or opposition of Uranus to a natal planet is very important.

Even with benefic aspects, Uranus changes are often disruptive, but it always changes the "status quo" for a new and better pattern. It destroys the ruts in which we can get stuck and sets us free. "Behold, I maketh all things new" is the keynote of Uranus.

As Uranus is invisible to the physical eyes, so we must use our 'inner perception' to respond truly to its higher vibrations. Only then does Uranus bring about the inner Awakening.

Basic	Positive	Negative
Independence	Progressiveness	Radicalness
Originality	Nonconformity	Rebelliousness
Genius	Inventiveness	Erraticness
Unconventionality	Spiritedness	Eccentricity
Idealism	Universal Love	Detachment
Reformer	Pioneer	Fanaticism
Intuition	Perception	Over-impulsiveness
Impersonality	Resourcefulness	Irresponsibility
Freedom	Individualism	Combativeness

NEPTUNE — THE DISSOLVER

"The brightest light casts the deepest shadow."

Neptune can reach the most sublime heights or the lowest depths. It rules the next dimension, the astral plane, and finds it difficult to be earthbound. It dissolves matter rather than builds it on the material level.

When Neptune is very strong in the chart, the native is very sensitive, secretive, and often dislikes the hard world of reality. They sometimes seek temporary escape by living in a dream world of their own creation, filled with visions, shadows, fantasy, erotic and bizarre daydreams. They dislike the awakening to reality. To them, the unreal seems real and the real seems unreal. They often feel the normal things of life are too commonplace and seek something more stimulating and sensational. Neptune is the great masquerader.

The positive aspects of Neptune show wisdom beyond reason, genius, creative ability in the literary, poetic and musical fields, intuition, clairvoyance, contact with the higher invisible realms, and the realization of the Unity of all life. Not everybody can respond fully to the higher vibrations of Neptune.

When afflicted, Neptune cloaks the issue with vagueness, obscurity, illusion, confusion, misunderstanding, intrigue and fraudulent appearances. The worst afflictions of Neptune indicate fearfulness, morbidity, introversion, sensuality, indulgence and obsession.

From the health standpoint Neptune sensitizes the organs and functions of the body. Afflicted it shows a hypersensitive, unhealthy and abnormal organ or function and can cause deceptive conditions which are extremely hard to diagnose correctly.

Being so slow in motion, Neptune's house placement is very important. It takes 14 years to go through a sign. The house it is placed in at birth is more important than the sign.

Basic	Positive	Negative
Sensitivity	Mysticism	Dreaminess
Inspiration	Impressionability	Fear
Compassion	Responsiveness	Over-sentimentality
Emotion	Sympathy	Self-indulgence
Imagination	Creativeness	Delusion
Clairvoyance	Visionary	Lives in fantasy
Universal Love	Understanding	Chaos
Quietness	Peacefulness	Inertia
Sacrifice	Devotion	Self-martyrdom

Ed. note: See p. 292 for the keywords of Pluto.

CHAPTER 5
Table of Planetary Powers

Planet	Ruler	Detriment	Exaltation	Fall
Sun	Leo	Aquarius	Aries	Libra
Moon	Cancer	Capricorn	Taurus	Scorpio
Mercury	Gemini	Sagittarius	Aquarius	Leo
	Virgo	Pisces		
Venus	Taurus	Scorpio	Pisces	Virgo
	Libra	Aires		
Mars	Aries	Libra	Capricorn	Cancer
	Scorpio	Taurus		
Jupiter	Sagittarius	Gemini	Cancer	Capricorn
	Pisces	Virgo		
Saturn	Capricorn	Cancer	Libra	Aries
	Aquarius	Leo		
Uranus	Aquarius	Leo	Scorpio	Taurus
Neptune	Pisces	Virgo	Cancer	Capricorn
Pluto	Scorpio	Taurus	Pisces (?)	Virgo (?)

PLANETARY POWERS

One of the most important tables to memorize in studying astrology is what is called 'Planetary Dignities.' On this rests all your understanding of 'the laws and the prophets.' In some signs the power of energy we call a planet is able to project itself without any hindrance for it is functioning in a field harmonious to its own nature. In other signs a planetary energy is blocked by being in a sign not compatible to its nature and its full expression is hindered. You will find the ability to judge the power of a planet very necessary in interpreting charts, especially when you are interpreting horary charts.

When a planet is in the sign it rules, it is said to be dignified because it is powerful in its own sign, and can express itself freely.

Planets in opposite signs to the signs which they rule are in their detriment. Their power is lessened by being placed in signs that are uncongenial to their own nature. For example Saturn rules Capricorn and the sign opposite it is Cancer and Saturn is in its detriment in Cancer. The mothering, nutritive, sentimental sign of Cancer is not a good place for the contractive, cold, practical Celestial Schoolmaster. It constricts and inhibits Cancer.

It is not hard to memorize the tables of detriments if you know the signs the planets rule. The detriment is the opposite sign. Planets in their detriment are regarded as unfavorable and weak.

Every planet has one particular sign apart from the one it normally rules in which it seems able to express its nature harmoniously and to the best advantage. This is its sign of exaltation. Here we see the expression of the energy in its highest form. Planets are only exalted in signs of compatible elements. Exaltation may be regarded much the same as a powerful and favorable aspect.

Planets that are in signs opposite to their exaltation are in the sign of their fall. It brings disappointment to the concerns of the planet and to a certain degree, those of the house in which it falls.

When a planet is placed in an angle (near or in the 1st, 4th, 7th or 10th house) it becomes very important. Hence, because of its place and not because of its sign, it is accidentally dignified.

A planet in its own sign is similar to a person in his own house. One is able to entertain as he sees fit or do as he wishes in his own home. He has the authority to do so. A planet in its detriment is like being in some-one else's house. He is not free and cannot do exactly as he pleases. Some-one else has the power so he is limited. A planet in its exaltation is similar to a person who is not only able to entertain in his own home, but has plenty of substance so he has no limitations whatsoever. A planet in its fall is like a person who has neither the substance nor the home in which to entertain. He must go to work to earn it. In the area where that planet is placed by sign he has failed to use, or perhaps has abused, the energy tied up in that sign.

SUN: Let's consider the Sun, the symbol of spirit, the life force of the universe. It is the greatest dynamo of all. It rules Leo, sign that rules the spine and the heart in the physical body. Will (spine) and Love (heart) are the motivating powers of desire and the will to be. Without the driving power of desire there would be no motivation of Will. In August, sign of Leo, the Sun is all powerful as far as self-consciousness is concerned. The Sun in the heavens is at its greatest power. In February, sign of Aquarius, the Sun is in Saturn's positive sign. It is held by the clear, cold, electrical power of Aquarius, congealed and crystallized. The personal warmth and affection of Leo are replaced by a cool, impersonal and intellectual ap-proach to life. Here the Sun is in its detriment. Does not the Aquarian need to remember that no chicken trying to break out of its shell ever hatched in a refrigerator. It takes loving warmth to bring forth new life and new desire to be. In doing charts it is well to remember that Aquarius is ruled by two planets, Saturn and Uranus. Freedom (Uranus) without discipline (Saturn) is license, not liberty.

The Sun is exalted in Aries. Aries initiates activity. It is the impulse to be — the divine spark in each of us coming into matter. Wherever Aries is placed in the chart is where we begin to operate; where we plunge into activity and this energy has all the power of the solar ego behind it. In nature lies the secret of life. The Sun force that pulls the sap up in the trees and the plants in the spring is the force that starts new energy flowing. There are two pulls operating all through nature.

The Sun force pulling everything upward and the Saturn force pulling the roots downward, centering them in the earth. The Aries person rushes into activity propelled by the will and the desire to achieve a sense of livingness. No Aries is ever still for long. Unless they are active they are not happy.

In Libra the desire toward self-motivation has to take a back seat. The ego has to step aside for the sake of the other person. In a field where Saturn has full sway (Saturn is exalted in Libra) the Sun (Will) has no power of its own. The Sun falls in this sign for neither the soul nor the personality dominates; they cancel each other out. The individual stands at the midpoint between them. This is the reason Librans find it so hard to come to a decision. They want to be liked by all, so they sit on the fence and try to take two sides at once. This can lead to difficulties.

MOON: Symbol of the feelings and the subconscious. It rules Cancer, the mothering, nuturing sign, that has so much to do with the ebb and flow of the tides, whether physical, emotional, or mental ups and downs. In Capricorn the Moon is in its detriment. Here the personality has congealed and crystallized and needs to break up the selfishness of a negative Saturn. The Moon rules the personality. Note the difference between the person with the Moon in Taurus (where the Moon is exalted) and the person with the Moon in Capricorn. They can be equally worthwhile, but the person with the Moon in Capricorn has a harder time selling himself to the public. He has subconscious fears and an undercover pride and ego that is felt by others even though not a word is said. With the Moon in Taurus the personality operates in a Venus way drawing to itself through the attracting power of love.

The Moon is in its poorest place in Scorpio because it is in its fall. Here the aggressive, combative power of Mars dims the feminine quality of the Moon. However, there is a feminine magnetism based on the pull of the sexes. Here the personality must take a back seat (which it does not want to do) and let the sun light of the Self shine through.

MERCURY: Planet of consciousness; messenger between heaven and earth. Why is Mercury in its detriment in Sagittarius? There is a mystery hidden here and it is one of the secrets hidden in initiation. Mercury rules the dual sign, Gemini, but in the sign of the Universal Mind there is no duality. All is truly one. When the link is made between the Universal Self and the personality then truly "I and my Father are one," and the mind as we know it no longer operates. This is a clue to the reason why Mercury is in its fall in Pisces. The critical, analyzing Mercury must be dissolved in the love and compassion of Pisces. When this is so, man needs no mediator but deals directly with his emanating source. For the un-evolved soul, Mercury in Pisces sensitizes him; first, to his own suffering, and then to the suffering of others. Doubt and depression are his greatest enemies.

Mercury in Aquarius is its best position for an earthling, and Mer-

cury in Virgo is the secondary place. Uranus, higher octave of Mercury, lends intuitiveness to the intellectual gifts of Mercury. Here the mind is not fogged up by emotion. Mercury in Virgo gives a practical common sense to the airiness of Mercury. Mercury in Leo is in its fall. The mind is dissolved in the light of the spirit (the Sun). On the personal level the ego must be dissolved and vanity and pride must depart.

MARS: Mars rules Aries and Scorpio. One goes forth to battle, the other retreats. The same energy is behind both signs. Scorpio's way of fighting is not direct and uncomplicated. It is subtle and powerful because it is contained and concentrated. Aries' battlefield is the world; Scorpio's battlefield is himself. Aries rules beginnings and Scorpio rules death, so the personality must die in Scorpio in order that the soul can come into activity.

Mars is exalted in Capricorn. Mars is the producer of conflicts and in Capricorn we have the triumph of matter. Mars in Capricorn is the warrior battling the earth in himself as well as the world outside. He has tremendous strength at his disposal and the power to use it. Mars in Cancer is shorn of strength where aggressiveness and combativeness are concerned. They are anemic psychologically as well as physically. They would rather run than fight and need to learn to face life with courage. Running away from conflict does not erase it. It is the postponement of an issue that must be faced later.

Mars is the polar opposite of Venus. Venus draws through the attracting power of love. Mars goes out to wrest it from circumstances. Venus is not happy in Mars' territory as Mars is unhappy in the territory ruled by Venus. Mars in Libra and Taurus are not very happily placed. Mars in Taurus is in a feminine sign; its difficulties have to do with overpossessiveness and jealousy. Mars in Libra is very difficult in a feminine chart for a masculine aggressiveness is apparent. The power of Mars is lessened in Libra for Libra is the halfway house between the sheep (Aries) and the goats (Capricorn). This deals with the positive and negative qualities; between those who follow blindly, either by tradition or instinct, and those who climb freely where they choose, and are self-directed. This direction may follow selfish desire or spiritual aspiration, but they will use their minds to decide which it will be. This gives a clue to the reason why Saturn is exalted in Libra. When one has reached the point where he can choose, he must be responsible for his decisions.

VENUS: Why is Venus in its highest position in Pisces? Because only through compassion does one sacrifice cheerfully and joyfully and not count the cost. The highest type of love is often misunderstood and crucified by the children of earth. So many of the great who came in Love to help the children of earth have been martyred; Jesus, Ghandi, Joan of Arc, Dag Hammerskjold and so many more. Venus in Pisces has a very difficult time on the planet. Their ideals of love are not geared to the earth. They are a bit different from the complaining one who said:

"Must I keep giving and giving again?

'No,' said the angel, piercing me through.

Give 'till the Lord stops giving to you."

Venus in Taurus is the earth Venus. Venus in Libra is more cultured and artistic. Venus is in its fall in Virgo. This is an indication that the critical and analytical mind is far from an understanding of love. When a person has Venus in Virgo they may be discriminating and proper but they are extremely unloving and apt to be faultfinding. They have not yet learned to love and have difficulty in attracting love because of their own lack. They can change, and the secret is hidden in the higher meaning of Virgo; service and humbleness of heart. Willing to be nothing in order that the hidden Christ can come forth. Venus in Scorpio or in Aries is not happily placed for the animal self (Mars) overpowers Venus.

JUPITER: Rules Sagittarius and is co-regent in Pisces. The energy that deals with the Superconscious or Universal Self. In the sympathetic, mothering sign of Cancer it is in a powerful position. It is exalted. It expands the feelings and expansive, optimistic feelings are the secret of living fully. In Gemini, where it is in its detriment, the Higher Mind is brought down to the level of the scattered and dualistic Gemini. There is waste for it dribbles away in non-essentials. Jupiter in Capricorn is held back by the materialism and cautiousness of Capricorn. In this sign Jupiter reaches its lowest and densest material aspect. Selfishness and materialism must be overcome.

SATURN: Lord of the World in us all. Keeper of the Records. Lord of Karma. Dweller on the threshold but also the Angel of the Presence. Here is a mystery and when one pierces through the veil Saturn proves to be the Angel of Light that reveals the meaning of it all. He plays a dual role. The greatest mystery sign of the zodiac is Capricorn. If the symbol of Capricorn is made correctly you will see that it is made up of Aries and Leo. The head and the heart. Do you remember what it said in the Scriptures? "The lion shall lie down with the lamb." When the head and the heart are united Saturn's work is done. The lion is tamed and the Ram is the Lamb of God. The goat becomes the unicorn (whose horn in the middle of the forehead depicts the third eye) and the going up to town of the old nursery rhyme (the lion and the unicorn were going up to town) contains the secret of the going up of the human being to the door of initiation. The defeat of the king of beasts (personality) and the emergence of the Initiate dedicated to selflessness and World Service are shown.

Saturn in Libra is exalted. Libra is the sign of union, of marriage, of cooperation and learning to compromise. What calls for more discipline (Saturn) than this? There is great strength and great power at the disposal of anyone with Saturn in Libra. They are not young souls and have been long on the path of evolution. The life may be one of struggle, but it will be a life of power if rightly used.

Saturn in Aries is in its fall. Saturn is the angel who 'followed the sons of man into their lowly place.' Saturn was the angel picked to play the least understood role of all; that of Satan or the devil. He puts the brakes on when Aries wants to go too far, too fast.

Saturn in Cancer is in its detriment. Like the Moon in Capricorn it congeals and crystallizes the nurturing, mothering principle. It inhibits the feelings and gives subconscious fears that are unrecognized by the individual. The person with this configuration needs to learn to mother; to pour themselves out whether it is returned or not. Thereby they will clean up their karmic slate.

URANUS: Uranus and Neptune are higher octave planets, and their powers are aligned to Mercury and Venus, respectively. Mercury is Intellect and Uranus is Intuition. Uranus works with the rapidity of lightning, and intuitive processes work as quickly. The intellect has been compared to a farmer, plodding along at 10 miles per hour and the intuition to a high-powered car passing the farmer at 60 miles per hour. The intellectual finds it difficult to understand the intuitive person. He finds him frustrating. The intuitive has reached his goal but do not ask him how he reached it because he does not know. The logic and reason of the intellectual individual concerns him not at all. He knows, and knows that he knows. Mercury (the Intellect) knows **why** he knows.

Uranus rules Aquarius. This explains the rapidity of vibration at the present time. An Aquarian Age is dawning and everything will be stepped up. The vibratory rate of the earth is changing, and this means every bit of life on it will be affected. Flexibility is the quality that has to be built into the consciousness of every earth child. Uranus is in its detriment in Taurus, the world of crystallized substance. Matter and material things are all important to the Taurian consciousness. The Uranian individual couldn't care less. Uranus' effect on Taurus is devastating for Taurus loves a rut and doesn't like change. Uranus went into Taurus in 1934 upsetting the world market and we went off the gold standard. The economic situation between 1934 and 1941 changed the status quo forever.

Uranus is in its detriment in Leo. This may be so on the outer levels, but this rule does not apply on the inner levels. On the personality, the Sun represents desire and the will; too often, self-will. When the little Will and the desire for significance have been turned over to the Higher Will, then Uranus in Leo can align the two selves, the little self and the High Self, and illumination is the result. It can be a very potent position for attunement.

Uranus is exalted in Scorpio, for there is great affinity between Mars and Uranus. Both are explosive, rapid, impulsive and work with great speed. Uranus is the healing power of Spirit. Mars is the celestial surgeon who cuts away all that hinders the flow of spiritual power.

NEPTUNE: Neptune is the higher octave of Venus. Venus is exalted in Pisces. Neptune is exalted in Cancer. Where Venus is personal love and affection, Neptune is Divine Love, sacrifice and compassion. Venus says, "I will love you if you will love me." Neptune says, "I will love you for it is the nature of Love to love."

Neptune is the Universal Solvent that melts all barriers with its persuasiveness. It is a feminine vibration of great exquisiteness. Neptune rules Pisces, the sign of understanding, and the last sign of the zodiac. Divine love is the final attainment, where sacrifice is joy, and suffering is lost; there is no personal self left to suffer.

Neptune is unhappy in the critical, analytical, detailed Virgo. Here it is in the sign of its detriment. Virgo discriminates, weighs everything to see if it is worthwhile in an earthly sense. Neptune has no sense of its own worth nor suffers from a lack of it. Naturally, it does not feel at home in Virgo. Neptune is exalted in Cancer. The emotional, nurturing, maternal side of Cancer makes Neptune feel at home in that sign. Cancer, on the higher side, is the Cosmic Mother; she who has been denied and rejected in our Solar System. Yes, there is much talk of the Father and the Son. How could there be a Father and a Son without a Mother? In Capricorn Neptune is in its fall. Saturn, its ruler, is Lord of the World of Matter. He is big business, politics, everything that is materialism and worldly. Neptune has no part of the world; it deals with the intangible realms and the next dimension.

THE ORBS OF HIGHER POWER

It has often occurred to me that to many students the term "higher octave" might be merely a high-sounding phrase. It is my purpose here to examine the subject with the hope of offering some uesful observations.

The meaning of the higher octave can be brought out by comparing it to the octave in the musical scale. The octave note, or eighth note of the scale, is exactly like the first note but with twice the vibrations. Sounding it completes the harmonic structure of the musical scale, thus fulfilling a periodic law. Then this final or completing note becomes the first of a new series which is like the first but on a still higher tonal vibration. Thus, each octave note is at once the ending and a new starting point. When radio evolved from the telegraph, a higher-octave step was made.

To call a planet a higher octave is to say that it connotes a fulfilling and renewing of the higher qualities of the lower octave planet with whom it is related. The higher octave planets also symbolize spiritualizing processes. In the individual horoscope, the octave planet symbolizes the potentiality to develop and improve special talents as well as to unfold spiritual powers in response to life's experiences. Thus, the octave planets represent man's advancing physical, mental, emotional, intuitional and soul powers.

What does it mean that Uranus is the higher octave of Mercury? Mercury symbolizes the consciousness, the reasoning, analyzing, discriminating, knowledge-seeking mind; the expressing of abilities whether of

mind or hand. Uranus is the intellect released from prejudice, precedent and tradition. Uranus awakens the mind to new knowledge or the seeking of it, which is beyond the range already achieved by Mercury.

Uranus stands for occult knowledge because it represents that which is hidden from common knowledge. It is the force which beckons to the discovery of the undiscovered. Thus, we associate Uranus with science and invention, psychology, metaphysics and with all forms of communication which transcend physical mediums — such as telephone, telegraph, radio, as well as such higher-sensory perceptions of the mind as telepathy, clairvoyance or psychometry.

Uranus is the persistent seeker of truth and wisdom, accepting nothing as final, always driven by the urge for richer experiences of life and for newer means of self-expression. If and when the individual becomes responsive to the octave development of Uranus, he has an inward feeling of what is right for him to do. His intuitions make his decisions for him, and he is not afraid to trust them.

The particular arts and sciences which may be described by Uranus are those of architecture, designing, engineering, scientific or metaphysical writing.

Neptune as the higher octave of Venus carries the objectified love nature — as well as the love of beauty, harmony and order which Venus represents — into higher realms. The passionate love of Venus — capable of its jealousy as well as tenderness, its possessiveness and absorption in another — becomes in Neptune a sacrificing, compassionate, selfless love. It is not that one should lose the capacity for human affections, loving individuals in family and marital relationships and in friendships, but that love nature finds its truest expression when it expands beyond the purely biological and possessive into the idealistic love which is giving and sacrificial. Only that nature which is capable of loving humanity as a whole is capable of loving individuals wisely.

CHAPTER 6
Quadruplicities and Triplicities

The signs of the zodiac are divided into quadriplicities and triplicities. The quadruplicities are aspects of force manifesting in matter. There are three basic modes of energy and there are four signs in each division. This may be illustrated by the properties of water; in its normal state it is called liquid; when crystallized and frozen it is ice; and in a vaporized state it is called steam. It is the same force manifested through three different forms. It is the signs that the planets are in that determine the quadruplicities and triplicities.

Every force belongs to one of three categories:

1. Active, dynamic or **Cardinal**
2. Latent, stable or **Fixed**
3. Harmonizing, adaptable or **Mutable**

It is necessary to memorize this division of signs. The whole foundation of astrological knowledge depends on the memory work done on the material in the first ten chapters. If you visualize the signs in this manner it will be easier to memorize them.

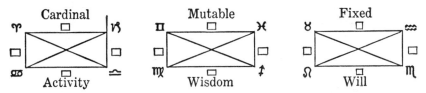

From this division we get the squares (obstacles) and oppositions in the birthchart. For instance: a planet in Gemini is discordant to any planet in Virgo or Pisces. Any planet in Aries is opposed to any planet in Libra. By counting the planets in the Cardinal, Fixed or Mutable signs one learns in which element the emphasis lies. The person with many planets in fixed signs will respond to life differently to one with many planets in mutable or cardinal signs.

CARDINAL SIGNS

The Cardinal signs are Aries, Cancer, Libra and Capricorn. These signs mark the return of the seasons. Aries begins the astrological year on March 21st. Cancer begins the summer season, Libra the beginning of the fall equinox, and Capricorn marks the beginning of winter. With many planets in Cardinal signs the keyword is "Activity." Action is fast, objective, direct and to the point; often too impulsive and impatient. Cardinal sign planets heighten activity and speed and lend executive ability. They give energy and strong ambition. They are the "go-getters" of the zodiac.

They like to meet an issue, solve it and go on to something else. They have the best temperament equipped to meet the immediate situation. Cardinal signs shoot first and argue afterwards. The keyword of Cardinal signs is "Creativity" for it is the outgoing, driving force of the universe in which the power to create expresses itself. All the Cardinal signs are self-assertive but in different ways. Aries is direct and uncomplicated out-going energy. Cancer is less direct, but is more subjective and assertive on the emotional level. Libra is self-assertive on the mind level and their drive needs unprejudiced activity where others are concerned. Capricorn is the most materially oriented of the Cardinal signs and his activity is directed toward social prestige and importance in the outer world.

Squares and oppositions in Cardinal signs are faults and unlearned lessons of the previous life. They can be changed by constructive action and, if handled rightly, will not manifest as fixed signs at a later time.

FIXED SIGNS

The fixed signs are Taurus, Leo, Scorpio and Aquarius. The fixed signs manifest as "Will." They follow the Cardinal signs. They are the most consistent and persistent of the signs. They are reticent and non-committal on first approach. The force in fixed signs becomes a quiet, organizing force. Fixed signs indicate action motivated by principles. They are unswervingly stubborn and will never deviate from a set path unless they want to do so. They are the planners, the formula makers, the con-structors. The fixed signs are the most difficult to describe for their basic motivations are seldom obvious and they do not reveal them willingly. They are reservoirs of energy or power. They have a definite pattern and resist all outer interference that will alter it.

The four fixed signs are power signs. They are called the serpent signs of the zodiac. In Taurus it is latent power; the serpent is coiled up energy (♉). In Leo it is active power and the forces are active (♌). In Scorpio the power has gone underground and is far more subtle and deadly if mis-used (♏). In Aquarius the higher serpent of wisdom is reflected in the earthly serpent force (♒).

Adverse aspects in fixed signs represent the harmful effects of self-will. These aspects are the hardest with which to deal for they represent the lessons we have failed to learn over many lifetimes, and are deeply ingrained patterns of behavior. They need a great deal of attention and self-discipline in order to divert the energy channels into constructive ones. There is an ancient aphorism that involves the four fixed signs for they are agents of karma. Karma is an eastern word for the law of cause and effect in action. Taurus — to do, Leo — to dare, Scorpio — to be silent, Aquarius — to know. The disciple has to build in his nature the qualities of action, courage, silence and knowledge.

MUTABLE SIGNS

The keyword for the mutable signs, Gemini, Virgo, Sagittarius and Pisces, is flexibility. There is a pliability and adaptability to circumstances that make them easygoing, tolerant and freeflowing. Their interests are centered in direct and highly personal relationships with people. They are great joiners and are interested in all the minute details of personal living. Mutable signs will take others into their private universes on all occasions. Many mutable signs in a chart makes good reporters for their all-over-the-lotness adds grist to the mill. They meet one deadline only to face another. They are good imitators and give things a new slant and a new angle. The versatile quality of a mutable sign type can lead him up too many alleys and he has to watch the tendency to scatter his forces. On the undeveloped side the individual with too many planets in mutable signs can be the drifter, the "rolling stone that gathers no moss." There is a changeableness, a lack of persistence and strength of will. Outside conditions dominate them for they lack the stability to assert their own individuality. Squares and oppositions in mutable signs are the easiest to handle for they are just beginning to manifest. They can be handled by the right attitudes of mind. If a person has many planets in mutable signs or has them on the angles of the birthchart one needs to use caution and discretion in counseling them. They are prone to negativity and worry and are apt to exaggerate anything of a negative nature. They are far more open to suggestion than the cardinal and fixed types.

CARDINAL SIGNS — interested in crisis, in activity and what is going on.

FIXED SIGNS — interested in values and ideas.

MUTABLE SIGNS — interested in people and relationships.

The quadruplicities show how the person is oriented toward the world without. We are what we are. If we can use this energy then it is an asset. If we can't, it's a liability. With no fixed signs in a chart you would not head a person into a field where imaginative or speculative matters are of concern. You would not sit a person down at a desk for eight hours if he had too many mutable signs. He would be a nervous wreck for he has to move around. The person with too many planets in cardinal signs would be apt to rush in where Angels fear to tread. Astrology helps you understand why round pegs in square holes won't work.

TRIPLICITIES

There are four elements known as Fire, Air, Water and Earth in which the signs are divided. Planets that are in orb in one of these elements form points in a trinity of harmonizing forces of the same nature. Such planetary aspects represent the virtues that the soul has attained and has brought over with him to help meet the problems presented by the

aspects in the quadruplicities. They are tools with which he may do his work. They are there ready for use.

Fire and Air signs are positive, masculine in expression, and represent the individuality in contradistinction to the Earth and Water signs that are feminine and receptive and represent the personality side of our nature.

FIRE: Fire signs represent energy and enthusiasm. The keynote for the fire signs is 'Inspiration.' Fire signs represent the spiritual side of our natures and they have a joy of living that is native to those born with planets in these signs. They are forceful, ardent and apt to be extremely impulsive.

The first fire sign is **Aries;** the fire of the head, the untamed fire of impulse, ardor and emotion; the fire of personality as it were. It is a Cardinal sign.

The second fire sign is **Leo;** the fire of the heart, the steady controlled fire of affection. It is a Fixed sign.

The third fire sign is **Sagittarius;** it is a Mutable sign and represents the fire of wisdom and understanding.

Those with an emphasis of planets in Fire signs are those who are direct and outgoing and they pour the fire of self into an active livingness.

AIR: The Air trinity represents the mental plane and has a great deal to do with relationships. The Air signs are the knowledge gatherers who work through the intellect and intuition. The keynote for the Air signs is 'Aspiration.' The first Air sign **Gemini,** represents the intellect; when the gates to the temple of wisdom are open the wisdom which is Gemini's as a Mutable sign becomes available. Gemini symbolically represents the 'light changeable breezes of late spring,' the gathering and the scattering of knowledge. **Libra,** the second Air sign, represents 'great line storms and high winds, followed by calm.' It is a balanced wisdom gained through suffering and experience, and it is the sign of active intelligence or judgment. It is a Cardinal sign. The Fixed Air sign, **Aquarius,** represents the intuition made constant through the use of Will, and is the sign of Inspiration. It is symbolized by 'the cold, electric air of winter.' The Air signs are positive and creative.

WATER: Water signs are plastic, unstable, reflective, responsive and fertile. The keyword for the Water signs is 'Emotion' for water has to do with our emotional vehicles and the astral level of expression. The first Water sign is **Cancer,** the sign of the Cosmic Mother who nourishes all humanity at her breast. It is the sign of the human family. Active, living, vital fertility is the Cardinal sign of Cancer. **Scorpio,** the Fixed Water sign, represents the control and mastery of the emotional nature through loving Will. **Pisces,** the Mutable Water sign, represents the wise use of the emotional nature and compasisonate understanding. Among the Water trinity Cancer symbolizes 'the ocean, the Cosmic mother; restless, tossing

waves of emotion.' Scorpio is 'the stagnant waters of the marshes; unhealthy and hidden things which must be brought to light and transmuted.' Pisces symbolizes 'clear rivers and streams, which when free from surface disturbances reflect that which is above.'

EARTH: Earth signs are physical and have to do with purely material affairs. They are the practical and stolid signs and represent the earthly field in which the personality is planted. The keynote for the earth signs is 'practicality.' **Taurus,** the first Earth sign, is a Fixed sign and represents endless patience and routine and the loving willingness to build slowly but for eternity. Virgo, the Mutable sign, shows practical efficiency in little things. They have endless patience where details are concerned. **Capricorn,** the Cardinal Earth sign, represents responsibilities, persistence and authority in practical matters; initiative and common sense.

FIRE SIGNS

Aries: the originator
Leo: the organizer
Sagittarius: the executive

AIR SIGNS

Gemini: the friendly one
Libra: the diplomat
Aquarius: the individualist

WATER SIGNS

Cancer: the insistent
Scorpio: the passionate
Pisces: the compassionate

EARTH SIGNS

Taurus: the concentrator
Virgo: the discriminator
Capricorn: the practical idealist

It is through planets in the same element that harmony prevails. Two Fire signs are in harmony with each other, two Water signs etc. They have the same nature so there is a basic understanding between them. These divisions **must** be memorized for they are extremely important. In a chart if the preponderance of planets are in Water signs the lessons for that individual lie in the field of relationships. If there are many planets in Earth signs the person puts too much emphasis on material things and he has to attain a truer sense of values. If there are too many planets in Fire signs the person is apt to act before he thinks and has to learn

to subject his impulses to his will and common sense before he acts. If there are too many planets in Air signs the person is too much in the plane of ideas and mind and has to learn to 'root' his ideas through activity on the outer levels. He must learn in the real issues of life that it is never 'head to head' but 'heart to heart.'

The four triplicities correspond to the four psychological functions in the Jungian school of thought.

Intuition — Fire
Thinking — Air
Feeling — Water
Sensation — Earth

Fire and Air are positive in expression. They motivate. Earth and Water are passive and receptive. They sustain.

Fire and Air signs are masculine. Earth and Water signs are feminine.

CHAPTER 7
Houses of the Birthchart

An astrological horoscope is divided into twelve arcs, equal in terms of time and space. The arcs are of 30 degrees each, one-twelfth of the circle of 360 degrees.

The beginning of the first house is the degree that, from a given point on the earth's surface, was rising above the horizon at a given moment of time. This point is the Ascendant just as the opposite point is the Descendant. Between them is the Midheaven (10th house) and the opposite point below the earth is called the Nadir (4th house). These are the angles of the figure.

The houses which fall away from these angles are called the Angular Houses: 1st, 4th, 7th and 10th houses.

The next houses to the angles are called the Succeedent Houses: 2nd, 5th, 8th and 11th.

The remaining four houses are called the Cadent Houses: 3rd, 6th, 9th and 12th houses.

Planets in the angular houses are the most powerful for they are active on the material level and play strongly on the personal self and its affairs.

Planets in the succeedent houses are tied up with the emotional nature and the individual's desires.

Planets in cadent houses are indicative of energies in the mind and mental equipment. They are less obvious and not apparent on the surface but have a very definite effect on the thinking.

FIRST HOUSE
What you look like.

The personal self. Its chief characteristic is action — destiny in the making.

The Present. Defines the personality, appearance, disposition and manner.

Outlook on life.

The window through which you view the world.

SECOND HOUSE
What you own; your resources.

Financial standing, money, possessions.

Peace of mind.

Manner in which person meets obligations.

Repository of the strongest desires.

That which the life is dedicated to redeem, therefore the house of values.
Earning and spending capacity.

THIRD HOUSE

What you think. Your ability to relate to your environment.
The synthesizing powers of the conscious mind.
Dexterity, duality, restlessness.
Early education and early environment.
Short journeys.
Brothers and sisters and their attitude toward the person.
Acquaintances and neighbors.
Writings, news, communications, rumors.
Memory, perception and speech.
Taken-for-granted skills.

FOURTH HOUSE

Your base of operations; in the outer world, your home. In the inner world, your soul.
That which is hidden in the depths of the self.
Index to home and all domestic affairs.
Counsels him whether to stay or to leave his birth place and advantage to be gained in either course.
Defines nature of one's residence.
End of matters. The latter part of life.
Matters relating to real estate and property.
Least prominent parent in the life. Some say it rules the mother, others the father. Depends on which is boss (10th house).
Outcome of any matter in horary astrology.

FIFTH HOUSE

Self-expression; any effort put forth to distinguish yourself from others — children you create, books you write, affections you display, anything that bears your personal stamp.
All emotional and romantic tendencies coming from the heart.
House of hidden karma; misuse of the will and the love principle.
Rules children — children of the mind and emotions as well as the body.
Speculation, amusement, dramatics, theater, schools.
Love affairs and luck or lack of it shown in this house.

SIXTH HOUSE

House of self-adjustment. House of work and health or lack of either. They are tied together. The busy person has no time to be sick.
Food, clothing, comforts and domestic pets. Mental or physical conflicts resulting from the expression of the Ego. As such it depicts any enmity between the dweller in the body and the physical body,

out of which mental, nervous, or organic disease may develop.

It is an obscure arc, since the nature of service rendered or received is more or less personal, unobtrusive and routine.

It has been termed the house of Service in that it portrays one's capacity to serve, as well as the character and qualities of those who serve him; his employees and dependents, and his relations with them. Sixth house action is generally under the person's control whereas twelfth house inhibitions, repressions and frustrations spring from causes over which the person has no control.

Working conditions if you are employed are shown in this house.

SEVENTH HOUSE

The house of the not-self in opposition to the personal self.

The angle of relationship.

The beginning of the individuality rather than the personal concerns. The "we" consciousness.

Marriage and Partnerships.

Cooperation or the lack of it.

Rules the lower courts where the 9th house rules the higher courts. Open adversaries.

EIGHTH HOUSE

House of generation (sex), degeneration or regeneration.

Regeneration through enlargement of viewpoint, both spiritual and mental.

Death and the manner of it.

Rules the psychic levels (the astral plane) and people with planets here have often brought over a legacy of sensitivity to invisible currents. If the planets in this house are afflicted the individual has been involved in the misuse of psychic facilities. This is particularly true if Mars is afflicted to Neptune or in this house.

Rules legacies and goods of the dead.

As it is the second from the marriage house it rules the partner's possessions and financial conditions.

Every eighth house operation is a celestial messenger in disguise and a challenge to penetrate this disguise and become the recipient of the blessing he bears. In the wake of an eighth house storm there is always a rainbow if we but lift our eyes to perceive it.

NINTH HOUSE

Realm of the superconscious mind and the deeply ingrained religious philosophy of the self.

Intuition, inspiration, spiritual visions.

Long journeys.

Expansion of horizons both mental and spiritual.

House of the Spirit. Probability of distant travel, timing, nature and results.

Worldwide contacts and mental adjustment to racial ideas.

With an author his works from the standpoint of publication.

Understanding.

House that rules in-laws, (third from the seventh house).

TENTH HOUSE

Prestige, honor and standing in society.

Amplifier of the personality as the public looks at him.

Professional career, reputation.

His father.

Employers if he does not work for himself.

If he does work for himself his work comes in this house.

ELEVENTH HOUSE

Goals and objectives.

Friendships.

Social relationships.

Hopes, wishes, projects and ambitions.

The ruler of this house and the planets in it are an index to his idea of happiness and the probabilities of his attaining it.

With an afflicted 11th house one has to work harder to attain satisfaction on the outer levels.

The 5th and 11th houses are an index to the personal and emotional desires.

The 9th and the 11th houses indicate higher levels of consciousness as to both mind and emotion.

If the ruler of the 11th is stronger than the ruler of the 7th, the person's friends and helpers are stronger than his enemies.

TWELFTH HOUSE

The house of drawn shades; that which is hidden.

The subconsciousness attitudes that are a hangover from the past.

House of self-undoing, frustration, limitation and confinement.

Also the house of Initiation and ultimate understanding.

Service or Suffering; with planets in this house it has to be a choice between one or the other.

House of charity, given or received.

House of Karma: the law of cause and effect from which there is no escape without atonement and attunement to that which is above and beyond the law: The Grace of God.

Rules hospitals and institutions.

The third house rules the conscious mind; the ninth house rules the superconscious mind and the twelfth house rules the subconscious mind.

The first six houses are more under the personal control of the individual than the last six houses. They are related to the not-self and are more under the sway of other people. For instance, his bodily health (sixth house) is under his control and largely dependent on his own actions. But

twelfth house matters are beyond his control, in that they comprise inhibitive influences, repressions, frustration, even loss of personal liberty dependent upon the way others react toward him and are the sort of things that must be endured if they cannot be cured. Yet, rightly used the twelfth house represents subjective sustainment. Its motto is "Serve or Suffer" and the choice is in your hands.

The houses are divided into four trinities:

Trinity of Life
- (1) Body
- (5) Soul
- (9) Spirit

Trinity of Association: Relationships
- (3) Brothers and sisters
- (7) Marriage and Partnerships
- (11) Ties of friendship, close associates and advisors

Trinity of Wealth: Temporal or Possessive Houses
- (2) Possessions, property and resources
- (6) Comforts, such as food, clothing, servants and health
- (10) Honor, prestige, credit, business or professional standing.

Trinity of Psychism
- (4) The environment in each epoch of life with particular reference to old age
- (8) The influence of others upon his environment particularly with respect to the effect upon him of their death. by way of inheritance and inherited responsibilities
- (12) Service to those limited and restricted or suffering due to self-undoing. Influences that can retard or accelerate growth.

The first house is the most important of the angular houses.

The angular houses are concerned with making manifest and concrete, bringing out into the open, unveiling and manifesting whatever may be latent in the personality.

IMPORTANT FACTS TO REMEMBER

In astrology you are dealing with the following factors:

PLANETS — are the energies that are operating. **WHAT** is operating.

SIGNS — are character — **HOW** the individual has used the energies in other lifetimes. Wise use is shown by planets in signs they rule and in their places of exaltation. Planets in their falls and detri-

ments show the misuse of the energies and these are the ones that show defects in character which need changing.

HOUSES — are circumstances, the environment through which the energies operate. **WHERE** you do it.

Your blueprint shows why you are here,
why you are here now,
why you are where you are.

Astrology is a dynamic potentiality; not a static fact. It is the use you make of the power (or planets) that builds your world. The horoscope is an X-ray or blueprint of the personal self. It shows how we operate within the magnetic field. Life flows, energy is released through action, changes take place.

An empty house does not mean lack of activity but the absence of serious problems there. In the houses where there are no planets there is more freedom of action. The houses where planets are placed are more vital issues in the life.

What you want: — **PLANET.** Where you seek it: — **HOUSE.** How you go about it: — **SIGN.**

RETROGRADING PLANETS

At certain intervals planets appear to be retrograding in their orbits. It is a backward motion which they seem to have, mainly in consequence of the relative position and motion of the earth. This is marked by the symbol ℞ in the ephemeris. There is also a time when a planet is apparently stationary in relation to the earth. This is marked by **S** in the ephemeris. When it starts to go forward and direct again, this fact is recorded in the ephemeris by the letter **D.**

When a planet is retrograde the energy is turned inward, making it more subjective, and the person does not receive the full and active power of the planet in the outer world. It operates more on the inner side of the life. Planets are not less potent but they operate in a different way from the normal way. They move more slowly so their messages may be more clearly perceived. Many geniuses and leaders have retrograde planets. People with many retrograde planets act differently from those who have their planets going forward. Things concerning the planets that are retrograde will be slower coming into manifestation because these people are inclined to be more subjective and to think more deeply concerning the energies involved. Especially in transits watch the planets that turn retrograde, are stationary, or go direct in the natal chart. The transit will emphasize whatever planet it contacts (by conjunction) to the nth degree.

Affairs are delayed, but not denied by retrograde motion.

CRITICAL DEGREES

Certain degrees of the signs are said to be much more important for good or ill than others. These are called the critical degrees. In Cardinal

signs they are 1', 13', and 26' degrees. In Fixed signs they are 9' and 21' degrees. In Mutable signs they are 4' and 17' degrees. Pay particular attention to planets in Fixed signs that are in 15' degrees. They are important. The Fixed signs are tied esoterically with the Lords of Karma, and planets in those degrees are very strong for good or ill. 29' degrees of the signs are also important for they are degrees of expiation, with 29' degrees of Pisces extremely important.

MEASURING THE CIRCLE

There are 360 degrees in the circle of the zodiac. Dividing these by 12 gives us 30 degrees — the number of degrees in every sign. Remember: There can be any number of degrees in a house (due to interceptions) but there are always 30 degrees in each sign. When you read aspects in a chart read them by signs, not houses. In latitudes some distance from the equator, we often have intercepted signs in houses and these houses are more important than others for they contain the whole of one sign and part of two others. They will give complexity to the environment or house in which they fall. One difficulty for the beginner is in realizing that even though a sign is always 30 degrees in length the house is not necessarily the same. The extent of the house is variable with the latitude.

ASCENDANT

The Ascendant can be known only when the birthtime is known. This is the horizon or Rising Sign at the moment of birth. Every two hours in the cycle of 24 hours one of the 12 signs of the zodiac is on the horizon, or Ascendant. This is the "why" of the differences in nature and experiences of those born in one day. Everyone born on the same day may have the Sun in the same sign, even the Moon in the same sign, which will give certain basic characteristics, but the environment in which they will operate in the outer world will be very different if they are born at differing times of the day.

Planets in the eastern section of the chart — that is, from midnight to noon, are said to be rising. They have more power than planets in the western part of the chart, where they are setting — that is, going from noon to midnight.

When many planets are on the eastern part of the chart the individual has more free will for he is in a sowing incarnation. He has more freedom of action. When most of the planets are in the western part of the chart he is in a reaping incarnation. Other people have much more to do with his destiny for his karma is very much bound up with others. He has much less free will.

All the planets above the horizon carry the individual upwards and elevate him from the sphere of his birth. If they are on the eastern side it will be in early life; in the center of the upper half the rise will be in middle age; if in the western side the rise will be through others.

ELEVATION

The planet or planets nearest the Midheaven, east or west of it are the most elevated; they come closest to the noon position of the Sun. These energies are very powerful factors in bringing a person to the attention of the world, particularly if they are in the tenth house. Edgar Cayce, the Virginia Beach clairvoyant, said that the planet which was nearest the tenth house cusp was the clue as to the planet which was our real home.

MUTUAL RECEPTION

When two planets are in each others' signs, it is called mutual reception. It gives a beneficial power to each. For instance: Mercury in Pisces and Neptune in Virgo help both energies to be harmonious and stable.

DIVISIONS OF THE CHART

A chart may be divided into two parts.

1. By a horizontal line (the equator) dividing the horoscope into north and south directions.

2. By a perpendicular line (the meridian) dividing the horoscope into east and west directions.

The southern part contains the houses from Sunrise to Sunset; the northern part contains the houses from Sunset to Sunrise.

In reading a blueprint we will find that many planets in the lower or night side of the chart, particularly if the Sun and Moon are there, will make the individual much more subjective and introverted. He will not want a public career, but will be perfectly content to work behind the scenes. His life will be similar to a slowly moving stream moving along in country surroundings. He will tend to think before acting and will want to know all the "ins and outs" before he moves.

If most of the planets fall in the day side of the chart, the southern section the person will be extroverted and his energies will be expended to the public and a career will be very important to him. He will be like the rushing torrent, heading for the sea, and sweeping everything before it.

Day Half
Positive Extrovert — Rising Planets — free will — sowing
Setting Planets — destiny — reaping

Night Half
Receptive Introvert — Subjective side

PART OF FORTUNE

The part of fortune is said to be the most fortunate position in the birthchart. Be that as it may, it does benefit whatever house it is in. The symbol of the part of fortune is ⊕ , which is the symbol of the earth and so indicates success in worldly affairs.

The calculations for it are found by adding the longitude of the Ascendant to the longitude of the Moon, and subtracting the longitude of the Sun. The signs must be figured too so that you will know what sign it is in.

If you run into difficulties in subtraction, add twelve signs and then subtract. For instance, you cannot subtract the ninth sign from the third so you would add twelve and then subtract.

Example: Ascendant is 23 degrees 45 minutes of Scorpio, Moon is in 11 degrees 15 minutes of Cancer, and the Sun is 25 degrees 32 minutes of Leo — the calculation would be as follows:

Longitude of Ascendant	8	23	45	
Longitude of Moon	+ 4	11	15	
	12	34	60	
Subtract the Sun	— 5	25	32	
Part of Fortune	7	9	28	= 9 degrees 28 minutes

The Part of Fortune falls in the 7th sign (Libra) at 9 degrees and 28 minutes.

CHAPTER 8
The Meaning of Aspects

Aspects are lines of force between the centers of energy (planets) in the magnetic field of the individual.

According to the ancient philosophers there are two lines of force in operation whereby nature is maintained in a state of equilibrium in order to produce life. These are the dual forces with which you have to reckon in every phase of living in a dual universe. Positive and negative, inbreath and outgoing breath, construction opposite to destruction, expansion and its opposite contraction. Since these forces are equal each complements the other.

All organic structure is built on cells which in their simplest form are hexagons, similar to those of the honeycomb. Therefore, the hexagon is the primary pattern of benefit and harmony. When light enters at the external angle of 60 degrees and the internal angle of 120 degrees, it necessarily illumines all parts of the structure in equal lines of influence. The light that comes in at either of these angles imparts harmonious vibrations which stimulate growth. Opposed to this process of construction is the process of crystallization, recognized in magnetism and electricity, wherein two forces operate at right angles to each other — a geometrical relationship that is destructive to organic form. This is an angle of 90 degrees or 180 degrees. As a result, side by side through nature two mutually antagonistic forces exist, which despite their antipathy toward each other, work together toward the ordered disposition of the whole; one based upon the quadrature, the other upon the hexagon — the square and the trine.

Astrology shows that the square relationship between energy sources is destructive to form through releasing the energy that is locked up in the various structures Nature has built; the trine aspects constitute the constructive side of nature, whereby organic forms are created, nourished, and held to be released when subsequent destructive configurations are encountered.

To comprehend fully the laws of polarity inherent in the universe is to come into the possession of the mystery of life itself. The laws of opposites apply in every phase of earth living and from the combination of the two opposites a third force is born, higher than either force. This secret is hidden in the triangle.

The two most important aspects in a birthchart are the **CONJUNCTION** and the **OPPOSITION**. In a conjunction the two energies involved are as close together as they can be; in an opposition the two forces are

as far apart as they can get. When the Sun and Moon are together we have a new moon; when they are opposed to each other we have a full moon. When you see this symbol in the ephemeris under aspects you will know it is a new moon ☌ . When you see this symbol ☍ you will know it is a full moon. When it is a new moon eclipse (solar eclipse) this symbol is used ☌ ; when it is a lunar full moon eclipse this is the symbol you will see ☍ .

ASPECTS

The major aspects with which the astrologer deals are the following:

Aspect	Orb	Keyword	Symbol
Conjunction	0 to 10 degrees apart	Power	☌
Opposition	180 degrees	Awareness	☍
Square	90 degrees	Obstacles	□
Trine	120 degrees	Creation, harmony	△
Sextile	60 degrees	Opportunity	✳
Semi-sextile	30 degrees	Slightly beneficial	�ⵣ
Parallel	Within 1 degree	Inner activity	P
Semi-square	45 degrees	Friction	∟
Inconjunct	150 degrees	Discord	⊼

If you have learned the lessons on triplicities and quadruplicities you will not have any trouble in recognizing your trines and squares and oppositions in a chart.

Elements of the same nature — for example, two fire signs, are of the same element and trine each other. The same with two water signs, etc. In the quadruplicities are shown the oppositions and squares. Fire is not in harmony with water; Aries planets square those in Cancer and Scorpio (water) is not in harmony with Aquarius (air). Cancer planets square those in Libra, etc.

There is an aspect seldom used by the average astrologer but it is of great importance to the spiritual student. It is an aspect called a Quintile, one fifth of the circle, which is 72 degrees apart and its keyword is "talent." They represent the definite talents of the person and show in what manner he may succeed in linking together his inner and outer being. Every person is an artist in some realm of expression, and only through his artistry is any analysis of his activity as a soul to be gained. The Quintiles which were known only to the inner initiates of the Chaldean mysteries reveal the special priviliges of each person and tell him in what way he may demand cooperation and personal assistance from the Cosmos. It is curiously fitting that these aspects which are so important to the seeker who is in a position to proceed to real accomplishment are closed to the careless layman, who instinctively shying away from aspects that cannot be counted by 'even signs', is of the temperament to avoid his real spiritual opportunities because of the self-actuated effort involved therein.

The orb of a planet is important. The closer the aspect, the stronger its effect. If you think of a stove in the middle of a room it will help you to

understand orbs. The nearer you are to the stove the hotter it will feel. As you move away from it, its influence is not as strong. The exact aspects are those where the planets are in the same degree: Jupiter in 20 degrees of Aquarius and Neptune in 20 degrees of Leo. That would be like sitting on the stove. I have noticed that exact aspects, either harmonious or inharmonious are very powerful in a chart. I call them 'fate' that must be handled wisely and well. Even those that are one or two degrees apart are very strong.

Aspects to the Sun, Moon and Mercury operate from 8 degrees to 12 degrees apart. The others will operate up to 8 degrees apart; that is the square, trine, sextile and opposition. The student must not regard these orbs as rigid for it is a characteristic of all astrological work that there must be flexibility in connection with interpretation. In all charts where aspects are exceedingly strong and numerous the fringes of the orbs are of less value than they are in a chart where the aspects are weak and distant. In the latter case it is necessary to consider that the region of the orbs is comparatively weak. The more aspects there are in a chart, whether harmonious or not, the stronger the soul and the more power it has to overcome in the outer world. The kindergarten soul does not have as many lessons or as much power and this is shown by a dearth of aspects and planets in weak signs.

Aspects to the Ascendant and Midheaven: these are important if you are sure of the birth time within five minutes. The interpretation of aspects to the Ascendant must be considered as of importance in determining temperament and character, and the aspects to the midheaven are of special importance in determining success and events in the outer world.

DO NOT COUNT ASPECTS BY HOUSES BUT BY SIGNS. Intercepted signs in houses would cause you to make mistakes if you do not count by signs rather than houses.

Sepharial, in his dictionary, has this to say regarding separating aspects:

> "When two bodies have been in exact aspect, the one which by its swifter motion moves away from the aspect, is said to separate from the other. When one of two bodies in aspect turns retrograde, it separates. When both bodies turn retrograde, doubtless a mutual separation is effected. In Horary Astrology these relations have distinct significance. The party representing the separating planet will decline the proposition, back out of the agreement or annul the contract. The party represented by the retrograde planet will default; and when both turn retrograde there will be an annulment by mutual consent. Similar effects in marriage too."

CONJUNCTION: Keyword: Emphasis. Orb: 0 to 10 degrees.

Planets within 10 degrees of each other. They emphasize, bringing the energies involved into prominence. A conjunction is known as power

operating. The conjunction may be harmonious or inharmonious, according to the planets involved. For instance: ♂ ☌ ♄ would be extremely difficult. Opposed in nature and would fight each other. Mars is dynamic, positive, active, and quick; Saturn is slow, limiting, and retards impulsive action. Venus and Jupiter together would be beneficial; both are beneficent, harmonious and work well together. When one planet is positive (masculine) and one is receptive (feminine) — for instance — ♂ ☌ ♀ — there will be a complex in the nature that must be released or understood in order to use the energy wisely that is invested in this conjunction. Note the signs the planets are in. The planet most at home in the sign will be the stronger planet. ♂ ☌ ♀ in ♏ will be very different to ♂ ☌ ♀ in ♎ . In the former case ♂ will overide ♀ ; in the latter case ♀ is in its own sign and will be able to overcome and subdue the animal tendencies. A conjunction is a concentrated massing of energy.

OPPOSITION: Keyword: Awareness. 180 degrees apart.

Oppositions are opposing forces that must be reconciled. They are easier to handle than squares, but call for cooperation. Opposing forces come from outside as well as inside, and often involve other people. It calls for compromise. Oppositions can cause you to be pulled apart by two contrary pulls, but like two poles of a battery, one may also be illumined by the spark flowing from pole to pole. "AWARENESS" is one of the keywords of oppositions for awareness causes consciousness to expand and develop. Without opposing forces how could we have any choice. Without choice there would be no growth in discrimination and awareness. Oppositions will not give difficulties if you learn how to handle people who do not agree with you. Learn strategy and diplomacy. Learn to agree with your adversary **while you are in the way with him.** In a conjunction **you** do something; in an opposition the other fellow does.

SEXTILE: Keyword: Opportunity. 60 degrees apart.

Planets two signs apart; these two energies work together harmoniously, and in a such a way to cause opportunities for success, coming through the energies involved, and the houses in which they are placed. A horoscope with many sextiles indicates a life replete with opportunities. They must be activated or they will not operate.

TRINE: Keyword: Harmony. 120 degrees apart.

Like Jupiter, trines throw a protective influence. Benefits that come without effort and without any activity on the part of the individual concerned. They are the results of constructive service, and harmonious actions in other lifetimes. We earn everything that happens, good or ill. What we send forth returns home again. Everything returns to its source. Trine aspects are the good we have given out returning to us.

SEMI-SEXTILE: Keyword: Resources. 30 degrees apart.

This aspect is one sign apart, and acts as a second house aspect. Because the second house is values and resources this aspect gives you a clue to finances.

SQUARE: Keyword: Obstacles. 90 degrees apart.

The cross relates to matter. It has more power than a trine if you learn how to handle it. Trines are static; they ease. Crosses are dynamic; they force you to face issues and in the process you grow. Crosses are the lessons we have failed to learn in other lives. The quickest way to release ourselves from difficulties is to face them and solve them. Every time we run out on trouble it awaits us around the corner through another instrument or another set of circumstances. Squares represent the lessons we have failed to learn and trines are the harmonies we have earned; the blessings that come when we love and love wisely.

SEMI-SQUARE: Keyword: Tension. 45 degrees apart.

This aspect is strain and tension beginning to manifest and if not handled will become a square in the next life.

INCONJUNCT: Keyword: Adjustment. 150 degrees apart. An inconjunct is on one side or the other of an opposition. If it is in the sign before the opposition it is in a 6th house relationship. If on the other side it is an eighth house relationship. This makes a difference in how it operates. The sixth house inconjunct gives difficulties in either work or health. The eighth house inconjunct has to do with the necessity of regeneration and transformation where the character is concerned.

GRAND TRINE: Keyword: Ease.

A pattern formed by three planets in a triangle of the same elements. These energies are in harmony with each other so that they bring harmony and ease in the houses and matters that the planets represent. In some textbooks it is said that it is not beneficial. It is good in the elements involved for it will be easy to attract pleasant and happy conditions. For instance: if the grand trine is in earth signs you attract material things without any difficulty. If you become very selfish through having too much in the world of appearance, the grand trine will be a detriment instead of a blessing. If you have a grand trine in fire signs (and do not bring your spiritual powers down to the outer level) it is similar to having millions of dollars in a closet on a high shelf. You are complaining of lack and all the time there is a treasure in your possession that is yours if you will claim it.

GRAND SQUARE: Keyword: Challenge.

A pattern formed by two oppositions and four squares. If you have a planet, within orb, in each of the quadruplicities, you will have a Grand Square in your chart. This is a dynamic configuration that can be a

balancing force if the individual can use these energies constructively. If this grand cross is not used wisely it can cause many difficulties. There is great strength in this aspect because it creates obstacles that demand attention where the grand trine can cause inertia and laziness because things come too easily. In cardinal signs the outlet for the grand cross is action. In fixed signs this energy needs an emotional outlet in some self-expressive way. Mutable grand squares are easier to handle than the others but need more attention. Too great a diffusiveness and too much indecision is evident. They see all sides so it is difficult to make a decision. Note the fixed signs in a chart with a mutable grand cross. If there are some planets in fixed signs it will be a big help in correcting the diffusiveness and vacillation of the mutable grand cross.

T-SQUARE: Keyword: Imbalance.

Planets in 3 signs of the same element (cardinal, fixed or mutable) with a planet missing in the 4th element.

A pattern more difficult to handle than the grand cross, because there is a lack of balance due to the empty end of the cross. It is like a table with three legs instead of four. The empty end of the T-square must be filled in. The quality needed will be shown by the sign that has no planet in it. When a heavy planet by transit fills in the empty end of the cross it will be a time of crisis for the individual.

* * * *

The energy shown through the aspects in the birthchart is neither constructive nor destructive. The energy is pure and at our disposal to use or abuse. It's **how** we use it that labels it good or not good. Once we activate energy we come up against the law of cause and effect, and must abide by the results.

You will never find a chart without difficulties, for this planet is a school where we who are rebels have come to learn the lessons of Life and Love. The blueprint we call the horoscope shows the age of the soul, which grade of Earth's school it is in, and the strengths and weaknesses of the individual. Every chart of anyone who has attained any spiritual as well as material stature in this life has been a chart replete with squares and oppositions. The obstacles come with the strength to overcome them. A chart that is what we call an 'easy' one does not give power and strength, but an ease and harmony that can create inertia if a person does not bestir himself. Never let a difficult chart frighten you. The blueprint shows the personality pattern, but not the Spirit or High Self behind it. That Self has the Power, the Love and the Intelligence and it will help us if we invite it to do so.

The aspects of Sun, Moon and Mercury to the higher octave planets — Uranus and Neptune — will give an indication of the age of the soul. When Uranus and Neptune are angular, even though afflicted, the soul is

not in the kindergarten of life. The young soul, like the kindergartener, does not have many lessons to learn. The soul in the college of life has much to learn and much to study in order to pass his grades. We chose our environment, our parents, our blueprint before we came into matter. The body is new but the soul in the body did not start here, and death is not the finishing line for anything but the vehicle we use on Earth. Let nothing dismay you. Whatever we have the power to create, we have the power to redeem.

There is only one planet whose power is completely out of our hands. This is Uranus. We can change the manner in which we use any of the other energies. for it lies in our hands to do so. Uranus is the planet of destiny, operating suddenly, unpredictably and through other people. We have no control over other people's actions. The one decision that does lie in our hands is how we **react** to it.

Read the last paragraph of Emerson's "Law of Compensation" in his Essays if you would have insight into the workings of Uranus in our lives. Uranus always breaks up existing conditions to free the spirit locked in crystallized patterns.

In reading aspects always note whether they are in cardinal, fixed, or mutable signs. The cardinal afflictions are debts from the past lifetime that must be changed through Action. The fixed signs, debts deeply ingrained over many lifetimes, must be changed through the giving up of self will. The mutable sign afflictions are faults beginning to manifest through wrong patterns of thinking in this lifetime. These afflictions are the easiest to redeem.

The mutable afflictions are tied with the respiratory system. Breath and thinking are tied together. Afflictions in Gemini affect the lungs; Sagittarius rules the hips and represents the power to move forward. Virgo afflictions gives difficulties with assimilation in the physical body, and in the psychological field, lack of ability to assimilate experience. Pisces rules the feet in the physical body and this part of the body represents our understanding. Those who lack spirit show it in their walk.

Cardinal sign afflictions are caused by wrong action. Afflictions in these signs affect the body through growths, tumors, kidney troubles and digestive difficulties.

Fixed sign afflictions affect the body through circulation, heart conditions and diseases that crystallize the body as in polio or paralysis. The body is the end terminal for difficulties. If our difficulties are handled on the mental and emotional levels they need never manifest on the physical level. The individual who goes the way of the Higher Self saves himself a great deal of pain and suffering.

APPLYING AND SEPARATING ASPECTS

Where aspects between planets are concerned it is important to note whether it is a waxing or waning aspect. If the aspect is applying the energy will be stronger, for good or ill, than if it is a separating aspect. As an example: if the Sun is at 8 degrees of Leo and Saturn is at 10 de-

grees of Scorpio, the Sun is moving up to an exact square. If the Sun should be at 10 degrees of Leo and Saturn at 8 degrees of Scorpio the Sun has already passed the exact square and is separating. Where the faster moving planet is applying to the slower moving planet it will be stronger, either for good or ill.

The difference between a sextile and a trine is one of degree. The sextile is called the "opportunity" degree because the tendency to harmony and right use can bring the harmony to fulfillment. If something is done to further the right use of energy the sextile can be of great value. The trine operates whether the person does anything or not; it is earned increment from good given out in other lives. Now the return flow may be expected.

In judging oppositions the judgment depends on which planet is stronger. This is why the table of dignities, exaltations, falls and detriments must be memorized and understood. The closest aspect in the chart will be of very great importance. An exact aspect gives no leeway. Whether it is a so-called good aspect or a negative one that aspect will be the keynote to the chart.

Many oppositions and squares give a difficult life and obstacles to overcome, but it gives strength and character. These are the people that attain success in varying fields of endeavor. They are forced to use their spiritual muscles and through having to conquer many obstacles gain great power and strength. Too easy a birthchart will give ease and a pleasant life but little stamina or character; the person is apt to drift along and have an uneventful life. Welcome the challenges for they are opportunities that lead to the abundant life.

CHAPTER 9
Ascendants and Decanates

The sign that is on the horizon at the moment of birth is called the Rising Sign. Without the time of birth we do not know the Ascendant or Rising Sign. Every two hours in every day (24 hours) a new sign rises on the horizon. It is the Rising or Ascendant Sign that marks the difference in temperament, disposition, physical appearance and personality of the individuals born on the same day but at differing times. Without the time of day it is not possible to tell in what houses the planets are placed at birth, or where the transiting planets are operating at any given time.

When a person does not know his birth time, put his birth sign on the Ascendant, without the degrees, and the other signs in consecutive order around the wheel. Then put the natal planets in the houses according to the signs on the cusps of the houses. This is a solar (soul) chart. You can tell a great deal from this chart, but you cannot read it as thoroughly as when you have the time.

As a professional astrologer I have used Evangeline Adam's method. I take the time a client comes into my studio, set up a horoscope for that time, and use the outer cusps as a frame of reference. I put the birth planets inside the wheel and the transiting planets outside the circle. It is amazing how many times the sign on the Ascendant at that moment shows the problem and why they have come at that particular time. If they are interested in marriage Libra will be on the horizon. If it is Cancer, it is a problem concerning a home. If it is about a job or position, Virgo will be on the Ascendant. And so it goes; each sign highlighting a certain aspect of earth living.

Think of the Ascendant as a window through which you look at the world. Each window is of a different shape and color, changing the way we see things. No one else can see things exactly as we do for no one else can look through your window — or your eyes.

The American Indians had a saying that can help us all. "Never judge a man until you have walked a mile in his moccasins."

ARIES ON THE ASCENDANT Brian

Energy plus. Impulsive. Argumentative, quick-tempered, outgoing and headstrong. Hard for a female, for it is positive, masculine and aggressive. Apt to rush in where angels fear to tread. Get out into combat with life early. Need to learn tact and diplomacy. Good in mechanical endeavors and physical activity. Keen, alert and quick reflexes. Make good salesmen and promoters. Need to learn to follow through in activities. Easily bored. Self-

centered in an unthinking sort of way. No deliberate meanness or calculated selfishness in their makeup unless Mars is heavily afflicted. More apt to be thoughtless. The aspects and sign position to Mars will be important and will show the personality and temperament.

TAURUS ON THE ASCENDANT

Strong, stable and stubborn. Slow in reflexes. Quiet until pushed too far then there is trouble. Passive personality, quiet and unassuming as a rule. Very possessive and fixed in convictions. Resources and possessions, whether people or finances, are very important. Cannot be pushed, but can be coaxed. Cannot be driven, but can be lead. Practical. Good financial sense. Affectionate. Good workers but cannot be hurried. Difficulty with studies due to a slow pace of mind. Inclined to put on weight for there is a love of good food. Short, thick neck with square type of body. Non-aggressive, patient and longsuffering. Can be unreasonable and prejudiced when pushed too far. Jealousy must be conquered if Venus or Mars is afflicted.

GEMINI ON THE ASCENDANT

Sense of duality strong. Two personalities in one body fighting for control. Indecisive and unsure. Friendly, adaptable, witty and clever. Extremely nervous and highstrung. Temperamental. Appear confident but lack confidence and inner sureness. People make them nervous but they love an audience for they love to talk. Talk with their hands as well as with their tongues. Make good conversationalists. writers, and reporters. Function from their minds and are very active mentally. Good dispositions when they are calm and serene within. Note position by sign and house and aspects of Mercury to know how this personality projects itself into the outer world.

CANCER ON THE ASCENDANT

Timid and quiet, especially in early life. Sensitive and retreats when threatened. Fond of traveling but must always have a homebase from which to operate. Sympathetic, receptive, passive and psychic. Responds to life through feeling not thinking. Moods changeable, up and down like the tides. Easily upset but do not stay disturbed for long. Note the sign the moon is in and its aspects. If the moon is angular the individual will be involved with the public (mass consciousness) in some way. A tendency to indigestion when emotionally disturbed. The solar plexus reaction upsets the juices of the stomach.

LEO ON THE ASCENDANT

Self-confident. Romantic and sentimental. Emotional, extroverted. Courageous, but sometimes foolhardy. Loves to take risks. Zest for life. Impulsive but faithful to those they love. Can be stubborn in a sunny sort of way. Likes sports and activity out of doors. Strong vitality but need to keep spine supple by exercise. Large shoulders, small hips, like the

lion. Can be quick-tempered but can't stay angry. Like the lion, they roar and lash their tail about a bit, then the storm dies down. Don't walk on their dignity or hurt their pride. They forgive but don't forget. Their need for love is very great. If frustrated they have no desire to live. Psychological heart trouble leads to trouble with the physical heart.

VIRGO ON THE ASCENDANT *Jammy*

Ingenious, active and alert mind. Quiet, unassuming, shy in manner. Never crude and coarse in personality. Thoughtful, albeit somewhat self-centered. Always looks ten years younger than they are, no matter what their age. This fact often helps to rectify a chart where timing is concerned. Very restless and nervous, so seldom have much weight on them. Practical, analytical and methodical in all they do. Sometimes indecisive and unsure, especially if Mercury is in a mutable sign. Needs to learn to digest every experience and assimilate it without rancor or resentment. Needs to get rid of a negativity that stems from a feeling of inadequacy. Refined in conduct and demeanor.

LIBRA ON THE ASCENDANT *Peggy*

Artistic, creative and sociable. Needs to let go of self interest and become cooperative, rather than competitive. Indecisions, yet a great fixity that doesn't show on the surface. Good arguers. Make good lawyers. Expedient and practical in a shrewd way. Diplomats, and have a friendly exterior, but note the aspects to Venus and to Saturn to see if they are dependable. Have a keen sense of color, and environment must be harmonious or they wilt. Cannot stand disorder. If Venus is poorly placed, there can be unbalance in nature. Apt to try too hard to please others and negate principles in order to be popular.

SCORPIO ON THE ASCENDANT

The hardest Ascendant of all. Battlefield where the soul and personality must come to mortal combat. They must come into alignment and the personality must die. The battle concerns the threefold personality. Physical, emotional and mental levels are involved. Strongest ascendant of all. Great depth. Devil or angel, no in between. Willfull, self-reliant, courageous. Reserved. hard to understand. Self-controlled and stoical. Appear calm on the surface, but extremely emotional inwardly. The silent type. Great determination and strength enough to overcome any adversary. Needs to overcome resentment and jealousy. No unevolved soul is born with a Scorpio Ascendant. The razor-edged path that can only be tread when there is strength and power enough to do so. Note the position of Mars (outwardly in the world) and Pluto (in the underworld) for they will show what work is to be done by the personality in this life.

SAGITTARIUS ON THE ASCENDANT

A breezy, outgoing, extroverted sign, but lacking in concentrative power. Has a love of horses, and of the out-of-doors. Many acquaintances,

but few friends. Casual contacts rather than in-depth relationships. Superficial unless Jupiter is well placed by sign and house. Loves to travel and does travel extensively. Great restlessness. Loves to be on the move. Inclination toward philosophy and religion. Very talkative. Direct and to the point, but lacking in diplomacy. Executive type. Positive and masculine in expression. If in a feminine chart, lacks femininity and quietness. Tall in body as a rule; small shoulders and big hips like the centaur, its symbol. Puts on weight in middle years.

CAPRICORN ON THE ASCENDANT

In early life has delicate health but improves as life advances. Sensitive, timid. inarticulate in early life and suffers from a feeling of inadequacy. Overcomes it through sheer necessity for there is determination to achieve their goals and purposes in life. Great ambition and have no peace until they have reached the heights they have set for themselves. Money and position are important. Reserve that often appears to be coldness in makeup. Because they are ethical, righteous and do their duty they do not feel that they are critical or cold. All too often they are. As children, always falling and scraping their knees. This is due to poor physical coordination. Later in life the bumps and scrapes come to the pride. Knees represent true humility, the power to bend. Any trouble with the knees is the outer manifestation of an inner inability to be flexible and flowing.

AQUARIUS ON THE ASCENDANT

Very positive and masculine in personality temperament. Uncertain and sudden impulses. Very intuitive. Good mind. Good in organizational ability. Capable and practical. Intelligent but often cold and calculating where feelings are concerned. If Saturn is strong by place, sign and aspects, then the Saturnian caution, coldness and selfishness will be accentuated. If Uranus is stronger, there will be more freedom and free-flowingness. The things of the spirit will be stronger than the materialistic worldliness. Circulation of physical energy will be impeded if Saturn is afflicted. Too much rigidity in the psychological makeup, and too much self-will will eventually manifest in the physical body as arthritis, especially in the spine. Rebellious tendencies need quelling.

PISCES ON THE ASCENDANT *Jerry*

Easy-going and indolent. Sympathetic, supersensitive, and affectionate. Weak, rather than strong. Plastic and impressionable. Always asking advice, but never taking it. Sentimental and extremely psychic, but in a negative way. Secretive and impractical. Romantic and a dreamer. Absent too often from focused awareness of the present. Often dreams through life rather than living it. Often involved in music. Has a lonesomeness that nothing in the outer world can assuage. A mystic who needs to search beyond the personality plane for himself. Aloneness at times an absolute necessity. Vibrations of the outer plane are difficult for their

sensitive mechanism to withstand. Very likeable, Need to learn to be practical and concentrate their energies on the here and now. Make excellent musicians. Must serve others in their life work. This ascendant gives mystical powers when the emotions are under control.

DECANATES

The signs are divided into decanates. Each sign is divided into three parts of 10 degrees each. The first 10 degrees are of the nature of the sign itself; the second 10 degrees of the nature of the next sign of the same element; the third 10 degrees of the nature of the third sign of the same element.

These sub-rulers modify the characteristics of the signs. All individuals born in the same sign are not alike. The decanate of the sign on the ascendant at birth is very important. Study your sign types and you will learn much about the importance of the decanate ruler. Note the aspects to the sub-ruler, also between the sub-ruler and the planetary ruler of the sign.*

Signs	0 to 10 degrees	11 to 20 degrees	21 to 30 degrees
Aries	Mars	Sun	Jupiter
Taurus	Venus	Mercury	Saturn
Gemini	Mercury	Venus	Uranus
Cancer	Moon	Mars	Neptune
Leo	Sun	Jupiter	Mars
Virgo	Mercury	Saturn	Venus
Libra	Venus	Uranus	Mercury
Scorpio	Mars	Neptune	Moon
Sagittarius	Jupiter	Mars	Sun
Capricorn	Saturn	Venus	Mercury
Aquarius	Uranus	Mercury	Venus
Pisces	Neptune	Moon	Mars

ARIES:

0 to 10 degrees — ♂

Impulsive and headstrong tendencies accentuated. Active, honest and outspoken by nature. Likes to be on the move. Note Mars by sign as well as aspects.

10 to 20 degrees — ☉

Martian force modified and less self-centered. Ambitious nature with more sustaining power than first decanate.

20 to 30 degrees — ♃

Desire to see the world and travel very strong. Interested in sports, gambling and out-of-doors

*For the water signs, Pluto can be considered a co-ruler of the Mars decanates.

if average type. If advanced, religion and philosophy of deep interest. Most restless decanate.

TAURUS:

0 to 10 degrees — ♀

Artistic and creative. Very stubborn nature. Cannot push a bull but you can lead him if you know the ring in his nose is Love. Sensual side of nature needs controlling. Aspects to Venus will be important.

10 to 20 degrees — ☿

More intellectual agility and discrimination. More sociable and adaptable. Flows with the tide if Mercury is unafflicted or there are not too many fixed signs.

20 to 30 degrees — ♄

Most materialistic of the Taurus decanates. Can be stingy. Ambitious and money and prestige very important. Note the aspects to Saturn. Conventional type.

GEMINI:

0 to 10 degrees — ☿

Most restless and diffused of the three decanates. Strong tie with family and cling to ancestral halls because of insecurity and indecisiveness. Most talkative, if Saturn is not strong. Needs to learn to be quiet.

10 to 20 degrees — ♀

Brent

Creativity and artistic talent strong. Should have a career dealing with people in a personal sense. Very likeable type. Very restless and dislikes routine work. Can be lazy.

20 to 30 degrees — ♅

Would have success in business, science or heading big corporations or large groups of people. Excellent business head and keen mind.

CANCER:

0 to 10 degrees — ☽

Reacts more subconsciously than consciously to life. Timid and shy in early life. Receptivity strong. Needs to learn not to respond emotionally to impressions or feelings.

10 to 20 degrees — ♂

Mystical tendencies strong. Note the aspects to the eighth house and the aspects between the Moon and Mars. Strong tenacity and stubbornness. Has to overcome resentment and jealousy.

20 to 30 degrees — ♆

Sympathetic nature. Very emotional and apt to over-identify with passing currents. Sponges that absorb atmospheres. Very psychic. Can be martyrs or servers of the race.

LEO:

0 to 10 degrees — ☉

Ambitious, fearless, proud and sincere, if Sun is not afflicted. Good vitality. Good friend and poor enemy. Don't step on his dignity. Ridicule would cause both parties anguish.

10 to 20 degrees — ♃

Awakens philosophical side if advanced. Wants freedom more than anything else. Apt to lack good judgment if Jupiter is afflicted. A friendly and sociable fellow. Open and above board.

20 to 30 degrees — ♂

Strengthens will power and adds to impulsiveness. Gives strong courage. Very independent. Will give more than they receive. Can unite head and heart if Sun is unafflicted.

VIRGO:

0 to 10 degrees — ☿

Quiet, reserved and shy nature. Needs the help of others to achieve goals and objectives. Lacks self-confidence. Self-centered and needs to include others in his world.

10 to 20 degrees — ♄

Accentuates practicality and business interests. Note aspects to Saturn. Makes an excellent teacher. Selfishness strong if Saturn afflicts Mercury. Needs to watch negativity and depressive moods.

20 to 30 degrees — ♀

Artistically inclined. Less self-centered than the other decanates of Virgo. More loving and

friendly. Not as compulsive in behavior as the first decanate. Finds the routine of every day drab and uninteresting. Needs a creative outlet.

LIBRA:

0 to 10 degrees — ♀

Good disposition. Strong intuitive power. Refined and cultured in nature. Can attract people without effort. Needs to work in association with others. Very artistic.

10 to 20 degrees — ♅

Strong minded. More controlled by reason than emotions. Tendency to fixed patterns. Good mind but not free-flowing in nature. Organizes the life out of projects. Better for a male chart than a female chart. Feminine too masculine in approach.

20 to 30 degrees — ☿

Adaptable and versatile in expression but can be too "airy." Finds it difficult to settle down and finish projects. Good reporters and journalists. Intuitive. Very restless in nature, especially if these are strong aspects to Uranus.

SCORPIO:

0 to 10 degrees — ♂

Reserved, secretive, outwardly calm but seething emotions inwardly. Strength enough to be devil or saint; no inbetween. To know what pathway the individual takes, the total chart has to be considered. Sometimes they go from one extreme to the other in the same lifetime. St. Francis of Assissi is an example.

10 to 20 degrees — ♆

This must be judged by the aspects between Mars and Neptune. Could be advanced type, spending their energies in sacrifice and service to the race; or the rake, dissipated and depraved, destroying others as well as himself. General tone of the chart will tell the story.

20 to 30 degrees — ☽

Much more sympathy and kindness than in other two decanates. Psychically very sensitive. Good aspects between the Moon and Mars will

give psychic powers. Stern outwardly but very soft inside the outer shell.

SAGITTARIUS:

0 to 10 degrees — ♃

Talker and traveler. Very restless. Easily bored. Wants to be on the move. Friendly, gossipy and sociable, but needs a strong Saturn to give depth. Intuitive nature. Optimistic Salesman type.

10 to 20 degrees — ♂

The pioneer in teaching or in new trends in philosophy or religious thought. Adventurous and independent. Doesn't want to be hemmed in. Courageous and can be foolhardy about taking risks. Apt to act and think afterward.

20 to 30 degrees — ☉

Best decanate for Sagittarius. Combines the light of the solar ego with the power of the superconscious mind. Kindhearted and generous. Intuitional and inspirational. If advanced can be of great help to others. Note aspects between Jupiter and the Sun. If afflicted, extravagance and vanity must be overcome.

CAPRICORN:

0 to 10 degrees — ♄

Most ambitious of all the decanates. Practical and persistent in attaining goals and objectives. If Saturn is afflicted they do not hesitate to use people for their own ends. Saturn in upper part of chart, energy-drive for success exceedingly strong. If beneath the horizon, more desire to retreat from the world.

10 to 20 degrees — ♀

Quickens artistic nature and talent where music and the dance are concerned. Ability to attain success materially if Venus and Saturn are well aspected. Gives loyalty and endurance. Can be quite stubborn if there are many fixed signs. This individual can be his own worst enemy or his own best friend. Self-undoing versus self-sustainment.

20 to 30 degrees — ☿

Quickens discriminatory and intellectual faculties. Apt to be critical and demanding if not

careful. Good worker in research, mental pursuits and scientific endeavors. Make good announcers and newspaper workers.

AQUARIUS:

0 to 10 degrees — ♅

Self-reliance and prudence strong. Difficulties in early youth, often due to pigheadedness, but as life advances hard work and perseverance puts the individual into positions of prestige and power. Makes a good scientist and can be a genius if Uranus is highlighted in the birthchart. Inventive type.

10 to 20 degrees — ☿

The type of mind that roams the universe sitting at a desk. Keen intuition. Ideas should be grounded by being used. Curiousity very active. More friendly than the first decanate.

20 to 30 degrees — ♀

Those in service to many people will find fulfillment in this decanate. Represents the lifting of the love consciousness to a higher goal than personal satisfaction. Artistic in nature, refined in consciousness, but can be too cold and impersonal. Needs heart warmth to balance mental power.

PISCES:

0 to 10 degrees — ♆

Only freedom for Pisces comes from relinquishing personal desires. This is the homeless wanderer, seeking and not finding on the earth plane. Only when separateness is dissolved will he know his divine heritage. Aspects between Neptune and Sun will be important. Overcoming of emotional response to life, yet not losing the capacity for feeling and compassion, is the task for this decanate of Pisces in particular.

10 to 20 degrees — ☽

The second decanate of Pisces is difficult, for the person is more at the mercy of subconscious moods and feelings than the other two decanates. Easily hurt and apt to withdraw

from any participation when challenged. Timidity and irrational fears if Neptune is afflicted to the Moon. A strongly sympathetic nature but has to learn not to identify with passing emotional currents. Indecision and worry can give this person ulcers. Ulcers come from letting environmental conditions eat one psychologically; then the body pays the penality. The phrase "What's eating you?" is worth consideration.

20 to 30 degrees — ♂

Here is strength and strong will. More fixed than the first 20 degrees of Pisces. Can be very, very bad or very, very good for there is power here. Can be very selfish and destructive if Mars is afflicted, especially to Neptune or Saturn. If well aspected to the heavy planets this person can be a tremendous force for good. The tone of the rest of the chart will show whether force is used for good or ill. The tone of the rest of the chart will show whether this individual is his own enemy or his own best friend. Self-Undoing versus Self-Sustainment.

CHAPTER 10
The Signs on the House Cusps

~~Brian~~ ARIES THROUGH THE HOUSES

If Aries is on the ascendant at birth, we have what is called the natural chart where the signs are in tune with the seasons and there is less friction. Aries can, as a rule, work faster than any of the other eleven ascendants. There are a great many people in the world's Hall of Fame with this ascendant. Aries gives us the people who think and the people who act. Aries — the fire essence — or the living flow of being, begins in the first house with Aries, is consolidated in the fifth house of self-expression, and is expressed in the ninth house of understanding. Aries people are very much alive within themselves. They are always the people who make the first move. However old they may be, Arians are never too old to start a new venture or to put something into action. The rest of the signs might wilt from stagnation but not Aries.

ARIES ON THE FIRST HOUSE: *Terry (But Pisces rising)*

Aries starts "head first." Born extroverts, Aries learns by putting everything he thinks into action. He has no physical fear. When he learns that he can get nowhere by butting his head against a stone wall, he then becomes more subtle. As a youngster he is simple and unsophisticated and trys to drive straight ahead. Later, he finds he cannot go in a straight line, so he becomes a genius in trying to take dangerous curves successfully. Aries does not attract as Venus signs (Taurus and Libra) do. Being ruled by Mars, planet of "go and get it," Aries can be aggressive in his seeking. This is why he irritates and annoys people. He uses too much force, and there is an instinctive tendency in the other person to retreat. He can fight if he has to do so, but he would rather use his wits.

TAURUS ON THE SECOND HOUSE: *Terry*

Here we have a love of possessions and a desire to hold on to them. Money (or security) is very important. Taurus here gives a love of money and the things money can buy. Aries thinks a great deal about money. Energy does follow thought so he does attract substance on the material plane. Aries is good in business because he is practical and "down to earth" with earth signs on the houses of the chart which rule material concerns. He makes the most of what comes his way. He has a sensible attitude toward money. He will spend money freely if he wants to be prosperous. His outlook is practical and factual and is based on a common-

sense understanding of the world he lives in. He likes good things and is willing to pay for them. He will work hard in order to secure the items he wants.

GEMINI ON THE THIRD HOUSE

Here we find a logical mind, with quick insight, a ready wit and quick speech. Aries has a dozen ideas at one time, yet his one-pointed ascendant tends to converge his actions, and loses much of the flightiness associated with the Sign Gemini. Aries can be a diplomat, for he can agree with one person and then agree with that person's opponent just as readily. He is easy to approach and basically idealistic in his contacts. Why Not? With the dual air sign on the house of daily associates and environmental conditions, he is one or a "twin" with every situation he meets. He is versatile, quick, responsible, and friendly. He is always ready to do a favor and lend a helping hand. He knows everyone in the neighborhood — from the janitor to the executive — and talks to all of them. That doesn't mean he is not aware of the difference in social importance. In taken-for-granted contacts, his approach is through the mind.

CANCER ON THE FOURTH HOUSE:

Here we have the sentimentalist, for in the final analysis, Aries is emotional, particularly in reference to family and the inherited pattern and responsibilities in life. He has a deep attachment to family tradition and home relationships. He may not be attached to his mother if the Moon is afflicted, but he is apt to talk sentimentally about the maternal relationship. He likes to feel that he has a home where he can feel he has "roots" and is centered. That he may have left the family roof as soon as he could has nothing to do with the sentimental attachment to the idea. As he grows older, he has a great yearning for a settled center. He is easygoing at home but inclined to be moody. He does a great deal of traveling from home in early life, but he wants a place to settle down when he is ready to come home, and he expects to find those he loves waiting patiently for his return.

LEO ON THE FIFTH HOUSE:

Here we have the dramatist, for people with Leo on this cusp dramatize themselves and love the center of the stage. They give full attention to whatever interest, romantic or creative, has their attention at the moment. If the next moment this attention has changed, does it necessarily imply that their interest is superficial? Aries burns out quickly if he does not have continual replenishment. He remains loyal and faithful if he feels that at all times he is the center of his world. He is eager for attention, naively accepting even flattery along with appreciation. These are Leo characteristics, for Leo is the natural creative sign, deeply centered, deeply self-aware, and wanting approval constantly. Leo here makes good teachers, and Aries is able to dramatize his knowledge and

make it simple enough for the child to understand. He is a born gambler and spectator. He gambles his money and his possessions — and he gambles his heart as well.

VIRGO ON THE SIXTH HOUSE:

This position gives Aries considerable ability for detail work. Mechanical calculations interest him, as well as all kinds of research work. He is the born historian. This sign also makes him a stickler for neatness and cleanliness. As regards health, Aries on the ascendant and Virgo here may give trouble with the intestines and liver. When Aries is sick, he is apt to be the most irritable of all the signs. Interest in health makes him take an interest in diet and right eating. With Virgo here, he gives willing service when it is required. He acts rather than promises to act. If you ask his help, he gives it though he has a reputation for impatience. Nevertheless, when he has a job to do, he coordinates details excellently with practical common sense. He never hesitates to offer his services. Because the sixth house rules health, when his fiery interest is aroused, he is capable of any amount of hard work, even to the point of wearing his health down.

LIBRA ON THE SEVENTH HOUSE:

With this position, Aries is never happy unless people share life with him in some way. Aries is sentimental as well as idealistic. If he is made to feel that he is a fine person, Aries innately thinks he is, he will share to the point of sacrifice. What is more difficult for him to learn is that sharing is reciprocal. The basis of sharing must be mutually satisfactory and not only as Aries sees it. Because his personality patterns are ruled by fire (fire signs on the first, fifth, and ninth houses), it is difficult for him to see others' frame of reference. This is one of the stumbling blocks in marriage, for if he sees the partner in his own personal context, this does not allow the other individual expression. Aries gets along best with one who understands him and accepts him as he is. Sentimental appeal and mental companionship hold the marriage together. The wise partner of an Aries ascendant person avoids direct contradiction. With tact, Aries can be lead by the nose. Remember, the nose is ruled by Mars, his personal ruler.

SCORPIO ON THE EIGHTH HOUSE:

With Scorpio on the eighth house of death and regeneration, the strong physical urges of an Aries ascendant are easily understood. Aries renews himself or begins life anew through the obliteration of the self in the marriage act. His reaction to love is simple and direct and implies no sentimental tie in ruthless Scorpio fashion. His sentimental attachments derive from other facets of his nature. His power for self-regeneration stems from the exalted solar force that flows from the foundation of life. If Aries wants to do so, he can arise from the worst

trouble and, gathering up his forces, càn start life anew. He loves life but faces death and dissolution objectively. This is why the Aries motto is "do it yourself," for no one knows better than he does that whatever is made over or regenerated must begin from within. Inside he is emotionally uncertain. This is why he clings to the objective realities of life. Aries is not quite sure he can go all out in faith and trust. He can but someone he trusts has to install this belief in him.

SAGGITARIUS ON THE NINTH HOUSE:

An Aries ascendant loves to travel and is apt to do a great deal of it. He has a broad outlook on life and his mind is enthusiastic about religious or legal reform. Aries has a very strong prophetic sense and should follow his impressions. He is optimistic and cheerful and always feels there is something better around the corner. In him, hope springs eternal — and why not? Jupiter rules the ninth house. The ninth house rules the highest mental concepts; his imagination and whatever within him is far-seeing and prophetic. With the sign of prophecy on the ninth house, Aries takes it for granted that he can go forward with all that is new, pioneering, and yet to be.

CAPRICORN ON THE TENTH HOUSE:

Capricorn on this cusp is conscious of worldly position. He is conservative in those matters which could be detrimental in any way to his reputation. He looks on the world with rather cynical eyes. Aries knows that he can't get anything for nothing. He is not a coward but, unless forced to the wall, he is apt to sidestep trouble. So if he gets unpleasantly involved he may decide the best thing to do is to make a break. This will be more in petty issues than big ones. If a thing is big enough, he will stand up against all kinds of hardship and abuse because of being in the limelight. It is the Capricorn quality of wanting to get to the high places and retain the place gained that is responsible for the conservative business and professional reaction in Aries. He wants no smirch on his reputation.

AQUARIUS ON THE ELEVENTH HOUSE:

Aries seems to have two entirely different sets of friends: one group of persevering type whom he usually meets in business or in governmental or executive positions. The other group consists of people who are the Uranians met unexpectedly at odd moments and whom he likes spontaneously. Needless to say, Aries is wise if he does not try to mix these two types. He has friends of all kinds and enjoys group interests. He is discriminating. He is "hail-fellow-well-met" with everyone, but he chooses his friends. He is interested in humanitarian concerns and has bigger objectives in life than others may think who consider him self-centered. He is self-centered, but he goes out from that center to help others.

PISCES ON THE TWELFTH HOUSE:

Here is where the compassion and sympathy of the Aries-born is found. Aries does not want anyone to know he is sympathetic and always willing to help, so he hides this phase of his nature under a brusque surface. He is far more sensitive than he would have you know. Pisces on this cusp is the reason why he decides to go out of circulation every now and then. He needs to be alone at times. To maintain his strength and increase his efficiency, he needs time to rebuild the energies he spends so freely. He has a strong and keen sense of personal service, and no sacrifice will be too great for him if he has lightened someone's burden or brought comfort to someone in need of it.

TAURUS THROUGH THE HOUSES

With Taurus on the cusp of the first house, we find Aries, the starting point of the self, in the twelfth house. Taurus begins where most other signs are inclined to leave off. When a task looks almost hopeless to other people, Taureans pick it up and carry it through to a successful conclusion. They have the energy to put new life into a seemingly lost cause.

ARIES ON THE TWELFTH HOUSE:

With Aries on this house, Taurus has an active subconscious life. He is seldom inwardly defeated unless he himself throws in the sponge. His destructive tendencies arise when anyone tries to tear down his self-confidence. It is difficult to understand Taurus. The personal ego makes its start in the twelfth house of secrecy. The motives of life and action are hidden from the beginning. Taurus may appear frank and open, but don't let that fool you. He is not as open as he appears. His feelings are strong, but suppressed. He has a fiery temper when aroused, is inclined to hold resentment, and is not apt to forget an injury. He feels misunderstood. He suffers from troubles he brings on himself, but it is hard for him to see this fact. The higher type is a leader of humanitarian movements, but he works from behind the scenes rather than out in front.

TAURUS ON THE FIRST HOUSE:

There is great personal charm in Taurus because of the Venus rulership. Often there is a loving personality and good looks. Taurus is the sign of values, and Taurus tends to appraise each new person he meets in a way that makes others feel — "can't tell whether he is for you or agin' you" — which is not the impression he intends to create. He translates experience into something that has meaning to him personally or he cannot use it. He learns far more from direct experience than any other way. You can talk "at him", and he may appear to be listening and agreeing, but it does not register if he does not want it to do so. He likes to put people and experiences into patterns for it gives him a sense of security. Not always do the patterns and the people fit as he would like to

think they do. Taurus rising usually implies considerable inertia which might hold him back, for his reactions are slow and methodical. It is impossible for him to jump to quick and rapid conclusions. He has to establish the idea that the new has something in it that he can use. He wants to be liked, but sensitivity to any rebuff, imagined or otherwise, can make him retreat into himself and become very moody.

GEMINI ON THE SECOND HOUSE

Gemini rules the practical mind. With Gemini on this house, the Taurean mind is on money or resources. Money or security is very important to Taurus. He expresses a lively interest in money matters and in the manipulation of values toward greater earnings. The mind is tuned to money and possessions. Relatives will either hinder or help in the acculmulation of money. He is resourceful in earning money and often has two jobs at the same time. He can get quite excited and talkative when the subject of money comes up. He has the ability to weigh and measure everything and everybody in terms of their material success.

CANCER ON THE THIRD HOUSE

We saw that the practical mind of Taurus is on money, but in meeting and contacting relatives and acquaintances, Taurus is entirely different. Here, his instinctive mind comes into action and **feeling** is the keynote rather than thinking. He is more restless than appears on the surface and does not like to stay quietly at home for too long a time. He has a great imagination and a very good memory. He does not like to study but is a good absorber of knowledge through listening to others in discussion. He can be very lazy mentally and needs to sharpen his mental tools by concentration on studies that stir up his brain cells. He is extremely impressionable and soaks up atmosphere with a psychic sense of what goes on around him. When he is interested he can remember exact words, information, gestures, and even the tone of voice. He is inclined to take those around him for granted and when he finds others have feelings, too, it is difficult for him to accept that the picture is not as he felt it was.

LEO ON THE FOURTH HOUSE:

To Taurus, home is his castle, and there he wants to rule. He wants attention to be focused on his home, for his home and possessions are the centers of his own being. He wants a settled place which is his center and where he can dispense hospitality in lavish style. He loves a good pantry, a good table, and nice service. Owning his home is very important to him. He expands at home, lavishes love on those close to him, and feels very badly when that is not possible. However, pride keeps him from admitting lack of real love in his basic relationships. He maintains the outer semblance as much as he can. Leo here gives Taurus a strong inner faith.

VIRGO ON THE FIFTH HOUSE:

When it comes to affairs of the heart, Taurus has a difficult time. The tendency to analyze or to criticize makes trouble in the home. He has a desire to enjoy the fruits of affection without committing himself to it wholeheartedly. Then he ends up wondering why love fails him. With children, he lacks the ability to give discipline, for Virgo here gives an easygoing nature, and "will" is not the keynote where love and children are concerned. This is the house of self-expression, and Taurus needs mental companionship, for he loves discussions, pros and cons of ideas, and the stimulus that comes through friendly arguments. He hates change and, while flexible on the surface, actually cannot be coerced into change unless by his own decision.

LIBRA ON THE SIXTH HOUSE:

With Libra here Taurus enjoys work that is a sharing of endeavor. Harmony in working conditions is essential; or, in the often-surprising Libra fashion, he can be bitterly antagnonistic. He he is perfectionist if he likes his work, which must remain interesting and have variety. He is open and easily approached in working relationships, for he believes in fair play. He often takes an interest in law or in Venusian trades — interior decorating, hairdressing, cosmetics, and dressing. Taurus has a keen sense of justice and will fight for the underdog because of his love of fair play.

SCORPIO ON THE SEVENTH HOUSE:

With Scorpio on the seventh house of partnership, Taurus brings a great deal of energy to all social relationships. It is said that he more than others, is subject to health complications in an unsatisfactory marriage. This arises because Scorpio, sign of sex and regeneration, is on the seventh house. There are many arguments because of sex in marriage if the ruler of this house, Mars, is afflicted. Loyalty has to stand many tests. Taurus hates to give up and takes a bad union as a personal defeat. Powerful emotions, once given, are not easily changed. Marriage can be a battlefield where victory comes by conquering one's self.

SAGITTARIUS ON THE EIGHTH HOUSE:

This position gives a strong interest in religious philosophy and in life after death. There is an inner faith that a better life and a higher one can be built on better principles. There is often involvement in inheritance or money through death when this sign is on the eighth house. Sex is of great interest, but it stems from a curiosity and a desire to experiment rather than from sensuality. The partner in a marriage may be more highly sexed than the Taurus. Often, curiosity leads them into difficulties.

CAPRICORN ON THE NINTH HOUSE:

In super-conscious matters, Taurus is skeptical, but he is willing to be shown. He will listen, weigh, and discuss spiritual ideas, but if these concepts are not realizable in practical and concrete gain, he is not interested. He has a respect for intelligent understanding but does not accept what he has not experienced personally. He is hard to convince, but if he sees it works on the practical level, he will accept the higher teachings. Except for his work he does not travel far afield. His approach to spiritual things is orthodox unless there is a powerful Uranus in his blueprint.

AQUARIUS ON THE TENTH HOUSE:

With Aquarius on the tenth house, Taurus is eager to do publicly useful work which somehow reflects the hopes and wishes of a group. Ambitions are seldom secret. He openly states his aims and is frequently helped to reach them through influential friendships. When Taurus has power, he is exacting in small things but big in principle and loyal to his ideals. He is unswervingly faithful to those who help him advance. Taurus often works in large organizations or corporations rather than for himself. He often seeks influential friends, for it gives him a greater sense of prestige and importance.

PISCES ON THE ELEVENTH HOUSE:

There is a loyalty and a sympathy toward friends when Pisces is on this house. Wholeheartedness in friendship once it is given, and willingness to sacrifice if necessary are characteristic here. What friends say means a great deal to Taurus, and if he feels slighted, he does not say anything, but there is a deep-seated hurt and resentment simmering within. His generosity and willingness to help make him loved by all. Friends are very important to Taurus, for here he gets his inner sustainment and nourishment.

GEMINI THROUGH THE HOUSES

The sign Gemini is concerned with associations, logical reasoning, deductions and relationships near at hand. Gemini's concept is "I think." Through the activity of Gemini, man learns to relate things, to place one thing into juxtaposition with another, and to consider the two together. Apparently nothing escapes the attention of Gemini. It is as if life passed in kaleidoscopic review before them and it is their task to fix for a moment their attention upon its every passing phase. As a result, they possess a vast fund of observations made from life itself.

ARIES ON THE ELEVENTH HOUSE:

Gemini begins in the eleventh house of friendships, goals, and objectives. Friends are more important to Gemini than to any other sign.

He has the capacity to make friends and remain uninvolved. He has the gift of sociability and makes the most of his contacts. He is interested in and attracted to all classes and all levels and is able to become one with whomever he is with at the moment, though once out of sight, out of mind. Gemini is a joiner but not a stayer and is often found to be the life of the party. He is apt to take things too lightly and turn his back at the first sign of unpleasantness. He needs to learn to be a leader of truth, not a mere reporter of rumor. Extremely communicative where his ideas and goals are concerned, his power is often wasted by talking plans over before they have gone through the seeding process. He needs to learn to be more silent. His nervous system is very highly geared and he loses a great deal of energy by scattering his forces.

TAURUS ON THE TWELFTH HOUSE:

In the twelfth house, we find our hidden fears as well as our subjective sustainment. Gemini has a hidden insecurity about finances, and he worries over them far more than one would suspect from his happy-go-lucky nature. Without hidden reserves where cash is concerned, he feels unprotected and naked. Taurus is the builder and Gemini must learn to build into the innermost self the quality of good judgment where true and lasting values are concerned. If he fritters away his resources — whether they be physical, material, or emotional — there will be restriction and limitation. This can apply to his health, material supply, or even peace of mind but it will stem from the misuse of resources with Taurus on this cusp. There is a stubborn resistance to change where his subconscious mind is concerned. There is far more fixity in their emotional equipment than one would expect, despite his seeming pliability. Arouse his feelings and he is much more difficult than if you appeal to him through reason.

GEMINI ON THE FIRST HOUSE:

Gemini's symbol — "the light, changeable breezes of early summer, here today and gone tomorrow" — is symbolic of the nature of Gemini. The symbol itself represents the two pillars as the gateway to the Temple of Wisdom (♊). The gateway is the mind but **not** the Temple itself. That is found in the opposite sign, Sagittarius, symbol of the superconscious mind. Gemini has the power to communicate ideas and has an active and alert mind. The sign is ruled by Mercury, which rules the mind, the hands, and the tongue. With Gemini on this house and Mercury, its ruler, afflicted, you find a caustic tongue, a tendency to lack of coordination, and a high state of tension in the nervous system. The butterfly, flitting from flower to flower, is another symbol of the Gemini nature. Artistic, a lover of beauty, with an innate desire for culture and refinement, Gemini is seldom coarse or crude unless there is a heavily afflicted Mars in the chart. He has a versatility and an adaptability that personifies the child of wisdom, but he needs to learn to concentrate and direct his forces in steady rhythmic fashion rather than in spurts and starts.

CANCER ON THE SECOND HOUSE:

Gemini has a "sixth sense" where public needs and desires are concerned and is excellent in dealing with the public where merchandising is needed. There is a natural flair for the promotion of art and beauty, and he can make money where the public is concerned if the channel he uses is connected with beauty. There is a basic fear of insecurity regarding money, though he is not stingy or frugal in sharing what he has with others. If emotions are involved, he can be very generous in the giving of his resources or himself.

LEO ON THE THIRD HOUSE:

In his environment and with his relatives and neighbors, Gemini must "shine" in order to be happy. For all his versatility and adaptability, he can be very fixed in ideas and opinions. His pride is very great, and humility is not his greatest virtue. If you puncture his ego or deflate the good opinion he has of himself he will get over it; but he will not forget or forgive you no matter how pleasant he seems to be. He is strongly tied to his relatives, and it is very difficult for him to cut loose from family ties. The power of self-expression — through writing as well as thinking — is strongly pronounced in him. He makes an excellent reporter and can dramatize any situation in telling it. Good conversation and keen wit are gifts of Gemini.

VIRGO ON THE FOURTH HOUSE:

Home for the Gemini is a spot where there is a place for everything and everything is in its place. Fussy and particular about details, he can be a perfectionist. Perfectionism is part and parcel of the roots of his nature. He is basically analytical and practical, and he frays his own nervous system in his desire for perfection. He gets caught in the "little things" that aren't important; but he rises to a big crisis in his life superbly. He fusses and nags over inconsequentials and has no idea how difficult his temperament is to cope with. Because of his dual nature, he is often considered two-faced — and sometimes he is! He is of two minds about so many things that he is often labeled unstable and erratic. In order to become of "one mind," he must go deeper than the mind — the gateway — and learn to center in the Temple of Wisdom itself.

LIBRA ON THE FIFTH HOUSE:

The ability of Gemini to express himself depends on his associations, and he cannot get on well alone. He is more dependent upon nourishment and sustainment through friends and associates than any other sign unless he has a powerful Saturn in his chart. He likes children when they are old enough to be interesting but cares little for them as "young fry" or babies. As a rule he does not want to have to feel responsible for anyone but himself and often Gemini stays single. If he marries it is usually late in life, when his family has gone and he does not want to be alone.

SCORPIO ON THE SIXTH HOUSE:

In work, Gemini wants a sense of freedom. He dislikes routine intensely and does not want to be confined to a desk or in an office. If he chooses something that keeps him active, interested, and busy with contacts, he is happy in his work. Nursing isn't a good profession for Gemini, for it requires the endless patience he does not have. Research or laboratory work would intrigue him. His "bump of curiosity" is very great, so he often is found among the ranks of the scientific world. Gemini makes a good salesmen where homes and land are concerned. The use of his physical creative forces has a direct bearing on his health. As a rule, he is not overcharged with physical energy, for the nervous system is highly geared and he uses a great deal of mental energy.

SAGITTARIUS ON THE SEVENTH HOUSE:

"Don't fence me in" is Gemini's war cry. He is adverse to close and binding ties, for he is concerned with his own growth. Often he stays single for this reason. He likes everyone and finds it hard to love "one" only. The more liberty he gets in marriage, the happier he is, though he wants the feeling of belonging to someone. He wants companionship and relatedness to others more than he wants sex or mothering. He loves to be on the go and expects the mate to go, too. Mentally restless, time flees more for Gemini than for any other sign. He needs to build an in depth psychology. Otherwise, he fritters away his energies. He suffers from nerves more than any other sign and has an unstable nervous system if he does not have psychological insight into the nature of his own being.

CAPRICORN ON THE EIGHTH HOUSE:

Gemini has a dread of growing old or dying. He feels young, and, like Peter Pan, wants to stay young. He runs into trouble in lending money and needs to exercise discrimination in the use of his finances. Careless and irresponsible in dealing with the money of others, he must learn to be protective where the partner's resources are concerned. On the physical side of his nature, he is not too highly sexed, for he lives in the thinking side of the nature more than he realizes. This is Gemini's house of service — the sixth from his own sign — and he needs to adjust his values and see more clearly. There must be no mental wobbling where adjustment to others is concerned.

AQUARIUS ON THE NINTH HOUSE:

This is the house of ideas and the spreading of them. Ideals made practical are the keynote — or should be — of Gemini's philosophy. The use of understanding, via the higher mind, will enable him to balance the "two minds" within. Here is the teacher, the traveler, the neighbor, the reporter, the first-class mixer. There is strong conservatism in his religious philosophy; and though he likes people with advanced and unorthodox ideas, he remains conservative to the end. He wants to be in

the swim but hug the snore, and he does not want to get more than his toes wet. Don't scare him by pushing any philosophical idea until he is ready to accept it. He is curious but nibbles at life rather than experiencing it fully.

PISCES ON THE TENTH HOUSE:

Gemini has to do work that appeals to his emotions as well as his mind. He often does two jobs rather than one. He has difficulty in knowing what he wants to do in life. Once he picks a career, he is always wondering if he picked the right one. There is a real interest in music and also a desire for success in the dramatic field. His tendency to act and dramatize himself before the world is due to Pisces on the tenth house cusp. He dramatizes everything that happens and is apt to allow his imagination to run away with him. He dreams "big" schemes but has to start at the beginning which isn't easy for him. Where Taurus lags behind, Gemini is always running to keep up with himself. His thoughts wing their way into the future long before the capacity to achieve has caught up with them. "Easy does it" should be built into his inner self if he wants to be healthy, wealthy, and wise.

CANCER THROUGH THE HOUSES

The sign Cancer is symbolized by the restless tides of the ocean, the surging and ebbing tides of emotion. Cancer is the maternal water sign. It is a feminine cardinal sign and represents the mothering or nurturing principle. It is the sign of the womb, the house, and the home, the interior of all these things, for it is the protecting or covering principle. Capricorn, its opposite sign, rules the skeleton or outer structure. Cancer represents the interior lining. Cancer is symbolized by the slow-moving crab, identified with its dwelling place, carrying his house upon his back and retreating into it when threatened by exterior forces.

ARIES ON THE TENTH HOUSE:

Cancer's drive for significance and his thrust into activity starts in the tenth house of prestige and activity before the public. Ceaseless activity is maintained by him until he has attained importance and recognition. He feels he was born for the limelight. With all his innate shyness and insecurity, the desire for recognition is very great and he is very unhappy if his worth is not recognized beyond the family circle. He rarely knows what he wants to do early in life. He often rushes into a profession and finds out it is not what he really wanted to do. He has an endless struggle arriving and maintaining his arrival when he gets there. Yet when a cycle ends, hard as he fights to hold the status quo, he adapts himself quickly to new conditions.

TAURUS ON THE ELEVENTH HOUSE:

Cancer's objective too often is money. With the second-house sign of Taurus (the sign that rules money and possessions) on the house that has to do with objectives and goals, it is not hard to see why. He has a basic insecurity that is rarely understood. It is not money for money's sake, as it is with Taurus, but money for the prestige and importance it gives. The strange thing is that, no matter what he has of material value, it never gives him any lasting satisfaction. Where friends are concerned, Cancer can hold his friends but has to guard against holding them too closely and leaning on them too much. He needs to feel he comes first in others' affections. If he does not feel it is so, he can go through pangs of jealousy that make his as well as his friends unhappy.

GEMINI ON THE TWELFTH HOUSE:

Difficulties often come through relatives, and the only relative he is apt to feel close to is the mother. The tie-up with relatives is a karmic one if Mercury is afflicted, and he will be happier away from too close association with brothers and sisters. He functions more from the instinctive and subconscious mind than from reason. Extremely psychic innately, Cancer finds it difficult to separate what he feels from what he thinks. He is apt to be at the mercy of his moods and feelings — up one day and down the next. He is what I call a "psychic blotter" and is very susceptile to atmosphere. He **feels** what you think and is very good at knowing exactly what you are thinking. He cannot study by rote, but he can sit and listen to others talking and soak up knowledge like a sponge. He tends to be very impressionable.

CANCER ON THE FIRST HOUSE:

Cancer has a very strong attachment toward their home and family, especially the mother. If there is a prominent Moon in the chart and this sign is rising, there is almost always a very strong mother complex that keeps him from maturing and becoming independent. If it is a masculine chart, the soul is feminine. This creates complications so that it is difficult for him to polarize on the masculine pole. The past and tradition are very important to him, and he clings with great tenacity to the past. There are more antique dealers under this sign than any other for Cancerians love to rummage in the past. Children with this ascendant have a very active imagination coupled with a great timidity. They need to be given constructive paths for their imagination to wonder in. They need a great deal of love and encouragement for they have a deep-seated sense of insecurity. Cancer rules mass consciousness and the public, and this sign on the ascendant often brings the individual into contact with the general public in his chosen career.

LEO ON THE SECOND HOUSE:

Cancer makes finances his major objective; he often ends up with money but little peace, for true security does not lie in material

things. There is a far more materialistic side than one would expect in meeting the gentle unassuming Cancer. Wherever Leo is on the chart is where the drive for significance is posited and where the individual wants to "shine." Cancer has the capacity to make money, for he has an instinctive understanding of what the public needs or wants and he can profit by providing it.

VIRGO ON THE THIRD HOUSE:

Mind and feelings, head and heart, can either clash or work together with Virgo here. Cancer possesses an inferiority complex, especially in early life, because of this sign on the house ruling the power to communicate and the house of the reasoning mind. In all story-telling (and Cancer loves to tell stories — he goes into minute detail. There is adaptability for writing. There is a tendency to be fussy and to allow unessentials to bother him too much. In a big crisis, he rises to the occasion magnificently. Cancer has a very sensitive stomach due to overtense solar plexus nerves and should never eat when he is overtired. Many of his digestives troubles do not originate in his digestive system but in his nervous system. He has a natural interest in health, with Virgo on this house.

LIBRA ON THE FOURTH HOUSE:

Cancer wants a home more than any other sign but Taurus and is not happy without roots. He wants to own whatever he has, whether people, home, or things. It gives him a sense of emotional security, where Taurus gets a sense of material security through ownership. He needs to get the proper balance between the soul and the personality before Cancer can know any peace. Because of his restless nature, he finds it difficult to sit still and stay long enough to know who he is and what his soul is really seeking in this life. Until he anchors himself in eternal value, there is no peace in him, though he appears very quiet and peaceful.

SCORPIO ON THE FIFTH HOUSE:

Secret or unusual love affairs are part of the Cancer pattern. Cancer is tenacious and intense in his love affairs while they last; but once the link is broken he adjusts far quicker than you would expect. There is a tremendous interest in sex but more from the angle of curiosity than passion. Where children of his body — or ideas of his mind — are concerned, Cancer finds it very difficult to release them. Unless there are higher-octave planets prominent in his chart, he is very selfish and everything revolves — or he thinks it should — around himself. He needs other people because he is not sure of his own center and his own worth. He attracts people, for he has much to give if he will, but when jealousy or possessiveness creeps in, they corrode any relationship.

100

SAGITTARIUS ON THE SIXTH HOUSE:

Cancer is not a vital sign. Unless there is a prominent Mars to energize the blueprint, Cancer does not have a great amount of energy. For that reason, he needs more sleep than some of the other signs. Because of his lack of vitality, there is a craving for sugar; the tendency to overeat where starches and sugars are concerned needs to be watched. He loves to be on the move. In his work he wants the type of job in which he can move around. Many of them do considerable traveling in their vocation, even though it may not be long distances.

CAPRICORN ON THE SEVENTH HOUSE:

Despite their tendency to protect and mother others, Cancer finds it difficult to maintain and sustain a long-term relationship. Any stable relationship calls for cooperation on both sides, and his nature is subject to moodiness and self-centeredness. He does not want to feel restricted himself but there is a strong tendency to want to restrict "the other" because of an over-concern and overpossessiveness. The type of partner he attracts is one that is self-indulgent, inclined to be lazy and have fluctuating emotions. Because of a deep uncertainty, Cancer attracts the type of partner who is unstable and fluctuating in responses. Cancer is strong for the "tie that binds" but do not want to feel the sense of responsibility that any worthwhile relationship needs. He has a delightful side and a keen sense of humor; and when the sun shines for him, there is no happier and easier sign to be with. "Home" is truly his castle and he loves to entertain in it. He is a wonderful cook and good host.

AQUARIUS ON THE EIGHTH HOUSE:

Cancer's conservative ideas on the creative force might surprise the people who judge from surface appearance. The tendency to dabble emotionally is very strong, not necessarily from passion but from love of sensationalism and a curiosity that wants to know all there is to know about sex. There are few people with this sign on the eighth house who do not have problems in this area. If Cancer is self-indulgent and unevolved and does not handle these currents wisely there is a strong tendency to obsession because of his extremely psychic nature. No sign can be taken over by adverse forces as easily as this sign. It is a more subconscious and instinctive sign than any of the others. The wrong use of the bodily functions with this sign on the house of death brings an ending that has to do with circulation difficulties or shock. Cancer needs plenty of exercise, but he dislikes exercise greatly.

PISCES ON THE NINTH HOUSE:

If Cancer chooses the higher way, there is a strong mystical tendency. He has an innately religious outlook, more devotional than intellectual. There is a tenderness and compassion in Cancer that makes

wonderful nurses, and he has a healing quality that is very helpful to the people he contacts. He is not aggressive or troublesome by nature and has a strong desire to please others. The Cancer's greatest need is peace, and he wants that particular quality more than any other. The strange thing is that, while he often lacks it he is able (because of his gentleness) to give it to others. This is the last sign for Cancer and it is on the ninth house. He does end up getting understanding and comes at least to the gateway of peace when he gives himself up.

The greatest strength of Cancers' will-to-life expresses itself in a broader world than that of the home in many ways. Cancer-born Mary Baker Eddy found a way of self-preservation for millions that linked the life wish directly with God through faith. Henry Ward Beecher, preaching for freedom for slaves must have been driven, being Cancer-born, by the conviction that slavery was contrary to the laws of nature. John Paul Jones, America's first naval hero, another Cancerian, translated the need to preserve life to the life of the nation. Perhaps it was something of this urge that caused "the woman he loved" to be more important to the Cancer-born Duke of Windsor, but it was not an urge that embraced anything but his own desires and his own little world.

America — land of the free — our Uncle Sam is Cancer-born. As a nation, we have all the strengths and weaknesses of this sign. We are overemotional, maternal, protective, and suspicious at the same time. We fritter away precious time in nonessentials and inconsequentials and have a very strong emotional response to the world's needs but do not use reason as much as we should. We **have** mothered the world, but on our terms, not on the other fellow's. We, like the Cancer-born, have to learn to know the peace the world cannot give, for it comes through the sacrifice of self — not through the enchantment of self at the expense of others.

LEO THROUGH THE HOUSES

Wherever Leo is in the chart is where he expresses his real self. When Leo is the Sun-Sign, the soul is more accentuated than normally with the consciousness of self. Leo is the sign of self-consciousness as Cancer is the sign of the instinctive consciousness.

That wonderful myth of Phaeton tells the story of the unevolved Leo native. The youth Phaeton, went to his father, the sun god, and insisted on being allowed to drive the sun chariot through the heavens. His father told him how much strength and control it would take to drive and handle it but Phaeton wouldn't listen. He had only one thing in his mind — he wanted to drive those horses. He did! But he couldn't handle them, for he wasn't disciplined and wasn't ready. He lost control and set everything on fire, including himself. He fell, afire, through the air to the earth. He had courage, but he was irresponsible as well as undisciplined and brought ruin on others as well as himself.

Because of Leo's solar power, his keywords have to be **responsibility** and **discipline;** and when these qualities have been incorporated into the Leo nature, then truly he is a child of the Sun.

ARIES ON THE NINTH HOUSE:

Leos start in the house of the superconscious mind, and the springboard of all his actions is an innate faith in life. No matter how rough he makes it for himself (and he does) he has a strong inner conviction it will be better tomorrow. Leo, the royal and kingly sign of the zodiac, in an age when kings are a thing of the past, needs the realization that the royalty of the new age dawning will be the spiritual aristocrats who function through the heart and soul in real simplicity. What is simplicity but going to the inner heart of things and seeing things whole? Leo begins in the house of insight and understanding and he can be a great blessing to others. When Aries is on this house, his ideas are his own. He is apt to be a trailblazer where metaphysical ideas are concerned and surge forward into the unknown with all the ardor of the fiery Aries. He has an assurance that strengthens those who are timid and maddens those who are seeking the power that is a natural gift of Leo.

TAURUS ON THE TENTH HOUSE:

Here lies the resources of Leo. Taurus is substance — the outer result of inner faith. Leo does not have difficulty manifesting substance for this reason. Leo people attract material things because there is a generosity and a givingness in Leo that are not found in other signs. Even though he may be as poor as the proverbial churchmouse. one would never know it by his manner. He feels a sense of abundance of life, and energy does follow thought. Hidden in this house is a block that causes difficulties of which Leo is not aware. Where authority is concerned he will not delegate it to another. He gives with one hand and takes away with the other, for the Taurean tendency to hold on operates here where authority is concerned. Wherever Taurus is in any chart is where we have difficulty letting go. To Leo (with Taurus on the tenth house cusp) letting go prestige, importance, and authority is the thing that doesn't come naturally.

GEMINI ON THE ELEVENTH HOUSE:

No one makes friends more easily than Leo. There is a mental click with younger people. There is an eternal child in Leo, and he never quite loses the wonder of life. Because of this quality, there is a naivete that is very appealing. Leo likes all types of friends, and the more varied the better. There is a keen sense of humor in Leo, and one of his saving graces is his ability to laugh at himself. He makes good friends for it is impossible for him to hold a grudge over a long period of time. No one knows better than Leo that life is living and "let's get on with the show."

CANCER ON THE TWELFTH HOUSE:

The twelfth house is always what is hidden and out of sight, that which we do not see on the surface. There is a very strong sensitivity in Leo, and his feelings are often deeply hurt because of this supersensitivity. His strong pride keeps him from showing it, consequently he does suffer more, for he does not express his deepest feelings easily. Often there is a karmic involvement where the mother is concerned that denied him a feeling of being loved when he was a child, leaving him with a feeling of insecurity despite his outer poise and assurance. "Am I **really** loved?" Leo is never sure!

LEO ON THE FIRST HOUSE:

Can the sun shine for itself or just for another? Only when Leo's nature becomes impersonal and gives warmth and love to all, does he come into his inheritance. Leo of all the signs, cannot live for himself alone. All energy comes from the Sun. It is the will to express and achieve the pattern of the soul. All our light and power come from the sun force inherent in Leo. But light and power can warm or blister, create or destroy. The solar radiation has the power to bring forth life, but Leo has to use that life wisely or pay a heavy price. That is why his "will" has to become God's will or he is in trouble. An undisciplined, egotistical, and irresponsible Leo, like Phaeton, can cause great difficulties not only to himself, but to everyone around him as well; that it was not done intentionally doesn't keep him from suffering the effects. There is dignity, self-respect, courage, and integrity in Leo. His virtues are big ones — and so are his faults. Honest and direct and fully dependable when he is evolved, he can be used as a channel of power; but never must he think he is the power. Leo on this house makes the individual incurably romantic and idealistic. He is a great dreamer but has the power to make most of his fondest dreams come true.

VIRGO ON THE SECOND HOUSE:

With the practical and serving sign of Virgo here, Leo's resources are used for others. Leo is practical and down to earth when it comes to handling money. He can spend lavishly when he has it, but he can be practical about finances when it is necessary. With an earth sign on the second house, there is a natural harmony; finances are not a matter of serious concern to the Leo individual. He may not have a great deal of money, but it doesn't bother him very much. He thrives on service to others, for his greatest resource is his ability to help others when they turn to him for help and guidance.

LIBRA ON THE THIRD HOUSE:

There is a strong desire in Leo to please those in his immediate environment because of a love of harmony and a reluctance to function where there is no peace. Circumstances are met and dealt with in a spirit of cooperation and adjustment with this sign on the third house. Leo does

not like to argue, and only when forced to do so will he become argumentative. There is a mental rather than an emotional sensitivity here. The mind is refined, artistic, and idealistic.

SCORPIO ON THE FOURTH HOUSE:

At the roots of the Leos' nature is the strong, intense, mysterious sign Scorpio. Here is the inner strength that so many feel in the Leo native. Persistent even unto death and loyal to the "nth degree", once he has given himself to a cause or to an individual, is the trade mark of a developed Leo. His very fixity and determination bring him through many crises — which are often of his own making because of his gullibility and tendency to trust too easily, more often than not the wrong ones. The end result of the spirit's entombment in matter is the resurrection; and Leo, like Scorpio, rises out of the dead ashes of the past with increased wisdom and understanding. His indomitable faith keeps him from bitterness, and nothing daunts him for too long.

SAGITTARIUS ON THE FIFTH HOUSE:

The gregariousness of Leo and his friendliness stem from this sign on the house of self-expression. Leo is the natural gambler of the zodiac and will take chances for the sheer joy of adventure. Self-expenditure is the keynote with Sagittarius here. There is an enthusiastic outreach into life and living that can become too exagerated and health suffers. When Leo becomes enthusiastic about something, he should sit down and count to 1,000 before he does anything about it. Then there would not be as much unwise expenditure of self and effort. Leo loves children and has a natural understanding of them. To him children are persons, and are treated as such. Children love him because they feel his respect for them as individuals.

CAPRICORN ON THE SIXTH HOUSE:

Leo's capacity for hard work is due to this sign on the sixth house. There is no harder worker in the zodiac. When he wants to be lazy, he is the laziest of the signs. He never counts the cost of his own efforts, for what counts is the achieving. He is often stern in his demands and is apt to be a disciplinarian but is willing to be just as hard on himself as he is on the other fellow. He commands an innate respect, and there is a point of no return when the lion's tail has been pulled once too often. While the lion roars, you are safe; when he stops and draws himself to the full dignity of his stature, his usefulness is over, for he has had it and he's through. Where health is concerned, Leo's difficulties are with the spine, the heart, and the knees; trouble in these regions have to do with the will and pride. Humility is not one of Leo's strong suits.

AQUARIUS ON THE SEVENTH HOUSE:

Here, there are apt to be clashes with partners because of the Saturn-ruled Aquarius, a fixed sign. Leo is too personal and Aquarius is far too

impersonal; the hardest lesson for Leo is to be unbiased by emotion. He often marries someone as individualistic as himself. There is freedom wanted on both sides, and if both agree, all is well. Try to fence Leo in and there is trouble; give him liberty and he does not want it. He wants the feeling of being free; but if he has it without undue effort, the lion can be domesticated. With Aquarius on this house, the partner must be given the right to be himself. Leo wants the right to be himself and takes it. He must give the same right to others. Only in mutual respect will a union thrive when Aquarius is on this cusp. If Leo brings to partners adaptability, tolerance, and understanding, all will be well.

PISCES ON THE EIGHTH HOUSE:

Leo's love must become divine compassion before his regeneration is complete. The Leo destiny is a high one; for that reason, it calls for sacrifice, obligation, and a willingness to be bound. No man can be a true leader or king until he has been willing to be the servant of all; then his high estate is his by divine right and no man can gainsay it. When we are worthy, we have earned the crown and can wear it with dignity and honor. With Pisces on this cusp he must not sacrifice other people's resources but his own. Pisces rules the feet, symbol of understanding; and when Leo comes to dominion over his own nature, then his gift to the world is an understanding heart.

VIRGO THROUGH THE HOUSES

When we know the house which Aries occupies in any chart, we know where the real ego — the self — makes its start in life and commences its real mission. That will be the starting point from which the individual projects his divine fire and initiative and goes out to meet life. Aries is where we begin activity, and Virgo starts from the eighth house, the region having to do with regeneration and transformation as well as with the resources of others.

ARIES ON THE EIGHTH HOUSE:

The transformation and regeneration of the self comes through giving oneself away in service to others. Virgo is the sign of service, and Virgo must serve if he would be free. His "dharma" is to serve, but also to learn discrimination in service. To lift the burden from one who needs the burden keeps that person from the development of character and strength that is necessary to his progress. Virgo is ruled by Mercury, as is Gemini; but here Mercury is in a different role. In Gemini, Mercury goes out to experience — and the more experience the better. But in Virgo, Mercury is assimilating the experience, building into his nature the power to discriminate — the power to evaluate, what he should keep that is of value to him in the experience and what he should eliminate.

We take in physical food and it goes through a process of digestion, assimilation, and elimination; but we are apt to forget that the mental and emotional experiences are food too. The same process is necessary where impressions are concerned. If experience, whatever it may be, leaves us suspicious and resentful, we suffer from faulty elimination and pay the toll in disease. Virgo has rulership over the house of health — the sixth house in the natural zodiac — and health has far more to do with our attitudes than we surmise. He who is busy in service does not have time to think of himself and consequently is healthier. Virgo is a mutable sign, and people born in this sign are adaptable and flexible. There is a strong independence within him that isn't apparent on the surface. He prefers to go his own way rather than ask for help. His independence sometimes deprives him of reward and support that he has truly earned and needs.

TAURUS ON THE NINTH HOUSE:

Virgos' approach to religion is practical and realistic. No visionary flights or fancies are part of his equipment. He has a subconscious fear that he will lose his grip on terra firma if he becomes interested in the superphysical. There is a dogmatic side to Virgo so that a conception of what a thing should be often blinds him to what it really is. If something displeases him, he is apt to ignore it if he can't change it rather than accept it for what it is. Even in his unorthodoxies, Virgo can be quite fixed. The reformer is strong in him; and while not a fighter, his outlook is critical. He tends to be mentally detached but curious about various philosophies, even if they do not accept them wholeheartedly. He must get something practical and useful from any concept or out it goes. The ninth house also pertains to relatives by marriage; and if Venus is afflicted, there is some adjustment to be made where in-laws are concerned.

GEMINI ON THE TENTH HOUSE:

With Gemini on this house, there is an outer flexibility where career and human interests are concerned. For real satisfaction in work, Virgo must have personal contact with many people and practical outlets for his abilities. Unless there are a variety of interests, he can become bored, restless and unhappy. He is a "doer" and must be doing. When things are dull, he loses interest. When the self-consciousness of Virgo is overcome, he makes an excellent speaker and is able to communicate his ideas to others. He must have a hobby other than work, for he feels the need for a variety of activities. Relatives play a prominent part in the life of Virgo people whether for good or ill, depending on the aspects of Mercury and the planets in this house. Virgo often has two jobs at the same time, and does both equally well.

CANCER ON THE ELEVENTH HOUSE:

Material security is Virgos' aim and objective, for there is an underlying and subconscious fear of lack. He has a strong money consciousness in his sense of material values, but that won't keep him from excessive spending under emotional compulsion. Virgos' do not like large groups of people because he has an innate shyness and finds it difficult to feel at ease with too many people at a time. He much prefers one or two intimates rather than a gathering of many. Cancer is the most personal sign in the zodiac, so Cancer on this house makes it difficult for Virgo not to be too self-conscious in social relationships. He is the one who gets "butterflies" in his stomach when a situation arises that calls for poise and assurance. He can appear perfectly calm outwardly; but, inside, he is unstrung. He makes a good friend to those to whom he gives his friendship, but takes only a few into the inner sanctum. He has strong feelings about people that are usually right. In his quiet way he sizes up people very accurately.

LEO ON THE TWELFTH HOUSE:

This sign — the powerhouse of the zodiac — locked up in the twelfth house of subjective sustainment and self-limitation is the reason Virgo can often be the power behind the throne, but is not allowed to be on the throne. His job is to sustain and strengthen others, thereby redeeming and transforming himself. He has dreams of magnificent self-expansion that are not likely to come true for the soul in Virgo has chosen to serve others, not himself. There is a self-sufficiency in Virgo that keeps him from being lonely when he is alone. He needs time out from the busyness of life in order to renew and revitalize himself. His power lies in understanding the depths of his own nature; when he does, he is a powerful aid in helping others to understand themselves. Virgo's power lies on the subjective level; and when he understands how to tap that power, he is able to attain any goal he sets for himself.

VIRGO ON THE FIRST HOUSE:

With Virgo on the first house, an individual born in Virgo or with Virgo rising at birth has the gift of eternal youth conferred upon him' due to Mercury's rulership. Many times, a time chart may be rectified by knowing this fact, for if a person has a Virgo ascendant, he never looks his age, no matter what it may be. A great sensitivity and a feeling of inadequacy are inherent in the person born in this sign. Because his power is locked up in the twelfth house, Virgo has a greater sense of power than he is able to express. The result is an inferiority complex. Psychologists say an inferiority complex is a superiority complex turned in on itself. The first house is the externalization of the self, and the personal self in this sign is learning the lesson of humble service and patience. Humility is willingness to be the least. The Master did say that those willing to be the least were the greatest of all. Virgo finds its fullest

108

expression through serving others, being willing to do it quietly, silently, but thoroughly. To him falls the endless details and routine jobs. In the long run, his is the greatest satisfaction. Despite how it seems in the world of appearances, to the earner belongs the fruits of the labor that no one can take away. Virgo has to do with the end of a cycle of purely personal development. It points to the overcoming of self through self-transformation. It can come through a devotional self-surrender of some sort, or by means of the acquisition of techniques or adequate training in skills, creative as well as manual.

LIBRA ON THE SECOND HOUSE:

This is the house of the resources of the self as well as possessions. Virgo is always trying to balance his checkbook as well as his human relationships. He can veer from throwing his resources to the four winds to being so stingy he is downright selfish. There is a hidden influence of Saturn in any house ruled by Libra; and Saturn makes for over-caution and selfishness if in a negative mood. With Libra on this house, Virgo likes a job where he does not have to get his hands or clothes dirty. He is neat and fastidious, as a rule, and likes order and system. One of the personal resources of Virgo is an innate refinement and dislike of any-thing crude or coarse. He is clean-minded and has a strong distaste for smuttiness.

SCORPIO ON THE THIRD HOUSE:

There are fixed opinions, prejudices, and theories in the mind of Virgo that is surprising to one who thinks he is easy to get along with. He is — but don't try to let anyone change his mind if he has made it up. Ask to change anything but his mind, and he will oblige. He may love to be on the go, being a mutable sign; but he wants a fixed environment from which to function. He can make a good detective for he has the ability to find out anything he wants to know without others knowing it. Excellent researchers, nurses. and doctors are born with a Virgo Sun-Sign or Virgo rising. Scorpio on this house gives Virgo the power to penetrate and the persistence to stay with a project until he has come up with a solution. If he has brothers or sisters there can be friction, for Virgo is not always understood by others. This is partly due to his un-communicativeness for he is silent in defense of himself.

SAGITTARIUS ON THE FOURTH HOUSE:

Virgo's home ground is important, and he has a great sense of security within himself if he is in his own domain. He is not one who likes to go visiting. As a rule, he enjoys his own home the best. There is a strong sense of fair play in his nature. When he sees injustices, despite his timidity, he can be quite vehement in letting others know about it. If Jupiter, ruler of this house, is afflicted, he can be quite critical and con-demning, not easy to live with. When he uses his higher mind and intuitive

perception, he is philosophic in concept and is able to bring great understanding to others. The fourth house is the roots of the being, the soul quality in the depths of the self. Virgo represents matter — the earth — and it is in earth that spirit must be grounded in order to gain experience and refine matter.

CAPRICORN ON THE FIFTH HOUSE:

Virgo's self-expression is of the earth, earthy. It is practical and matter of fact. He is the worker, good with details, but finds it difficult to get his feet off the ground. Saturn is the teacher and rules this house. Virgo is a good teacher and is often found in the field of education. He is apt to be a stern disciplinarian especially if Venus or the Moon is not as strongly placed in the chart as Saturn. Virgo needs more love in the make-up to soften the hardness and crystallization of Capricorn on the fifth house. He is not a giver by nature; disappointment in love comes when he does not give of himself. Through disillusionment and supersensitivity he builds walls to keep others out, forgetting that the same wall will lock him away from life. Where children are concerned, he does a good job of bringing them up but finds it hard to switch off the parent role to that of a friend. Speculation is a fifth-house affair and with Capricorn on this house, he finds out he cannot get something for nothing. He has to work for what he gets. He is not apt to be the life-of-the-party type, for he is serious minded.

AQUARIUS ON THE SIXTH HOUSE:

The reason Virgo has jittery nerves and a highly geared nervous system is Aquarius' position on the house of health. His state of mind has a direct bearing on his health. He becomes hypochondrical when he thinks too much about himself and becomes too self-centered. Nerves are the difficulties the person in the body afflicts upon the body. Only the person in the body can readjust mental attitudes so that the body is eased and not diseased. Though Virgo likes to be alone at times, he does not like to work alone.

PISCES ON THE SEVENTH HOUSE:

Virgo's self-undoing can come by not relating himself properly to others. No man is an island and no one can be completely independent, no matter how much he may want it so. We live in a world where everything has to relate to every other thing, for each is a part and not the whole. Pisces is the sign of self-sacrifice. When it is on the house of relationships, there has to be the surrender of the self for others. Virgo is apt to be self-centered unless highly evolved and when it finds itself in the house that contains everything but the self, it is often at sea. With Neptune ruling this area due to its rulership of Pisces, he is apt to encounter peculiar and unusual experiences and hard-to-understand people. This is where Virgos' ability to analyze and to learn discrimination

comes in. If Virgo nags — and he can — he becomes overcritical — which he often is — no partnership can stand up against his withering fire. Virgo's role is a supporting one and according to his willingness to be nothing does he really become something. Though he appears placid and matter of fact on the surface, he is apt to be at the mercy of his moods and emotions and can be extremely negative at times. When he is in an emotional dither, physical activity is his need and his solution.

CHAPTER 11
The Signs on the House Cusps
(continued)

If Libra is on the ascendant, then Aries, where the self projects itself into activity, is in the seventh house, the angle ruling sunset. When everyone else is ready to call it a day, Libra is ready to go into action. The power to relate to others should be his greatest concern. He comes into this sign to attain balance and equilibrium. If he had it already he would not be born in this sign. The sign Libra stands half way between the strictly personal and material Aries and the impersonal and spiritual Pisces.

ARIES ON THE SEVENTH HOUSE:

With Mars-ruled Aries on the seventh house, Libra represents "high windstorms and hurricanes, followed by calm." The Libra tendency to stir up a storm where other people are concerned is related to the Mars rulership. The stirring up of the energies of the partner usually starts with the Libra, but so sweet is the Libra personality that the partner is at a loss to account for actions into which he is goaded by Libra. When Libra's sense of justice is outraged, he will fight to the death. Many of the war leaders are Librans. It is the angular Mars rulership that is responsible. Hitler and Mussolini had Libra ascendants, and former President Eisenhower is a Libra. In relationships, he has to learn to adjust but if the other fellow doesn't want to, there is war. Aries on this cusp brings strife and difficulties in relationships. Early marriages contracted impulsively in which there are many lessons to learn (Saturn, the celestial schoolmaster, is exalted in Libra) can be part of Libra's experience. An individual with Aires on this cusp would be wise to use the common sense of Saturn and not leap impulsively into any partnership, whether it be business or marriage. Because Libra is a masculine sign it is a difficult sign for the feminine sex. There is a tendency toward domination and positivity that can give trouble where partners are concerned. Uranus, the planet of independence, is the esoteric ruler of Libra. Can one assert independence in the area which has to do with cooperation and compromise? Hardly.

TAURUS ON THE EIGHTH HOUSE:

This is the house of other people's resources as well as regeneration If Venus is unafflicted, there is a willingness to share and to help others attain their goals and objectives. With Venus afflicted, there is unwilling-

ness to part with any resources. There is a "this is mine and no one can have it" sort of attitude that can lock up the individual psychologically. The position of Taurus in any horoscope is where we are apt to lock up ourselves in matter by getting caught in illusion or its reflection. This is a subconscious reaction due to the exaltation of the Moon in Taurus. Breaks and disruptions can come if the partner's money is dealt with selfishly and unreasonably. This is the seventh house from Taurus' own home and there must be cooperation with "the other" or "others" if there is to be a free-flowing lovingness and shared experience.

GEMINI ON THE NINTH HOUSE:

There is love of travel due to a great curiosity about life and people. Libra's approach to religious philosophy is through the mind, not the mystical and devotional approach. It is through reason and logic he wants to know the why of the cosmic law, and his journey to the mountain top of spiritual consciousness is through knowledge and the occult path. On the personality level, the ninth house rules in-laws (third from the house of the marriage partner) ; and if Mercury is afflicted, it would be wise for Libra not to live close to his in-laws. Gossip and bickering would be a constant source of irritation.

CANCER ON THE TENTH HOUSE:

Cancer rules the public, and this sign on the tenth house shows the power that draws Libra into a public career or work that has to do with the public. There is a subconscious feeling that enables Libra to know what the public wants. If the Moon is afflicted, this can involve many changes in the career, due in some measure to an innate restlessness in the individual. With Cancer here, the mother would be a very strong influence in the life — whether for good or ill would be shown by the aspects to the Moon, especially in relationship to Saturn. For instance, with Saturn square the Moon in a Libra's chart, there would be too strong a domination from the mother. Because of the strong sense of duty and responsibility, the Libra will not be able to get free and break from the "womb of the past." This blockage causes deep-seated resentment which is stronger because it is unexpressed. In later life, when the parent is gone, there is a feeling that life has passed the Libra by. Because of these conflicts, Libra often has difficulty with skin eruptions. Irritations of this sort have to break through and, if not talked out, will break through the skin. Sympathy and understanding must be emphasized.

LEO ON THE ELEVENTH HOUSE:

There is a great friendliness and outgoingness in Libra. He is the diplomat par excellence for he is friendly and optimistic in his approach to life. Libra has many friends since he seeks to please. He wants to be pleasing and to be liked. His desire for approbation is very strong. In group associations, he shines because he is tactful and conscientious and has a strong sense of justice and good will. This is the house of goals

and objectives; through kindness and the right use of his will, he can achieve success. If the Sun is afflicted, obstacles and difficulties due to false pride and egotism will stand in the way of achievement.

VIRGO ON THE TWELFTH HOUSE:

With Virgo here, there can be a strong interest in health and a secret concern about health conditions. The twelfth house is the hidden side of the personality, the subconscious self which can mean subjective sustainment or self-undoing. If Libra is inwardly critical where other people are concerned (even though he may be outwardly friendly), there will be health difficulties with which he will have to deal. If he gives himself in service (Virgo) through understanding and compassion (the twelfth house is ruled by Pisces) he will have superb health. Wherever Virgo is placed in the chart, there must be service and no criticism. This is doubly so when it is on the twelfth house, for the keynote of this house is "serve or suffer."

LIBRA ON THE FIRST HOUSE:

With the sign ruling the seventh house (others) on the first house of personality, it is the development of the Libra's relationships with others that is of primary importance. He cannot function as a personality, for he has turned the corner of the nadir of involution and is starting the journey back to "the Father's house". He is evolving out of materialism into a deeper understanding of the meaning of life. Thoughts of marriage relationships, partners are natural to Libra from childhood. He thinks in terms of what "we" shall do. His need for companionship is very great, for he does not like to be alone. It is difficult to get a clearcut decision from a Libra. He sees both sides of the question so clearly it is hard for him to take sides. It takes time for him to form opinions and arrive at facts. He prefers to play safe, for he wants to be liked by everyone and does not want to declare himself even if a principle is involved. This is why many people consider him to be undependable in a crisis. He will not stand and be counted in an important issue if it will put him in disfavor with anyone. Libra is forever trying to strike a balance — mentally and emotionally — but he rarely attains it. The scales dip to one side and then the other in an effort to see both sides and judge fairly. Back of it is the tremendous desire not only to please, but also to have peace at any price. In order to attain any peace worth having, it is necessary to function from the highest principles and let the chips fall where they may. Venus ruling this sign gives him charm and kindness, but Venus is apt to get lost on the personal level if it doesn't use the strength of Mars (ruler of the first house) to give courage and conviction.

SCORPIO ON THE SECOND HOUSE:

It is difficult for Libra to be generous with his resources, for Scorpio's reserve and tenacity in the house of finances does not make

for sharing tendencies. This is why it is difficult for him to part with his resources or possessions. He clutches these too tightly because of a hidden insecurity. He is afraid of lack in his later life, not realizing that "what is fear of need but fear itself." Libra is very secretive about his finances and personal affairs and will resent deeply any attempt to pry into his affairs. Wherever Scorpio is placed in the horoscope, there is a need for reorientation and regeneration; in this house, it calls for a new slant of values, an orientation toward spiritual values, for this is the half-way point between Aries and Pisces. Personality must die in order that the soul may come forth in all its glory. Then Libra learns the true peace that the world can never give — nor take away.

SAGITTARIUS ON THE THIRD HOUSE:

Optimism and cheerfulness are the signature of Sagittarius, sign of the higher mind, in the third house. An executive and legal type of mind and good judgment of character make Librans excellent lawyers. In my files, I have more lawyers born in Libra than any other sign. Libra, ruler of the seventh house, rules the lower courts; Sagittarius, ruler of the ninth house, rules the higher courts. With Sagittarius on the house of the conscious mind, it is not difficult to see why we have so many lawyers born in this sign. Libra is not a stay-at-home, for he likes to travel and explore far horizons, whether mentally or physically. Brothers and sisters have a philosophical trend of mind, and there can be literary talent in their family ties.

CAPRICORN ON THE FOURTH HOUSE:

The sign of responsibility on the fourth house defines the attitude of Libra to his home and family. There is a strong link with the mother. With Saturn rulership here, a tendency to cling overlong to home ties and a resentment creeps in later life because "the umbilical cord" was not cut sooner. There is a strong tendency to selfishness in the roots of the being which must be broken or there will be much solitude in later years. Libra is property conscious. He wants to own his home and usually does. He does not like to be moving around, for he wants to put his roots in one place and stay there. There is strong pride in family ancestry. It is difficult for Libra to part with family heirlooms, for he is bound to family possessions through sentiment.

AQUARIUS ON THE FIFTH HOUSE:

Here is where the Librans "let off steam." Aquarius is the lawbreaker, while Capricorn is the lawmaker. You can be free of the law only when you no longer need it. Uranus' freedom comes after the discipline of Saturn if it is to be true freedom and not license. Libra can have the freedom of self-expression in this house if he has accepted the discipline of Saturn. Many Librans appear extremely conventional to the world, but is isn't always so with Aquarius on this house. Unconventional love affairs are often part of Libra's incarnation, especially in his early

thirties. The co-regent of Aquarius, Saturn, presents his bill in due time, and Libra decides the price is too high. Later in life, the understanding gained through suffering is helpful in aiding others toward understanding. Trouble with children comes through the rebelliousness of Uranus. Libra should teach his children the value of discipline early in life; with Aquarius on this house, he will not be able to teach it to them when they reach their teens. If he spoils his children. with Uranus and Saturn as co-rulers of Aquarius, the parent will pay a heavy price.

PISCES ON THE SIXTH HOUSE:

This is the house of self-adjustment, and Pisces here can bring subjective sustainment or self-undoing. With Pisces in the house of health and service, Libra must sacrifice his personal supersensitivity to the needs of others. When he allows his emotions to run riot, the result can be ulcers. Too much worry, especially where his job is concerned, can lead to difficulties in the physical body. Libra is a hard worker and, with Pisces on this house, is very apt to overwork because of his strong sense of responsibility. Libra needs to leave his work behind him at day's end and relax with some creative hobby. He must learn to let his mind be the controlling factor in his service and work, not emotions.

SCORPIO THROUGH THE HOUSES

In Scorpio lies the battlefield between the threefold personality and the soul. This is the most critical of the signs, for here the battle rages between the two selves until there is a victory or defeat. In Scorpio, Mars rules the death of the personality and the birth of the soul, whereas in Aries, Mars represents the birth of the personal self. Scorpio deals with creativity, generation, degeneration, or transformation. It is the only sign that has three symbols: the scorpion, symbol of the unevolved self, who will sting himself to death rather than forego the pleasure of stinging; the eagle, the bird that flies higher than any other; and the phoenix, the bird that rises from the ashes of its old self, symbol of resurrection.

ARIES ON THE SIXTH HOUSE:

Scorpio's first impulse into activity starts in the house of adjustment, humility, and service — the willingness to be nothing in order to be something. This is Scorpio's hardest lesson. Scorpio has a sense of tremendous power, but he is not always able to bring it into operation on the outer levels until he is regenerated. He is an excellent and indefatigable worker, but he is seldom in the foreground until the personal self is mastered. "He who loses himself shall surely find himself" is the sentence that gives the key to the Scorpio mission. In Taurus, the power is coiled-up energy and latent; in Leo, it is in activity becoming self-conscious and the personality must die. "Lest a seed fall into the ground and die (or seem to), it shall not bear fruit." Scorpio runs into difficulties with co-workers and

employees because of his super-critical nature. Also he is far too quick to pass judgment on others. He is a good worker and a hard worker often driving himself mercilessly. He is apt to drive others as well. When his efforts go unnoticed and unappreciated, he feels much resentment. He needs to know that only those who appreciate earn the right to appreciation. There is a keen interest in health and dietary laws. Often the best doctors and nurses are born in Scorpio.

TAURUS ON THE SEVENTH HOUSE:

Scorpio's resources lie in the house of "the other" and not in himself. Scorpio has to learn stability and steadiness where partnerships are concerned. There is a great stubbornness in this sign that makes for difficulties in partnerships. Relationships call for equality and a responsibility that Scorpio would rather avoid. He would much rather be a lone wolf — and often is. With Taurus on this cusp, there is an air of independence that is camouflage, for he is very dependent on other people. Scorpio must serve others, since this is Taurus' seventh house. Once he gives his affections he does not change easily. He is fixed in his ideas as well as in his affections. He has a deep and intense nature. When he marries, he will do all he can to stay in the marriage, no matter how difficult the going. His pride will not allow him to give up. Seldom do you find people with Taurus on the seventh house going through a divorce court. The higher types in this sign have great gentleness and kindness for Venus rules the seventh house. This gives Venus the opportunity to lend its warmth and lovingness to any relationship.

GEMINI ON THE EIGHTH HOUSE:

This gives curiosity about the mysteries of life, especially the after-death states. There is an insatiable desire to understand the "why" of life, and there is often a great restlessness until there is a centering on the inside of the nature. Scorpio is the mystery sign of the zodiac and deals with the mysteries of life on inner levels as well as outer ones. Scorpio is the mystery sign of creativity, the sign of sex in its deeper as well as superficial aspect. Scorpio has a great interest in sex; but with Gemini here on the eighth house, it is an interest more of the mind than the emotions. An afflicted Scorpio person is truly a "Dr. Jekyll" and "Mr. Hyde," for if he does not relate to the higher forces, he can be a split personality as well as a destructive person. There is no sign more vindictive than Scorpio when unredeemed. This native passes judgment on others and shows little mercy. He seldom is able to face his own mistakes and errors. Often beset by guilt (though he does not decieve himself , he projects his guilt and feelings and accuses others of the very things of which he feels guilty. Yet when he has risen above personality reactions, there is no greater strength and power than this sign. He is truly powerful when he does not seek power for self but seeks to be used by the power to heal and bless others.

CANCER ON THE NINTH HOUSE:

This sign on the ninth house gives sensitivity and psychic awareness of the needs of the public. He makes a fine teacher because his feeling has the understanding quality that comes from the ninth house, which is related to the superconscious mind. He feels the reactions of other people intuitively. There is a great desire to travel, not only on the outer levels, but to the far-flung horizons of spiritual consciousness as well. Scorpio people can penetrate the mysteries of life through unusual dreams and visions when Cancer is on this cusp. There is a strong desire to mother and sustain others. Furthermore, the religious philosophy is strongly tied with service to others.

LEO ON THE TENTH HOUSE:

Here lies the reason for the Lucifer-like pride often found with Leo on this house. The natural house of Saturn (Lucifer) behind the individual's drive for significance would give a desire for power. But Saturn is the tester; and in the natural house of Capricorn, he would have to work and wait and be tested before he would be entrusted with leadership. A Scorpio ascendant does not lack ability to organize — far from it — but until he uses a loving attitude rather than a demanding one, he will not receive the prestige or power he wishes. In order to give orders rightly, Leo on this cusp needs to learn how to take them. This is not easy. In his career, Scorpio has to learn to understand the other fellow and how to bring out the best in him. When he rules through love and not through discipline, he reaches the top in any field he selects. "Radiation through being" is the keynote of any house when Leo is found on the cusp; when Scorpio learns this lesson, he goes far.

VIRGO ON THE ELEVENTH HOUSE:

This is the house of aims, goals, and objectives. With Virgo here, goals are reached by service, purity, dispassion, and humility. When Scorpio serves others and forgets himself, he is truly dynamic and majestic. He has a willingness to help the underdog. In fact, he finds it easier to be with those he considers inferior to himself rather than those who would be equals. Note Scorpios' desire for animals as companions, especially the small animals. Pets are not demanding and cannot argue with their owners' fixed ideas. Scorpio people make excellent veterinarians and often choose this profession as being the one liked best. They have a magnetic attunement with animals, probably due to their love for them. There is a strong inferiority complex in Scorpio that is not apparent on the surface. He is far more shy than people think and is apt to shun crowds or large groups of people, for he feels uncomfortable with them.

LIBRA ON THE TWELFTH HOUSE:

Marriage, unions, and partnerships are lessons when this sign is on this house. Seldom does a Scorpio Sun-Sign or ascendant have a happy marriage until he has redeemed and transformed his nature. Yet mar-

riage and relationships are extremely important to him, for his re-
generation lies in learning to be cooperative and outgoing toward others.
He would like to be on a desert island with no one to bother him, but
life will not allow him to escape. Whether he wills it or not, he is
plunged into the fray and the battle is on. Because Libra is extroverted
and Scorpio is introverted, the within and the without must be balanced in
the subconscious before there is any inner peace for the person with Libra
on this cusp. If Venus or Saturn is afflicted, then be sure that there are
dues to pay because of lack of cooperation and lack of love in a previous
life. The house in which these planets are placed will show the area of
his life where lovingness and cooperation must be used. The twelfth house
is the foundation of the first house and is the house of self-undoing or
subjective sustainment. It is the house of the subconscious — the night
side of the self. — Here insight and perception are very important. The
tendency is to see others through the eyes of self, rather than to see them
in their own light. The recognition for the need of change, without self-
pity or self-condemnation, is very important.

SCORPIO ON THE FIRST HOUSE:

There is a strong reserve in the individuals who have this sign on the
house of personality, the exteriorization of the personal self. It is not easy
to know these individuals, for much lies hidden under the surface. They
command respect, for there is a great strength that is felt, no matter how
silent the individual may be. Here are the stoics who will suffer in silence,
and no one can guess what is hampering below the surface. Not lacking in
courage and persistence, he will see things through, no matter what the
cost to his personal self. This individual is creative and has great re-
sourcefulness. In an emergency, he is the one who stays cool and col-
lected and is able to handle a crisis in a quiet manner. Regardless of how
much strain may be put upon him he is able to carry through to a
successful finish. If Mars is heavily afflicted in the chart, this sign can be
ruthless, for they are extremely perceptive and know the other fellow's
weaknesses. With Scorpio on the first house, he is extremely intuitive
and psychic, though he is apt to be silent about many of his impressions
and feelings. There is a great need to guard against sarcasm, for his
tongue can be deadly if he uses it vindictively. Healing power instead of
hurting power is the key for Scorpio on the ascendant. Once he has con-
quered his lower nature, there is no greater healer in the zodiac.

SAGITTARIUS ON THE SECOND HOUSE:

The reserve of the personality does not extend to the pocketbook
with Jupiter-ruled Sagittarius here. There is a generosity that is very
great, and he is willing to share his resources with others. He
is little concerned about money and material possessions, yet he does
not like to be without enough to take care of his needs and to share.
Once one with a Scorpio ascendant has connected his conscious self with
his superconscious self, there is protection financially and where re-

sources are concerned. He attains through the faith of Sagittarius, for this sign on the second house means not only material security, but also the spiritual wealth that brings inner serenity. So long ago, a Master said: "Seek ye FIRST the Kingdom of Heaven and its righteousness and all else will be added unto you." The "all else" includes abundance on every level. With Sagittarius on this house, seeking a job for the salary alone will not be satisfactory. If he spends his money or resources on his own interests, he will be miserable. He may not admit these things or choose to believe them, but this is the law. You can see why. The second house is the ninth from the sixth house, where the Scorpio ascendant's activity begins. The sixth house is the house of service and self-adjustment. Wherever Sagittarius is placed in the chart, the key is "spirit first", not matter.

CAPRICORN ON THE THIRD HOUSE:

This individual is serious-minded, for Capricorn is the most reserved and serious of all the signs. Life to him is grim and earnest, and the grave of the personality IS his goal. If Jupiter or Venus is angular or well aspected in the chart, it will help to lighten the load. His early environment is seldom happy, for he is the "odd one" in the family. He is not understood and feels it is useless to try to explain himself. He is apt to have his early education interrupted, but he will be searching and studying long after the other signs have put their books away. The tendency to moods of depression must be guarded against and not allowed to linger. There is an inclination to brood over disappointments. He needs to learn to touch life lightly. He takes himself far too seriously and needs to cultivate the ability to laugh and to see life in its proper perspective. In early life, the health of Scorpio is not robust but as he gets older, he gets tougher and has much more vitality than most people.

AQUARIUS ON THE FOURTH HOUSE:

Deep in the being of an individual with Aquarius on this house is a power drive second to none. He will have to make his way, no matter what the cost. At least, he thinks so! A tremendous desire for freedom is inherent in the roots of his nature. But Saturn, negative ruler of Aquarius, in the house of the roots of the being stands guard at the portal of freedom until the individual has learned that only through self-discipline and service can he have the freedom he wants. There are many domestic upsets with Aquarius here. Many changes of residence are part of the plan, and Scorpio does not like to move. There are predispositions to irritation in the individual that makes him difficult to live with. He is not peaceful and loving until he is functioning on the soul level, rather than in the personality. Scorpio, of all the signs, knows the least about love. What he calls love is desire. A tremendous self-love, utterly unrecognized by the personality, brings difficulties. He blames the other fellow for the troubles that he generates himself. With Aquarius on this house, it is very necessary to learn the lessons of

cooperation. There is a tendency to be attracted to unusual and bohemian types of people. He feels more at home with them, for basically they are rebels at heart. It is very important to the person with a Scorpio Sun or ascendant to air (Aquarius) his difficulties with someone who understands and then bury them forever in the grave of forgotten things. This will eliminate Scorpio's besetting sin — resentment. Resentment means living over and over again past hurts, frustrations, and angers. Its poison affects the mind and emotions and, inevitably, the body — which is the end terminal of inner attitudes.

PISCES ON THE FIFTH HOUSE:
This is the house of self-expression, as well as of children of the body, the mind, and emotions. Wherever Pisces is placed in the chart, there is always some frustration. Scorpio often feels frustrated where his creativity and self-expression are concerned. He feels a far greater sense of power than he can express. Sorrow and sacrifice regarding children and love affairs are indicated if Pisces is on this house. This is difficult to understand unless we realize that this incarnation (Scorpio) is one where we have to function on the soul level rather than that of the personality. Until the personality loses its hold, the soul cannot come forth in all its glory. All that the personality holds dear must be relinquished. When there is a letting go, then the individual can retain all he wishes to retain. Why? It is because then they cherish it for its own value and not for the value it has for them. Scorpio — devil or angel — the choice is theirs! There is no in between for these individuals.

SAGITTARIUS THROUGH THE HOUSES

If Sagittarius is on the ascendant, then Aries — where the self projects itself into activity — starts in the fifth house, the house of self-expression. This is the dramatization of the self and helps to explain why Sagittarius is self-concerned and self centered, in spite of his outgoing exuberance and enthusiasm for life. When we understand "how" the other fellow operates, we understand "why" he operates as he does.

ARIES ON THE FIFTH HOUSE:
Ardor, enthusiasm, a zest for life, and independence, as well as a desire to be on the move continuously, are part of the Sagittarian's equipment. A love for sports, horses, gambling, and a desire to take a chance on anything are inherent in his nature. There is a great love of the out of doors. "Don't fence me in," is his motto. He wants to keep moving, although he may not know where he is going. The going is more important than the destination. The far horizons beckon him. In the first part of life, it is the physical horizons that call him. In the later part of life, the spiritual horizons of the superconscious mind beckon him to the highlands of spiritual understanding. Aries on this house makes this na-

tive impatient with children, and an irritability toward them has to be overcome. He enjoys children most when they are old enough to be pals. His children have keen and alert intelligence. Sagittarius is the salesman of the zodiac. He can make anything he sells so attractive that people will want to buy it, whether they need it or not. If Mars, ruler of this house, is afflicted, there will be rashness and impulsiveness to overcome. A tendency toward extravagance does not extend to the considered needs of those around them. It is not calculated selfishness but an inability to project himself outside the periphery of his own interests. A tendency to ill-advised love affairs brings difficulties that could be avoided with due forethought. With Aries on this house, any tendency to domination where love affairs or children are concerned could bring difficults.

TAURUS ON THE SIXTH HOUSE:

If the Sagittarius ascendant would have a true sense of values, it must come through service. With Taurus here, an individual should choose something he really loves to do where work is concerned if he wants to be happy. There is a dislike of taking orders, and he must watch the tendency to develop a "bossy" sort of way. There is a need to watch fixed and inflexible opinions when dealing with co-workers. Discipline is needed where diet is concerned, for he has a "sweet tooth" and weight is sure to be a problem. The weak parts of the body are the throat and generative system; there is a direct link between the two. If there are continuous sore throats, the generative system should be checked. With Taurus on this house, there is a great deal of stamina and strength. Sagittarius can throw off physical difficulties easier than some of the other signs, because of the Taurean earth strength.

GEMINI ON THE SEVENTH HOUSE:

With the double-headed Gemini on the marriage house, there is a possibility of two marriages, especially if Mercury, ruler of Gemini, is in a dual sign. Gemini operates from the mind rather than the emotions, and the mate is not demonstrative as a rule. Unless the Sagittarian has many planets in water signs, (emotions), he understands this undemonstrativeness, for he too, is the casual type. At times, due to nervous tension, there is a strong irritability in the partner, though it is not long lasting. He sputters, frets. and "stews" for a short time; then it is quickly forgotten unless Saturn is heavily afflicted. Grouch.iness comes from an afflicted Saturn. Mercury gives the quick tongue and sharp retort. Nerves (Mercury) are the person's communication wires from the brain. There is a direct relationship between attitudes of mind and the nervous system. Nerves are the person in the body giving the body a hard time. Relatives are very important to the Sagittarian and often there is a strong attachment to ancestral ties. This can interfere with success in marriage: Where Sagittarius is concerned, marriage is not taken too seriously unless

there are steadying influences through planets in fixed signs. Note the position of Mercury by sign, house, and aspects to know what to expect in marriage and partnerships.

CANCER ON THE EIGHTH HOUSE:

This is the house of re-creation in terms of the soul. Self-indulgence and dabbling in sensuality are dangers with the Moon ruling this house. There is difficulty where the emotions are concerned if the Moon is afflicted. The Moon rules our subconscious habit patterns; and until there is emotional control of our feelings, we are not "captains of our ships." With Cancer here there is a tendency to drown in feelings and sensitivities rather than understand the other fellow's feelings. There is a psychic sensitivity to the next dimension, and he often feels coming events casting their shadows before. He gets negative impressions, but he has the power of the superconscious mind behind them. If he will call on this higher power he can avert the negativity that lies ahead. Often it is not realized that these negative feelings and premonitions are given so that higher energy will be called upon to nullify the looming picture. Sex can be a problem with the self-indulgent Cancer on this house. If sex is tied with love and not with lust, with desire to give and not desire to posess, it can bring blessings rather than harm.

LEO ON THE NINTH HOUSE:

With Leo on the this house, there is an optimistic faith and confidence in life that comes from the Leo quality of faith focused in the house of the higher mind, the superconscious. There is idealism and a love of truth. Sincerity and honesty of purpose are very strong if the Sun, ruler of this sign, is not afflicted. If the Sun is afflicted, there is a tendency to arrogance and conceit that must be overcome if there would be a happy, integrated life. The house where Leo is placed in the chart will show where energies are consolidated in the things that one loves. With Leo on this house, no wonder there is an interest in higher education, whether material or spiritual. He loves to travel; and far horizons, inner or outer, are always beckoning him on. On the material level, this is the house of in-laws because it is the third house of the marriage partner and rules relatives. If there are afflictions in the ninth house, it would be wise to live at a distance from them in order to avoid difficulties with them. Domination on their part would or could cause difficulties.

VIRGO ON THE TENTH HOUSE:

The tenth house sign is of great importance, for it gives the clue to the purpose of the life. The tenth house rules the limelight, prestige before the public, and how the individual will gather and focus his aims where the public is concerned. The service rendered, the work to be done, not the glorification of the ego, is the secret of success when Virgo is on this house. A willingness to serve and not exact due service will bring great blessing. The return blessing will come, for this is the cosmic law, but only

when the service is more important than the server. Virgo on this house makes a good teacher. Mercury rules Virgo, and this planet gives the power of communication and interpretation. Often there are two professions, for Mercury is a dual planet. It rules the ability to analyze which pre-suposes dual forces. Virgo is keenly critical of self as well as others. This comes from a keen desire for perfection. He dislikes being wrong and needs to watch the tendency to rationalize and justify. There is timidity in meeting the public that has to be overcome. If Mercury is well placed by sign with many aspects, there is excellent intelligence. Any contact between Mercury and the other planets increases awareness and gives an active and keen consciousness. For this reason, any afflictions to Mercury are better than no contact of any kind.

LIBRA ON THE ELEVENTH HOUSE:

With Libra, Venus-ruled, on this house, there are many friends of an artistic nature. Often there is marriage to a friend. There is need of discrimination in picking friends and associations if Venus is weakly placed or afflicted. A desire to be all things to all people can bring difficulties. Wherever Libra is placed in the horoscope, there is always a need for balance. This is the house of goals and objectives, and it is necessary to define goals and objectives clearly with Libra on this house. Too much indecisiveness and vacillation can keep Libra from success. A clearly defined objective and the willingness to use Saturn (work and patience) are needed. Saturn is exalted in Libra and can achieve results. Venus, ruler of Libra, is lazy and is not always willing to bestir itself to attain the needed results. Venus ruling the eleventh house gives many friends and a social life, for people seek the Venus-ruled; but too much socializing and too many friendships may take one down the primrose path of pleasure and away from the goals and objectives that were meant to be attained.

SCORPIO ON THE TWELFTH HOUSE:

Here in the twelfth house is subjective sustainment or self-undoing. The energies in this house can be used or abused, the choice is ours. Scorpio on this house can give a powerhouse in the subconscious that can light the way or can be very destructive. Secret enemies are found in this house — and there can be enemies in the world of appearance — but the greatest enemies are often hidden in the unknown part of us. The greatest enemy a man has is the person he imagines himself to be. The necessity of regenerating the hidden emotions and the underground feelings is a "must" with Scorpio ruling the twelfth house. The battle rages in the underground and is not seen by the unperceptive and the sleeping ones, but it goes on. Scorpio is the battleground of the senses and the soul, and here it is the subconscious that must be illumined by the light of the superconscious self. The individual with Scorpio here has known the hidden wisdom in the past (in past lifetimes) and, if Mars is afflicted, has misused that power. The choice in this lifetime is to "serve or suffer," for the power is there and felt and must be used. Many secret

enemies on the outer side can bring difficulties with Scorpio on this house. Jealousy of others in a past life brings the jealousy of other people in this lifetime. It can be cleared through the attitude of "What is that to thee? Follow thou Me." All tendency to resentment must be uprooted. It is deeply embedded, so it is not an easy task; but the great strength hidden in this sign makes it possible to do so. The battle is great; but the victory is sure, for the twelfth house is the gateway to the superconscious self. Only through cleansing the stable (the subconscious) could Hercules conquer, and the streams from the higher levels (the superconscious) had to be used if they were to be kept clear. Hercules is the soul; he had great power but didn't use it wisely until he learned to do so through the experience of earth living.

SAGITTARIUS ON THE FIRST HOUSE:

The keyword here is freedom, and any restriction is very hard for the Sagittarius ascendant to take. He has a breezy friendliness and an optimistic outlook on life that endears him to others. He has a keen sense of humor and loves a good time. One of his liabilities is procrastination. He has a strong desire to please and be liked, so he will promise anything in a moment of impulse and then later will back down when expected to carry through his promises. For this reason, he is considered unreliable, and often is so unless a strong Saturn gives him a sense of responsibility. Though he appears carefree on the surface, there is a great deal of nervous tension, for there is a lack of organization if Saturn is not strong in the blueprint. He scatters force due to lack of concentration. There is a great restlessness, especially in the early life. Later in life, he becomes interested in spiritual horizons and there is a definite change in personality that quiets the restlessness and brings a deepening serenity and peace. People born with this ascendant come into this particular lifetime to experience many varying conditions in order to learn the lessons the soul has set. Life will never be dull; he generates a desire for a full and active life and gets it. In the physical body, Sagittarius rules the hips — the power to move forward; the keyword for Sagittarius is perception or understanding. In the Scriptures, Jacob was lame in the hip — his understanding — and he could not let the angel go (his problem) until he got the blessing in it. When he did, the angel departed and it was morning; light had come to him and his darkness of ignorance was over. So it is with Sagittarius when he seeks the wisdom of the superconscious self.

CAPRICORN ON THE SECOND HOUSE:

With this sign on this house there is a tendency to be generous with himself but not always with his possessions. This is due to the Saturn rulership here. It is always a surprise when one meets with the stinginess of Sagittarius where sharing is concerned for he gives a feeling of openheartedness. He has this trait in his personality, but it does not extend to his pocketbook. Saturn rules the safety urges, and fear of loss can make

selfishness strong. Capricorn ruling the second house does not mean lack where money is concerned. People with inherited money often have Capricorn on this house. It does mean a lesson in true values, for this is the house of "what a person values" and is the reason peace of mind is found (or not found) in the second house. There is a lesson to learn where true values are concerned. One doesn't buy peace without earning it when Saturn rules the second house. The porblem here is selfishness. Money or resources are a trust to be used wisely and well. Capricorn's keynote is "I use"; and we are called to an accounting of our stewardship in whatever house Capricorn is master. Saturn calls for work and responsibility and this cannot be evaded even if we would like to do so. The use of personal resources calls for wisdom, for Saturn represents cosmic justice and keeps a perfect set of books. Practicality and prudence are the better side of Capricorn in the second house. Money can be acquired through real estate and building. If Saturn, ruler to the second house, is well aspected, Sagittarius can do very well in speculation where land or anything to do with the earth is concerned.

AQUARIUS ON THE THIRD HOUSE:

There is an ability to sense and know higher truth with Aquarius on this house. There is a great desire for freedom of action, but a necessity for discipline will keep those with this placement from having it until this freedom is earned. There is a strong will involved here and the positions of Saturn and Uranus will show the predisposition to use this will constructively or destructively. If Saturn is afflicted, there is too much self-interest and the Uranian principle of brotherhood cannot operate until there is a change of mind. The Greek word **metanoia** has been translated into English as meaning "repentence," but its true meaning is "change of mind." If Uranus is afflicted, there is too much self-will. Physically, Saturn and Uranus ruling the third house can give difficulties in breathing and the circulation in the lung area is not good. This can be overcome by deep-breathing exercises in order to get more oxygen in the system. The individual with Aquarius on this house feels like an alien in his own surroundings. He is one apart from his relatives, for this individualist is interested in the forward thrust and the future and do not cling to the past and old traditions. He is the one his relatives think is too far out, but he acts as a catalyst on the family tree and plays his part even though it may be a terribly lonely one.

PISCES ON THE FOURTH HOUSE:

With Pisces here, the emotional nature is strong and sensitive and there is service to be rendered where the family is concerned. Conditions are limiting and unsettled and are essentially karmic where Neptune holds sway. There are obligations to meet and they must be met, but they cannot be allowed to impede the individual's growth and development. There is a strong desire for a home and family interests are strong, but too much sacrifice can be harmful to others. The givingness can be carried

too far. It would be wise to have interests beyond the family circle so that the tendency to be absorbed and over-involved with the family would be overcome. A secret sorrow and a spiritual aloneness are deep in the roots of the being; their purpose is to help the soul seek the heights of spiritual consciousness. Mystical sensitivity and retreat to the inner center can bring great joy and inner serenity with Pisces on this house, for the real freedom lies within, not in the world of appearance.

CAPRICORN THROUGH THE HOUSES

If Capricorn is on the ascendant, then Aries — where the self projects itself into life — starts in the fourth house. The fourth house in the horoscope represents the roots of the being, what we have inherited from the family tree, as well as what we have inherited as souls from a past the outer self does not remember. It is the midnight side of the blueprint. "Midnight," in a psychological sense, means the deepest part of our nature. Does not this help to explain the deep reserve and seriousness of the one born with a Capricorn ascendant? He is not a surface person, and it takes time (Saturn) to get to know him. Life is not easy for him, and it is difficult for him to approach life in an easygoing and free-flowing manner.

ARIES ON THE FOURTH HOUSE:

Capricorn starts from the foundation of his being, and his ability to entrench and establish himself strongly in matter (earth — material living) is vital to him. A home is very important to him, even though he may not be in it much of the time. Ambitious and a strong drive for material security are strong and keep him from enjoying his home as much as he would like. In a way, perhaps, it is well. With Mars, ruler of Aries, lord of this house, there could be strife and argument in the home that would keep him from enjoying it. If Mars is afflicted, there would be a tendency toward irritation and impatience in this individual that would bring difficulties in the home life. There would be a tendency to force issues and demand too much from those in his domestic surroundings. He wants to "rule the roost," but the position and espects of Mars are going to show whether his leadership is constructive or destructive. People with Capricorn ascendants are successful in real estate or in construction or building. With Aries on this house, there is a strong link with the mother; her influence is very great in the life.

TAURUS ON THE FIFTH HOUSE:

Capricorn has very fixed and strong ideas and feelings about his children, whether they are physical children or children of his mind and emotions. His children can be great blessings to him if they recognize that "they come through you but not from you; they live in the tomorrows you cannot visit even in your dreams." This is the house of

creative expression the self expressing itself through love and pleasure. The Capricorn ascendant has the ability to express charm, and if Venus is well placed in the horoscope, there is a loving nature and a steady and stabilized love life. But if Venus is poorly placed and afflicted, the tendency to love self first is very strong. Saturn, ruler of Capricorn, rules the coiled-up serpent power in the base of the spine. If this power is used for self-satisfaction, then lust — not love — holds sway. Heart trouble — psychologically as well as physically — will be the result of the wrong use of this energy. Energy is God-given and to be used in a constructive way; if we misuse it, then we suffer in order to learn the right use of the energy that has been given us.

GEMINI ON THE SIXTH HOUSE:

The sixth house deals with work and service as well as health. Gemini, sign of the conscious mind, helps to explain why the work those with a Capricorn ascendant does is so vitally important to him. Work comes first with him. He has a strong desire to excel in whatever his occupation may be. Because he puts so much effort into it, he does not stay long in the lower brackets for income and position are important. In the process of achievement, he can overdo and his nervous system suffers. When the nerves are ragged, the disposition suffers; he becomes irritable and the people around him find him difficult. There is a direct relationship between thinking and the nervous system. An upset nervous system means the person in the body is giving the body a hard time. When we lose mastery over our thinking, our nerves (the telephone wires to the brain) are transmitting the wrong signals — and there is tension. With Gemini on this house, there is a need to learn the art of relaxation — not the sullen, morose quiet of the negative Capricorn, but the quiet vibrancy of a system hooked to a higher powerhouse will keep the Capricorn healthy as well as wise.

CANCER ON THE SEVENTH:

The seventh house describes the kind of mate one attracts. With Cancer on this house, the mate would be home-loving and a good provider, if the Moon is unafflicted. This native would be in need of constant reassurance of his importance and worth, for there is a great emotional insecurity in Cancer. A man with Cancer on this cusp is constantly looking for a mother rather than a mate Some women are willing to play the mother role, but some are not. It will be important to the person with a Capricorn ascendant to pick a mate who fits his needs. A woman with Capricorn on her first house is apt to pick a receptive, passive mate who will lean and not lead. He would not be too energetic and because of her strong ambition, this could create problems. Whether man or woman, Cancer is strong for the tie that binds, so they must pick a mate who will respect their sense of freedom and not try to smother the individual with too much attention. The placement of the Moon by sign and aspects will show what to expect from any marriage or union.

LEO ON THE EIGHTH HOUSE:

This is the house of reorientation and regeneration. There is a need to reorient his pride, for it is overdeveloped. The ego needs shrinking. Emotions are strong and the drive for significance (Sun) can be over-emphasized by the wrong kind of pride. The virtue hidden in pride is self-respect. This is our divine birthright. Let nothing take it from you. Wherever the Sun rules in a horoscope, the problem is one of sharing and shining. If there is too much desire to claim all the limelight, others are offended and will not cooperate; too little drive and they are passed by and frustration and resentment fill the magnetic field. So it is a matter of proportion and balance. Everyone — even marriage partners — are entitled to their place in the sun. On the physical level, there is a need to guard against over exertion and heart strain. This is especially true if the Sun is afflicted to Saturn in the horoscope. The eighth house is the natural house of Scorpio and is spoken of as the house that rules sex. The fifth house is the expression of sex (love affairs), but the eighth zone is what our inner attitudes are toward sex. There is a difference. With Leo on this house, in the sex experience, it must be a sharing, not a taking. Then there can be harmony in the union.

VIRGO ON THE NINTH HOUSE:

With the practical, analytical, earthy Virgo on the house of religion and the superconscious mind, it is not difficult to see that the Capricorn attitude would be skeptical where religious matters are concerned. If it can be proven to him that religion works in the world of material values, he will accept it. Virgo, an earth sign, on the ninth house gives a prac-tical approach that is strongly centered in the "here and now". Far-away fields do not look greener to him. He makes an excellent teacher and a pro-fessor, for he is good in detailed work and conscientious in all that he does. There is a great deal of discrimination that will veer too much on the over-critical side if Mercury is afflicted. A person with a Capricorn ascendant may do a great deal of traveling, but it will be in connection with his work. In this trait, he is unlike Sagittarius, who travels for the sheer joy of traveling, of being on the move, seeing new places, and meeting new people. This is the house of understanding, and under-standing comes not from the mind but from the heart. To learn by loving to get by giving, to be willing to find the values hidden in the soul, not the personality: these are the lessons the one with Capricorn on the ascen-dant needs to learn before the real beauty in his character comes forth.

LIBRA ON THE TENTH HOUSE:

The tenth house is the most important in the chart from the material point of view, as the ninth house is the most important from the spiritual side of life. The tenth shows the career, reputation, and social standing in the world. With Libra ruling Saturn's own house, there is a strong sense of justice and the willingness to work and work hard to see that justice is done in any cause he sponsors. Libra makes the good lawyer or judge,

for Libra has to do with legislature and the law. Libra on this house gives diplomacy and tact in dealing with the public. Often he is far more tactful in dealing with the public than he is in his own family circle. Many times their families listen in puzzlement to the praises the Capricornian receives from the world at large. Venus' sign in Saturn's house is often loving for the sake of expediency. This is not true of the more evolved individual. Students often ask the question, "How can one tell the evolvement of an individual in the chart?" Character is shown by the signs in which the planets are placed. Planets in their sign of exaltation and in the signs they rule are indications of an evolved consciousness. Also, the higher-octave planets — Neptune, Uranus, Pluto, and Jupiter — in the first, fourth, seventh, or tenth house show that the individual has had much soul experience in other lifetimes.

SCORPIO ON THE ELEVENTH HOUSE:

This is the house of friendships, goals, and objectives. Scorpio is not too happy a sign to be at home in the impersonal and brotherly house of Aquarius. In Scorpio, there is great emotional intensity and a strong possessive desire to hold friendships closely. He is apt to be rather demanding. A Capricorn ascendant is not gregarious and outgoing unless he has an angular Jupiter. He is the true isolationist of the zodiac. The lesson here is tolerance, not sitting in judgment on others or expecting perfection from ordinary mortals. Each individual does the best he knows (with his realization, not his intellect); and when he knows more, he will do more. There may not seem to be a relationship between goals and objectives and friendships. But there is. No man is an island. If he would be successful, friendliness and cooperation will pave the way and make it easier to arrive at his goal.

SAGITTARIUS ON THE TWELFTH HOUSE:

Capricorn's understanding — or lack of it — stems from the twelfth house. This is the house of self-undoing or subjective sustainment; which it is, depends on his vision and understanding. Because of the austerity and seeming coldness of Capricorn, this native does not attract the happier things of life without a good amount of hard work. But he could. A Capricorn ascendant is the "do-it-yourself" type of person for it is hard for him to understand there is another way. Locked up in the storehouse of their personality (twelfth house) is a secret for the Capricorn ascendant. An optimistic faith in life, a willingness to realize the power that comes through letting go and letting the higher power work, a relaxing in the flow of life, herein lies the answer. If he uses the tolerance, kindness, philosophy, and broad outlook of the Sagittarian Jupiter, life will be much easier. The nature of Saturn in the world of appearance is to be concerned with material matters. Jupiter's rulership here can lift the load and set Capricorn free. In the depths of himself lies lifting power.

CAPRICORN ON THE FIRST HOUSE:

With Capricorn here, there is delicate health in the early life; but the strength and endurance of Saturn helps to throw off any weaknesses as the years go by, and he usually lives to an advanced age. Capricorn is the hardest worker in the zodiac. This is partly due to his strong ambitions to succeed in the material world. Like the mountain goat, he wants to climb to the top. He usually does. In the process, so many of the joys along the way may go unrecognized and lost. There is a compelling need in the Capricorn ascendant to achieve in tangible terms. He has dignity, persistence, patience, and great fortitude; these are the qualities that make for success. Capricorn should watch the tendency to become too limited and too disciplined. If Saturn, ruler of this house is afflicted, there can be arrogance and false pride. This can harm and not help in his progress. In the physical body, Capricorn rules the knees. The symbol of humility and the power to bend is the inner meaning of this part of the body. Any trouble with the knees is an outer manifestation of an unbending and rigid will. Our bodies are the outer reflection of our inner states of being. If this ascendant will use his strength and power to serve others, there is no greater server in the zodiac. He has patience. persistence and purpose; when these are used for others, he is truly a magnificent soul.

AQUARIUS ON THE SECOND HOUSE:

Finances are often attained through work with large organizations or corporations. Intuitions are strong where financial advantages are concerned. There is great creativity in this individual that enhances his money-making abilities. To the indibidual with Aquarius on this house, money is important as a means of power. If Uranus is stronger than Saturn in the chart, plans for a sustained and steady income can be upset. This is the person who may work on commission and have a fluctuating income. Capricorn is often found in managerial fields that have to do with sales. As life advances, he accumulates money, for he is not a free spender. At times. he can veer to the stingy side. The negative aspect of Saturn is fear. Behind all lack of giving is fear. He is concerned about saving money for his later years. This can be carried too far. As one wit said, "There are no pockets in a casket." Another soul said: "What is fear of need but fear itself?" The underlying keynote of the second house is the Taurean sign; and Capricorn can do very well in real estate, construction and banking.

PISCES ON THE THIRD HOUSE:

With Pisces here, there are clever and original ideas that can pay off in the coin of this world. There is imagination and insight with Neptune ruler of this house. This is excellent for the creative writer, for this house rules the intellect and the power to communicate. It's hard to stick to what is fact so there can be emotional fog if Neptune is afflicted, especially to Mercury. In the everyday environment, there is need to learn to

organize and concentrate. It is best to have papers and documents carefully scrutinized before signing. Always read the fine print if Neptune is in charge of third house affairs. Sorrow and sacrifice where brothers and sisters are concerned are part of his destiny if Neptune rules this house. Accept them gracefully and know them to be a debt owed that must be paid. There is a strongly psychic side to the individual with Pisces on this house. This can be a great help if used wisely. Mind and feeling meet in this house, and there are no limits to what the Capricornian can attain if the balance of mind and emotions is maintained.

AQUARIUS THROUGH THE HOUSES

If Aquarius is on the ascendant, then Aries, where the soul projects itself into activity, is on the third house. Wherever Aries is placed in the horoscope is where the soul initiates activity on the outer level of expression. For Aquarius, the starting point is the third house. The third house in the blueprint represents the thinking equipment of the conscious mind as well as the ability to relate to others in the environment. Aquarius relates to others through reason and logic, seldom through emotions and feelings. This is a valuable clue to the Aquarian nature. One should never appeal to his emotions but to his reason. The greatest gift of Astrology is understanding. All of us do not respond to life in the same way. Astrology tells us why.

ARIES ON THE THIRD HOUSE:

The Aquarian ascendants get off to a flying start with Aries on the house ruling the conscious mind. No wonder Aquarius is predominantly intellectual. Aries rules the head, Aquarius is an air sign, and air signs are the intellectual signs of the zodiac. With Aries here, he is the mental pioneer, the forward-thinking heralding the new age. His mind is restless, fearless — always seeking new knowledge, new concepts, and new ideas. Aries is cardinal fire and gives an independent and impulsive type of mind. If Mars, ruler of this house, is afflicted, there is a tendency to domination, arrogance. and egotism that must be overcome. Otherwise, he will not relate correctly to the people in his environment. He can appear brilliant intellectually but prove to be superficial rather than deep in his thinking unless Saturn is strongly placed in the horoscope. Mars springs forth into action and leaps at any new idea or concept; but without the sustaining power of a strong Saturn, there is apt to be lack of concentrative force. There are two types of Aquarians, and this must always be taken into account in doing an Aquarian's chart. Saturn and Uranus are co-rulers of Aquarius. We must pass the rulership of Saturn before we have access to the true power of Uranus. Freedom without discipline can be license. If Saturn is more strongly placed than Uranus in the chart, he will be Saturnian in type and often appear more like Capricorn than Aquarius. If Uranus is the stronger planet (in the first,

fourth, seventh, or tenth house), he is a true Aquarian. The Uranus-ruled Aquarius is a rebel with strong opinions and convictions; these are the individualists of the zodiac. He can be especially trying in his early years, for if he cannot dominate his environment he makes things difficult for everyone around him. With Aries on the third house, there is talent for writing, speaking, the power to project ideas through these mediums.

TAURUS ON THE FOURTH HOUSE:

While Aquarius is not at all conservative in his thinking, he is extremely conservative in domestic surroundings. Home is very important to him. A passion for accumulation is strong, and it is difficult for him to let go any possessions, whether material or personal. A comfortable and artistic home is important, because of the Venus rulership here. He is extremely economical and wants full for his purchases. The fourth house represents the basic values that are deeply ingrained in the roots of the being. This house also represents the final outcome of what we do with our values. This is why it represents the latter part of life and the end of matters. What we are in the roots of our being will come to the surface in later life. Wherever Taurus is placed is where we can be locked up in matter. If materialism and money are all-important to this person, there cannot be peace and serenity in later years. Security comes from a correct set of values. This house represents the mother, and often the mother is extremely possessive when Taurus is on this house.

GEMINI ON THE FIFTH HOUSE:

This is not the type of parent who is basically emotional where his children are concerned. He enjoys them most when he is able to talk with them rather than when they are small children. He wants his children to be intellictual, for he wants them to reflect his own intelligence. In love affairs, he is not demonstrative or ardent. He is so strongly mind-oriented that it is difficult for him to show his feelings. Where Mercury holds sway, Venus doesn't fare very well. In fifth-house matters, this can cause problems in understanding. There can be dual love affairs, for the Aquarian ascendant can touch life lightly where love affairs are concerned. Gemini is the butterfly of the zodiac that flits from flower to flower — and from one experience to another. There is dexterity and cleverness in self-exprssion and an ability to projct the self in a free-flowing manner.

CANCER ON THE SIXTH HOUSE:

Aquarius is much more involved emotionally with his work and career than he is where personal relationships are concerned. Because his feelings are so strong in connection with work and service, he can be very unhappy if not doing work he likes. Cancer rules the stomach as well as the feeling. There is a direct relationship where the digestion of experience and the digestion of food are concerned. If the Moon is afflicted

there can be ulcers when there is unhappinss in the work area. The Moon, ruler of Cancer, rules mass consciousness, the public. He is happiest in work that benefits the public in some way. The Moon has rulership over the subconscious mind. In his work, he has intuitional feelings that are very helpful to him. He would not call it psychic. He is too intellectual to believe in such "nonsense." Nevertheless, he uses it in his work constantly. He has great material ambition, even though it is not obivous. His drive for material achievement comes from a feeling of inadequacy where the emotional side of life is concerned. He has a love for good food. When unhappy in his work, he can be a compulsive eater, which in turn, can lead to complications where well-being is concerned.

LEO ON THE SEVENTH HOUSE:

The strong individualism of this sign makes it difficult for the Aquarian ascendant to fit smoothly into partnership, marriage, and general cooperation. The strong desire for independence and to have control of every situation mitigates against compromises that are necessary where other people are involved. The kind of partner he attracts is equally individualistic in his own right and would not play the subordinate role very long. If the person with Leo on this house would be happy, there must be no attempt to make the marriage partner over. Accept him as he is. The sign on the seventh house is what we lack, the quality we need to build in. Leo on this house needs to build in the capacity to love from the heart. The Aquarius ascendant, with his crystal-clear mind, needs more heart understanding. He needs to have more active (e-motion) where the love consciousness is concerned. He often attracts a marriage partner who functions from the heart rather than the head. From the mate he expects complete devotion but is not always willing to give it.

VIRGO ON THE EIGHTH HOUSE:

Every sign has negative qualities as well as positive ones. The sign on the eighth house is always important, for it shows the negative qualities that need reorienting and redeeming. The tendency to be too critical and to pick things apart must go if Virgo here would reach the highest potentials. He needs to learn that universal brotherhood is not attained with the mind. Love and unity are the inner essence of cooperation that can bring synthesis, and love comes from the heart. Virgo is the power to tear down and break up. The power to discriminate and to analyze is necessary in areas of our livingness; but there are areas in which this power is detrimental. This explains why Venus is so poorly placed in Virgo. If Mercury, ruler of this house, is afflicted, then there is need for regeneration where the uses of the analytical mind are concerned. There will be difficulties in the sex life that will come from too critical a nature. This is the house of partners' money, and there will be a very practical approach in the use of it. Unless there are planets in water signs or an angular Neptune, there is little interest in psychic or occult matters.

LIBRA ON THE NINTH HOUSE:

There is an innate refinement in the nature of Aquarius that comes from the artistic and esthetic Libra on the house of the super-conscious faculties. Anything of a rough or coarse nature repels. Libra always recognizes its obligation to good taste and appearance. It is only when Venus is badly afflicted that we find the lazy and careless who offend by an unattractive appearance. There is a strong need for balance between the inner world of the soul and the outer world of appearance; when this is obtained, Saturn no longer rules the Aquarian. Uranus becomes the ruler, and freedom of the spirit is assured. Legislation and law are attractive and Libra here often attracts the person to law as a profession. This house rules higher education. Aquarians make wonderful professors and teachers, especially along scientific lines.

SCORPIO ON THE TENTH HOUSE:

With the Scorpio emotional intensity and determination in the house of career and reputation before the public, it is understandable that Aquarius is not satisfied until he has made his mark in the world. The power sign in the power house has all the drive necessary to succeed in the material world. The limelight is extremely important. His power will be felt in whatever he does. Mars, ruler of this house, its placement by house and sign, will show the areas in which success can come. Because of Saturn's underlying influence in the tenth house, there must be effort and work directed toward achievement. It will not come without effort. In Saturn's domain nothing ever does. Saturn rewards those who work for what they want. People with Scorpio on this house are often found in government work or in research. Medical research would be of great interest. Scorpio on the tenth house has a natural healing ability and makes an excellent doctor.

SAGITTARIUS ON THE ELEVENTH HOUSE:

Jupiter's rulership in the house of friendships, goals, and objectives gives a friendliness and a pleasantness of manner that make the Aquarian ascendant well liked by his friends. The casual give and take of Aquarius makes no demands on friendships. The fire sign Sagittarius on this house makes the person direct and impersonal in his approach to life. He can show these qualities in friendships far easier than he can do so in the emotional life. He is able to achieve his goals and objectives, for he is willing to work and expend effort. He is a leader in humanitarian movements and will join others in organizational work, though he resents any encroachment on his personal life. He has loyal and devoted friends who play a big part in his advancement in life.

CAPRICORN ON THE TWELFTH HOUSE:

Saturn's keynote here is: "What shall it gain a man if he gains the whole world and suffers the loss of his soul?" The hidden drive for power must be sublimated into a sense of responsibility to all those in need when

Saturn rules the twelfth house of self-undoing or subjective sustainment. There is inherent selfishness to be overcome if Saturn is afflicted. Dues will be paid through sickness and suffering if the tendency to live for self is not transmuted into service for others. Saturn is strict and undeviating justice; it is the lord of karma. Health must be guarded, for the tendency to crystallize and contract the self spells trouble for the physical body in time. Arthritis is a Saturn difficulty that starts in prejudiced, rigid, and intolerant attitudes of the mind. With Capricorn on this house, the flow of life is impeded by crystallized attitudes regarding the over-stressing of ego, prestige, and importance.

AQUARIUS ON THE FIRST HOUSE:

With Aquarius on the house of self-exteriorization, there is a friendly outgingness to the personality that is likeable and attractive to other people. He is positive in his approach to life and very confident in manner. There is a stubbornness not apparent on the surface. With an Aquarian ascendant this individual cannot be pushed into doing anything he does not want to do. The stubbornness of the proverbial mule will be mild compared to his quality of inflexibility. His friendliness hides this quality, but it is there and must be taken into account when dealing with him. If Uranus is strong by being in an angular house or close to the Sun, Moon, or Mercury, he will be a rebel. Any sort of constraint will be difficult for him to accept. Freedom is his battle cry. Unless this is tempered by a good amount of Saturn's common sense, there will be difficulties that will be hard on the personality. Aquarius has a great deal to do with circulation — not only in the mind and emotions. but in the physical body as well. This ascendant needs physical exercise more than any other sign. Because of the drive for success, he does not spare his body and can take himself out of it via a heart attack. He needs to learn the art of relaxation. If he will balance his great capacity for work with equal time for relaxation and play, he can stay in the body and enjoy the fruits of his labor.

PISCES ON THE SECOND HOUSE:

Aquarius finishes in the house that has to do with resources, values, and peace of mind. This is significant. Where Aries is placed in the blueprint, we start things; where Pisces is placed, we finish them. Just as Taurus shows where we are locked up in the world of matter, Pisces is where we can free ourselves from the call of the world and how we can go about it. Where Pisces and Neptune are involved, this must come through personality sacrifice and reunuciation of the separated self. The self must decrease that the soul may increase. On the outer level, Pisces on this house gives a strongly emotional tone to the feelings about possessions, whether material or personal. It is hard for Aquarius to keep material affairs in order with Pisces here. If Neptune is afflicted, there can be deception where money is concerned. It is important to scrutinize any contract or document before signing it if Neptune is afflicted. To

learn to share, to learn to let go, to learn a true sense of values is the lesson Pisces is trying to teach in the second house of values. The keyword for Neptune is "obligation," and if some part of this income is shared with those in need, the reason for Neptune's being called the "Cosmic Santa Claus" will be apparent.

PISCES THROUGH THE HOUSES

In the last sign of the zodiac, Pisces, we come to the ending of the personality that started its pilgrimage in Aries. Freedom for Pisces does not lie in the valley of personality achievement but on the higher levels of spiritual growth and development. The symbol of Pisces, two fish tied together represents the two aspects of self: the personality and the soul. If the personality becomes the servant of the soul, all is well with Pisces. "Serve or suffer" is the keynote of Pisces. Where Aries is concerned with beginnings, Pisces is concerned with endings. Pisces begins where Aquarius leaves off, in the second house of resources and values. The values gained through the journey through all the other signs must be brought into full consciousness in Pisces.

ARIES ON THE SECOND HOUSE:

Wherever Aries is placed in the blueprint is where the soul initiates its activity and begins to operate in the world of appearance. For Pisces, values and resources are of utmost importance. Not only must he feel successful in financial matters, but the uses of his personal resources are very important as well. There is great ambition to achieve. Capricornians want to achieve worldly success for the power it brings. Not so Pisces! He needs to achieve success in order to prove his own worth to himself. A deep-seated inferiority complex is behind his drive for significance. He is the one who is never satisfied, no matter how well he does or how successful he is. He is much harder on himself than he is on other people. With Mars as ruler of the second house, Pisces finds it difficult to hold on to money. Wherever Mars is ruler in a house, there is need for control. In this house there is a need to curb the tendency to extravagance. Mars hates to stop and think. It would much rather act first. Pisces can be very shrewd about money if Mars is well placed by sign. Mars does not wait for money to come but goes after it. If Mars is afflicted to Neptune, the tendency to gain money through deceit and deception will bring great difficulties to those born in Pisces.

TAURUS ON THE THIRD HOUSE:

Being an earth sign, Taurus on this house wants to belong, to feel he is useful and necessary to those in his environment. There is a stubbornness in the Piscean nature because Taurus is standing guard at the portal of the mind. He can be far more fixed and rigid in thinking than one would expect in casual contact with him. He seems easy-going and pliable.

It isn't so! Folks in his environment know well his rigidity and inflexibility. Gemini is the most flexible of the signs, and Taurus is the most stubborn. Look to the sign in which Mercury is placed to know whether the individual is rigid or mutable in his mental attitudes. If Mercury is in a fixed sign, he will be fixed and stubborn; if it is in a mutable or cardinal sign, he will be much more pliable. He is strongly artistic and creative. There is a strong interest in music and art. In dealing with him people must not try to force conclusions upon him in any discussion even if they are right, they will be wrong!

GEMINI ON THE FOURTH HOUSE:

Pisces does not like to stay in one place too long. He wants a base of operations — a home to come to — but he is not in it too much. He is too restless. He likes to have people around him but not the same people for too long. There is a dual aspect to the Pisces nature that is hard to understand unless one has a knowledge of Astrology. Pisces is two people, not one. Two fish: one is friendly, kind, outgoing, swimming around freely on the surface of life; the other hides in the depths, remote, isolated, moody, and withdrawn, wanting no part of anyone. When this fish is in the supremacy, nothing you can say or do is going to be satisfactory. Wait. One should not try to draw this fish into active participation. He won't come. When the tide changes. he will go back to the deep and the other fish will appear. If people involved with a Piscean would understand the dual aspects of this sign, life will be easier for them. Living with a Piscean is not easy, but it is interesting. One part of the Piscean nature will never be shared with anyone. If this is accepted, all will be well.

CANCER ON THE FIFTH HOUSE:

Hidden in this house of creativity and self-expression is the reason Pisceans are night birds. He loves the night (Moon-ruled), where the world is still and quiet. He does his most creative work when he works in the late night hours. He has a strong imagination and is able to dramatize himself to the "nth degree." He loves the theater. There is a frustrated "ham" in every Pisces. Due to the Moon rulership here, there is a strongly maternal and nuturing side to Pisces — not only with his children, but in his love affairs as well. He yearns to mother those he loves. There is real devotion and loyalty toward loved ones. He belongs to an extremely creative sign and can appeal to the public through his ability to dramatize life and its possibilities. He has writing ability and can communicate his ideas more easily in writing than talking.

LEO ON THE SIXTH HOUSE:

Work is the most important part of the Pisces' life, it is vitally important that his heart be in it. He can lose himself completely in work and service. He puts a tremendous amount of energy in his work. No matter how hard he works or how good his performance, he is never

satisfied. Too many Pisces people have heart attacks from overwork. He needs to learn balance. All work and no play raises havoc with the body as well as the nervous system. Pisces obtains real recognition through the concentration power of Leo in the service station of Virgo. His real powers lie in the service he renders to others. If he tries to live for self alone, he is miserably unhappy and becomes a drifter instead of a doer.

VIRGO ON THE SEVENTH HOUSE:

The tendency to choose a mate who is inferior to him in quality comes from Virgo on the seventh house. The underdog arouses his sympathies and, the needs of the other call forth his desire to help. Pisces marries beneath himself and usually regrets it, for there is no common meeting ground where interests are concerned. Pisces seeks suffering, for there is an unsuspected but strong martyr complex in him. One of my Pisces students made the remark: "Let's face it! We are only really happy when we have something to be miserable about." Pisces is more critical than any other sign but Scorpio. Often he marries a very critical person and fails to see that this is a projection of his own critical quality coming home. He does serve his marriage partner and works hard to please. Often there are two marriages and the second happier than the first. He is more realistic in maturity than he is in youth. The seventh house is the house of relationships as well as marriage, and he must serve others without expecting adequate return. Pisces is the sign of sacrifice. Neptune is the planet of obligation and renunciation; but it is also the "Cosmic Santa Claus" and teaches that everything we do for others, we do for ourselves.

LIBRA ON THE EIGHTH HOUSE:

The key to regeneration in any blueprint is hidden in the sign on the eighth house cusp. With Libra on this house, Pisces' keynote is cooperation not competition. Balance must come through sharing one's resources with others. There is gain through partnership. There is growth for him through marriage, even though it may be difficult. In the physical body, Libra rules the kidneys. He must guard against difficulty in this section of the body. If he over-indulges where alcohol is concerned, this part of the body will suffer. Due to his physical sensitivity, alcohol can cause more havoc in the Pisces than to any other sign. Every organ in the body is an outer symbol of a psychological principle. The kidneys — ruled by Libra — are the purifiers of the bloodstream in the body; they filter out the impurities. Marriage acts as a purifier for the ego. Having to learn to compromise and relate to others purifies us from our selfishness and our self-centeredness. It is not by withdrawal from the arena of life that we grow a soul. It is through participation and learning to flow unresistingly with the stream of events.

SCORPIO ON THE NINTH HOUSE:

With Scorpio on the house of the superconscious mind, Pisces seeks the meaning of life. There is depth in his desire to know its meaning. He is not superficial and does not live on the surface of life. There is emotional intensity in his desire to know and understand the purpose of living. Pisces is not orthodox in the search for truth. He wants to understand the occult laws and investigate until he feels satisfied there is a meaning and a plan. He likes to travel and does so a great deal. There can be activity in publishing or higher education. He has healing power. If he chooses to work in the medical field, he makes a wonderful physician and healer. His quiet presence brings a blessing to all with whom he comes in contact.

SAGITTARIUS ON THE TENTH HOUSE:

There is executive ability and the ability to be a leader in the career. Money, work, and service are vital issues because Pisces has fire signs on the second, sixth, and tenth houses. He is ambitious and wants to be successful. This is not so much a drive for power as a desire to achieve where service to others is concerned. He wants to express idealism in his career. He is able to reach the top in his profession because he is willing to work very hard to do so. He is able to sell his ideas to the public due to Jupiter influence in this house. He is friendly and outgoing in his work with the public. This is the house where the friendly, outgoing "fish" operates.

CAPRICORN ON THE ELEVENTH HOUSE:

Pisces does not want a great many friends. He would rather have a few close friends and is "choosey" where his intimates are concerned. He is not naturally gregarious and does not like crowds. He is not a joiner. When he is through with his work, he prefers a good book and a quiet fireside to company. Because of Saturn's influence in this house, in youth his friends are sought in an older age bracket. He is more comfortable with older people than with those of his own age. His goals and objectives are usually reached, for he is willing to work very hard to make them possible.

AQUARIUS ON THE TWELFTH HOUSE:

It is difficult for Pisces to feel hemmed in and restrained, but he does. Of all the signs, he is the one who feels he is doing a lifetime at hard labor in a "prisonhouse of skin." There is a longing for freedom in the heart of every Pisces, a nostalgia for the highlands of the spirit. His psychic sensitivity is very strong. It is difficult for him to cope with the harsh, dense world of matter. If he is an evolved Piscean, he can accept exile from his true homeland for the sake of service he came to earth to render. If he is unevolved, he seeks escape from the outer world through

drinking and often through drugs. To this type anything that takes the pressure off earth living is justifiable. But the price is steep and the payment sure. Through descending into darkness, the light is found. It is a lonely road, but it leads to light and love.

PISCES ON THE FIRST HOUSE:

The last sign on the first house means the ending of the personality and the dissolution of the animal self. This isn't easy. The keyword of Neptune is sacrifice, and here the personal self must be given up so that the soul may come forth in all its glory. There is not a great deal of physical energy when Pisces is on the ascendant. The emotional reaction to life is great and drains energy from the physical body. Pisces is a dual sign, and there are two definite types of people with Pisces ascendants. There are the servers, the doers, not strong physically but who lose all thought of self in service to others. He draws energy from higher levels for he is tuned to dimensions beyond the earth plane. Calm, introspective, compassionate, and detached, he goes about his work quietly and with no fanfare. He is the "salt of the earth." Then there is the drifter, the dreamer. He dreams big dreams and vast schemes seethe in his mind; but he goes no further than dreaming. He is the "lotus-eater", losing himself in the land of dreams. He cannot face failure, so he will not try. Pisces on the ascendant is not practical but emotional in outlook on life. He is easily discouraged and is apt to be moody. Music is very helpful and feeds his emotions as food feeds his body. If he would learn to play a musical instrument, it would help to harmonize his emotional equipment and balance his forces. There is a great lonliness in Pisces that nothing in the world of matter can take from him. The dark night of the soul is an integral part of the Pisces incarnation. It must be so in order to release the soul from the bondage of the personality. A willingness to accept aloneness will set him free. The way is up for Pisces, not down.

CHAPTER 12
The Sun in the Houses

SUN IN THE FIRST HOUSE — Keynote: to be.

As the first house is the outward reach for experience, and the Sun represents the drive for significance, this is a good placement for the Sun. They are the executive types with leadership qualities, and they are happiest when they are in a position of dominance. They want the freedom of being on their own. There is courage, enthusiasm, dignity and nobility if the Sun is not heavily afflicted. If it is afflicted, especially by Mars or Saturn, then arrogance and ego have to be overcome if these individuals would be a success in life. Too much of the Martian force in their magnetic field will drive people away from them rather than draw them to them. An attracting personality draws through the power of Venus and an unattractive personality repels through the force of Mars. Back of any planets in the first house is the energy of Mars, for Mars is the natural ruler of the first house. The Sun is the most powerful force in the universe. It can warm or it can scorch and burn. Let the person with a first house Sun learn to use it wisely and well.

SUN IN THE SECOND HOUSE — Keynote: to possess.

Here the desire for power is concerned with resources, values and material success. With the Sun in the second house there is the power to attract finances and gratuities. Desire for material success is strong and desire is potent. There is a strong stubbornness and with it a stability and a persistence. If they want something they never give up until it is attained. Because energy, backed by action, is extremely powerful they usually attain what they want. Where the first house Sun wants recognition on the personality level the second house Sun is interested in material values. If the Sun is unafflicted there is security where resources are concerned. If the Sun is afflicted there is ability to attract money but often there is no happiness with it.

SUN IN THE THIRD HOUSE — Keynote: to know.

This is the house of communications, taken for granted skills, the extension of the self into relationships, especially those near at hand which would be brothers and sisters. The Sun is not a fertile planet so often there are not many brothers and sisters but there is a good relationship with them. The Sun shines in the early years, and if the Sun is not afflicted the early environment is usually a happy and carefree one. Emphasis here is on the conscious mind and the mind is usually scientifically ori-

ented. The individuals with the Sun here are facile talkers and are able to communicate ideas to others. For this reason they make good teachers, writers or lecturers.

SUN IN THE FOURTH HOUSE — Keynote: to establish.

Where the background of the third house (due to Gemini being its natural ruler) is intellectual, the background of the fourth house is Cancer, and there is an emotional undertone that colors the Sun in the fourth house. Here the self-protection urge is strong. Self-sustainment principle is very strong. The person with the Sun here is somewhat like a squirrel; gathering in more and more so he can have more and more to save him from the fear of not having. This is the one angle that doesn't give the assurance an angular Sun usually does give. This is the house that shows the roots of the person's being — the midnight side of himself, that which is hidden in the depths and is not apparent on the surface. If you really want to know what a person is like in the depths of his being see what is operating in the fourth house. These forces or energies will tell you. The person with the fourth house Sun is quiet and mild but if the Sun is afflicted do not let that mildness fool you. At the heart of this individual is a very strong self, and that self is "me first" but it is so quiet in performance you may not perceive it for it acts subtly. The latter part of life is the best of the years when the Sun is in this house at birth. There is a strong pull toward home and mother in the early years and it is hard to cut the umbilical cord psychologically.

SUN IN THE FIFTH HOUSE — Keynote: to express.

Leo is the natural ruler of the fifth house so the Sun is well placed here. This position of the Sun greatly stimulates the power of self-expression. The fifth house is the ability to do anything that marks it as yours; any effort put forth to distinguish you from others. This may be the children created, books written, affections displayed, pictures painted or what you will. Tests may arise from too much self-projection and too much desire for power. Though none of the textbooks say so, this is the house of hidden karma. It is not difficult to see why this is so. Will and desire (both attributes of self-expression) are the qualities that tie us to the wheel of rebirth. Act and create we must, but not for self-glorification. If the Sun is afflicted in this house it brings difficulties with children. Love affairs also need wise handling. Good placement for people involved with theater and movies, radio and television.

SUN IN THE SIXTH HOUSE — Keynote: to improve.

The person with the Sun in this house has chosen to come into this life with his individuality and his drive for significance set aside in order to serve and help others. This is the house of service to others. It is not a good position for the Sun, for it lacks vital force and the individual has to learn to take care of his body in order to compensate for the lack of energy. To be born with the Sun in this house, especially if afflicted,

means the person has not given his body right nutriments in a past life and has neglected it badly. In this life it will be extremely important for him to take care of his vehicle, the body, if he wants to stay in it and be healthy. On the psychological levels the person is learning humility, often working in humble circumstances. The best work will be done in cooperation with others.

SUN IN THE SEVENTH HOUSE — Keynote: to relate.

In this house the accent is on "we" not ' me." People with the Sun in the seventh house have to learn to adjust to the demands of others to be successfully oriented where the basic drives are concerned. They are not allowed to consider their own wishes but must consider the needs and wishes of others. In marriage the partner holds the power. This can lead to frustration if not understood. The soul chose to be born with a certain pattern for the lessons shown therein are the necessary lessons for the present lifetime. We can't run out on any lessons we need. If we do we meet the same lesson around the corner. It might not come through the same individual, but the same lesson will be centered through another set of circumstances. Power lies in relationships with the Sun here and they must help others to shine. They must adjust to the demands of others if they wish others to adjust to them. The marriage partner will be the dominant one in the relationship.

SUN IN THE EIGHTH HOUSE — Keynote: to transform.

With the Sun in this house the keynote for the basic drive has implications of the necessity for regeneration and transformation. The first third of the life is difficult often due to the loss of the father or his inability to be a father in the true sense of the word. There must be the reorientation of the ego, and in this house the ego (the separated self) must die. In sharing, much that belongs to the personal self must die. The personal drive must be transformed and the resources of others are the important factor. Inheritance and wills are highlighted. Often there is money from the masculine side of the family. This position of the Sun would be good for anyone whose vocation had anything to do with the goods of the dead, or anyone having to deal with death in a vocational way. Insurance brokers and undertakers would come under this category.

SUN IN THE NINTH HOUSE — Keynote: to understand.

In this house understanding is born. This position of the Sun gives the religious leaders, the philosophers, the higher educators and those who deal in publishing and informing the public of higher truths. People in religious life often have this position of the Sun. It is the house of the Super-conscious mind for the natural ruler of the ninth house is Sagittarius, ruled by Jupiter — energy of the superconscious faculties. The basic sustainment is not in the material world but in the abstract levels of religious experience. This is the house of long journeys, but if the Sun is in a fixed sign often these journeys have to do with the spiritual realms rather than

physical travel. If it is in a cardinal or mutable sign the person with the Sun in the ninth house often settles a long way from his place of birth or marries someone born in a foreign land.

SUN IN THE TENTH HOUSE — Keynote: to achieve. *Jerry*

The material plane is the one that is important to individuals with the Sun in this house. Here are found the politicians and those working in the government. Here is the material ambition and the basic drive is toward success that brings prestige and power. The Sun in the tenth house shows the person who thinks in terms of his own importance. Naturally authoritative and dictatorial, these individuals need to aim for activity above self if they would feel secure. The drive for significance must be publicly useful in some way to bring security with the Sun in the tenth house. This is Saturn's stronghold (due to Capricorn as natural ruler) and Saturn is strict and undeviating justice. Any planet in the tenth house is tested by Saturn but none so strongly as the basic drive for significance which is the Sun.

SUN IN THE ELEVENTH HOUSE — Keynote: to transfigure.

This is the house of goals and objectives, hopes and wishes achieved or not achieved. This is also the house of friendships and when the Sun is found in this house the goals and objectives are realized through friends. There are those who think friendships are not important. Those who are much wiser know no man is an island. Many times the objectives in life are achieved by being a friend, or having a friend who can help toward the fulfillment of goals and purposes. With the Sun in the eleventh house the basic drive for significance is tied up with a strong desire to achieve certain goals and recognitions. Without friends this will not be possible. With afflictions to the Sun in this house the wrong kind of friends can play havoc in the life.

SUN IN THE TWELFTH HOUSE — Keynote: to transcend.

The twelfth house shows what we are in the depths of ourselves; what we have brought over from a past life to work out in this one. It is the house of the subconscious mind and shows what lies hidden in the submerged and unknown part of ourselves. The signature here is "serve or suffer" and we can choose which we will do. But the choice is limited to "either — or." These individuals work behind the scenes rather than out front. They make good doctors, researchers and those who can work well with those limited and afflicted in some way. Early conditioning may be affected because of the father. If the Sun is heavily afflicted in this house the individual is his own worst enemy but he can change the pattern if he so wills. If this house is highlighted by the Sun, limitations in the life are due to conditions that are directly tied to the misuse of energy. The person with the Sun afflicted in this house has allowed his ego and his destructive drives to have their way in past lifetimes. Now the bill is presented and must be paid. The bill can be paid through service rather than suffering.

CHAPTER 13
The Moon in the Signs and Houses

MOON IN ARIES

Aggressive spirit. Temper. Quick reactions. Spontaneous, direct, inclined to impulsive and quick temper. Feelings are keen and intense at the moment. Courage, but foolhardiness. Hides a sense of insecurity behind an independence and an aggressive exterior. Poor judgment. Jumps into action from feelings rather than from reason. Makes friends quickly, but often finds it difficult to keep them because of emotional instability. In a male chart attracts a dominating woman as a partner.

MOON IN TAURUS (Exalted)

Strongly centered on material plane. Money important. Has devotion and persistence. Emotions strong. Much charm. Beauty loving. Pride and stubbornness strong. Sensitive. Resourceful in difficulties. Holds temper, but when they blow up — look out. Apt to be lazy. Tremendous desire for security. Desire nature strong. Goodnatured and an attractive personality. Not aggressive as a rule. Fixity is not apparent on the surface. Instinctive response to all emotional impacts. In a male chart this describes the type of feminine he attracts. She would have an attractive personality and be a loyal type of partner.

MOON IN GEMINI

Versatile, shrewd and critical. Dual forces in subconscious. Superficial. Because it is the 12th house sign of Cancer (Moon ruled) can be own worst enemy. Needs to be honest. Restless in search for truth. Needs to look beneath the surface. Longing for knowledge. Spread themselves too thin and scatter their forces. Unless Saturn or Scorpio strong, can waste tremendous energy in chattering. Jittery nervous system. Torn apart by changing feelings which reflect in nervous tension. Too strong a tie with relatives. Not a free agent if they cling too long to family pattern. In a male chart attracts a nervous and highstrung mate.

MOON IN CANCER (Ruler)

Too sensitive. Must not react to feelings of those around them: Subject to moods. Easy going and sociable. The need to mother others very strong. Everything experienced held in feeling memory. Introverted on subjective levels. Conservative. Operates in a deliberate social way. Can be carried away by tides of emotions. Far too sensitive in response to environment. Can be psychic. In a male chart would attract a feminine more mother than mate.

MOON IN LEO

Accents personality. Causes tendency toward display. Leadership qualities. Proud and easily offended. Must be center of attraction. Self-sculpturing necessary. Must learn to govern emotions. Want their own way and do their best to get it. Strong affections and a nobility about them. Ambition and a drive for security strong. Subconscious desire to be someone in authority. Money more important to them than one might think. Power drive but on hidden side. Keen and enthusiastic interest in life. In a male chart would attract a positive and dramatic type of feminine.

MOON IN VIRGO

Apt to want to be considered superior intellectually because of a deep seated inferiority complex. Reserved in expression. Very critical and analytical. Not very loving. Apt to be cranky and fussy about minor details. If afflicted, bickering can become a mania. Irritation leads to bad health and this position can give indigestion and nerves due to negative emotions caused by the desire to perfect everyone else. Very proper and conservative. Needs to achieve adjustment by detachment and non-criticism of others. Strong desire to serve people but not enough understanding of the other person's feelings. In a male chart would attract a quiet, reserved and shy type of mate. If Moon is afflicted she would be critical and apt to nag.

MOON IN LIBRA

Gentle people. Elusive sweetness masking a masculine strength. Ambitious, but dependent too. Home ties very important. Unconscious motivation to be undisturbed by any friction, but peace at any price is hard to achieve because of the masculinity of Libra. Not apt to stand up for a principle if Mars isn't strong, for they want to be liked by everyone so are apt to be all things to all people. If Mars is afflicted to the Moon, they will fight blindly rather than intelligently. Need for purification where motives are concerned. Need to be honest with themselves as well as with others. In a male chart attracts a positive type of feminine that will want to run the ship.

MOON IN SCORPIO (Fall)

Dominating and aggressive. Impatient and moody, given to brooding. Easily hurt and can be jealous. Impulsive. Desire is the motivating force. Strong pride and will. Intensely passionate in response to life. Set in ways and very stubborn. Apt to be disappointed in love. Apt to demand too much and not give enough of understanding. Sit in judgment on others too quickly. Greatest need: to learn to forgive and forget. Strong physically. Sensual. Extremist in temperament. Strong deep feelings but they need handling. Needs to achieve an optimistic attitude toward life. Go after what they want and usually get it and then find out it's not what they really wanted. In a male chart will attract a possessive and jealous mate if Moon is afflicted. A magnetic feminine.

MOON IN SAGITTARIUS

Wants to feel free to roam. Restless and lacking in continuity. Needs fixed signs to anchor them. Philosophical. Friendly and optimistic. Wants to help others but "forgets." If afflicted to Jupiter, too extravagent. Faults are those of overdoing, not underdoing. Keen love of sports if aspected to Mars. The gamblers of life. Not apt to have many close friends but many acquaintances. A feeling for religious philosophy but not dogma and creed. Loves to roam. Needs to learn to think before speaking. In a male chart will attract a freedom loving female. Direct and talkative.

MOON IN CAPRICORN (Detriment)

Poor place for Moon and especially so for a female. Works against itself. Conservative. Strong ambitions. Power complex. Security of subconscious lies in authority. Contest is bread of life. Wants to win recognition as an important and powerful person. Needs to watch tendency to harden ego complex in a shell of self-centered ambition. Not a happy person as a rule. Rigid and crystallized feelings. Not a truly sympathetic and emotional person. Parental influence very strong. Subconscious fears need to be brought to the surface and dissolved through understanding. In a male chart attracts a serious and quiet type of partner.

MOON IN AQUARIUS

Progressive. Can bring difficult lessons through erratic and ill considered actions. Good minds, but erratic and unstable. Much originality of thought if it can get out of rigid thought patterns. A very cold feeling nature because of not understanding the other fellow's needs. Aquarius is a mental sign, not emotional at all. Feelings are cramped and limited, and do not operate freely. A strong selfishness behind a friendly manner. Often has arthritic conditions in later life due to rigid will and crystallizations of emotions. In a male chart attracts a fixed and stable partner that cannot be pushed but can be coaxed.

MOON IN PISCES

Visionary. Dreamer. Romantic, sensitive, emotionally posited with a divine discontent that nothing of this world will take away. Poetical and mystical, if unafflicted. Makes a great gentleness in the person but doesn't help in a worldly sense. Good for musicians and artists for this gives a greatly heightened sensitivity to life. A great sympathy for the underdog. Suffering through the emotions for this position of the Moon is difficult. Needs to strengthen the will in order to withstand the impact of negative vibrations from others. In a male chart attracts a sensitive and sentimental feminine. Not overstrong physically.

148

MOON IN THE HOUSES

Brian

MOON IN THE FIRST HOUSE

Centers "feelings" in the Martian area of the chart. Difficult to get away from emotions. Everything depends on how they feel though they think they think.

A strong desire for personal recognition makes them over eager to please. Then there is resentment if they aren't appreciated. Apt to give too much for too little. Strong tie to the mother. Close to the Ascendant can give a deep and strong mother complex. Srong imagination and great sensitivity to environing conditions. Makes femininity too strong in a male chart. Needs to learn not to react to life through the emotions. Dissipates great deal of vital force in wishing things were different but lacks the courage to make them so. Apt to live in the emotions of the moment rather than taking the long range point of view.

MOON IN THE SECOND HOUSE

Changing conditions in finances. Often makes money through public or public commodities. Shrewd and acquisitive. Money and material possessions are important for the emotional security they bring. Rapid turnover where money is concerned. Fluctuates where attitude toward money is concerned; can be very penurious and then veer to the other side and be over generous. Strong tenacity in holding on to people as well as possessions if Moon is in a fixed sign.

MOON IN THE THIRD HOUSE

Emotional type of mind. Dreamy and "wool gathering." Sensitive and imaginative. Likes to be on the move for there is great restlessness. Not good for concentration and study. Not the "book cracking" type. Absorbs through listening to others. Easily swayed by environment. If afflicted, unstable and lacking in continuity and staying power. Dislikes routine of any kind.

MOON IN THE FOURTH HOUSE

Self-concerned instincts dominate. "Me" and "mine" is the motivating force. Have to learn to project feelings beyond the periphery of self interest. Apt to insulate himself from reality. Love of home strong. Gain through mother but must not cling to her. Parental influences strong. Subjective tendencies strong and in the roots of the being is much insecurity and uncertainty. Inner desire for peace but has to go beyond the personality to find it.

Jam

MOON IN THE FIFTH HOUSE

Constant search for pleasure. Has to cultivate the will. Desires attention because of a need to feel important. Great deal of charm. Poetic imagination. Vacillating in moods and not too constant in love unless there

are strong fixed signs in the chart. Good mothers but are apt to keep their children in psychic bondage. Strongly emotional where affections are concerned.

MOON IN THE SIXTH HOUSE

Functional difficulties in physical body. If afflicted apt to have stomach difficulties due to distorted emotional attitudes. Strong interest in mothering people and serving them. Make excellent cooks and do well in restaurant work. Nurturing, sustaining quality strong if Moon is not afflicted. Needs to watch diet. Should not eat when overtired or emotionally disturbed.

MOON IN THE SEVENTH HOUSE

Very sensitive and responsive to the needs of others. Wants mothering rather than a mate, especially in a male chart. Often marriage partner is unstable if the Moon is heavily afflicted. Can't be a lone wolf. Feelings must take in the other fellows feelings. Partner sensitive and moody. Changes in feelings where partnerships are concerned. Moon changes its course so often and so do the individuals with the Moon in this house.

MOON IN THE EIGHTH HOUSE

Very sensitive where others are concerned. Can be too vulnerable. Personality must be concerned with helping others with their resources. Very sensitive to social currents and social demands. Very psychic. Has experiences of an astral nature because of interest in after-death states. Must sacrifice feelings and learn to live impersonally. Affection means much more than sex with this position of the Moon.

MOON IN THE NINTH HOUSE

Dreams and visions can be of great significance for this person is able to dream true if Moon is not heavily afflicted. Receptivity toward the superconscious realms. Orthodox in religion if higher octave planets are not strong. Finds their inner philosophy through feelings and devotion to the ideal. Loves to travel. Many journeys. Will have many varied experiences that enable the personality to build a philosophy of life.

MOON IN THE TENTH HOUSE

What others think (reputation) very important. Feelings too often dominated by desire for achievement. Highly self-protective. Works for public in some way. Success through occupations ruled by the Moon. Many changes in career. Ambitious for worldly success and attains it when emotions are controlled. Can't live for self. Must make social usefulness primary.

MOON IN THE ELEVENTH HOUSE

Many friends, especially women, who are helpful. Easy to make friends but must guard against superficiality. Large group of acquain-

tances but few intimates if Moon is afflicted. If Moon is heavily afflicted in this house person has used friends in a past lifetime and will have unreliable friends who will use him for their own gain in this lifetime. That which is sent forth, returns again to the sender.

MOON IN THE TWELFTH HOUSE *Brent*

Very active subconscious, open to the feelings and instincts of others. Psychic and subjective. If afflicted, scandal through women. Serve or suffer is the keynote here. Suffering through the mother can be a debt incurred in another life. If individual will serve those who are limited and afflicted he will not suffer limitation and restriction himself. Can be emotional suffering through sub rosa love affairs.

* * * * * *

Wherever the Moon is by house, conditions will fluctuate.

Prominent Moon (in angular houses) caters to the public and their needs. Knows how to please them.

Moon in the chart shows how you appear to others; how you take them into account. If Moon is afflicted the person must build in more empathy and consideration for others.

Moon is the capacity for experience; capacity for function. It is the mask the self wears and speaks through. It is related to everyday pattern of living, ever changing. Moon is the psyche; the essence of your personality. Your need that expresses itself in the world of appearance; need of the self is what that self **does**, not what it **says**.

The Moon represents the subconscious patterns previously developed that are now the instinctual habit patterns of the individual. In this sense the Moon represents what has been brought over from the past. More than any other factor in the chart, it shows what is operating under the surface; in the dark self. The karmic patterns of the past are shown by the house and aspects of the Moon.

The Moon represents the pull of matter; past habits, the Subconscious. The Sun represents the pull of spirit; the Superconscious. The Moon is particularly strong in childhood. When the individuality begins to manifest the Sun force will begin to operate.

CHAPTER 14
Mercury in the Signs and Houses

Mercury is one of the most important planets we have in the chart, and the position of it by sign and aspect gives the clue to how we think. Mercury represents the soul-consciousness. It is the messenger of the gods flying between Heaven (Spirit) and earth (personality) carrying messages between them. It represents the mind behind the brain mechanism. When the link is broken the automatic body processes can go on, but the soul has lost its control over its instrument. Any aspect between Mercury and the other energies is better than none, for it channels energy, regardless of whether it is constructive or destructive. How you use it can always be changed.

If you wish to improve your thinking in order to create happier circumstances for yourself, notice the position of Mercury in your blueprint. What is the quality — fixed, active or mutable? Are you too set and opinionated and rigid in your thinking? That is an afflicted Mercury in a fixed sign. Are you apt to be too impulsive and talk before you think? That is Mercury in a Cardinal sign if it is not manifesting rightly. Mercury is well-placed in a mutable sign if you have some fixed signs to back it up to give you will and purpose, for your mind is adaptable and versatile. However, even a virtue carried too far becomes a vice — and this position can make you a will-of-the wisp; too much vacillating and too great a tendency to be swayed by every breeze that comes your way.

How is Mercury aspected? Is it an ambitious, aspiring mind, or a grumbling, peevish and dissatisfied one? Is it of a devotional nature or purely intellectual? To your real self this matters more than any personal, outer condition. How are you thinking today? That is going to have everything to do with your today as well as your tomorrow.

Choose the thoughts you allow to remain in your mind. When you find a thought that is good and constructive, dwell on it, nourish it, and send it out stronger than when it came in. When you find an evil or ugly thought gaining entrance, turn it out with all possible haste, but do not send it out to fasten on someone else. Send it back to its source and ask that it be lifted up for light and be released to manifest in beauty and harmony.

"You never can tell what your thoughts will do
 In bringing you hate or love,
For thoughts are things and their airy wings
 Go swifter than carrier doves;
This is the law of the Universe
 Each thing must create it kind
They sped o'er the track to bring you back
 Exactly what came from your mind."

MERCURY IN ARIES

A positive, impetuous, impulsive type of mind, taking up ideas with enthusiasm but needs to learn concentration to ground ideas in consciousness. Reaction to impressions are apt to be in the light of the ego. Witty, inventive, and quick on the trigger type of mind. Quick-tempered if it's afflicted. Impatient of opposition or delay. Planets in Taurus or Pisces will help this type of mind for it slows it down and makes it more thoughtful and stabilized.

MERCURY IN TAURUS

Here is a slow plodding conservative type of mind. Learns more from travel and experience than from textbooks. A strong inertia that can become stubbornness. Pushing facts at this type of mind will not help. They are "eye-minded" and touch is more developed than hearing. There is a cautiousness here that is based on an inner security and because of that insecurity what they possess — whether things or people — are clung to with a tenaciousness that is very grasping. There is an artistic side to this position, for Venus is involved through its rulership of Taurus.

MERCURY IN GEMINI (Ruler)

Here the senses are keen and alert, almost too much so. This is a very restless mind and there is apt to be an overdevelopment of the "think-box" at the expense of the vital forces. Restless anxiety and overwork can lead to a breakdown. Anyone with this position of Mercury needs a quiet time every day in order to get away from themselves and the world of appearance. Mind is clear but intellectual rather than instinctual or intuitive. Apt to jump to conclusions and miss the necessary facts. Can be silly but never stupid. Great versatility but lacking in steadiness. With planets in Taurus there is more stability for this position of Mercury.

MERCURY IN CANCER

Here is an extremely emotional and receptive mind that can be drowned in its own emotions if they are not careful. Cancer rules the instinctual consciousness and while there is sympathy and feeling strong, this sign is too receptive, and can be swayed by the senses too readily. Argument with this type of mind arouses stubborn resistance but an appeal to their sympathy is the way to help them grow in understanding. Makes the mind passive but not a stable position for the mind. They are extremely psychic and find it difficult to learn by study but absorb knowledge by listening to others.

MERCURY IN LEO (Fall)

Mercury is the perpetual adolescent and here the solar force makes a man out of him. Adds heart to brain, and brain without heart is the essence of all devilishness. A great deal of ambition and if afflicted can be opinionated and rigid in viewpoint. Apt to be lazy in mental activity and

153

there is a need to cultivate more attention and exercise the mind. **Gives a dignity and a sense of innate refinement.** This nature, when purified, can be of very great worth when taken away from the personal levels, **and** given in service for Love's sake.

MERCURY IN VIRGO (Ruler)

Mercury is at home in this sign and gives a strong stability to the mind. There is a practical and logical trend of thought. Common sense is strong. This is a card index type of mind and is quick to learn but doesn't concentrate enough to retain knowledge. Good speaker. Essentially honest. Can be critical and intolerant toward stupidity. Apt to forget that the world is **NOT** ruled by reason, but by prejudice, emotion and self-interest. Because the mind is analytical it is very necessary to polarize this position of Mercury with it's opposite, Venus. Notice position of Venus in regard to repolarizing a negative or afflicted Mercury. They have to balance each other for equilibrium of mind and feeling.

MERCURY IN LIBRA

This is a masculine positive type of mind so it is better in a man's chart than in a female chart. In a female chart it shows an over-masculinity that needs the building in of a more feminine attitude. It can be a very positive type of mind and yet at the same time inwardly indecisive and vacillating. It gives judgment and there is sensitivity and pliancy on the surface. Tendency to fussiness because esthetic sense is highly developed. A strong perfectionism which isn't too comfortable to live with. This position does help to stabilize Mercury for Saturn is exalted in this sign. Do not be surprised to see a strong saturnian trend in those who have planets in Libra. Remember: Saturn is exalted in Libra.

MERCURY IN SCORPIO

Quick and powerful, sharper than a two-edged sword. Intensely secretive Hate to commit themselves to any positive statement, so don't try to pin them down. Extremely perceptive and know the other person's weakness so well they know where to strike. Fierce acuteness of mind. Farsighted and clear-sighted, but are often overcritical. "I" of the ego and sixth sense strongly developed. Must watch tendency to pass judgment. Can be the judge, the jury and God help you! Excellent in secret service or in police work. Have to regenerate the mind stuff where the creative functions are concerned. Too much emphasis on sex if the total chart does not show evolvement.

MERCURY IN SAGITTARIUS (Detriment)

Keen senses but lack concentration. Mind doesn't need sharpening but directing. Apt to miss details because mind is focused on farther off things. Directness of thought and expression and are apt to say exactly what is in their mind. Do not wound deliberately as does Mercury in Scor-

pio but it does not occur to them how what they say reacts on others. Their thoughts are like shooting stars. Impatient and sometimes do not wait long enough to form correct judgments. Sincere and honest and cannot stand deception. Thoughts disconnected. May promise with sincerity but lack patience in carrying it through. Acute perception. Need to learn to be quiet and still and reflective.

MERCURY IN CAPRICORN

Good concentrative power. Dignity and earnestness. Good memory and attention to detail. Tendency to lack of humor and can be "heavy" because of it. Can be bores due to their lack of empathy. Down to earth type which can be wonderful if they don't forget their branches reach to the sky. Old head on young shoulders. Tendency toward moodiness and sulking. Apt to be "earthbound" and need to learn joy. Fear strong where material things are concerned. Needs to cultivate faith and optimism. Schoolteacher type. Makes excellent teachers and excellent diplomats if they do not overdo on intolerance and sternness.

MERCURY IN AQUARIUS (Exalted)

This is a good position for Mercury. The combination of Saturn and Uranus help to steady the mind, making it resourceful, intuitive, and a good judge of human character. Keen wit. Not earthbound, but when afflicted it can be extremely stubborn. Excellent for balance and good sense. Writing and speaking comes easily to one with the mind in this sign. Usually involved with groups or organizations.

MERCURY IN PISCES (Detriment)

Poetical, psychic and visionary type of mind. Love of music strong. Have poetical ability and are extremely sensitive. Apt to follow instinct rather than reason. A very strong tendency to react from the subconscious level rather than level of reason. Dependent on environmental conditions and they react strongly to atmosphere. Tendency towards moodiness and negativity that needs changing. Over-sensitive and easily hurt. Needs to guard against resentment. A gentleness and innate refinement. Are unhappy in the outer world. A strong desire to be "out of it all" and "'on their way."

MERCURY IN THE HOUSES

MERCURY IN THE FIRST HOUSE

This position gives intellectual vitality, adaptability, and alertness but can make individuals with this position of Mercury too self-centered. It is how they think that is important, not the other fellow. Too much self-preoccupation gives nerve tension and Mercury in this house suffers from jittery and jumpy nerves. This is accentuated if Mercury is afflicted. Able to communicate ideas readily.

MERCURY IN THE SECOND HOUSE

Mercury in the house of resources and finances brings gain through writing, speaking, communications, personnel work, secretarial work and salesmanship. Mercury is the talker and rules the ability to communicate ideas to others. The mind is centered on making money. Apt to work with relatives in business.

MERCURY IN THE THIRD HOUSE

Very good mind if not heavily afflicted. Good for teaching and detailed work. Apt to have an itch to be on the move. Fond of studying and curious about everything. Makes a good investigator or researcher. Experience must be strained through the mind, rather than the emotions. Worry about relatives and apt to be strongly tied to them.

MERCURY IN THE FOURTH HOUSE

Mercury in the fourth house gives many changes of residence, anxiety about home and domestic affairs. High strung and easily irritated. The naggy type if Mercury is afflicted. Needs to learn to relax and not let inconsequentials irk them.

MERCURY IN THE FIFTH HOUSE

Gives writing and speaking ability. Mind is centered on love affairs in early life; later the emphasis is on the children they create, whether of body, mind or emotions. Apt to worry about their offspring. The sign in which Mercury is placed is important. Can be very fixed and opinionated.

MERCURY IN THE SIXTH HOUSE

Any planet in this house has a direct bearing on the work the individual does, as well as sickness or good health. Any ill health, with Mercury in this house, stems from wrong thinking habits. Too much worry and concern about the body needs to be overcome through service to others. Busy people do not have time to think about themselves and consequently the body, which has an intelligence of its own, takes care of itself. Gives a restlessness and a desire for change where work is concerned if Mercury is in a cardinal or mutable sign. A fixed sign helps Mercury in this house. Need to watch the diet with Mercury here. Needs the vitamin B family to nourish the nervous system.

MERCURY IN THE SEVENTH HOUSE

Marriage is of the mind, rather than the emotions. Apt to marry someone younger. Partner is quick-witted, keen and alert. If afflicted, bickering and arguing must be overcome. The seventh house rules the lower courts, as well as partnerships. If Mercury is afflicted at birth, or by transit of one of the heavy planets, it would be well to settle difficulties out of court. Watch what you sign or put on paper.

MERCURY IN THE EIGHTH HOUSE

Concern over partner's money indicated. All documents, wills and contracts should be scrutinized carefully. Money through death of relatives. If Mercury is afflicted there can be worry, disagreements, and harrassment before it is collected. The lungs need plenty of oxygen if Mercury is in this house or ruler of it. Trouble in the respiratory system could be the cause of death. Those with Mercury in the third or eighth house should not smoke if they want to live a long life.

MERCURY IN THE NINTH HOUSE

Interest in higher education and philosophy but needs depth and concentrative power to deepen the mind. This house represents the future, more than the past or present, and in this respect governs dreams, visions, intuitions, and far-flung horizons of the spirit as well as of the material plane. Mercury rules relatives and in the ninth house has rulership over in-laws. If Mercury is afflicted in this house it would be well to live a distance from in-laws. It would avoid many difficulties.

MERCURY IN THE TENTH HOUSE

The tenth house is the amplifier of all that the individual represents, going out into the material world. It represents the reputation, honor and public standing of the individual. Planets rise, culminate and set; the culminating point is the mid-heaven, the tenth house. With Mercury in this house, the sign it is in, and its aspects are going to be important. Mercury is a reflector, a mirror. What it reflects will be shown by its tie-up with other planets. Each contact, whether good or ill, is important. Mercury is consciousness and is the avenue through which consciousness may operate. Mercury in this house denotes the speaker, the writer; the individual able to communicate his ideas to other people successfully. The mind is active and alert. It has more practicality and steadiness due to it being in the house of Capricorn.

MERCURY IN THE ELEVENTH HOUSE

Gives friends who appeal to the mind, rather than the emotions. Friends are usually younger. If afflicted there is difficulty with gossip and scandal through the wrong choice of friends. The goals and objectives are gained through the use of the mind power and through a persistence that has to be acquired if Mercury rules the eleventh house or is posited in it.

MERCURY IN THE TWELFTH HOUSE

A subtle mind, secretive, and often unable to express itself easily. Interested in occult subjects. Lacks confidence but hides the fact. Relatives are not on the same wave length as the individual and he is not understood by those in his environment. The person who centers his mind on serving those limited and afflicted will use this Mercury well.

CHAPTER 15
Venus in the Signs and Houses

VENUS IN ARIES (Detriment)

Venus is in its detriment sign. Here is "self" satisfaction. Where Venus loves she is apt to do much for the loved one, but in this position she is apt to love herself through the loved one. A tendency to touchiness and is apt to be easily offended due to self love. Apt to be inconsiderate of others without realizing it. This is a love springing into activity with ardor and enthusasm, but not a sustaining and nurturing kind of caring. Passion and aggressiveness can be strong, thus Venus may lose her sweetness in this sign. The lesson needed with this placement is the ability to put oneself in the other fellow's shoes. In spite of an impulsive approach to love, Venus in Aries is idealistic, and is always seeking outwardly that which can only be found within. There is a tendency to lack stability for Venus can tire quickly and change her mind often in the impulsive, restless sign of Aries.

VENUS IN TAURUS (Ruler)

Venus is the ruler of Taurus and is powerful in an earthy sense in this sign. Physical and sensual responses to emotions and feelings are strongly accentuated. Demonstrative and affectionate as well as passionate and extremely possessive. Material possessions are important because Taurus is the sign that brings everything into focus on the material plane. Emotions color the life. Fond of comfort. Can have a pleasing voice. Strong domesticity. Good disposition if not heavily afflicted. Very stubborn in a quiet and unassuming way. Loyal in friendships and in love if jealousy and resentment do not enter in.

VENUS IN GEMINI

Here is the light, airy, charming, superficial Venus if she does not have fixed signs to balance her forces. Great charm, wit, and expressiveness. Understands passion but does not feel it too strongly. Emotions are sifted through the mind instead of through the feelings. An entertaining companion but not one to be taken too seriously. Needs to learn constancy. Hard for them to decide on one love when there are so many from which to choose. Often two important loves in the life, though not always at the same time. Very friendly and makes a delightful companion if you do not try to pin the butterfly down. Strong relationship with kinsfolk.

VENUS IN CANCER

Brian

Here is sentimentality rather than strong or ardent affection. Venus in this sign is plastic, kindly, gentle, receptive, changeable, feminine and forever looking for security. The basic need is security, whether it is exemplified by dependency on persons or material possessions. Venus in Cancer operates subconsciously so it is completely emotional and instinctive in its dependency, and its search for security never ends. Loyalty to the family is strong. Despite her tenacity when the emotional life is frustrated or blocked, Venus in this sign is susceptible to depleting diseases. If the love life is not satisfactory this Venus can have psychological indigestion that will affect the physical digestive organs eventually. Because of their lack of aggressiveness people with Venus in Cancer are liked. There is a quietness that has charm, yet because of the Moon's influence there is little constancy. They are mothering rather than mating people. They love children and are fond of home and parents.

VENUS IN LEO

No one with Venus in Leo is ever talked into anything unless they want to be. They can shut desire on and off at will, through the will. Venus in Leo dramatizes emotional experience to the hilt. Emotional responses are honest, frank, and many times calculated. Loyal and affectionate where their affections are concerned. Very attractive. Loves pleasure and is particularly fond of the theater. Colorful personality. Venus in Leo is not as impatient as Venus in Aries, or as possessive as Venus in Taurus, but is kindly and extremely compassionate towards others. Even when afflicted there is a dignity and warm-heartedness that makes them very pleasing to others.

VENUS IN VIRGO (Fall)

Venus is very unhappy in the sign of Virgo. The person who has Venus in the sign of its fall has to learn to be loving. It is the signature of one who has been unloving and superficial in past lifetimes; one who has not learned that when criticism comes in the door, Love departs. Makes an excellent housewife, but needs warmth and lovingness to make a home. Cold and critical and needs many good aspects to warm her up. Fastidiousness and purity are strong but does not relate to others easily. Conventions stand guard over the emotions but "don't let the tail wag the dog." Inclined to put off marriage because they see so many imperfections. Harmonious in their work if Venus is unafflicted. Benefit through employees. Strong desire to serve.

VENUS IN LIBRA (Ruler)

Brent

In this sign Venus is at home and at her best. Released from the earthly bondage she knows in Taurus, and because of the airy, intellectual quality of Libra, an air sign, she is more refined, esthetic, and artistic. Expresses on the mental and spiritual levels rather than the physical plane. Direct and clear emotions; the young at heart. Easily hurt but

do not hold a grudge unless Venus is afflicted. Gives keen sense of color. Makes a good hostess for Venus in Libra relates to others easily. Sincerity and yet impersonality too. Can not function in a discordant atmosphere without the health being affected.

VENUS IN SCORPIO (Detriment)

Venus in Scorpio is in its detriment. Venus cannot function well in a domain ruled by Mars, for Mars is everything that is aggressive, forceful and outgoing while Venus draws to herself through the power of love. She represents the attraction principle while Mars represents the repulsion principle. Venus draws everything to the center. Mars rules the animal soul while Venus, the love principle, rules the human soul. Passion and aggressiveness need curbing when Venus is in Scorpio. There is selfishness masked by a friendly outward manner. Selfish desire and self will are too strong. Can be cruel or suffer from cruelty because of karma tied with the misuse of the love principle. Makes individual strongly passionate yet can be very inhibited. The love nature needs regeneration and reorientation. Though they can be very attractive to the opposite sex, their love is usually a stormy one until the lack of real lovingness is recognized and redeemed.

VENUS IN SAGITTARIUS

Demonstrative and friendly in affection. A breezy attitude toward love. Not always dependable where affections are concerned. Good intuition. Two different types are shown when there are planets in Sagittarius. The gambler type who loves fun and a good time; extravagant, easygoing, and always ready to be on the move. The other type is philosophical, religious, great inner strength, and idealistic in nature. To know which type study the aspects to Venus and if ♀ is afflicted to ♃ it will be the first type. Good aspects and a strong ♄ will indicate the second type. ♀ in ♐ is well placed for it is a combination of ♃ and ♀ and both are benefics. In studying a horoscope there must be a synthesis of all the energies operating before a judgment can be made. In early lessons you learned the meaning of the planets in the signs and now you will learn how to synthesize the energies to know the total pattern. Think of the domain in which the planet is placed as being the home of the ruler of the sign. They work together. Here we have Venus in Jupiter's home. Both are benefic in operation so Venus is well-placed in Sagittarius.

VENUS IN CAPRICORN

Venus is in the domain of Saturn in this sign so there is an entirely different expression of the love nature and emotions than there is in the sign of Sagittarius Here will be the seriousness, caution and pride of Saturn. Intensifies ambition and a desire for prestige and status. Behind an outer assurance is a timidity in love and reserve in expressing feelings. There is a fear of giving too much of oneself, and a desire to shield the self from hurt. Disappointments in love during the youth, especially if

Venus is afflicted, can be overcome by willingness to go the way of love and hold no bitterness or resentment toward the one who brought the suffering. Fear and selfishness must be overcome and Venus in Capricorn has the strength and patience to do it.

VENUS IN AQUARIUS

Venus in this sign is cool, calm, collected and detached. How can the personal Venus feel happy in the impersonal, aloof sign of Aquarius? She isn't! She can function well in friendships, with acquaintances, and in groups. But when it comes to the personal equation she does not do very well. Venus in Aquarius finds it very difficult to understand the emotionally oriented for she strains her feelings through her mind stuff. She has a clear cut mind but icy and cold emotions. Often has a background of an early life where demonstrations of lovingness were missing. If Venus in this sign is afflicted by Saturn, Uranus, or Mars, the love life will be unfortunate until a true sense of love is inculcated. There would be a debt from a past life where love is concerned. Until that debt is paid by willing sacrifice and of love that asks nothing in return, the individuals would not have the love in their lives they would like. A person with Venus in Aquarius could be righteous, ethical and correct but lacking in lovingness and understanding.

VENUS IN PISCES (Exalted)

Venus rules personal affection and Neptune rules divine compassion. Venus in Neptune's home, Pisces, symbolizes the love that is willing to sacrifice and is not afraid of suffering. It is wounded often by its understanding of love. It is exalted in the sign Pisces because it has come to understand that only through love can we know the freedom of the spirit. Aphrodite, rising out of the foam of the ocean (ruled by Neptune), symbolizes the love that rises out of the sea of emotions and finds herself free in the upper air (symbol of spirit). Highly emotional and supersensitive, she suffers through love. Through suffering she goes free. Poetical and musical. Extremely psychic. Attracted to the underdog and those less fortunate. Needs to learn discrimination where love of a personal nature is concerned. Softness and tenderness is part of her nature with a great capacity for self-sacrifice and devotion. An extremely romantic nature. In the younger soul a strength of character is missing. When disappointment and disillusion come there is a retreat rather than a facing up to difficulties. With Venus in Pisces one must love for love's sake. Personal love must be lost in divine compassion.

Freedom in Pisces can only come through spiritual growth and understanding.

VENUS IN THE HOUSES

VENUS IN THE FIRST HOUSE

Charming, friendly, unusually attractive personality, but "me" first. Makes the early life pleasant and harmonious. Brings luck into the life. Person does well if he works in an intimate or personal way with the public. Can be lazy about stirring themselves for others unless Venus is well aspected and in a good sign. A love of harmonious and orderly surroundings. A love of beauty and an artistic nature. Often quite good looking.

VENUS IN THE SECOND HOUSE

Draws benefits of a financial nature and is able to attract benefits and resources without difficulty. "Lucky" person where money is concerned. Money often comes through inheritance. Venus people can be successful in feminine occupations: hair dressing, jewelry, gift shops, art, etc.

VENUS IN THE THIRD HOUSE

Early life pleasant, good relationships in environment. Attracts benefits in environment due to pleasant nature. Can be lazy mentally for Venus is not happy using her mind. Likes to move around but not too far from home surroundings. Is artistic and creative. Does not like to argue. Venus operates through persuasion, not pressure. Love of art and music. Very pleasant type of person.

VENUS IN THE FOURTH HOUSE

A love of home and mother if Venus is not heavily afflicted. There is a lovingness at the roots of the being, and the latter part of life will be blessed with happy conditions. A love of social contacts and an interest in people with Venus in this house. An optimistic nature that makes for popularity if Venus is well placed by sign. A strong desire to own her own home. This will be fulfilled. Strongly artistic nature that is capable of making that home beautiful. Peaceful ending to life in comfort and surrounded by love if person uses this Venus wisely.

VENUS IN THE FIFTH HOUSE

Creative ability. Successful love affairs and gain through speculation if unafflicted. Gain through children of mind and emotions as well as children of the body. Attractive to the opposite sex. Capacity for self-expression through art or music. Can be of great service to young people of teen age and early twenties.

VENUS IN THE SIXTH HOUSE

Very favorable for health if not seriously afflicted. Good for employment. Gives diplomacy and popularity in working conditions. Good position for those who act as mediators, agents, arbitrators, or in any work done

for or with women. Self-indulgence can affect health if Venus is afflicted in this house. The part of the body afflicted will be shown by the sign Venus occupies. Sugars and starches should be avoided.

VENUS IN THE SEVENTH HOUSE
Harmonious relationships due to the friendliness of Venus in this house. Partnerships favored if Venus is well-placed by sign and well aspected. Person draws happy conditions due to a loving nature. Gives a happy marriage if unafflicted. If Venus in this house does not marry it will be from choice for there will be many opportunities. This person attracts love because of having been a loving person in other lives. What we have given to others comes back to us through others. The seventh house shows what is coming back.

VENUS IN THE EIGHTH HOUSE
This is the house of money, inheritance, and possessions coming through legacies. When Venus is in this house person inherits money. Often the inheritance comes through the marriage partner, or his relatives. Tendency to inertia is characteristic of this position. Venus smooths the way in whatever house she is placed, but sometimes a smooth road can be a detriment. There is a laziness, a lack of discipline, and sensuality if Venus is afflicted in this house.

VENUS IN THE NINTH HOUSE
Long journeys bring much happiness. Person often moves far from his place of birth after he reaches maturity. Far away fields are greener and more fruitful with Venus in the ninth house. May marry someone born in a far off country. A happy relationship with in-laws shown. The ninth house is the third from the marriage house so it rules the relatives of the marriage partner. Gives a refined and artistic type of consciousness and a keen appreciation of the higher, cultural aspects of life.

VENUS IN THE TENTH HOUSE
Gives success and prestige before the public. Favors prosperity and good will, for the individual has a loving and friendly approach to the world. For this reason he attracts benefits and blessings from the world. The attracting power of Venus is very strong in any angle but particularly in the seventh and tenth houses. In the seventh, Venus attracts a loving partner. In the tenth, Venus attracts those she contacts in the world of business and the public.

VENUS IN THE ELEVENTH HOUSE
Brings gain through friends whose desire will be the forwarding of the interests of the person. This is the house of goals and objectives, and these are attained through friendships with Venus placed in this house. The afflictions would give self-indulgence and lack of discrimination in choice of friends.

VENUS IN THE TWELFTH HOUSE

Gives a secrecy to the emotional life and a tendency to seek solitude. What this person really feels within is seldom expressed. Sometimes there is a hidden love affair not known to others. If afflicted by Neptune the person may be in love with someone who is not free. Self-indulgence in drink or drugs can bring difficulties with Venus afflicted in this house. To those who are evolved, this position can give a strong compassion and a desire to serve God through helping those less fortunate. Worldly success would not be important. Devotion to an ideal would be the motivating force. Venus in this house is extremely protective and denotes a guardian angel that guides and protects though the individual may not know it.

Mars in the Signs and Houses

Mars is the planet ruling Aries and Scorpio.* In Aries, it is the beginning of all objective manifestation. Aries is the sign in which Mars initiates activity on the outer side. In Scorpio it rules the inner life and involves the emotional and mental levels as well. Without energy, being could not manifest. Motion is necessary to matter if a universe is to exist. This energy must be directed and controlled, and not allowed to dissipate or escape in ways unwilled. Mars is the dynamic in life that drives over and through obstacles. The character which is lacking in Martian aspects never comes to grips with life.

Mars is a masculine, positive power. When it is too strong in a feminine chart (especially when afflicted to the Moon) it gives difficulties with too much masculinity and a dominating element which is very unattractive. When Mars is afflicted it gives temper, destructiveness and aggressive action. When wisely used, it is courage, initiative and outgoing energy of a positive nature.

Mars has a great deal to do with the blood stream for it rules the energy flow in the blood stream. It vitalizes, purifies, cleanses and stimulates all aspects and organisms in the body. The muscular system is under the rulership of Mars. It has rulership over the adrenal glands (sharing the rulership with Saturn). When Martian force is running rampant, one must run or fight. When Mars is afflicted by transit or progression in your natal chart, learn to channel that energy correctly, for you must **do** something. Mars is closely related to sex, an aspect of the pairs of opposites. Mars is the most unbalanced of the planets, and the one most in need of restriction and direction.

Mars is the symbol of the animal nature whereas Venus is representative of the human soul. If Venus alone governed the actions of individuals there would be no enterprise, no initiative, no strength to battle with the lower sides of the nature. We would not have the energy to meet the tests of life successfully. We call Mars a malefic, but is it?

Without energy there would be no activity or growth. Mars rules the right arm and represents the warrior who fights to protect the weak. Mars represents the fear of the Lord that is the beginning of wisdom. We have a healthy respect for the person who can put the fear of God in us, which is more satisfying than the love that can be walked on because it is sentimental and soft. Discipline is the keynote needed to direct the Martian force constructively.

Mars is concerned with the release of force in activity. Good and evil

*Pluto is a co-ruler, with Mars, of Scorpio.

are not things in themselves. Evil is misplaced energy. Misplaced in space if it turns up in the wrong place, like wood burning on the living room floor instead of in the fireplace, or bathwater coming through the ceiling instead of being in the tub. Misplaced in place, or misplaced in time if we allow ourselves to be weakly sentimental when we should be strong, or when we allow children to go undisciplined because we want them to love us. Dynamic energy is as necessary as generosity (Jupiter), love (Venus), and patience (Saturn). Too much charity is the handiwork of a fool; too much patience can be the hallmark of a coward. What we need is to have the right proportion of every energy operating in our magnetic fields. If you have Mars in a poor sign or afflicted to other energies, study it well. You have the power to change the pattern. Accident prone people are those who are bad tempered. This is shown in the blueprint by the afflictions to Mars. When control of temper and right use of energy has been achieved there are no more accidents.

MARS IN ARIES (Ruler)

Acts positively from within, outwardly. Relatively independent of environment. Increases physical and mental activities. Gives ambition and drive to the nature. Courageous, rash, impulsive and enthusiastic. Aggressive and impatient if afflicted. Not good for a female; too positive and masculine in their approach. Gives strength of character in any chart, but a great deal of self-assertion. Quick on the trigger. Temper can cause trouble if Mars is afflicted. Irritability and restlessness needs changing.

MARS IN TAURUS (Detriment)

Mars is not well placed in Taurus where it is in detriment. Mars is persistent and patient in this sign but also extremely stubborn, jealous and possessive. Money and sex are important. Values need refining for they are of the earth, earthy. Security whether invested in money or people is important. Acquisitiveness is strong as is pride. If Mars is afflicted there is a tendency to resentfulness. Selfishness and too strong a possessiveness must be overcome. Sharing must be cultivated as a quality. Apt to be penurious.

MARS IN GEMINI

Alert, energetic, witty, sarcastic, often strife with relatives and friends. Energizes the tongue too much and makes it sharp and caustic. Can be the gossip and can have a forked tongue. If afflicted, not trustworthy. Lively, mechanical minded, and capable of doing many things well. Has to learn to conserve energy and direct it wisely. Otherwise the nervous system gives trouble. Biggest fault is failing to follow through and keep promises. This is why it is undependable. Scatters force and needs to learn concentration of power.

MARS IN CANCER (Fall)

Very sensitive. Over-emotional. There are difficulties with digestion due to emotions. Strife in home conditions. Ambitious and hard workers, but changeable. Very domesticated. Can not fight for is not aggressive outwardly. Holds everything in and steams inside. Timidity is strong if there are not other positive energies to help. Very sensitive stomach. Should not put juices on an empty stomach for it irritates the stomach linings. People with Mars in Cancer have a "red" stomach so acids can give upsets. Should not eat when tired or upset. Digestion strongly affected by moods and feelings.

MARS IN LEO

Brent

Here is energy plus. Leo is a fire sign, and Mars is a fire planet. Dramatic, enthusiastic, ambitious and passionate. Have no intention of taking a back seat to anyone unless there is a strong Neptune in the chart to nullify the ego. Quarrelsome and jealous where those he loves are concerned if Mars is afflicted. Hates to be wrong and can be extremely fixed in convictions and opinions. Tremendous vitality and courage. Can have heart trouble if he overdoes physically.

MARS IN VIRGO

Here is the fuss-budget! Energetic worker, very willing to serve, but fusses over inconsequentials. Narrowness of effort because of an inability to see the forest for the trees. Quarrels with employees and dependents due to endless fussing over details. Kindly people and not bad-tempered as a rule. Higher type very helpful with a strong desire to be of help to others. Practical, ingenious and industrious. Hard workers but get very irritated when others do not work as hard as they do. Their great virtue is mastery of detail, but they must learn not to waste time on nonessentials.

MARS IN LIBRA (Detriment)

Jan

Persuasive and at the same time argumentative. Enthusiastic and active in partnerships. Often strife in relationships due to strong desire to have one's own way. Can be easy-going, lazy, and lacking in self-reliance if the rest of the chart is not strongly positive. Alternately as meek as a lamb and as angry as a hornet. Need objectivity of approach to other people. Mars is in its detriment. Anger will not accomplish its purpose, but diplomacy and patience will. Purification comes through marriage and the problems it brings. Gives an intuitive mind. Balance needed between self-surrender and self-aggression.

MARS IN SCORPIO (Ruler)

Strongest position for Mars, but needs handling. Fixed fire in a water sign generates steam. Intense, proud, strong-willed, stubborn where con-

victions are concerned. Here the animal must be tamed for the personality must be redeemed. In best form energies flow into channels that make for deep, personal security. Must learn to draw to him through love, not fear. Instincts so strong his presence can be felt even though he says nothing. As effective in silence as he is in speech. Self-discipline is a necessity. Healing power very strong if individual is spiritually oriented.

MARS IN SAGITTARIUS *Brian*

A breezy, friendly, optimistic Mars. Impulsive, sometimes unreliable, for it scatters energy far and wide. Often talks too much. Good salesmen. Active traveler. Average type is interested in sports and gambling, but the higher type is interested in religion and philosophy. Very independent and wants no restrictions of any kind. "Don't fence me in" is the battle cry. Energies need to go into physical channels. Apt to be blunt and tactless if Mars is afflicted. Can be self-righteous. Needs to recognize the rights of others as well as his own.

Jerry

MARS IN CAPRICORN (Exalted)
Active, ambitious and works toward goal with persistence and patience. Pride is very strong. Self-reliant. Battle between animal soul and human soul. Much hostility aroused through efforts to reach the heights. Silent type, not apt to explain himself. Difficulties with superiors and in working relationships because of this fact. Has great strength. Need to work as though ambitious, yet hold no personal ambition. The need is to work for work's sake. Capable of much responsibility. Slow to learn but sure in the assimilation of knowledge. The best position for Mars, because the Saturn force restrains and checks the animal energy.

MARS IN AQUARIUS
The airy influence of Aquarius tends to cause Mars to expand his force in intellectual pursuits. Gives more freedom than Mars in Capricorn, but it is not as cautious and can be very quarrelsome and contentious if afflicted. Independent, aggressive, and enterprising. Gains friends through merit and ability. Rebellious, impatient and perverse if afflicted.

Ray

MARS IN PISCES
Mars is not well-placed in Pisces. Pisces is receptive, over-emotional, sensitive and psychic, the very antithesis of the fiery, dominant, aggressive Mars. The drive for power is drowned in Pisces, and it is difficult for people with Mars in Pisces to attain the success they want so badly. Quiet on the outside, but very restless within. Not physically strong and can appear lazy. Can be unstable. Alchohol and drugs are dangerous. Very good position for musicians. Apt to be two marriages. Liable to disappointments in love affairs.

MARS IN THE HOUSES

MARS IN THE FIRST HOUSE *Jam*

This position of Mars causes the personality to throw itself into whatever it wishes to do. Intense activity is necessary if this energy is to be used constructively. Self-assertion, physical strength, positiveness very strong. Inclines to personal risks, and if afflicted, danger of personal violence. Needs to guard against accidents due to undue speed and impulsiveness. Tremendously independent. If afflicted, temper has to be overcome as well as overemphasis of ego. Organizing ability strong. Self-confidence strong.

MARS IN THE SECOND HOUSE

Can bring finances through engineering, mechanics and anything to do with Martian pursuits: i.e. government or military service. Money comes through enterprise and hard work, but it does not stay. Scatters money and possessions to the winds if afflicted in a fire sign. More cautious in earth and water signs. Test relating to the second house is the test of ownership. How we use our resources needs checking when Mars is in this house. If afflicted to Uranus, sudden and unexpected losses.

MARS IN THE THIRD HOUSE *Brent*

Right thinking important. Too impulsive thinking can bring trouble. Difficulties in environment with brothers or sisters. Many short journeys and, if afflicted, there is a need for caution where accidents are concerned, particularly in early teens. Usually a brother or sister will be in the armed services. If heavily afflicted can cause loss through the sudden and unexpected death of relatives. Quarrelsomeness and irritation in early home environment can make person high-strung and nervous. An abundance of mental energy that can further aims and objectives.

MARS IN THE FOURTH HOUSE

The activity of the fourth house centers on the building of the foundations of the person's life on the material and spiritual planes. This includes the instinct for security and the building of consciousness through experience. This house shows the roots of the person's being; the midnight side of the chart. The energies operating in this house are hidden from view, nevertheless quite potent. Strife and tension in the soul reflect through the domestic surrounding when Mars is in this house. There is no peace until the karmic decks are cleared by overcoming the hidden quarrelsomeness within the individual. Apt to have an active and dominating mother if Mars is afflicted. Strong emotions need toning down.

MARS IN THE FIFTH HOUSE

This energizes the drive for creative self-expression. The fifth house is the release of power; the compulsion to express yourself. Unusual force and impulsiveness to a person's desires with Mars in this house. Strong

power of will, but can be foolhardy. These are the gamblers of life. Selfishness of a past life shows up through children that are self-centered and not particularly loving.

MARS IN THE SIXTH HOUSE

The sixth house is the adjustment to necessity. In this house you must work for what you get. Mars here makes the person dynamic and active in work but too much irritation and impatience can give trouble through co-workers and employees. Mechanically minded. Tendency to fevers when ill.

MARS IN THE SEVENTH HOUSE

Early or hasty marriage without due forethought. Strife in marriage if afflicted. Legal difficulties. Trouble in business through partnerships. This house rules the lower courts. Anyone with Mars in this house would be well advised to settle difficulties out of court. Apt to want his own way and if gets it all is well. Marriage partner is combative and bad-tempered if Mars is afflicted.

MARS IN THE EIGHTH HOUSE

Strife over partner's money. Difficulties where legacies are concerned. Death is sudden, and if the Martian force has not been regenerated and Mars afflicts Uranus it can come through accident or violence. Sex energy is very strong. If Neptune is afflicted to Mars in this house, avoid anything to do with psychic phenomena. Misuse of psychic power in a past lifetime could lead to obsession and psychic difficulties.

MARS IN THE NINTH HOUSE

Long distance traveling. Strife with in-laws so it would be best to live at a distance from them. Enthusiastic mind. Independent. Religious zeal can become fanaticism if Mars is afflicted. Strong desire to travel. Very restless mind.

MARS IN THE TENTH HOUSE

Friction with the father. Often a separation from him by choice. Needs to avoid scandal where public is concerned. The slightest bit of offence where morals are concerned will be used against this individual. This is a karma of gossiping and maligning others in a previous lifetime. Energy directed toward achievement where profession is concerned. Self-reliance and ambition strong. Practical person. Would do well in vocations dealing with mechanics, engineering or military pursuits.

MARS IN THE ELEVENTH HOUSE

Energy strongly directed toward achieving goals and objectives. Can use friends and acquaintances toward that end. Important to seek the right kinds of friendships for the wrong kind can bring plenty of difficulties with Mars. Needs to learn caution and integrity. Overemphasis on social life. Needs to learn to say "no."

MARS IN THE TWELFTH HOUSE

May appear mild, but if driven to the wall can be a formidable foe. Intelligent non-resistence best defense here. Gives intense emotional reactions, stronger for being suppressed. Must depend on self alone. False accusations by hidden enemies. Needs to overcome inner resentments. Should not repress or inhibit feelings but learn to express them in a non-combative manner.

CHAPTER 17
Jupiter in the Signs and Houses

JUPITER IN ARIES
Energetic and enterprising. Strong self esteem. Good executive. Leadership qualities. Lover of freedom and independence. Rash judgment and extravagance if Mars afflicts Jupiter. An optimistic nature if Jupiter is angular. Liking for science and philosophy. Benefits mentally and physically through travel. Attracts abundance and the good things of life easily.

JUPITER IN TAURUS
Love of home and luxury. Able to attract substance and material benefits. Materialistic. Sensuality strong. Fond of good food and has a keen appetite. Ability to make money, and it is important to Jupiter in Taurus to have it. Quietly stubborn and cannot be pushed. Inclined to put on weight in middle years.

JUPITER IN GEMINI (Detriment)
Not a good place for Jupiter. The expansiveness and judgment of Jupiter is scattered by the dispersiveness and inability to concentrate of Gemini. Does not attract the abundance of Jupiter for self-centeredness shuts off the flow. Rash speech can cause difficulties if Jupiter is afflicted. Unafflicted can give a happy carefree disposition. Fond of travel. Does well in the travel business or any occupation that involves selling, communication of ideas or teaching.

JUPITER IN CANCER (Exalted)
Jupiter is well placed in Cancer for it expands the nurturing, caring principle of Cancer. Gives a good personality that attracts benefits because of its nature. Personality friendly and sociable. Works well with public. Can have weight problems. Does not reach its full potential until middle age. Material success promised. Good position for accumulation of funds and properties. If afflicted, person can be overcautious about money and very stingy in his givingness.

JUPITER IN LEO
Strong vitality but apt to have an enlarged heart if the person puts on too much weight. Self-reliant. Courage and loyalty. Extravagant and apt to have a big ego and rash judgment. If Jupiter is afflicted faults come from over-doing. Dignity and pride very important. Great desire to impress others. Apt to be egotistical, especially if Jupiter afflicts the Sun. Capable leader and executive.

JUPITER IN VIRGO (Detriment)

Here the expansiveness of Jupiter is curtailed by the detailed, unconfident, insecure sign of Virgo. The bigness of Jupiter is held down by the narrowness of Virgo. Cautious, practical, scientific outlook on life. More intellectual and critical than emotional. Discrimination strong but if Jupiter is afflicted apt to be critical, irritable and petty. Too much attention to little issues and apt to lose the larger vision. Good dieticians and excellent nurses. A good investigator or detective.

JUPITER IN LIBRA

Refinement and idealism strong. Impartial, friendly and outgoing in nature. Loves art and beauty. Often a collector of art. Attractive to others. Excellent position for artists or lawyers. If unafflicted can bring gain in partnerships and marriage. Gives success in business, especially in large corporations. If afflicted can bring trouble through partners and legal entanglements. Dislikes manual work.

JUPITER IN SCORPIO

Shrewd and critical judgments. Subtle type. Very devious if afflicted. If Mars is afflicted to Jupiter it gives trouble with senses and the passions. Strength and courage strong. Very secretive. If individual is evolved it gives healing power and a magnetic quality that draws success in the outer world. Good for police work, engineering, chemistry or medicine.

JUPITER IN SAGITTARIUS (Ruler)

Carefree, outgoing, optimistic type of individual. Outdoor type, fond of sports and willing to take a chance on anything. Natural financiers. Often money through inheritance. Women good executives. The more highly evolved are interested in metaphysics, religious philosophy and humanitarian pursuits. A great love of freedom and travel.

JUPITER IN CAPRICORN (Fall)

Here is the conscientious plodder who is concerned with factual matters and getting ahead in the world. Jupiter's expansiveness is often held down by Saturn's cautiousness. Necessary to learn giving-outness for there is a tendency to be miserly with the expression of loving feelings, as well as with money and material possessions. Too cautious for their own good. If Jupiter is afflicted a change in consciousness will be necessary before there will be abundance in the world of appearance.

JUPITER IN AQUARIUS

Makes a good scientist interested in large projects and reform. Expands interest in group endeavors and can work well with others. Keen judgment and good intellect. Gives originality and ability to implant new ideas in other minds. Make good diplomats, labor relations experts, personnel managers and organizers.

JUPITER IN PISCES (Ruler)

Good samaritans interested in helping others but do it quietly behind the scenes. Disposition quiet and unassuming. Not a great deal of worldly ambition. Inclined to be easy-going. Apt to suffer from over-sensitivity but doesn't show it on the surface. Interest strong where occult and psychic laws are concerned. Can work well with people for there is a deep understanding of their needs. Emotion and sympathy must enter into his work or he will not be happy.

JUPITER IN THE HOUSES

JUPITER IN THE FIRST HOUSE

Expands the horizons where travel is concerned, as well as expanding the physical body where weight is concerned. Gives abundance where material world is concerned. Makes person pleasure loving and self-indulgent. Increases vital force. If afflicted must watch tendency to egotism and hypocrisy. Interest in sports and would do well in them. Executive type of individual.

JUPITER IN THE SECOND HOUSE

Attracts resources and money easily because of an inner optimism and confidence. If afflicted, extravagant and apt to spend all he gets. Would make a good income in banking, stocks and bonds or in anything to do with traveling or salesmanship.

JUPITER IN THE THIRD HOUSE

Likeable, optimistic type of individual. Growing up years are happy ones. Early environment conducive to well being and confidence. Good relationship with relatives. Many benefits through brothers and sisters. If afflicted, apt to scatter energies and be impractical. Good mental powers and intuition is strong. Mentally restless so needs an occupation that keeps him moving.

JUPITER IN THE FOURTH HOUSE:

Openhearted and generous person. Strong soul powers. Success in vicinity of place of birth. Gain through parents. Benefit through inheritance. Home must be comfortable and roomy. Needs a sense of space around him. Happiness and blessings as well as abundance encircles latter part of life.

JUPITER IN THE FIFTH HOUSE

Loves sports and good times. If unafflicted, extremely creative and much success and happiness through children of the imagination as well as children of the body. Gain through speculation and investments. Senses under control and sympathetic nature brings happiness to bless the person.

JUPITER IN THE SIXTH HOUSE

Success in work that deals in service to others. Good relationships with employees or fellow workers. Is a loyal worker and dependable. If afflicted, trouble with health would come through carelessness or overindulgence where food is concerned. If Jupiter is afflicted, the liver and the blood would be affected. Arrogant if afflicted to Sun or Moon, "Look out. Here comes God."

JUPITER IN THE SEVENTH HOUSE

Sociable type of person. Good natured and able to attract benefits because of optimism. Capable of attracting beneficial partnerships. Often two marriages. Material abundance through marriage partner. May marry someone who has been married previously.

JUPITER IN THE EIGHTH HOUSE

Money through partners and through inheritance. If afflicted, can cause extravagance and lack of good judgment. Strongly emotional type and needs to weigh conditions carefully before action. Sexual drives strong.

JUPITER IN THE NINTH HOUSE

Interest in religion and philosophy. Much travel and expansion of horizons through it. Would be highly successful in higher education, religion or in the publishing or writing field. If unafflicted, in-laws would be a source of pleasure. Good judgment and keen intuition. Favorable for residence in foreign countries.

JUPITER IN THE TENTH HOUSE

Best position of Jupiter for success and prosperity. Great desire for achievement. Attracts honors and great success through profession. Career usually one that entails service to those limited and afflicted. Excellent for someone in the medical field or working with people. Has an expansiveness that attracts people to him. High moral standards and will attract position of importance in life.

JUPITER IN THE ELEVENTH HOUSE

Attracts friendships that are an aid in achieving goals and objectives in life. Ambitions attained through friendships. If afflicted, extravagance and wrong type of friends can cause downfall. A love of social life. Many benefits through travel. If unafflicted, intuition and good judgment.

JUPITER IN THE TWELFTH HOUSE

The invisible protector. Unseen help that acts as a guardian angel. Should work in hospitals or institutions. Reversals (if afflicted) followed by success. Good position for research or working behind the scenes. Ideas should be worked out in private before presentation. If afflicted, haste may hurt chances of success due to poor judgment and bad timing. Gain directly or indirectly through enemies who will be turned into friends. Success in middle life. Help comes from friends even when Jupiter is afflicted.

CHAPTER 18
Saturn in the Signs and Houses

SATURN IN ARIES

Spontaneous flow of life force inhibited. Apt to be suspicious and distrustful. Often suffers from those in authority over him. Held back by subconscious fears or a sense of great conflict. In female charts a strong father complex can be part of the pattern. Gives the ability to concentrate and stabilize the mind. Good reasoning power. Likes an argument. Reserved and acquisitive. Too much congestion in the head can give trouble with headaches. Needs physical activity to keep life force circulating and operating. Due to reflex action in the opposite sign, there can be difficulties with the kidneys, so people with this placement of Saturn need plenty of water. **Test of self-centeredness** with Saturn in Aries.

SATURN IN TAURUS *Jan Brian*

Great persistence and stamina. Can be extremely stubborn. Gives lessons in true sense of values before this position brings peace. Lessons in use of creative force, sex and speech involved here. Extremely possessive where loved ones are concerned and has to overcome jealousy. Need to guard against making material things too important. If afflicted, doesn't deny money but can bring many difficulties through finances. **The test of ownership is here.** He who has no desire to possess has no fear of loss.

SATURN IN GEMINI

One of the better positions for Saturn. It takes away the superficiality of Gemini and deepens the mind, giving it the ability to concentrate and to penetrate deeper into the meaning of life. An adaptable, keen mind. Would make a good teacher. One apart from relatives and would not find it easy to relate to them if Saturn is afflicted. People with Saturn in Gemini have a tendency toward weakness in the lungs and should not smoke. They suffer from oxygen starvation if they do not get plenty of air in their lungs. Need to guard against nerve strain and tension. **Test lies in learning to have faith and optimistic viewpoints in mental attitudes toward life.** Inclined to be negative in approach with Saturn afflicted in this sign.

SATURN IN CANCER (Detriment)

Emotions too crystallized. May come, not from innate selfishness, but from a hurt to the feelings early in life or by a parent. The result would be that he would build up a self-protective coating where emotions are

concerned. Can be kind but finds it hard to put himself in the other fellow's shoes. An ambitious and shrewd person to whom material things are very important. Apt to withdraw from too close emotional involvements. Lack of relationships can lead to aloneness in old age. Psychic tendencies strong. Test of Saturn in this sign is the need to learn the **value of responsibility and empathy.**

SATURN IN LEO (Detriment)

Heart center needs developing. Constriction where heart is concerned, psychically as well as physically. Great pride and often too strong an ego drive for power. Very strong willed. Disappointment through love and children if Saturn is afflicted. Great mental vitality that can be overpowering to the other fellow. Hasn't been a loving person in past lifetimes, and is often denied the love he seeks in this lifetime until his spiritual bookkeeping is balanced. Can be reserved and cautious. Saturn tests for **true humility and lovingness,** in this sign.

SATURN IN VIRGO

Gives orderly, critical, analytical mind. Needs to cultivate a sense of humor. Life is very serious for this individual. Good worker but apt to have difficulties in working relationships due to over-criticalness. Difficulties in assimilating the experiences that life brings can give nervous complaints. Apt to have an irritable disposition if Saturn is afflicted. Nagging could be a detriment that the individual should eliminate. A tendency to worry over inconsequentials needs to be overcome. This position of Saturn makes a good researcher. a scientist or one who works in accounting or bookkeeping. A job that involves a great deal of detail will not bother him. **Test is the lesson of discrimination** between what is important and what is not.

SATURN IN LIBRA (Exalted)

The person with Saturn in Libra stands at the midpoint between the personality that has become involved in matter, and the soul he must become. Saturn is strict and undeviating justice and keeps a perfect set of books. Saturn is exalted in Libra for it is through the sign of relationships that we grow in grace. If a person lived on a desert island by himself he would have no problems. Only through patience, endurance, responsibility, and humility can we learn to relate to other people. Saturn demands cooperation, not competition. If Saturn is in Libra competitiveness must go and cooperation must become a habit. If Saturn is afflicted trouble in marriage relationships due to lack of cooperation in past lifetimes. Marriage will be a discipline and love is the only way out. Good judgment, diplomacy and tact is there and must be used. Difficulties with the kidneys due to impurity in the blood. Vitamin C is important; as it keeps the blood pure. **Test is relatedness to life.**

SATURN IN SCORPIO

Gives emotional intensity and strength but needs careful handling. Strong ego tendencies. Great secretiveness and shrewdness. Can be extremely vindictive and jealous if afflicted. Strong lust for power. Aspects to Saturn will show whether it will be satisfied or not. Resourcefulness strong. Apt to have moods of withdrawal. Psychic ability and strong interest in occult matters. Desire nature is extremely strong and until that is brought under control there is much suffering and pain. Pain is the great teacher. The pain that the Saturn in Scorpio individual brings on himself purifies the emotional nature. Gives ability to love greatly or hate bitterly. Not weak character, but can be destructive if unevolved. **Test of outgoing desire** is found in this sign. Difficulties with deposits in the body due to crystallization (gallstone, arthritis, arteriosclerosis, etc.) due to emotional and mental attitudes.

SATURN IN SAGITTARIUS

Philosophical type of individual. Apt to be outspoken and fearless if challenged. Keen intuition. Makes a good teacher. Has desire to work with those limited and afflicted. Strong sense of pride and will not let affront go unchallenged. Unafflicted, it gives a very frank, open and honest character. Good in religious life. Also favors those who have a scientific type of mind. If afflicted the individual is apt to be careless, indifferent, inclined to indecision and rebelliousness. When Saturn goes astray in Jupiter's sign, faults are apt to be the result of overdoing the wrong things and underdoing the things that should be done. **Test of understanding.** Needs physical exercise for there can be lack of circulation in the lower extremities. The sacroilliac nerve that extends down the legs may give trouble that can be obviated by osteopathic adjustments.

SATURN IN CAPRICORN (Ruler)

Karmic clearing house. Can express best or worst of the sign. Ambitious, cool-headed and clear-sighted where material things are concerned. Gives a practical, down to earth viewpoint where the world is concerned. Prestige and social standing is very important to the unevolved Capricorn. Serious, solitary and suspicious if Saturn is afflicted. Apt to be selfish and egotistical. Gives a love of power and a desire to have mastery over others. Can give a great deal of loneliness and a sense of limitation if afflicted. The way out is through giving. Saturn gives a strong sense of duty but that can be very grim if there isn't joy in the doing. **The test lies in the use of power.** Humility in its truest sense means letting the Power have its way, not trying to be the Power. In this sign Saturn is the bridge between selfishness and service. In the physical body over-crystallization can affect the joints and bones, giving arthritic conditions. If Saturn is unafflicted in this sign it gives strength, persistence and a strong sense of responsibility. The individual would be a very evolved soul and none of the negative qualities would be manifested.

SATURN IN AQUARIUS (Ruler)

Saturn in this position acts as the bridge between the Higher Self and the lower self. A critical incarnation, for the soul must accept the responsibility of regeneration and be about the Father's business. The High Self or Superconscious must be the positive pole, not the personality. Fixed in nature, strong, just, impersonal and scientific when unafflicted. When afflicted he can be vindictive, opinionated, cold and unloving. He would resent being told anything that did not please him. To the spiritual disciple it gives the ability to judge character, to concentrate and meditate, and to become the instrument of the Higher Forces of Light. In the physical body circulation of the vital forces must be kept in good condition. The test for Saturn in Aquarius is the **test of responsibility.**

SATURN IN PISCES

Influence of Saturn is weakened in this sign. Takes life too seriously and reacts emotionally to negative conditions. Too self-conscious and fearful. Fears are apt to stem from the subconscious and appear on the surface as vague anxieties and depressions. They need to let go of the past and dump the ghosts that haunt them. Capable of sympathy and compassion but identify too personally with other people's troubles. Need to learn a loving detachment. **Test is one of severance,** letting go and letting God. Pisces rules the feet, symbol of understanding.

SATURN IN THE HOUSES

SATURN IN THE FIRST HOUSE *Brian*

If Saturn is close to the Ascendant the birth has been a difficult one; the soul was reluctant to come in. This knowledge helps one to rectify timing. In every case of Saturn in the first house close to the Ascendant the birth is difficult for the mother. This position of Saturn gives early maturity; the person is born "old" and gets younger in attitude as he grows older. Shy and introverted. Makes an early start in life. Needs to cultivate self confidence and a sense of their own worth as an individual. Has fear that has to be overcome. Ability to work hard and through determination, persistence and self-control can achieve success in life. Early life austere and disciplined and not apt to have a feeling of being loved in the early part of life. There can be a great deal of selfishness and self-centeredness if Saturn is poorly placed by sign or aspects.

SATURN IN THE SECOND HOUSE

Posits a lesson where a true sense of values is concerned. Does not negate the ability to attract money for there can be a gain by inheritance. The person does not gain inward peace unless he has learned to share what he has with others. Real estate or anything to do with land is a good investment. This house rules peace of mind and this depends on where the individual's values lie. Saturn in this house focuses a definite

need to re-evaluate attitudes and find a more stable basis from which to operate in the world of appearance. Too much materialism and possessiveness where "me" and "mine" are concerned.

SATURN IN THE THIRD HOUSE

Serious and penetrating type of mind. Capable of deep concentration. Keen sense of justice. Early life apt to be unhappy. One apart from his relatives and feels no sense of kinship with them. Tendency to despondency and depression needs overcoming. Education interrupted, but individual is an "eternal student." Will go on seeking knowledge the whole life. Apt to cling to the known and familiar due to unrecognized fear of new situations. Loneliness of growing up years apt to be an undertone that needs understanding in later years. Otherwise the person holds back from full participation in any situation or with others through fear of disappointment and disillusion. Lungs not strong and this position of Saturn says "Don't smoke."

SATURN IN THE FOURTH HOUSE

In the third house the negative side of Saturn operates in the early life, (years from 7 to 18). In the fourth house Saturn operates in the latter part of life when its negative aspects are much harder to take. In the roots of the being is a selfishness that must be broken up or the dues will be collected in the latter part of life. This can be avoided if the individual will put capital in his spiritual bank book from which he can draw. He must give himself away and give up a basic selfishness that lies hidden in the depths of his being. Can be gain through real estate and land. Possibility of trouble with indigestion due to emotions. The ulcer type. Pride strongly centered in family and ancestry. Often strong mother complex and a tendency to cling to the past. Needs to get away from home in order to get over psychological bias. Appears independent but fears to leave home. Will be happier away from place of birth.

SATURN IN THE FIFTH HOUSE

Here the self expression and creative ability are apt to be inhibited. Lessons to learn where lovingness is concerned for individual is apt to be cold and inhibited. Difficulties with children due to lack of understanding where their needs are concerned. Often children are denied. Not wise to adopt children with this placement of Saturn. More sorrow than joy would come through them. Psychological block where sex is concerned. Pride and drive for power, though unrecognized, can be detrimental to best interests. Teaching or working with young people would be a constructive use of a fifth house Saturn. Look for the good aspects and the houses from which they operate to show where this position of Saturn could be used constructively. Circulation needs attention, and the heart needs to be kept in good condition. Constrictive emotions can cause constriction in the physical body. Learn to forget the self and care about others.

SATURN IN THE SIXTH HOUSE

Have to work for what is received Difficulties with employees and in working conditions due to a separateness and a demandingness. Hard worker but shouldn't expect everyone else to have the same attitude about the job. Person's nerves and heart can suffer if he is too demanding of himself as well as others. The power to assimilate experience needs to be cultivated for the tendency to worry and fret can cause health problems. Can be a nagging person and be irritated far to easily. Makes for cautiousness and practicality. Work isn't as important as attitude toward it.

SATURN IN THE SEVENTH HOUSE

A separative tendency deep within makes it difficult for this person to relate to others. This is the signature of someone who withdrew from contact with others in a past lifetime. In this life he must come to grips with the world outside and learn how to handle it. Must learn to cooperate with others. Early marriage brings difficulties because of lack of maturity. Marries for security rather than love. Extremely sensitive but hides it from the world. Often marriage is delayed and it can be to an older person. Really wants a mother not a mate. Needs to learn to cooperate and to develop empathy so he will understand the other fellow's feeling. Not good for partnerships in business if Saturn is afflicted. Lone-wolf type who does better alone but he doesn't learn as much.

SATURN IN THE EIGHTH HOUSE

Regeneration of nature where ego and pride are concerned. Strong sensuality needs restraining. Lesson to learn where sex attitudes and appetites are concerned. Expression of sex shows in the fifth house but the attitude toward sex is an eighth house matter. Blockage is psychological. Too much or too little is out of balance. Person has a long life due to Saturn's staying power Can be psychic but if Saturn is afflicted, especially to Neptune or Mars, it would be well to leave the psychic field alone. Partner's money is tied with this house and partner's attitude toward money can cause distress if Saturn is afflicted. Financial difficulties in partnerships, whether business or marital.

SATURN IN THE NINTH HOUSE

Saturn's best positions by house are the third and ninth house; the third house steadies the conscious mind and the ninth house stabilizes the superconscious faculties. Early in life it will make the individual dogmatic and crystallized in his philosophy. Later in life the wisdom side of Saturn will make itself felt. Gives a practical philosophy of life. Crystallizes if Saturn is in a fixed sign. Not good for relationships with in-laws if afflicted. Best to live a distance apart. Makes good teachers, professors, workers in publishing fields or scientific pursuits. Good at detailed work. Exacting and concentrative. Can be fanatical and intolerant in religious concerns if Saturn is afflicted.

SATURN IN THE TENTH HOUSE

Saturn's own house. Good position if person doesn't build a super-ego into his personality. Pride is the great danger here. Called the Napoleonic complex. A rise to the top followed by a fall. This is only true when the person hasn't learned humility and built his foundation on secure ground. Can be social climber, and make money and prestige more important than service. Not an easy incarnation for it is a testing one. Power will be the test. Self-reliance and ambition strong. Good business ability. Apt to have trouble through dominant parent. Often lack of father image in life.

SATURN IN THE ELEVENTH HOUSE

Hard to obtain goals and objectives but they can be attained if the person will be patient and willing to work. Have to earn everything with this position of Saturn. If it is done the rewards are great, and life gets better as it advances. Many acquaintances, but few intimates. An unrecognized fear of the demands made due to friendship. Attracted to older people. The type of friends sought will be of great importance for if they be the wrong type great difficulties come to the one who has Saturn in this house. Saturn delays but does not deny objectives.

SATURN IN THE TWELFTH HOUSE

Always a subconscious wish to retreat. Craving for solitude. Fear on the unconscious levels causes difficulties for person is always being threatened (he thinks) but it actually stems from his own fears. Great sensitivity. A deep seated selfishness has to be dissolved through suffering. An underground egocentric attitude needs dissolving and Neptune, ruler of the 12th house, is the dissolver. Serve or suffer is the keynote here and the individual can choose which way he will take; but choose he must.

SATURN — ANGEL OF DISCIPLINE

In the deep darkness of grief and pain,
I found the angel of Light again.
She wore no lovely garment of white
But was garbed in robes as deep as night.
I saw in her arms no flower fair,
Instead, a crucifix nestled there.
She didn't walk with joyous tread
Or offer me relief from dread.
But I felt her peace and her quiet power
And knew in that night of awe filled hour
She was the angel of Eternal Dawn.
Lifting her hood I saw her face
And knew the glory that hid her grace.
From earth blinded eyes too dim to see
That only through her, could we ever go free!

Isabel M. Hickey

CHAPTER 19
Uranus in the Signs and Houses

According to the Greek myth Saturn robbed his father, Uranus, of the dominion of the world. Uranus was given the rulership of the heavens. Behind the Sun that is the ruler of our system is another Sun which is the real power behind our Sun. There is no power in the chart stronger than Uranus. It is the symbol of the Super Will when it is operating in its most constructive sense. The keyword of Uranus is "Behold I maketh all things new." The American Indians spoke of the Sun being a hole in the sky and said the real Sun was behind the hole. They were talking of Uranus. It is the one planet in the chart that you can do nothing about. It always operates through another person or through circumstances over which you have no control. What is in your power is how you will react. You have the ability to react rightly or wrongly.

No one can tell exactly how Uranus will act in your chart where progressions or transits are concerned. It is unexpected, sudden and unpredictable in its action. If it conjuncts or opposes a strong planet in your chart by transit there will be a change in direction, an unexpected turn in the life that will change circumstances for you. Uranus never leaves you where it found you. It never takes anything from you without giving you something better in its place. It frees you from the ruts in which you may be comfortably ensconced in order to bring new growth, new expansion and new experiences. Uranus has a seven year cycle and if it is in an angle, especially the first house, your life will run in seven year cycles. The 41st and 42nd year are important for Uranus has made its opposition point to the place it was at birth. The cycle of Uranus in its travel around the Sun is 84 years. So one gets a conjunction or opposition once in a lifetime to whatever planet it contacts.

If you would know whether Uranus is the ruler of Aquarius, or if it is Saturn, note the positions of Uranus and Saturn in the birthchart. If Saturn is stronger, by being angular or powerfully configurated with the Sun or Moon, then the individual will be much more like Capricorn than like the new age Aquarian. If Uranus is angular, even in the charts of those not born in Aquarius, you have the new age ego who will not be bound by tradition, or the past. Saturn is the lawmaker. Uranus is the lawbreaker in the sense of not conforming merely because he is expected to do so. The new age ego marches to a different drumbeat than those who cling to the past. Their only authority will be within and not in the outer world of appearance. It will be the spirit and not the form that will be of importance. Whenever you find Uranus in angular houses, especially the first and the tenth, then you will know this is an indi-

vidualist who will march to his own music and not that of any other person's making. We are on the edge of the age of Aquarius. A new keynote is being centered on the planet and this helps to explain why the people all over the planet are in revolt against the "status quo."

Always there is a going to extreme when there is a breaking up of the crystallized and old patterns. Later there will come a leveling off. The Piscean age of limitation and restriction is dying and a new age is being born. Birth is always painful, but out of pain and suffering will come a rebirth for the planet.

Uranus in the sign is not as important as the house it is in, and the aspects it makes. This is due to the fact that everyone born in a seven year period will have Uranus in the same sign. Uranus rules the changes that come to the planet as a whole and shows the trends in civilization as well as the nature of the individual.

Uranus in Aries ushered in a new world in 1928. The egos born into this planet since then have been of a different nature than those born before that year. Due to certain Cosmic initiations, changes began that were to change the scheme of things as they were. We were to be stepped up in consciousness and a new world was to be born. In 1968 the opposition point to Aries brought crisis after crisis and the end is not yet in sight. All the established values are being tested. Humanity is on the march toward freedom but not knowing what real freedom is, there is chaos and confusion. Until we will the Will of our Higher Will, there will be no peace on earth or any ending to the confusion. Until there is true brotherhood on earth there will be no ending to wars. Do not expect it. The geographical disturbances, the tornados, the hurricanes and the earthquakes that so many are prophesying are the result of man's misuse of God-given energy. The atomic testings are disturbing the atmosphere and the price we will pay will be great. Only those whose magnetic fields are free of tension can come safely through the times of crisis. The lack of discord in the magnetic field of the individual is the greatest protection one can have. We cannot escape influences but we can choose what influences us.

URANUS IN ARIES

Note the positions of Uranus and Mars, and the aspects between them, to know how this position of Uranus will operate. If the two planets are in harmony this can be the individual who has genius, healing power and the ability to project new ideas and make them work. It is the pioneering spirit backed by enough energy and individualism to bring new concepts and new ideas to the earth. Action is quick and impulsive. If Mars is afflicted to Uranus there is difficulty due to rebelliousness, erraticness, impulsiveness and foolhardiness. The individual is accident prone. His rashness can take him out of the body very suddenly if he doesn't learn to control his temper and his impulsiveness. Inventive ability is strong. Tendency to headaches caused by inability to relax the nervous system. If Uranus is angular the person is highly geared and temperamental.

URANUS IN TAURUS (Fall)

Here Uranus is operating through Venus' field. Emphasis is on feeling rather than action. Taurus deals with the world of matter, and Uranus isn't interested in material matters. It belongs to the intuitive and higher realms of thought. It is in the sign of its fall in Taurus. When Uranus went into Taurus the U.S. went off the gold standard. The banks were closed. The depression set in and the values inherent in materialism were challenged as never before in the country's history. With Uranus in Taurus note its relation to Venus in the chart. If the two planets are afflicted there will be upsets and separations where love affairs are concerned. Unconventional attitudes can bring grief where marriage is concerned. Unexpected upsets could cause upheavals, especially when there would be a Uranus transit to the natal Venus. If Venus and Uranus are harmoniously configurated in the birthchart there would be charm, magnetism and the promise of a union that would bring great happiness to the individual. Creativity of an artistic nature would be strong.

URANUS IN GEMINI

Though this position makes a nervous restless temperament, it is a good place for Uranus. The emphasis is on the mind and as Uranus is the higher octave of Mercury it steps up the ability of the mind to grasp new concepts and ideas quickly. Person is successful in any occupation that deals with ideas, teaching, writing and in the communication fields such as radio and television. Trouble with relatives if Mercury is afflicted to Uranus. Very restless type of individual and likes to move around. Education is very important and should not be bypassed with Uranus in this sign. When Uranus went into Gemini the whole emphasis on education was altered in our country. Through the G.I. bill thousands of people were enabled to go to college. There was a time when a high school education was enough but when Uranus went into Gemini the emphasis on higher education caused the requirements to be raised. Today a college education is necessary and demanded in positions of importance in the world. Note aspects between Mercury and Uranus in the birthchart.

URANUS IN CANCER

Uranus operates in the field of the Moon in this sign. Emotions stemming from the subconscious need attention. Erratic and irrational feelings especially if Uranus is configurated with the Moon. If Uranus is afflicted, difficulties in the home in the early years will have an effect on the person's emotional life in later years. Insecurity will cause emotional upheavals that will have no logical explanation. During the time Uranus was in Cancer books dealing with the subconscious began to appear. The irrational world of feeling began to be explored. Cancer rules homes and new concepts, gadgets and ideas dealing with home making began to operate. Ranch houses and split level dwellings began to dot the landscape. Basements (fourth house influence) became playrooms. The old fashioned mother who stayed in the home and reared her children disappeared. She wanted to be an individual in her own right.

URANUS IN LEO (Detriment)

Here the rebels have been born. Strong will and determination are the labels of these souls. Compounded will that will brook no interference. Spirited and highminded if Uranus is well aspected. If afflicted, misuse of the will is going to cause difficulties until the will is made subservient to the Will of the Higher Self. Can be extremely destructive if not disciplined in childhood. Tremendous vitality and forcefulness. Similar to Uranus conjunct the Sun. Leo rules gold and Uranus in Leo has disturbed the gold standard and the end is not yet in sight. Leo rules governments and dictators. Uranus always upsets the status quo. Dictators came and went in these seven years. Dictators always do for tyranny has the seeds of its own destruction within it. New nations were born and have been going through the birth pangs inherent in any birth into freedom.

URANUS IN VIRGO

From the seven years that Uranus has been in Virgo will come our new age scientists, inventors, advanced medical researchers and our new educators. Ability to analyze and to discriminate will be strong in them. Interest in natural foods and natural means of building a strong body is already manifesting. Back to the soil for organic foods will be the demand of the young people. Interest in natural means of maintaining health will be strong in those born with Uranus in Virgo. The power of the mind in regard to healing the body will be promulgated. An upsetting of the status quo in order to have a different set of values has been part of the transit of Uranus in Virgo. Virgo represents the "little people" and all over the planet they have demanded that their rights as individuals be recognized. This will not abate for Uranus is the planet of evolution as well as the planet of revolution. He will work constructively or destructively according to how the energy is used; but, like a juggernaut, he cannot be stopped. The civil rights movement is part of the effect of the Uranian change that began with Uranus in Virgo.

URANUS IN LIBRA

Uranus was in Libra from 1885 to 1891, and the planet was reborn into a new era when it entered Aries in 1928. The years when Uranus is in Libra (1968–1975) are very important for the world. The symbolic meaning of Libra is "High winds and linestorms followed by calm." Always the wreckers must prepare the way for the builders. Libra rules law and justice. Legislation will change the status quo. The Piscean age leaders will be part of the past having no say in the future. Youth will be controlling legislature where government is concerned. New forms of art will emerge as the convention smashing art subsides. The planetary subconscious is in upheaval throwing up the tensions that have been underground so long. Chaotic music, crashing colors, psychedelic art forms are breaking up crystallizations but are not here to stay. When they have accomplished their purpose they will depart. Those born with Uranus in Libra will bring in the new forms of harmony and beauty. They will

be freer flowing than the generation of today. Uranus is the esoteric ruler of Libra. The person who has Uranus in Libra wants harmony and beauty around them and will work towards attaining them. Many upsets in relationships and marriage due to the fact that these souls are individualists that want freedom. Unless it is given the relationship will be broken. Attitudes toward marriage will not be conventional for the spirit of the union will be more important than the form. Legalities will not be as important as love. If Uranus in Libra is afflicted, the kidneys in the physical body will neeed attention. Kidneys act as purifiers of the toxins that can accumulate in the body; relationships act as purifiers where the psychological body is concerned.

URANUS IN SCORPIO (Exalted) Brent

A powerful position for Uranus. Tremendous will and persistence that will find an outlet, whether it be constructive or destructive. Makes a fine healer, psychologist or surgeon for they have the ability to probe deeply into the cause of distress. If Uranus is afflicted, jealousy, envy and possessiveness has to be overcome. Can be a devil or a saint and are capable of the highest or the lowest where morals are concerned. Self will or God's will; the choice would have to be made in this sign. The necessity for transformation and regeneration is a "must" when Uranus is in this sign. There can be no freedom without it. Passion must become compassion; resentment must be displaced by understanding.

URANUS IN SAGITTARIUS

When Jupiter and Uranus join as they do in this combination of forces, intuition and judgment go hand in hand. An inner optimism stems from this combination. There will be a desire to expand the horizons, whether inwardly through knowledge of the higher planes or outwardly through travel. Advanced views on religion. Do not want to feel bound by orthodoxy or dogma but have a strong religious faith that is part of the inner life. Sagittarius rules the thighs and hips in the physical body and difficulties with the sciatic nerves that go down the legs will give trouble if Uranus is afflicted in this sign. Osteopathy will do far more good than medicine if there is this difficulty. The lower back region can give difficulty.

URANUS IN CARPRICORN

Uranus in Sagittarius is philosophical and Uranus in Capricorn is practical in an earthy sense. It is ambitious, political in its approach and worldly prestige is very important. Uranus is the planet of change and Capricorn hates change. So there is conflict. Capricorn is delegated authority. One side of the nature resents not being free. The other side is conventional, traditional and stuffy and wants to stick to the status quo. One side clings to the past while part of the individual is trying to go forward into the future. The health is affected if the person doesn't resolve

the conflict by deciding whether he is going to be a Saturnian or Uranian. He can not have it both ways. The physical body is the terminal point of mental and emotional disturbance and with Uranus in this sign difficulties are apt to be in the stomach and digestive system. The inability to digest experience where the psychological equipment is concerned manifests as ulcers and digestive problems in the physical body.

URANUS IN AQUARIUS (Ruler)

Here is the intellectual, scientific type of consciousness. Unless there are planets in water signs this position can make the person too detached and impersonal. Needs to learn compassion and understanding of the emotionally oriented individual. A strongly inventive type of individual who prefers to work alone or behind the scenes. An independent strong willed nature that cannot be pushed but can be reached through logic and reason. Circulation in the body apt to become sluggish if the person doesn't exercise his body sufficiently.

URANUS IN PISCES

This position breaks up the old habit patterns and brings intuitive wisdom and understanding. Very psychic type. Interested in helping and serving humanity. Is not the business type who wants money and power. Suffers from oversensitivity. Nervous system apt to be strained from overwork. Needs to learn to relax physically and emotionally, if they want to be healthy. Need for the B vitamins very important. An inner longing to be free of earth and its complexities that is only assuaged when the personality becomes the servant of the soul. When this position of Uranus is heavily afflicted the person seeks to escape through alcohol, drugs or sex.

URANUS IN THE HOUSES

URANUS IN THE FIRST HOUSE

Individuality very strong. Must follow his own intuitive sense, whether it be for good or ill. Very original theories and methods of working. Erratic and sudden impulses not always understood, not only by others but by himself. Must surrender the willfulness inherent in this position of Uranus. Unrest and isolation will always be felt until the will becomes willingness. Has his own code of ethics for the spirit is important not the form. Not a conformist and apt to be too direct and blunt in opinions. A wayshower and a leader, not a follower.

URANUS IN THE SECOND HOUSE

Sudden and unforseen circumstances where finances and income are concerned. Ups and downs in money conditions. Not a fixed income. Great desire for independence so do well in their own business. Not good for speculation if afflicted. Inventive where business ideas are concerned. Original methods of making money.

URANUS IN THE THIRD HOUSE *Jerry*

Must learn to accept environment in early years. Willfulness and rebelliousness can cause difficulties. Upsets in home life in growing up years can cause suffering especially if Uranus is afflicted. Good position for the scientist, chemist and those interested in research. Great mental restlessness. Sudden and unexpected urges to travel keep this individual on the move. Upsets where brothers and sisters are concerned. Apt to feel like an alien in his home environment. Keen and alert mind but lacking in concentration. Has to be willing to give up self will.

URANUS IN THE FOURTH HOUSE *1993*

Upsetting domestic conditions unless Uranus is well aspected. Not a domestic type and doesn't want a fixed and settled home life unless Uranus is in a fixed sign. Restlessness in the roots of being can cause unstable conditions in the life. Crystallization is broken by sudden and unexpected changes. Many changes of position and location. Interest in astrology and metaphysics in later years. Unsettled conditions around mother effect this individual emotionally.

URANUS IN THE FIFTH HOUSE *Brent*

Self-restraint and self-knowledge needed as person can be reckless and foolhardy. Too strong an assertion of individualism if Uranus is afflicted. Children are original, independent and unusual. If the child's energies are channeled rightly in early years all will be well. If children are not disciplined, parents will suffer through their children's destructive actions. Creative and inventive type of individual. Unconventional where love affairs are concerned. Wants to feel free no matter what the cost. Wants to work for himself rather than for others.

URANUS IN THE SIXTH HOUSE *Brian*

Good worker but needs a job that enables him to move around. Routine is not for him. Ingenious and original in nature. Highly nervous so prolonged job is unbearable. Either drives himself mercilessly far beyond his physical strength or fights his job all the way. Has to learn the hard way to be obedient and do as he is told. Chronic illness can play havoc if the ability to control irritation and impatience is not gained. Apt to be hasty and impatient with others. If he is an employer many upsets where employees are concerned due to his own bruskness and lack of empathy.

URANUS IN THE SEVENTH HOUSE

Difficulties in marriage. Too independent. Divorce or separation, sometimes by sudden death if Uranus is afflicted in this house. Apt to attract a partner who wants to feel free and be a law unto themselves. Partnerships in business as well as marriage or unions will demand a great deal of discipline. The kind of a partner we attract denotes karmic conditions either good or ill. If Uranus is afflicted to Venus or Mars marriage is difficult and ends in separation. Can be a very unusual marriage if both parties are evolved.

URANUS IN THE EIGHTH HOUSE

Very strong psychic feeling as well as keen intuition. Unexpected and sudden upsets where deaths are concerned. If Uranus is afflicted to Mars, individual can meet his death through accidents or violence unless he eliminates discord from his magnetic field. Must be careful where business partnerships are concerned. Should not go into partnerships without due forethought. Difficulties with inheritances but a well aspected Uranus in this house could mean an unexpected windfall. Sexual impulses need controlling if Uranus is afflicted. When death comes it is apt to be sudden and unexpected. This does not show the time death would occur. When heavy planets would be afflicted to the natal Uranus the individual should use caution where cars and machinery are concerned. Bad temper would cause accidents. Don't drive when angry is excellent advice to anyone with an afflicted Uranus in this house.

URANUS IN THE NINTH HOUSE

Success in publishing, teaching, or in foreign affairs. Gives unusual journeys, either on material plane or unusual experiences where the superconscious planes are concerned. Not orthodox in religious views. Difficulties with in-laws if Uranus is afflicted. Apt to marry someone from another country.

URANUS IN THE TENTH HOUSE

Not a conformer. Needs to be own boss due to strong individualistic pattern. Altruistic and humanitarian in outlook. Strong imagination and originality. Rather peculiar concepts at times but cannot be argued out of them. The indirect approach is better with this individual. Gives an interest in astrology and occult subjects. If configurated with the Sun, the person would be a good astrologer.

URANUS IN THE ELEVENTH HOUSE

Unpredictable changes where goals and objectives are concerned. Person will change his mind a number of times before he settles into his life work. Two types of friends; the conventional Saturnians and the bohemian Uranians and never the twain do meet. Feelings of sympathy and antipathy very strong and changeable. Uranus afflicted in this house can cause trouble because of association with the wrong types of people.

URANUS IN THE TWELFTH HOUSE

Tremendous desire to feel free but often feels cribbed, cabined and confined. Self-control a necessity for person is his own worst enemy. In dealing with people and situations this person must use persuasion and not force. Good position for researchers or those who work behind the scenes. Person apt to be a loner. If Uranus is afflicted, investigation into psychic or occult worlds could bring trouble, especially where the nerves are concerned. With Uranus in this house the need is to accept life as it is and not set up subconscious resistances.

CHAPTER 20
Neptune in the Signs and Houses

Neptune's keynote is Sacrifice — the obligation to give one's self away. In whatever area of the chart it is placed, sacrifice of self-interest is necessary. This area is where you have taken from others in the past. Now the balance must be restored through giving, not receiving. Willingness is the higher keyword for Neptune. Willfullness (Uranus gone astray) is the opposite to willingness, deriving its energy from satisfying its personal needs, rather than helping to fulfill the needs of others. Neptune's inner nature is freedom and joy. Will, inturned, spends itself in serving self. Willingness is the eager desire to see others attain joy and freedom. The Piscean Master said: "I came that your joy may be full." Joy comes in self-relinquishment and not in self-preservation.

Neptune works by persuasion, never pressure. It is called the Cosmic Santa Claus. There is a secret hidden in sacrifice. The more you give yourself away the more you have to give. "Seek ye **first** the kingdom of heaven and **all** else shall be added unto you" is as true today as it was 2,000 years ago. The cosmic laws never change.

Neptune belongs to another dimension (the psychic worlds) and is not at home in the world of matter. It is not interested in worldly success. It is psychic, mystical, dreamy, sensitive, emotional and receptive in nature. It works subtly and unseen. On the negative side it works undercover, like the termites who invade wood and cause disintegration, or the cancer cells that eat away at the physical structure, unknown and unrecognized, until considerable damage is done.

Fog and mist are related to Neptune for they screen the landscape and one does not see clearly. Neptune rules the ocean and the Moon rules tides. The symbol of Neptune — ♆ — shows its tieup with the Moon. The cross piercing the Moon is symbolic of the emotional suffering that has to be undergone to set the personal self free, making it a reflector of the Solar Self. Neptune is the higher octave of Venus. Venus is personal affection: "I love you because you love me." Neptune is divine compassion: "I love because it is the nature of Love to love."

As the ocean eats away the land as it laps the shores, so our negative emotions eat at the physical body and break it down. The cosmic laws are reflected in nature if we have insight to perceive them. Water, (emotions) Air, (mind) Earth, (physical substance) and Fire, (energy or spirit) are necessary for the expression of life. When they are unbalanced they create havoc instead of harmony. What we feel as well as what we think affects the body for good or ill.

In the unevolved horoscope Neptune spells chaos and confusion. Person feels as though he were doing a lifetime at hard labor in a prison house of skin. Doesn't recognize that it's resistance to life that causes suffering. To the awakened soul Neptune is the Liberator from all that cribs, cabins and confines. Its secret power is in non-resistance; letting go and letting things happen. An effective mantram for an afflicted Neptune is the following: "Life is flowingness and in its flowing there is meaning and law. I can not lose what is my own. I need not seek what is my own for what belongs to me shall come. If anything goes, it is because it does not belong to me. What I am alone has power. If I give up the personal struggle and ambition, all that is rightfully mine will be drawn to me. I let go and let God run my life."

Neptune's orbit around the Sun takes 165 years; therefore, it is in a sign for 14 years. Its sign in the birthchart is not as important as the house in which it is placed. As it goes through the signs it works more as trends of consciousness in the collective unconscious.

NEPTUNE IN THE SIGNS

NEPTUNE IN GEMINI 1887-1901

These were the egos who had strong ties with relatives. Many of them were to lose relatives in the first World War. New ideas for commerce and concerning trade were born. Gives mental sensitivity. Often education has to be sacrificed for the sake of the family. Great restlessness and desire for change. Neptune will not return to Gemini until the year 2168.

NEPTUNE IN CANCER 1901-1915 (Exalted)

The last peace the world was to know until the year 2000 took place in these years. Neptune is exalted in Cancer. The emotionally oriented feelings of Cancer are lifted into true compassion and the willingness to give up the self for others. This position gives a strongly psychic and emotional nature if Neptune is strong at birth. If it is related to Sun, Moon or Mercury in the angles at birth, it is an important influence. If afflicted it would give upsetting conditions in the home and karmic lessons to learn through the mother.

NEPTUNE IN LEO 1915-1929

Brought upsets in governments; the dictators of future years had their beginnings with Neptune in Leo. Strong-willed egos who had to dissolve the will through passion or suffering were born. If afflicted, love affairs would cause suffering, for love would demand more sacrifice than the person would be willing to give. Trouble through children for they would be a reflection of the self as it had been in a past life.

NEPTUNE IN VIRGO 1929-1943 (Detriment)

In these years labor unions were born and the common people began to have some power. New concepts concerning health and diet were promulgated. Psychosomatic medicine was born showing the relationship between negative emotions and disease. Tension strong between feelings and reason. Many of the egos born with Neptune in Virgo have become neurotic and fogged up because of an inability to face responsibility and reality. Psychiatry has flourished due to the nervous tensions generated when the mind is choked by emotion. Those who have Neptune well aspected in this sign have become humanitarians and servers and work to reduce tensions in human relationships. Neptune in Virgo says "serve or suffer." Forget yourself if you would know the peace that goes beyond understanding. The tendency to criticism is strong when Neptune is in Virgo. This must be dissolved through lovingness or suffering. These egos were the first ones to begin the revolt against the establishment.

NEPTUNE IN LIBRA 1943-1957

The dissolving of harmony and peace between nations is indicative of Neptune in Libra. Strangely enough Libra (relationships) brings more war and trouble than peace. Alliances built on expediency and diplomacy, nationally and internationally, are still bringing the harvest of discord. Uranus (will) is the esoteric ruler of Libra and Saturn (discipline) is exalted in Libra. Until the lessons of love are learned collectively and recognition of the rights of every man are respected, there will be no end to war and no peace on earth. Neptune in Libra gives karmic lessons in unions and marriages if afflicted in the birth chart. Need to compromise and to sacrifice necessary. Divorce will not change the picture for there must be an inner change of consciousness before outer circumstances can change. Change of attitude will bring changes in the outer world. Artistic tendencies strong and new forms of art will come from those born in this cycle.

NEPTUNE IN SCORPIO 1957-1970

This is the era of escapism. Some try to escape through alcohol, sex or drugs. Others do escape the pressure of the world through meditation and an inner connection with their real self. Medicine has taken enormous strides. Many of the souls born into bodies in these 14 years will pay past karmic debts through their parents' use of drugs. Scorpio rules generation, regeneration or degeneration. Neptune in this sign sounds a warning to choose the higher way for it's either-or where transformation or degeneration is concerned. Many deaths through violence. A strong interest in outer space is reflected on the inner side by interest in the inner worlds and after death states. The interest in the ancient mysteries will be greatly increased because of the chaos and confusion in the world. Many psychics and sensitives are born with this configuration. If afflicted, they have been involved with the misuse

of magic in past lifetimes. The opening of their psychic centers will cause obsessions if they do not go through the discipline of purification first. Neptune afflicted in Scorpio will make the individual unreliable, irresponsible and unstable. Peculiar sex experiences if afflicted to Mars or Venus.

NEPTUNE IN SAGITTARIUS 1971-1985 *Brent*

This position combines the forces of Neptune and Jupiter. This will bring into incarnation very different types of souls than have been born with Neptune in Scorpio. There will be more recognition of the higher realms. It will give the psychic sensitivity that will give the ability to pierce the veils of matter and know Truth. Educational concepts will undergo revolutionary changes. Orthodox creeds and dogmas will have to change because of the incoming Light. There will be far distant travel at rates of speed unknown to us previously. Difficulties for the United States are shown as Neptune in Sagittarius opposes the Gemini planets in the U.S. chart. The karma of unleashing atomic energy to destroy has to be faced and cleared. Space is curved. There is no such thing as a straight line in the universe. Everything, by cosmic law, must return it its source. In affliction Neptune in Sagittarius will lack judgment and give a strongly emotional nature that will be indecisive and unsure. The intuitive nature will be highly developed. Upheavals, geographically as well as in the economy, will have a positive side for it will bring a much deeper understanding of the meaning of life. It is these egos who will usher in the next century and rebuild the world.

NEPTUNE IN CAPRICORN 1985-2000 (Fall)

This will bring us to the end of this century. These years will not be easy for it will mean the purification of selfness and selfishness. After great stress and strain a World government will be formed. Only those who have found their inner center will be enabled to survive these years. The ccmbination of Saturn and Neptune will bring socialistic forms of government into operation. The ocean will be tapped for minerals and for new types of food for there will be famine in many areas of the world. Earthquakes will change the contours of the planet. Into incarnation will come many advanced souls as statesmen, educators and spiritual guides. They will be wayshowers to bring a planetary rebirth into being as Neptune goes into Aquarius and the new century is born.

NEPTUNE IN THE HOUSES

NEPTUNE IN THE FIRST HOUSE

Psychic sensitivity very strong. Emotional disturbances react on the physical body, producing strange physical disorders difficult to diagnose and more difficult yet to overcome. Inner attitudes can do more to change conditions than any outer medicine. Vague approach to reality. Confusion and chaos in the life until the individual becomes spiritually oriented and

gives up the emphasis on the personal self. Gives a discontent with things as they are. Never satisfied until the person no longer reacts to life emotionally. Apt to be like a sponge absorbing the vibration of those around them.

NEPTUNE IN THE SECOND HOUSE

Do not look to matter for support. Neptune dissolves matter and material things will dissolve, if Neptune is afflicted in this house. Involved finances. Assets completely washed out unless there is absolute honesty. Don't go overboard by buying on the installment plan. Self deception or deception through others if Neptune is afflicted. Poor judgment where finances are concerned. Obligate yourself to use it for others and you will find it will come back. Neptune is the Cosmic Santa Claus.

NEPTUNE IN THE THIRD HOUSE

Artistic and imaginative type of mind but it does fog the clarity of thinking and the ability to concentrate. Not good student for this reason. Dreams their way through school unless there is a powerful Mercury-Uranus aspect. Woolgathering type of mind. Apt to be karmic lessons through relatives, brothers and sisters. Some hurts or disappointments where early environment is concerned. Insecure feelings in early life give nervous conditions that have to be dissipated by understanding.

NEPTUNE IN THE FOURTH HOUSE

Domestic life will involve the element of self sacrifice. Unsettled home conditions. Often a skeleton in the family closet. Can be an alcoholic in the family that will be the source of unhappiness. Latter part of life can bring withdrawal from activity and an aloneness, self chosen.

NEPTUNE IN THE FIFTH HOUSE

Secret love affairs or lack of freedom of emotional expression because of former ties. Often in love with someone who isn't free. Great sacrifices made for children but receive little in return. This is a karmic condition from past lives and, if understood, can be accepted without bitterness or resentment. The fifth house is the house of esoteric karma. It is the house that shows the use of your will, good or ill, in past lives. Desire is the tie that binds us from lifetime to lifetime. Desire and will are twins. Ties with children apt to dissolve as they become adults. Neptune in this house, if afflicted, demands too much and gives little. Makes a good actor for they dramatize life and can play many roles. Imagination powerful and often it can run off with common sense.

NEPTUNE IN THE SIXTH HOUSE

Tendency to inertia caused by lack of vital force, especially if Mars is not strong. Tendency to "leaky" aura. Neptune has no direct influence on the physical plane but works through the psychic or emotional levels,

It is hard to diagnose illness when Neptune is in the sixth house. More open to psychic infections than they know. Over suggestibility to negative feelings of those around them. Supersensitivity. Difficulties in working relationships because of this sensitivity. Apt to feel too much is demanded of them. Drugs of any kind harmful with this position of Neptune. Natural methods of healing and positive thoughts will aid more than traditional medicine.

NEPTUNE IN THE SEVENTH HOUSE

Always brings dreams, subconscious or otherwise, of finding a true mate. Gives a constant yearning for perfection. Often is in love with someone who isn't free and makes great sacrifices where reputation or fulfillment is concerned. Out of the ordinary type of marriage; usually to someone on a different wave length. Needs to give a great deal and expect nothing in return. Have taken instead of given in other lifetimes. Now the spiritual bookkeeping must be balanced. Sacrifice is the keynote.

NEPTUNE IN THE EIGHTH HOUSE

Not much gain through partnership, whether business or marriage relationships. Legacies can come but there will be trouble in getting them. Astral and out-of-the body experiences. Death cames in coma for person has already withdrawn his consciousness from the vehicle. Dreams important for this person can bring back knowledge gained while his body sleeps. Must give the self away in order to help others gain their resources.

NEPTUNE IN THE NINTH HOUSE

Mind is impressionable and easily influenced. Ninth house denotes the unexpressible, the motive behind the deed, the thought behind the speech; that which is possible to unfold in the future. All planets in this house have a higher vibration than when placed in any other area. Hard to make tangible the superconsciousness faculties with Neptune here. Makes the intangible extremely nebulous when it is already nebulous enough. Makes a person mystical and if well aspected can have spiritual visions. If afflicted the judgment is poor and the mentality clouded. Brings difficulties with in-laws due to lack of empathy.

NEPTUNE IN THE TENTH HOUSE

An unusual career. Must give more than will be received where career is concerned. Will never receive the satisfaction of credit given for work done. This is a karmic condition due to having taken the credit when it had not been earned in other lifetimes. Father not of much benefit to individual and often is alcoholic, or an evader of responsibility. This is a good position for those who serve people. Good for medical work, work in institutions or humanitarian work of any kind.

NEPTUNE IN THE ELEVENTH HOUSE

Unfavorable conditions in friendship. Can be too gullible. Very necessary to use discrimination in choice of friends for Neptune afflicted means either deception toward friends or from them. Needs to have definite aims and goals in order to achieve success in life. Apt to be a dreamer instead of a doer.

NEPTUNE IN THE TWELFTH HOUSE

Feeling of being cribbed, cabined and confined strong. Stress on the subconscious levels due to extreme sensitivity. With Neptune afflicted, this individual feels like an exile far from home on a foggy night and he can't see where he is going. Deep-seated loneliness that only connection with the Higher Self will abate. "Serve or suffer" is the keynote here. Excellent position for doctors, nurses, or those who work in hospitals or institutions.

* * * * * *

Neptune represents social responsibility. Reveals the pattern of social obligation showing how the individual will conform to group consciousness. Neptune subjects you to the group and shows where you must conform to the demands put on you by others. Uranus is the freedom guaranteed by the group. Neptune shows us the cosmic debts we must pay.

Ed. note: For discussion of Pluto in the signs, see pp. 293–299; for Pluto in the houses, see pp. 300–309.

CHAPTER 21
The Moon's Nodes

The Moon's nodes and their importance have not been stressed enough by the modern astrologers. The South Node always shows the way of least resistance; the habit patterns of other lives that should be outgrown or discarded. The North Node shows the way out; the path of integration through which there can be fulfillment.

The Moon's North Node is the point on the ecliptic where the planet passes from south latitude to north latitude; this is the Dragon's Head" or ascending Node. The symbol is ♌ . The South Node or "Dragon's Tail" is symbolized by ☋ . In the ephemeris only the North Node, the degree and sign it is in, is given. The South Node is always in the opposite sign and degree. Example: on July 5, 1968, the North Node was at 14' of Aries; the South Node would be 14' of Libra.

The Moon rules the subconscious, and the Nodes have a great influence where subconscious patterns are concerned. The South Node has to do with the subconscious motivations of the past. The North Node represents new conscious patterns to be unfolded. The ancients said the North Node was benefic and the South Node was malefic. Not necessarily so. When we cling to the past and refuse to go into the future or into the new and untried experiences we retard our growth and development. Crystallization is not evil. It is merely stupid. Lot's wife looked back and turned into a pillar of salt. This symbolizes what happens when we cling to the past. The North Node represents the new work to be done, the new faculty to be developed. The South Node is the line of least resistance and operates with ease because it has become a repetitive pattern. The North Node is the new channel to be made; the new challenge and the point of spiritual fulfillment.

NORTH NODE IN 1ST HOUSE — SOUTH NODE IN 7TH HOUSE

Person must develop his own initiative and his own personal power. Has relied too much on other people in the past and has been dependent or dominated by others. Now he must hew and carve out his own destiny. Through his own efforts and his own actions he will gain the confidence and self-reliance he needs.

SOUTH NODE IN 1ST HOUSE — NORTH NODE IN 7TH HOUSE

Needs to get away from himself. Has lived for and to himself until he has become too independent. Needs to take other people into account and get away from too much self-centeredness. Self-assertion has to be eliminated. Integration and fulfillment come through giving up the personal ego and helping others to attain a sense of their worth.

NORTH NODE IN 2ND HOUSE — SOUTH NODE IN 8TH HOUSE

Emphasis is on developing personal resources. Can attract money and needs to do so in order to develop "attracting" power. The ability to attract, (Venus) whether it is material or spiritual, is to be built in. Reliance on other people's resources or other people's money must go.

SOUTH NODE IN 2ND HOUSE — NORTH NODE IN 8TH HOUSE

Subconscious habit patterns of the past have been the "getting" principle rather than the "giving" one. Must help others to find their resources and their sense of worth. The play on the senses must give way to the transforming of passion into compassion. Before the seed can bring forth fruit it must be buried in darkness, break its self-enclosed shell and reach for the Light. Helping others to find their resources and values is the clue to the right use of the North Node in the eighth house.

NORTH NODE IN 3RD HOUSE — SOUTH NODE IN 9TH HOUSE

The integration lies in the developing of the mental powers. The ability to reason logically and the power to analyze the objective world realistically must be brought to bear on the environing conditions. The person has had blind faith and has been religious in the past but it has been in a non-thinking dogmatic fashion. He also has to learn to stick to routine and everyday matters and not think far away fields are greener. His pastures lie close at hand. His opportunities and challenges are in the environment close at hand. His subconscious motivations of the past will make him long for far distant places and a desire to escape from the near-at-hand pressures.

SOUTH NODE IN 3RD HOUSE — NORTH NODE IN 9TH HOUSE

Too much emphasis on mind and not enough emphasis on superconscious power. Faith and devotion to an ideal needed. Separative tendency strong for mind separates; heart unites. Faith is tied with feelings and with the heart. Inner philosophy along devotional lines needed to balance the intellectual faculties. Should travel, outwardly and inwardly, for expansion. Relatives are the source of difficulties and it would be well to be away from them if possible.

NORTH NODE IN 4TH HOUSE — SOUTH NODE IN 10TH HOUSE

The fourth house represents the midnight or deeply hidden depth of the personality. This is why it represents the soul powers; what we are in the depths is not what we always appear to be on the surface. In the depth of oneself (home) the inner powers must be released. Not for this one the acclaim of the public and the limelight. He has had it all in the past. He gained from it the sense of power that made him feel his importance as a person. Now he must grow a soul. Through his domestic surroundings, through a quiet withdrawal, and through the wise use of his emotions he will find fulfillment.

SOUTH NODE IN 4TH HOUSE — NORTH NODE IN 10TH HOUSE

This soul has had his soul powers developed. He has withdrawn and lived in a quiet reserved manner. Now he must come out into the public and

the limelight and give himself in some public way to the world. In a career he will find his fulfillment. If he tries to cling to home it will in some manner fall apart. Unconscious desire to retreat has to be overcome. Has to learn to be with people rather than retreat from them.

NORTH NODE IN 5TH HOUSE — SOUTH NODE IN 11TH HOUSE

Through self-expression (through the use of the individual's creative force, whether it be children of the body, mind or emotions) he will find fulfillment. Attention must be given to developing his own desires and will and not be led by others. In the past the attitude was "Let George do it." Now George won't do it and the person has to develop his own goals and objectives. Friends have helped in the past and thereby weakened the person instead of strengthening him. Dependence is a habit pattern buried deeply in the subconscious, but this time the will to stand on one's own strength and attain their own goals is the necessary ingredient for a successful life.

SOUTH NODE IN 5TH HOUSE — NORTH NODE IN 11TH HOUSE

There may be children in this lifetime but they will not be of much help or give much love to the individual. Energy expended in personal affections will not bring adequate satisfaction. Perhaps a treading of the primrose path, seeking pleasure and evading responsibility is a subconscious pattern of the past that is being redeemed in this lifetime. Friends will bring far more satisfaction and sustainment than family ties. Goals and objectives that deal with group endeavors or service of a universal nature will be successful as well as a means of spiritual integration.

NORTH NODE IN 6TH HOUSE — SOUTH NODE IN 12TH HOUSE

Integration only comes to this individual through service. Must come out of his shell and work. Has been isolated through self-undoing in the past. Either enforced seclusion or restrictions due to lack of compassion in the past has made it easy to retreat this time. Fulfillment comes to this individual through serving others and losing the sense of separateness. Humility, the last virtue to be attained, can be the keynote of this life if the individual is willing to serve others with no concern about the self. In order for any of us to become something we have to be willing to be nothing. This is the message of the sixth house.

SOUTH NODE IN 6TH HOUSE — NORTH NODE IN 12TH HOUSE

Has ability to clear payments due from past karma by self-initiated channels of service. Work with those limited and afflicted would be fulfilling and integrative. Hypochondriac tendencies of the past must be overcome. Subconscious tendency to identify with negative conditions needs eliminating through positive and uplifting emotions. In other lifetimes negativity brought on disharmony and disease in the physical body. In this life helping others achieve a new and happier outlook is the way for this person to find fulfillment and peace of mind.

ARIES:

North Node in this sign gives self-assertion and a progressive nature. Should develop independence and stand on their own convictions. Personality should be brought to full development. Before you can give yourself away you have to have a self to give. **South Node** in this sign means an over-assertion of self has been the problem in the past, and personality should become the servant of others in this lifetime.

TAURUS:

North Node here gives resourcefulness and the ability to be very practical in the approach to material world. Attracts possessions and those who want to be possessed. Must help others to be independent by refusing them the luxury of being dependent. Crutches if used too long, even psychological crutches, can keep the individual from developing strength. **South Node** in this sign means emphasis has been on material things in the past. Person has overemphasized their importance. In whatever house this node is placed there must be relinquishment of a possessive or materialistic attitude.

GEMINI:

North Node increases versatility, adaptability and mental agility. Benefits through relatives and friends because of an optimistic viewpoint toward life. This kind of attitude should be cultivated in this life. **South Node** in Gemini shows too much superficiality in past lives; to little willingness to stabilize and a flitting from one experience to another. If continued in this lifetime there will be little success or any sustaining power.

CANCER:

North Node gives domesticity and a mothering nature. Integration comes through furthering these qualities. Great sensitivity toward the suffering of others. Homekeeping would be an integrating force in the life. **South Node** emphasizes acquisitiveness and self-centeredness; a carry-over of selfishness that must be overcome by caring for others and developing the nuturing qualities.

LEO:

North Node in this sign gives executive ability and qualities of leadership. Needs to be independent to do a good job. Has nobility and pride. The virtue hidden in pride is self-respect. To this Leo has the right. If self-respect is lacking the individual would have the ability to cultivate it in this life. **South Node in Leo** is the indication that the person misused his power and developed far too much ego in the past. This time there must be concern for others instead of a concern for self-agrandizement.

VIRGO:

North Node in the sign of discrimination and purity shows these are the qualities that will lead to growth and progress in this life. The hidden "Christ within" must be expressed through service. **South Node in** Virgo shows the qualities of criticism and passing judgment must be left behind. They have been the cause of self-undoing in the past and are still hidden in the subconscious motivations and need clearing.

LIBRA:

North Node implies spiritual integration which comes from moving from self to others; from personality levels to the soul levels. Emphasis should be on loving others and getting away from self love. **South Node** shows there has been to much emphasis on leaning on others and letting them run the life. Now this person must make his own decisions whether they are right or wrong. Growth comes through one's own expression and experience.

SCORPIO:

North Node shows need to go the way of regeneration Spiritual integration comes through going from selfish interests to concern for others. Must let the Divine Will be done, not the personal will. Only through the way of the Higher Self will this person find peace. **South Node** implies that the downward path has been trodden in the past and this must be redeemed through overcoming resentment and not using force to compel. Lust and greed must become love and the giving spirit must overcome the grabbing tendency.

SAGITTARIUS:

North Node points the way to far horizons, physically and spiritually. Person gains through associations with others and pioneering in new lines of philosophical or educational endeavors. An inner positivity can be developed that will be of great help in overcoming any negative aspects in the birthchart. **South Node** gives poor judgment and adds to the restless and rash tendencies that keep individual from accomplishment. Has to learn to concentrate and focus forces and not go dashing off looking for other fields to conquer. Conquering, like charity, begins where the person is placed.

CAPRICORN:

North Node in this sign implies that business ability and ambition would be directed toward public good, or could be so directed. Integration would come through persistent sustaining effort to climb the heights of attainment and become a redeemer for others. **South Node** would show past habits of selfish ambition and a desire for power for self and to dominate over others. This tendency would have to be faced and overcome.

AQUARIUS:

North Node shows the path of spiritual progress is the pathway of service to the group, through an understanding of the unity of all life. Field of activity should be one that affects society and not an individual. Science, medicine, research and philosophical or educational fields would be the avenues that could be used magnificently. **South Node** shows the past habits have been to retreat from the world because of a snobbishness or distaste. Strong egocentric tendencies have to be overcome.

PISCES:

North Node here implies the complete relinquishment of the self in service to others. Passion would become dispassion without losing compassion. **South Node** would show past tendencies of escapism, coping out of responsibility and it would be easy to follow that pattern in this life for the tendency could be there unless the rest of the chart showed differently. Senses and sensuality have been strong in the past; now the higher senses must prevail.

CHAPTER 22
Aspects to the Sun

The sun represents the central power to do and to be; the purpose or will as it projects itself outward in its drive for significance. It vitalizes any planet it aspects.

In studying aspects it is extremely important to understand the essential nature of the planets rather than to read the aspects from a book. The same aspects will function in different ways in cardinal, fixed and mutable signs. Fixed aspects are very strong and are tied with will and desire. Aspects in Mutable signs have to do with the way we use our minds. Cardinal sign aspects have to do with initiative and how we inaugurate activities.

The central drive is shown in the chart by the Sun. It is tied to the ego drive on the personality level. Everyone needs and wants to feel important. The basic sense of selfhood and the individual's worth in the world is his by divine right and should be respected. It is when this drive is over-emphasized at someone else's expense, or frustrated and inhibited that difficulties arise. The Sun represents superiors and those in authority.

The Sun is the source of vitality coming into form. It rules prana, or life force. A person with a strong Sun has energy and vitality. If he has a poorly placed and afflicted Sun he does not have the vital force he needs, and needs to learn the laws of nutrition and to build up his vital forces. There is nothing in the pattern that says it cannot be done. An afflicted Sun does say that the individual has wasted his life force and needs to rebuild it through right understanding of cosmic laws.

The aspects between the Sun and Moon are very important. The Sun represents the Solar Ego, the Individuality. The Moon represents the personality and the subconscious self. The lunar forces rule the form side of life. The solar forces rule the vitality that flows into the magnetic field from the etheric field of energy. The Sun rules the constitutional strength; the Moon rules the functional strength. In judging health and longevity these two energies will be the key. When the Moon is afflicted and the Sun has no afflictions the body may be weak and troublesome but the vitality coming into the body will keep it going. When the Sun is afflicted and the Moon is not afflicted the person may appear healthy but has not the vital force to stay in the body unless he builds his vital forces.

The relationship of the Moon to the Sun shows the time of the month when the person was born. A conjunction of the Sun and Moon shows the New Moon. An opposition of the Sun and Moon occurs at the time of the

Full Moon. Only when the Sun has married the Moon (New Moon has taken place in this sign) will the person be a true type of that particular sign in which the birth took place. If there hasn't been a New Moon in the sign of the person's birth the individual subconsciously will be more like the preceding sign. He will not be a true type. Check the ephemeris to see if the New Moon has already taken place.

People born when the Moon is going from the New Moon to the Full Moon are more objective in consciousness. Those born when the Moon is going from the Full Moon to the New Moon are more subjective or reflective. People born in the last quarter are lacking in vitality but if the Sun is in a strong sign it will help to overcome the lack. The Moon phases deal with nature's rhythms. The Moon is the mother-side of all existence for it rules matter; the form side of life. The Sun rules the father-side of life; positive, masculine, spiritual force.

If you wish anything on the material side to succeed, start projects, enterprises and new jobs when the Moon is going from New to Full Moon. Then you are in tune with nature's rhythms for everything is on the ascending arc. Anything started in the last quarter, especially the last three days, will not have any vitality and will not succeed. The Moon is the principal influence of all that is physical and those who react more to their emotions than their minds are deeply affected by the Moon. Lunar types are moody, passive, receptive and react emotionally to life rather than act on life through positivity. The waning Moon is best for planning projects for spiritual work, for meditation and comtemplation.

The Sun represents the faculty of Integration or Individuation as a Spiritual being. The spiritual potentialities are shown by the Sun, its sign, house and aspects. The Moon represents the habit patterns of the past; the subconscious trends and the ancestral patterns and impulses. The Moon rules the personality for it is the Unlit self: It, like the Moon in the heavens has no light of its own but shines from the reflected light of the Sun. Until the personality becomes the servant of the Real Self (the Sun) it has no wisdom or understanding. When Jesus said "I and my Father are one" He meant that his personality had become one with His High Self and that Self was operating through his outer self. That is the destiny of every one of God's children, sometime, somehow, somewhere.

⊙ ☌ ☽ : This aspect gives vitality and a zest for life. The sign and house it is in will be of extreme importance in the life. The person will be a "whole hogger" in whatever direction is indicated. The emotions and desires will be so closely entwined it will be difficult for the individual to have a clear perspective regarding his own nature. He will be inclined to put all his eggs in one basket. This conjunction is best when the Sun is stronger than the Moon. This will be shown by the sign the Sun and Moon are in.

⊙ △ or ✱ ☽ : Harmony between inner and outer self is reflected through harmonious parents at the time of conception. A harmonious soul cannot come through a disharmonious union. Good health, success and harmony shown through this aspect is earned increment from the past. Gives independence, stability and self-reliance.

⊙ ☐ ☽ : Conflict between the inner self and the subconscious forces. There is tension between the Will and the emotions. There will be psychological difficulties until there is a resolving of the frustrations that keep the individual from following the course he desires to pursue. He will be inclined to blame his parents but the trouble lies in his subconscious patterns. Health is apt to be disturbed if the inner conflicts are not resolved. Can be separation between the mother and father while the individual is still young enough to feel this division keenly. There is conflict between the past and the future. This aspect gives the impulse to escape from limitation by plunging into new experiences, then he lacks stability and perseverance to carry the effort to a conclusion. He is his own worst enemy but feels everyone around him is wrong.

⊙ ☍ ☽ : The main difference between a square and an opposition lies in the fact that limitations and frustrations of the square are within the individual while oppositions are losses and separations that come through others. An opposition is 180 degrees of the 360 degree circle. This is as far as one can go; there is only one way to go from there. One must turn back to one's self. Full Moon charts are particularly difficult because there is separation between the Inner self and the personality. Disharmony in the soul pattern is reflected through disharmony between the parents at the time of conception. If this union between the inner and outer self is not achieved there is disharmony where any union is concerned in the outer world. Marriage on the inner side between the two selves has to be achieved before there can be a happy marriage in the outer world. The energy flow in the physical body is uneven and causes difficulty until the person adjusts to his own particular rhythm. There will be ebbs and flows of energy. The individual has to learn to use his peak times to do all that needs doing and then learn to relax and rest when the energy tide is out.

⊙ ☌ ☿ : Egocentered if the orb between the Sun and Mercury is closer than eight degrees. Intellectually posited. Nervous type. Makes a good teacher for they are able to communicate ideas through speech and writing. Quick witted. Apt to be selfish without realizing it. Everything is related to self and frequently there is no thought of the other fellow. Perspective poor if Mercury is too close to the Sun.

⊙ ☌ ♀ : Easygoing. Can be lazy and self-indulgent. Usually attractive in appearance. Feminine, affectionate, cheerful and noncombative. Not good for a male unless it is in a masculine sign. Brings

gratuities and blessings into the life. Can be loving if the sign it is in is a strong one; if afflicted can be self seeking but because of charm often gets away with it. Luckier in occupations dealing with women than in the competitive business world. Solar energy is refined through this conjunction and in the more evolved soul manifests as beauty, harmony and love. Artistic in expression.

The Sun and Venus cannot get so far apart that they can be opposed or squared to each other. This has deep significance to the perceptive student. The Solar Self and Love are never in disharmony. Love (Venus) and Spirit (the Sun) cannot oppose each other. They are One. It is the same situation where Mercury (Consciousness) is concerned. There can be no disharmony between the soul (Mercury) and the spirit (the Sun). Mercury never moves more than 28' from the Sun.

⊙ ☌ ♂ : Gives great vital force unless Mars is in its detriment. Very martial and combative type of person if it is afflicted and in a positive sign. Fearless and impulsive in action. If afflicted can be bad-tempered and extremely willful. Tendency to domination. Outgoing energy that goes after what it wants. Not always diplomatic. Needs to be active to be happy. Quick in decision, alert and able. Mechanically inclined. Gives a very strong body and person is able to overcome many illnesses because of super energy in the magnetic field. In a feminine sign the martian force is not so strong and the person is not aggressive. If this conjunction is afflicted, especially to Uranus, the individual is accident prone and if he doesn't learn to control the animal self he can leave the body through an accident or violence.

⊙ △ or ✳ ♂ : Vitality excellent. Action and Will will operate well together. In a female chart gives attracting power where males are concerned. In past lifetimes the animal nature has been subdued and brought under the control of the will. Hence, right and constructive action come naturally and bring success in this lifetime.

⊙ □ ♂ : The solar rays pouring through Mars as blind forces represent desire rushing toward anything that will give pleasure. Mars rules the animal man and when Mars is afflicted to the Sun the animal forces need transmutation and regeneration. Mars in affliction is responsible for cruelty, violence, accidents and often acts precipitiously and without any forethought. Guns are dangerous for anyone with Mars square the Sun. The square gives as much physical energy as the trine but is apt to be used destructively.

⊙ ☍ ♂ : Rash actions. Tendency to draw antagonism from others because of inner resentment and anger. Learn to be conciliatory with this aspect and trouble can be avoided. Apt to have trouble with superiors and with father. Sun-Mars afflictions are difficult in a woman's

chart for it makes her opinionated, dominating and animus-ruled. She has to learn to come to grips with the male in her subconscious before she can have a peaceful relationship with the males in her outer life.

☉ ☌ ♃ : Not only protective of the vitality for the individual but shows a strong and powerful spirit in operation. Not an aggressive person for strength is used to help others in a quiet way. If heavily afflicted by Saturn or Mars this would not be true. If this conjunction is in a feminine chart, benefits would come through the males in her life. In the chart of a male it would describe his character and his optimistic outlook on life. Benefits would come to him through his father. If unafflicted, this conjunction is very fortunate. It attracts benefits, morally, physically and financially. There will be much travel in the life.

☉ △ or ✶ ♃ : Similar to the conjunction but even more beneficial in its effect. Gives a religious philosophy that has been brought over from other lifetimes. Earned increment in the spiritual bankbook will bring very harmonious and beneficial conditions into the life. Benefits through males. Good for health and success in life. Good for anyone in the medical field as well as for counselors and psychologists for there are innate intuitive powers.

☉ □ ♃ : This is similar to the opposition — too much false pride and a desire to be on top without being willing to earn it. Not good for health if diet is not moderate. Need for honesty and straightforwardness. Tendency toward untruthfulness and exaggeration must be overcome. Love of display. Poor judgment. Need for reevaluation where attitudes are concerned.

☉ ☍ ♃ : Jupiter has a great deal to do with judgment. Here the drive for significance has been overemphasized and there is an inflation of one's importance causing conceit and an expanded ego. Jupiter afflictions are those of overdoing, whereas Saturn's troubles are lacks, inhibitions and fears. On the physical level this aspect affects the liver. Too many carbohydrates and too much rich food will give difficulties. Wherever Jupiter is afflicted judgment can be impaired. Watch wise use of finances if you have this affliction at birth. Apt to be penny-wise and pound-foolish. Extravagance.

☉ ☌ ♄ : Here is self-restraint and great reserve. Saturn holds back the vitality, zest and enthusiasm of the Sun. Many limitations and much discipline in life but a great strength and persistence. Strong, controlled type who attains through hard work and determination. Not a happy childhood. Often due to the lack or neglect of father's influence in the life. In a female chart the father has too prominent a role often resulting in a father complex. This is the disciplinarian, the organizer, the individual with power to attain his goals and objectives through hard work,

patience and persistence. Strong personality going his own way, regardless of the opinions or feelings of others. A strong pride often to the detriment of the individual. The lone wolf type. For a female this aspect brings responsibilities and hardships through marriage.

⊙ △ or ✶ ♄ : Practicality and the drive for significance go hand in hand. The power drive is well-directed so the person attains his goals without too much difficulty. The genes inherited from the male side of the family will have physical strength. Even with a trine or sextile Saturn makes the individual work for what he gets, but he is willing to do so. This individual has integrity and a highly developed moral character.

⊙ □ ♄ : This is an aspect of egocentered selfishness and stinginess that needs redeeming. A negative attitude toward the world has to be overcome. It brings disappointments and frustrations because the individual has frustrated and disappointed others through self-centeredness, coldheartedness and an overemphasis on materialism and not enough emphasis on love. This aspect affects the physical vitality as well as relationships with the males in the life. Look for good aspects to either the Sun or Saturn as the key to release from the overemphasis on self. No good astrologer tells a person what is wrong with them without telling them the way out of their difficulties. No one comes unbound into this livingness. The blueprint shows what we have brought over to work out in this lifetime as well as the blessings we have earned. Saturn's adverse aspects show the hardening and crystallizing of the ego. This has to be broken up by suffering. There is no other way except through the relinquishment of the personal self.

⊙ ☍ ♄ An opposition differs from a square in that the opposition comes from opposing forces in the outer world. Oppositions always affect us through others. Squares are the innate difficulties within the individual. This aspect brings difficult people into our orbit causing the necessity to learn to compromise. We meet ourselves as we once were on the path of life but we don't recognize ourselves in the other person. Obstacles and difficulties which are karmic in origin, frequently manifested through father, husband or son. Selfishness must be overcome. A tendency to be drawn to negative and stingy people must be handled through understanding.

⊙ ☌ ♅ : With Uranus afflictions, difficulties are due to over-crystallization on the side of self-will. Independent and individualistic. Strong self-will. Very intuitive. Originality in thought and action. Powerfully magnetic personality. Over-sensitive and very impulsive. Not good in a feminine chart for it gives too much masculinity.

⊙ △ or ✶ ♅ : Originality and independence. Strong magnetic healing force. In a woman's chart, makes her attractive to males on an

intellectual and impersonal level. The "pal" type, not an emotional attunement. Successful career through own ingenuity. Strongly intuitive person.

⊙ □ ♅ : Self-willed and rebellious. Unexpected and sudden upsets. Tendency toward abruptness of manner and rudeness. Needs to learn respect for the opinions of others as well as his own. Needs to guard against impulsive and hasty action. Many disruptions and upsets in life until self-will is overcome.

⊙ ☍ ♅ : Disruptive, upsetting conditions where relationships are concerned. Too much self-will operating and it is apt to arouse the self-will in others. Has over-crystallized on the side of self-will in other lifetimes and so attracts the self-willed in this life. Difficulties with males, especially husband or father.

⊙ ☌ ♆ : Psychically sensitive. Extremely emotional. Apt to deceive oneself unknowingly. Sentimental and romantic. Apt to day dream and fail to achieve their dreams if Saturn isn't strong in the chart. Mystically inclined. Not an easy person to understand for they do not understand themselves. What is undercover is far more important than what is on the surface and if the person isn't evolved there can be something undercover that is detrimental and disintegrative in effect. Needs to be absolutely honest in all their dealings with others. Watch the tendency to color and shade the truth where this aspect is concerned. This tendency stems from the aim to please. This individual works through persuasion, never through pressure.

⊙ △ or ✳ ♆ : The outer drive and the inner idealism work hand in hand. Person extremely sensitive to inner currents and is by nature a mystic. Gives good taste and refinement. Love of art and music. Does very well in creative fields. Good imagination. In the medical field this aspect would give healing power.

⊙ □ ♆ : This is a difficult aspect, especially in a male chart. In a female chart it would attract a male that would be the cause of disillusion and it would call for much sacrifice. Inability to see clearly where emotions are concerned. Deception and deceit must be eliminated. There are karmic debts to pay when Neptune is afflicted by the Sun. The sign and the houses involved will show where the payment is due. Wherever Neptune is placed by house is where the obligation to sacrifice will manifest. Here is where you took in other lives; now you must restore the balance.

⊙ ☍ ♆ : Tendency to obsessive behaviour. Deception and disillusionment come through others. Similar to the square. Confusion and chaos where emotions are concerned. Only in seeking nothing for the separated self can the individual go free where this aspect is concerned.

210

Ed. note: For Sun–Pluto aspects, see pp. 310–311.

CHAPTER 23
Aspects to the Moon and to Mercury

☽ ☌ ☿ : The consciousness and the feelings can work together if this conjunction is in compatible signs. Note which planet is stronger by sign. For instance: if ☽ ☌ ☿ is in ♓ the feelings would be stronger than the reason, for the Moon is more akin to the sign Pisces than Mercury. Aspects to any conjunction in the chart would show whether the power inherent in the conjunction would be used constructively or not. This position gives versatility, adaptability and an alert mind. Witty individual with a talkative nature. Apt to be self-centered. Literary talent, especially if aspected to Uranus.

☽ △ or ✳ ☿ : Very good for harmony between the mind and the emotions. Mercury represents the thinker behind the brain and the Moon rules the brain and the brain capacity. Ability to communicate ideas and concepts to others. Makes good teachers, writers, reporters. Quick perception and an alert mind. Interesting conversationalists.

☽ □ ☿ : Conflict between the mind and the emotions. The houses involved will show the areas of life where difficulties will arise. Concentrate on the house and sign Mercury is in to overcome or control the emotions. Subconscious needs help. It is not amenable to reason but it will respond to love. Wrong emotional attitudes can be changed by understanding. Trouble with relatives. Need to use caution where writing or signing papers and contracts are concerned. With this aspect be sure to read the fine print.

☽ ☍ ☿ : Subconscious goes on a binge and forgets to use common sense and reason. Person apt to suffer through unwise and impulsive speech. Mind is keen and the tongue is sharp. Gossip and criticism must be avoided. If this individual is the victim of it, it means the boomerang of his own past conduct is coming home. Highstrung temperament, restless and nervous. Signs involved and aspects from other planets will either tone down or emphasize these tendencies.

☽ ☌ ♀ : Gives a pleasing personality and physical beauty if it is in an angular house. Artistic type. Subconscious sensuality that seeks emotional satisfaction with little regard for others unless Saturn is strong enough to strengthen the moral fiber. If afflicted by Mars eroticism will be strong and there will be conflict between lust and love. In male chart apt to pick his mate because of her personal appeal and outer beauty. Depends on other aspects in the chart whether beauty will be more than skin deep.

☽ △ or ✳ ♀ : Attractive and loving personality. Artistic type of person and should choose an occupation that would allow the artistic, creative power full sway. Gives a harmony and love of order in the nature. Benefits through the domestic life and the public. Able to attract financial benefits. Environment beneficial.

☽ □ ♀ :Suffering through the affections. Debts of un-lovingness in the past keep love from the door until the bill is marked "Paid." Has to give more than they will receive until the accounts are balanced. Keep on giving and loving and the love will begin to come back. Tie with mother apt to be an unhappy one. Tendency to carelessness and disorder has to be overcome.

☽ ☌ ♀ : An opposition works through other people and is considered a separative aspect. It can be overcome by compromise and co-operation. The choice is there. This is why an opposition is easier to handle than a square. Often loss of mother through separation, either physical or psychological. Money conditions can bring difficulties if finances are not handled wisely. Subconscious feeling of being unloved has to be over-come by becoming a more loving and loveable person.

☽ ☌ ♂ : Acts impulsively without due forethought. In a female chart gives difficulties where the male in her subconscious is con-cerned. Will not be able to relate properly to any male in the outer world until this conflict is resolved. Too aggressive, opinionated and too martian in attitude. Would dislike her own sex because of her own lack of femi-ninity. Good as a career person or capable executive. Tendency to extremes in action needs curbing. Apt to be hot-tempered.

☽ △ or ✳ ♂ : Subconscious feelings and energy work hand in hand. Courageous and energetic. Strong vitality and good recuperative powers. Animal tendencies have been brought under control in other life-times so energy can be used constructively on the personality levels. Good aspect for relationships with the feminine sex.

☽ □ ♂ : Antagonism between animal self and feelings. Emotions can get out of hand and cause many difficulties. Very selfish where interests are concerned. "Me first" aspect. Apt to indulge the un-redeemed self through sex or liquor if the rest of the chart shows lack of evolvement. Dislikes the female sex but can use them for their own pur-pose. Obstinate and self-willed. In a male chart it would show that he would attract an aggressive female and would have trouble if he was un-willing to be dominated. Domestic harmony lacking.

☽ ☌ ♂ : Acts somewhat similar to a square. Causes separa-tions and quarrels due to a brusk manner and a dominating tendency, es-pecially if in a masculine sign. Accident prone if afflicted by Uranus. Many

212

difficulties in friendships if argumentative manner is not overcome. Needs to learn to be more patient and loving. This affliction can be overcome by self-restraint.

☽ ☌ ♃　　　　　　: Excellent combination. Jupiter is exalted in Cancer, the Moon's home. Pleasing personality with an optimistic outlook on life and a sympathetic nature. Gives good health but overindulgence in food will put on weight. Jupiteer's tendency to expand anything it contacts will expand the physical body in this sign. Protection around the individual due to compassion within. Protected physically and financially. Excellent position for someone working with the public.

☽ △ or ✳ ♃　　　　: Brings great blessings into the life because of earned increment in the spiritual bankbook due to compassionate service rendered in another lifetime. What the world would call "Good luck" but good was given out and good comes home. Bread cast on the waters returns but not always through those you have fed. Assistance through the domestic surroundings and the mother. In a male chart this brings women of good character and high ideals into his life. Increases faith and devotion

☽ ☐ ♃　　　　　　: Conflict between false pride and feelings; between conceit and emotions. Difficulties because of keepingness rather than givingness. Extravagance and self-indulgence need controlling. Can be lazy and procrastinating. Like Scarlet O'Hara: "I'll think about that tomorrow." A friendly type of person, not antagonistic but indulgent. Diet is important for the liver can give trouble.

☽ ☍ ♃　　　　　　: Oppositions work through other people. Will be brought in contact with people who will represent the individual as he or she was in past lifetimes. Arrogance and extravagance could cause distress. Attracts money but poor judgment in the use of it could cause loss. Troubles and disappointments through misplaced faith.

☽ ☌ ♄　　　　　　: Difficult aspect until the personality is transcended. Saturn by transit, and the Moon by progression, keep this aspect in effect the life long. Only by tuning into the High Self can this aspect be overcome. "In the Center of All Light I stand; nothing can touch me there." This affirmation used constantly (the subconscious learns by repetition) will enable the individual to get the detachment necessary to overcome this aspect. Gives depth, a sense of responsibility and staying power. Especially difficult for women for not only are the emotions affected but the health. Strong tendency to depression. Negative thinking and feeling is a hangover from a past life; the "Gertie Glooms" that took the joy out of life for those around them. In this lifetime, joy, optimism and faith have to be cultivated. Very sensitive. Suspicious, timid and moody nature. Innate self-centeredness and selfishness have to be overcome. In a male

213

chart it shows a subconscious dislike of women. It colors his attitude toward them. The feminine in his subconscious resents them. Gives homosexual tendencies if there are many feminine planets in the chart. Either strong identification with the mother or resentment because there has been no mothering. The house in which this conjunction is placed will be the area of the life that needs regenerating and transforming.

☽ △ or ✳ ♄ : Harmony between the feelings and common sense. Responsible and practical type. Good worker. Tendency to aloneness in any aspect of the Moon and Saturn. Introversion is strong. Good organizational ability. Sense of duty very strong. Good for occupations that deal with business, real estate, contracting and work that involves the public. Makes an excellent teacher. Strong and happy ties with the mother. Mothering and nurturing quality in individual is strong without being sticky. Man with this aspect attracts a practical and faithful mate. She may not be exciting but she has sterling qualities.

☽ □ ♄ : Like the conjunction, this aspect gives coldness, depression and a tendency to negative fears that are irrational because they stem from forgotten events. Person is apt to be very selfish. Difficulties with the mother and in a feminine chart, a lack of maternalness or an overpossessiveness can be a problem if there are children. This aspect, like the conjunction, can cause difficulties of a sexual nature in the male chart. Too much femininity and not enough maleness. Lacking maleness he tries to compensate by being petty and tyrannical. He does not realize why he acts this way. Any aspects to the Moon are more on the subconscious than conscious levels.

☽ ☌ ♄ : This aspect gives some of the fearfulness and selfishness of the square, but it is easier to change the negative patterns into a more positive expression. Cautious and inhibited in expression of feelings. Often suffers from lack of love because of their own inability to be truly loving. Not a giving person unless Jupiter is strong by house and sign. Materialism and ambition strong. In a male chart it attracts a mate who will be undemonstrative and demanding. Often loses parent early in life if the fourth house is ruled by Capricorn or Cancer.

☽ ☌ ♅ : Strong intuition. Good intellect. Very independent. Not orthodox where religion or conventions are concerned. High emotional tension and erratic, sudden impulses can cause difficulties. Dislikes routine of any kind. Personal magnetism strong. A difficult aspect unless the rest of the chart shows good judgment and moral character. This is "dynamite" that can be used constructively or destructively. Great obstinacy and determination. If afflicted by other planets can give erratic tendencies and an unstable nature that is undependable. Needs to learn control of emotions or nervous system will give difficulty.

☽ △ or ✶ ♅ : Original in ideas and concepts. Keen intuition and alert mind. Interested in progressive movements. Genius. Inventive, inspirational and creative type of person. Individualistic in temperament. Would have an unusual life with many varied experiences. Changes come suddenly and unexpectedly. In advanced types would give great healing power.

☽ □ ♅ :Sudden and unpredictable emotional storms can raise havoc with life. Needs to guard against sudden or hasty marriage for the individual, may meet someone after marriage to whom they may become attached. Strong self-will and unwillingness to be bound by moral principles can cause much suffering. Not good for motherhood for the person is too highstrung and nervous and the children suffer. Not a maternal type. Very unpredictable person; up one day and down the next where emotional tides are concerned. In a male chart it would attract this kind of mate.

☽ ☍ ♅ : Highly geared type of individual whose choice of associates would be very important. The wrong type of companions could cause needless suffering. Strong self-will and rebellious tendencies. Energy inherent in this aspect is powerful and needs directing so that it will be channeled rightly. In a male chart would attract a very positive type of mate who would rule him whether he wanted to be ruled or not. In a female chart there would be conflict where the mother or other females are concerned. Would not be too popular with her own sex unless there were strong Venus aspects in the chart.

☽ ☌ ♆ : Mystical, intuitive type. Great sensitivity and impressionability where feelings are concerned. Dissolving of emotional reactions to life necessary through many disappointments and disillusionments. Hides real feelings so the sensitivity is not apparent on the surface. Very psychic nature. Not talkative unless Gemini or Sagittarius is highlighted. Inner longing for love and freedom that can only be found within, never in the world of personality. Peculiar experiences in domestic life. Secret enemies will bring difficulties into life. Great devotion to an ideal or to those loved. Strong attraction to art and music but seldom chooses to follow a career along these lines. May pick a career where helping and serving the public is concerned. Body mechanism a delicate one. Not a strong robust type though they may appear to be healthy. Trouble with the health early in life. Body has adverse reaction to drugs of any kind. Anesthesia gives trouble if it is necessary. Best to have it when Neptune is well aspected by transit.

☽ △ or ✶ ♆ : Keen psychic sensitivity. Love of music and can be excellent musicians. Imaginative powers strong and if Mercury is well-placed can be very successful in a literary field. Can dramatize life and needs to watch the tendency to exaggerate and distort events. So psychic they are susceptible to emotional atmosphere around them and they react

strongly. Health suffers if in an atmosphere of discord and friction. In a male chart this aspect attracts a sensitive, refined and creative type of mate.

☽ ☐ ♆ : Tendency to delusion and illusion strong if person lives completely in the personality. Subconscious feelings of insecurity and inferiority unrecognized, but damaging to individual. Draws strange and unusual people into the orbit and trouble could ensue through lack of discretion. Need to be careful where opposite sex is concerned. Liable to be deception through trusting the wrong people. Link with the mother can cause suffering. Sometimes a laziness and an unwillingness to act in a positive, definite manner to achieve success in the world. A dreamer but must act as well as dream.

☽ ☍ ♆ : This aspect is somewhat similar to the square. Emotional upsets through the the house in which Neptune is placed. That area will call for sacrifice and understanding. May be separation, mentally or physically from the mother. Must cultivate reasoning power and not allow emotions to govern action.

Ed. note: For Moon–Pluto aspects, see pp. 311–312.

ASPECTS TO MERCURY

☿ ☌ ♀ : Governs the mind that is essentially refined and artistic. Indicates good breeding. Individual has outgrown coarseness and crudeness. When Venus conjuncts Mercury by progression, a refinement of consciousness takes place. Optimistic nature. Great charm of manner.

☿ ⚹ ♀ : Harmony between the mind and feelings. Artistic talent. Musical ability. Friendly and sociable type of person. Gives healthy nerves and a healthy mind. Doesn't give depth and apt to be superficial unless the rest of the chart shows strength of character.

Mercury and Venus are never more than 78 degrees apart. This has deep significance. Mercury is the planet of consciousness (the soul) and Venus is love. Love and consciousness on the soul level are never at odds. It is when the personality comes into play that conflicts appear.

☿ ☌ ♂ : Gives a mind that is mechanically inclined. Impulsive, argumentative and aggressive, especially in a masculine sign. Gives vitality to the mental processes. Sharp tongue and keen wit. Aspects from other planets will emphasize or tone down these tendencies. Not a good conjunction in a feminine chart. Makes her too blunt, sarcastic and forceful. Can be courageous and has the determination and energy to succeed in life. The sign and the house in which this aspect is found will be important. Martian force has to be controlled by reason.

☿ △ or ⚹ ♂ : Alert and clever mind. Practical and positive approach. Reason and action work well together. Enjoys arguments and debates. Very active and restless type of person. Wants something doing every minute. Manual and mechanical dexterity. Literary talent and good mathematical ability. Can be crude if Venus is not well placed in the chart.

☿ □ ♂ : Can be a very difficult aspect if the chart shows lack of evolvement. Sarcasm and bad-temper have to be overcome. Accident prone if temper is not handled. Mentally cruel if Scorpio is strong in the chart. Apt to ride roughshod over others to attain their objectives. Animal nature fights with reason. Instability and irritation will affect the nervous system if anger and resentment are not controlled. Muscle spasms can be source of aggravation. Apt to have difficulties with circulation if the body isn't exercised. Guard against dishonesty and exaggeration.

☿ ☌ ♂ : Apt to be combative, faultfinding and self-seeking. If involved with the first house, individual would generate these qualities. If it was involved with the seventh house, karma of the past would be tied with these qualities, and projections would come through others for redemption. Must watch tendency to gossip and slander. If the seventh, fourth or tenth house is involved may have to suffer through the gossip and slander of others. Ambitions strong. Determination strong and can achieve goals through perseverance and well-directed energy.

☿ ☌ ♃ : Links mind to superconscious states giving compassion. mercy and sympathy. Philosophical type of mind. Attracts many benefits due to generous spirit. Is willing to give of their abundance so it comes back. Good natured type. Not ambitious and can be lazy. Can be self-willed and stubborn in a quiet noncombative way. If afflicted to Mars. has to watch egotism and arrogance.

☿ △ or ⚹ ♃ : Good judgment and keen powers of observation. Above the average in intelligence. Travel beneficial. Religious type of person with a strong faith in life. Always knows everything is coming out rightly no matter how badly things look and it usually does. Make good doctors, teachers and professors. Mercury's self-centeredness nullified by the expansiveness of Jupiter.

☿ □ ♃ : Poor judgment and needs to guard against rash decisions that can be cause of self undoing. Good natured and easy going. Procrastinators. Apt to be in difficulties because they can't say "NO." Then they fail to follow through and others become antagonistic. Mind active but forgetful. Apt to be extravagant where finances are concerned. In physical body liver can be the source of trouble.

☿ ☍ ♃ : How this aspect acts depends on signs they are in. Mercury polarizes Jupiter (Gemini-Sagittarius polarity). In mutable signs this opposition could be good. In cardinal signs right action backed by good judgment would be important. In fixed signs, difficulties would be caused by a stubborn, resistant will. Gives strong convictions and opinions but not always correct ones.

☿ ☌ ♄ : Gives depth of mind. Morbid and depressive outlook if person is a Saturnian type. Over serious if Jupiter or Venus do not lift the consciousness. Tendency to neurosis due to depressive moods. Up one day and down the next, but downs come more often than the ups. Extremely self-centered and like all self-centered people, lonely. Inhibits feelings and builds a wall around himself. Ambitions strong and attain success through hard work and persistence. Make good organizers and teachers. Very methodical and orderly.

☿ △ or ⚹ ♄ : Practical, disciplined and responsible nature. Intelligent with good reasoning power and a retentive memory. Gain through education and brothers and sisters. As life advances, success increases. Real estate and land are good investments and will bring profit. Makes an excellent teacher. Self control strong. Good aspect for physical health. Feelings constructive and affect the body constructively. Able to organize and plan systematically.

☿ □ ♄ :Gives a poor memory and causes difficulties where studies are concerned. This can be overcome by patience and persistence. Person has to guard against negative thinking and depression. Difficulties and responsibilities where relatives and family are concerned. Individual should not smoke for lungs are affected with this aspect.

☿ ☍ ♄ : Lack of lovingness and understanding that needs redeeming. Separation or difficulties through relatives if aspect is connected with third or fourth houses. Education may be interrupted by conditions beyond the person's control, but it will be nullified by knowledge gained from reading and from life. Person is intelligent and can overcome much that is limiting and depressing in the life. Apt to be suspicious and distrusting if Jupiter isn't angular or well aspected. Unhappy in early life if this aspect is tied with first or third house. May have to be responsible for one or both parents in later years. Could be separation, mentally or physically, from relatives.

☿ ☌ ♅ : All aspects between Mercury and Uranus are good for they tune the conscious mind to the Universal Mind. Uranus, being the higher octave of Mercury, tunes the mind to a higher octave and speeds up the perception and quickens the intuition. This conjunction can make the mind contrary and willful. Progressive in concepts and ideas. Very indepen-

dent and wants to feel completely free. Has genius that can be harnessed for the good of humanity or left to run wild and become destructive to the soul.

☿ △ or ✶ ♅ : Aspect of inventiveness and genius. Original in expression. Quickens the mental processes so much that it can give impatience with those whose minds are not as keen and quick. Talent in writing and talking, excellent ability to communicate ideas to others. Denotes the advanced soul. Not orthodox or dogmatic. Individualism strong and can not be bound by the past or tradition.

☿ □ ♅ : As inspirational and mentally keen as the conjunction and trine aspect but more erratic. Independent, intuitive and proud. Apt to be sarcastic, brusk and frank in speech and needs to be more gentle and loving in their approach to others. Honest and direct but lacking in tact. One apart from family and considered heretical and "way out" in their ideas. Are leaders but find it hard to follow. High strung temperament that does not always show on the surface. Willfulness needs to become willingness to be guided by the Inner Self. Then the inherent genius will come to the fore.

☿ ☍ ♅ : Can give nervous troubles due to irritability and impatience. Adventuresome and erratic. Very important to choose the right associates. Rebellious and self-willed if afflicted by Mars or Saturn. Sudden gain or loss if tied with second or eighth house. If tied with seventh house can bring sudden upsets and separations where partners are concerned. Needs to use caution in signing papers or documents to avoid loss. If chart shows evolvement this aspect can be prophetic, dedicated to teaching truth, but finds it difficult to express subjective perceptions in objective terms.

☿ ☌ ♆ : Difficulties with mental processes due to diffusion of energy. Lack of ability to separate logic from illusion. Extremely impressionable. Romantic and dreamy type of individual. Lives in a dream world if Saturn is not well placed in the chart. Sensitive nervous system that is easily shaken. Neptune sensitizes any planet it contacts. Much depends on aspects from other planets. Should be careful about opening psychic senses for there could be liability to obsession. Needs to learn focusing and concentrating where the mind is concerned. Good for dramatic work or musicians. Needs to be absolutely honest in all affairs.

☿ △ or ✶ ♆ : Inspirational, poetic and creative mind. Aptitude for psychic and mystical fields. Can benefit from dreams and visions. Practical idealist. Is able to use his inspirational powers constructively. Exquisite sensitivity toward the subtler aspects of life. Strong love of the sea and should live near it. Has ability to contact higher planes of consciousness in sleep and in meditation and bring instruction through to the conscious mind.

☿ □ ♆ : Lacking in concentrative ability and the power to think clearly. Impractical idealist, always dreaming dreams and scheming schemes, but needs to bring them down to earth. Psychic and emotional difficulties. Astute person where other people's weaknesses are concerned. Can be deceptive and cunning. Secretive type of person. Needs to be absolutely honest in all their affairs. Deception of any kind will bring confinement and suffering. "Slick" type of mind.

☿ ☌ ♆ : Trouble through relatives or through wrong associates. Can give too vivid an imagination that is not always dependable. Lack of self-confidence that can be overcome by action, leaving the results to speak for themselves. Apt to suffer from the deception of others. If tied with the second or eighth house, wise to be cautious about trusting others in financial matters. Any get-rich-quick deals would be disastrous. Emotional upsets could affect the nervous system. Breathing could give difficulty. This aspect often tied with asthma, which is emotional in origin.

Ed. note: For Mercury–Pluto aspects, see pp. 312–313.

CHAPTER 24
Aspects to Venus and Mars

♀ ☌ ♂ : Hard to handle these two forces because Mars is representative of the animal soul and Venus of the spiritual soul. Mars stimulates the senses and the passions while Venus lifts the consciousness to love, harmony and beauty. Sex is the dominant keynote of Mars in the younger soul; in the more evolved it gives strength, courage and the energy necessary to tame the animal. Venus gives the faculty of loving someone outside oneself. Mars rules the early stages of individualism. It can be crude and combative. Venus represents love. Mars represents lust, whether it be a lust for power or lust in a sensual sense. Note the sign this conjunction is in then note which planet is the stronger. ♀ ☌ ♂ ♏ would be different from ♀ ☌ ♂ ♎ . In the first case, Mars is stronger and so will be the animal instincts; jealousy and possessiveness will need to be overcome. In the second case there will be emotional stress and suffering but love will triumph for Venus rules Libra and Mars is in its detriment in Libra. In this conjunction there is always hidden conflict between the anima (female) and animus (masculine) in the subconscious. Sex appeal and magnetism strong. Sensual type unless Venus is stronger than Mars.

♀ △ or ✶ ♂ : Feelings and action are harmonious and work together. Animal self subjugated in a past lifetime and the love nature is strong. Person attracts a harmonious love life because of innate kindness and lovingness. Individual sociable and affectionate. Attracting principle extends to money as well as love.

♀ □ ♂ : Emotions and passions need controlling. Animal self needs domesticating. Can be cruel and ruthless if individual is lower martial type. Conflict between passion and love. Often leads to an early marriage due to sexual attraction. In female chart produces emotional suffering from father or husband. Will feel oppressed or suppressed. Will suffer from jealousy and resentment. An unwise marriage can cause suffering. Cruelty, inflicted on others in a past life, will come home for redemption. This square hardest to overcome if it is in a fixed sign. In the physical body there can be trouble with the generative system.

♀ ☍ ♂ : Similar to the square but easier to handle for there is more choice. Has to learn cooperation and compromise. May have to suffer through the disloyalty and unfaithfulness of others. Temperament swings between being loving and being irritated and angry. Transits of Mars will stimulate Martian force; transits of Venus will stimulate the love nature.

♀ ☌ ♃ : One of the most fortunate aspects of them all.
What the world would call a "lucky" person but it is earned increment in
the spiritual bankbook. Intense appreciation of beauty. Orderly and artistic
nature. If connected with second house, material wealth and abundance.
Courtesy, compassion and refinement strong. Gives popularity and bene-
fits through the public if in a congenial sign. Restless individual that wants
to be on the move. If in a cold sign for Venus the manner will be gracious
and cultured but there will be coldness and self-centeredness within.
Overindulgence in appetite and extravagance need controlling.

♀ △ or ⚹ ♃ : Similar to the conjunction but more givingness.
Religious faith and devotion strong. Soul forces are active and awake.
Jupiter represents the Super Conscious or Higher Self and the attunement
has been made in previous lifetimes. Gives optimism and cheerfulness.
Money affairs prosper. Individual is able to attract abundance and wealth
due to attracting power of faith and positive attitudes.

♀ ☐ ♃ : Jupiter afflictions come from overexpanding and
overdoing. Extravagance and arrogance need overcoming. The "Let's take
a chance" type. Must not live beyond means. Can be hypocrisy if af-
flicted to the Sun. Great restlessness and prone to seek new experiences
before assimilating the ones at hand. Self indulgence where food or liquor
is concerned will give trouble with the liver and gall bladder.

♀ ☍ ♃ : Much the same as the square. Ostentatiousness
and vanity need changing. Wastefulness where money is concerned can
leave one without it in later years if this aspect is strong in the chart.

♀ ☌ ♄ : Over cautious and inhibited. Saturn contracts
Venus, inhibiting the emotions and bringing sorrow through lack of love.
Depends on the house it is in whether the person is selfish or has karma of
selfishness to pay. In the latter case they would attract selfish people into
their orbit and suffer through the selfishness of others. This aspect can
make a person parsimonious and miserly. Saturn chills and contracts the
love nature as well as the pocketbook. Sacrifice, willingly and cheerfully
given, is necessary to break up the separateness and hardness of the ego
complex. Can be the martinet and the disciplinarian. Needs to cultivate
generousness and compassion in order to overcome the negative side of
this conjunction.

♀ △ or ⚹ ♄ : Gives loyalty, faithfulness and a strong sense of
responsibility. Dependable nature. The first part of the life will be difficult
if Saturn is in the first three houses of the chart. As life advances it will
get better. Brings tried and true relationships into the life because of the
caliber and quality of the person. Spiritual beauty begins to emerge because
of hardships endured and overcome. Strength and the ability to accept suf-
fering as part of the growth process. Saturn (necessity) irradiated by
Venus (love) is lifted to a high level.

222

♀ □ ♄ : One of the aspects that are karmic in origin on the debt side of the spiritual ledger. Disappointments through love due to disillusionment in love and marriage. Disappointments through love due to selfishness and separateness often unrecognized by the individual. Self is apt to come first. This causes loneliness and limitation as life advances. Especially true if Saturn rules or is placed in the fourth house. Difficulties with finances are tied with lack of givingness. This entails a cosmic law scarce understood by the children of earth. Venus rules love and money; loving and sharing are directly related to the power to attract abundance. One can get money through greed and manipulation but it does not bring happiness with it. Can be fixation where one or both parents are concerned. Finds it hard to be independent unless Uranus is strong.

♀ ☍ ♄ : Very similar to the square but there is more choice. Easier for this individual to redeem his lack of love by being loving to the unloving people he encounters. The people we meet on the path of life are projections of our own qualities as they were in a past that the personality does not remember. When Saturn by transit would contact either Venus or Saturn, tests would come that would be difficult. They could be overcome by the right attitude. Money difficulties could manifest at these times as well as emotional problems.

♀ ☌ ♅ : Personal magnetism strong. Unusual taste and creative talent. Highly temperamental. Emotional "highs and lows." Strongly self-willed. Reckless and unconventional where affections and love are concerned. Sensuality strong. If afflicted, individual gets bored with routine and with people. Seeking changes constantly. Abrupt and sudden separations bring upsets. Strong independence and individualism that doesn't consider "all for love and all well lost." Their feeling is "someone else will come along." This person does not give himself completely to any love relationship unless there are many planets in water signs.

♀ △ or ✳ ♅ : Unusual magnetism and ability to attract love as as well as money. Artistic talent. Original in ideas. Attracts unusual love relationships into life. Brings unusual, unexpected and exciting events into the life. Can bring sudden separations but it works to the advantage of the individual.

♀ □ ♅ : Individual must use caution in partnership or marriage for this aspect can bring sudden separation and upsets in emotional affairs. The divorce aspect. Emotions and feelings need to be more stabilized before lasting ties are formed. Gives the same magnetism as the trine but it is not as reliable. Person apt to be fickle and unstable.

♀ ☍ ♅ : A separative aspect where finances and affections are concerned. Very similar to the square though not as apparent on the surface. Many unexpected separations where associations are concerned. Difficulties will stem from the other person. It is the law of the

boomerang coming back. What once was done to someone else is returning to its source. Very necessary for the person with this opposition to give the other person as much freedom as they demand for themselves.

♀ ☌ Ψ : Inspirational nature strong. Talented where music and art is concerned. Gives a romantic, dreamy nature that has a gentleness and winsomeness about it. Attractive to the opposite sex. Psychically sensitive. Can be timid and insecure. In average chart, may give instability and changeableness where affections are concerned. Mystical and spiritual tendencies in the chart of an advanced soul. Neptune steps up the personal affections to the plane of Universal Love and Divine Compassion.

♀ △ or ⚹ Ψ : Neptune does not operate directly on the physical plane so this aspect is not much help materially. A spiritual blessing not always recognized by individual to whom material things are important. Gives taste, refinement and the inner qualities of real worth that attracts people who will seek to aid and support the person. Possibility of a deep love union in this lifetime. Through sacrifice and loving service rendered in a past life this union has been earned. A quiet, unassuming gentleness toward those they love. Artistic nature strong. Love of music and has ability to be a good musician. Would dislike a routine job or to work in the competitive business world. Sixth sense strong.

♀ □ Ψ : This aspect often found in the charts of spiritual students. An important incarnation for the individual has to turn deep desire for personal affection into a universal sense of love and compassion. Often personal affections bring disappointment and heartache. Person comes into life with a depleted spiritual bankbook where love is concerned. Does not attract love until his dues are paid. To overcome this aspect there must be a relinquishment of the desire for love; it must be replaced by being Love. In a financial sense individual must learn practicality and caution. Could be loss through deception and by giving wrongly.

♀ ☍ Ψ : Has some of the same problems as the square but easier to handle. In an opposition, the individual can choose personal love to satisfy own desires, or be willing to serve love by sacrificing own interests. Rose colored glasses can keep person from a wise choice of marriage partner. May marry the wrong person through emotionalism and lack of clear vision. Self delusion can be strong and judgment weak unless Jupiter is well aspected. The affairs of the house in which Neptune is placed will entail obligations and sacrifices. Values need reassessing if this aspect is operating. Neptune dissolves self love through suffering when it is afflicted to Venus. Great loneliness that will not be assuaged on the personality level.

Ed. note: For Venus–Pluto aspects, see pp. 314–315.

ASPECTS TO MARS

♂ ☌ ♃ : Law (Jupiter) too near energy (Mars) may lead to inclination to take law into own hands, and if Mars or Jupiter is badly placed the energy may run away with the law. Let us take this aspect as a typical example of how astrology works. Man has Mars in Aries and Jupiter in Aries. In that sign both planets are well placed; the action of the person tends to be just. Another person has Mars and Jupiter in Gemini where Mars is in a neutral nervous sign and Jupiter is in its detriment. There would be lack of good judgment and the tendency toward impulsive and rash action that would bring difficulties. Understanding the nature of the planets in the signs is essential in reading aspects. This conjunction gives frankness and directness of speech. Rash actions bring afterthoughts that can be painful. Has energy plus and great pride.

♂ △ or ✻ ♃ : Optimistic nature. Sincere and straightforward in action. Sense of justice and responsibility strong. Will defend principles and causes vigorously. Abides by promises and respects the rules. Many benefits through travel. In a male chart there is interest in athletics and sports. Active physical body that must be on the move. The reformer type, often interested in religion.

♂ □ ♃ : Energies (Mars) work against opportunities and judgment (Jupiter). Seems forceful and aggressive and wants success but often works against the self in an unrecognized way causing defeat. Can make "Splash" type of personality. The go-after-it type of personality. Doesn't know when to quit and drives past the point of success. Brash, confident and irritating to the other fellow, so doors close that could have been beneficial openings. Anyone with this conflict needs to evaluate and examine material motives, reasons behind excess, and how much defeat is due to self rather than others. Spendthrift where time, money and energy is concerned.

♂ ☍ ♃ : Can be biased by strong convictions and opinions, especially in fixed signs. Apt to be intolerant and prejudiced. Financial loss through lack of good judgment. May lack moderation where pleasure, alcohol and diet are concerned. This would cause toxic conditions where the blood stream (ruled by Mars) and the liver (ruled by Jupiter) is concerned.

MARS VERSUS SATURN

The relationship between these two planets must be thoroughly understood by the astrological student. Their natures are not compatible, yet they must learn to work together. Saturn represents the demands made by circumstances that a certain part of the life be set in order. Mars represents energy and impulse to action, pure and simple. One must direct

energy and the activity of Mars to the task of accomplishing the demands of Saturn. Saturn, the planet of necessity, provides the form or mold that contains Mars, the planet that provides the drive and power to direct the life. If Mars is weak and Saturn strong the individual has little ambition and lacks the energy to fill the mold of Saturn. He can feel limited and restricted in his little world. He will not feel the limitation or restriction of Saturn but he will not feel a sense of achievement and fulfillment either. Needs to bring in more energy and drive. If he has a powerful Mars and a weak Saturn his martian forces can break the boundary of common sense and necessity, creating disorder and chaos where order is required, leaving things in a mess.

Saturn is the law of limitation. Until power is limited and focused it cannot be used. Saturn says: "So far shall you go and no farther." In any aspect between Mars and Saturn wisdom says, "Follow Saturn; ignore Mars." Mars and the area in which Mars is placed looks more attractive. Who wants discipline and the confining of energy. The trick is to use the right amount of martian energy by confining it within the bounds of Saturn. The best interest of the individual is served by following Saturn, especially in regard to career. The old fable of the hare and the tortoise represents Mars and Saturn so well. The hare was so confident he could win the race. He was so much faster than the tortoise. He started running at high speed and got so far ahead he decided to lie down and have a nap; the slow, patient, persistent tortoise kept on going and won the race. Mars is primarily the planet of youth and this principle of Saturn is so hard for youth to understand.

When there is no aspect between Mars and Saturn the individual will find it easier to integrate these two forces. For that reason he may fail to accomplish as much as the person who has the conflicting aspects to reconcile. It takes struggle and conflict to develop the psychological and spiritual muscles. To give an example of conflict between Saturn and Mars: Saturn in the third house square Mars in the twelfth house. The person refuses to take discipline in his environment early in life: he rushes out into life and finds he has been the cause of his own undoing (12th house) because of his unwillingness to take any restriction in the environment (third house). He does not complete his education and later in the life regrets it because it limits him in so many ways.

In afflictions between Mars and Saturn, read the house, position of Mars, as being the agency through which difficulties will come. Saturn always demands discipline, sacrifice and hard work. Wait for the right time for wider, freer, fuller expression for Saturn always demands time. You can not rush God or the Cosmic forces.

♂ ☌ ♄ : If weak by sign, this aspect can produce inertia. Saturn (fear) holds back Mars' action. Gives poor timing. Needs to face issues and do something about them. Sign and house in which this con-

junction is placed is important. This conjunction is most detrimental in fixed signs. Extraordinary capacity for making enemies. Asks no quarter or expects none. Lust for power is very strong, for there is tremendous ambition, but ultimate power is denied because of abuse of power in past lifetimes. Robert Taft who almost made the presidency had Mars conjunct Saturn in Leo. Robert Kennedy had Mars, Saturn and the Sun in Scorpio, afflicted to Neptune in Leo. One case in my files had Mars conjunct Saturn in Gemini in the third house, the Sun in Leo opposed to Uranus. She has spent her life in a mental hospital due to epilepsy. Clairvoyant investigation showed she had been a very cruel queen in Egypt in a past life and had used her power brutally. Her will is indomitable and in spite of forty years in a mental institution and years of drugs, her mental faculties are still operating enough so that she has reasoning power.

♂ △ or ⁎ ♄　　　: Active and ambitious, especially in business. Through keen judgment and constructive action much success comes as life advances. Willing to work for what is wanted. Sound and practical common sense. Martian energy is stabilized and controlled by Saturn's stabilizing influence. Courage and reliance strong.

♂ ☐ ♄　　　: Struggle between the instinctive desires of the unredeemed self and the human soul. Engine and the brakes need equalizing. Mars says "Go"; Saturn says "Wait." Should prove an important lifetime for through hardship and conflict the consciousness is transformed and the past redeemed. Willingness to take the disciplines focused will set this soul free. Aspect of self-conquest. Impatience and hidden resentment must be overcome. Apt to make enemies bcause of a lack of kindness and gentleness. Tendency to criticism and passing judgment must be changed to lovingness and compassion. Signs in which Saturn and Mars are placed shows difficulties in the parts of the body ruled by the signs.

♂ ☍ ♄　　　: Pull between action and the necessity not to act. Psychological difficulty in reconciling the masculine (Mars) principle with the feminine (Saturn) principle. Mars is feeling constantly restrained by Saturn. Individual needs to acquire an inner respect for the Saturn necessities. Apt to "blow hot, then cold" with sudden and non-lasting enthusiasms. Must concentrate on the house Saturn is in and bring the circumstances of that area to fruition if this energy is to be channeled rightly.

♂ ☌ ♅　　　: Courage and persistence strong. Lacking in patience. Headstrong and self-willed. Tremendous vitality and healing power if individual wants to use it for others. Needs to pay attention to intuitive sense. Apt to be direct and blunt in approach. Can not stand hypocrisy or double dealing. Hot tempered. The sign this conjunction is in will be important. If Mars is stronger than Uranus there can be tendency toward violence and individual can be accident prone. If in or connected with eighth house, death will be sudden and unexpected when it comes. This

is true whether it is a conjunction or a square. Tendency toward violent temper needs controlling.

♂ △ or ⚹ ⛢ : Strong and magnetic personality. Has stamina and ability to withstand difficulties. Wants, and usually gets, an exciting life. Can stand anything but boredom. The adventurers, the pioneers and the explorers seeking new worlds to conquer. Individualists who will not conform to the rules unless the rules make sense. Any Uranus — Mars aspect can be productive of genius if rightly used.

♂ □ ⛢ : Most violent aspect of all if not handled wisely. Can draw violence to them. Sudden and unexpected accidents due to discord and tension in the magnetic field. Explosive and disruptive in action. Too reckless. Restraint and control needed. Quicktempered. Can have tension headaches due to chaotic rhythm in the psychological makeup. Hardest to handle when in a fixed sign. J. F. Kennedy had this square in Taurus, tied with the eighth house of death. Taurus rules the throat and Mars rules gunfire.

♂ ☍ ⛢ : Similar to the square but not as drastic. Sudden endings and misunderstandings where other people are concerned. As impatient and erratic in action as the square, but not as violently responsive to stimuli. Needs to be sure of sound judgment before he acts. Apt to have someone with a quick temper around them and the individual has to learn not to react to it.

♂ ☌ ♆ : Any aspect between these two energies, except the trine and sextile, are difficult. Their natures are radically different. Much depends on the evolvement or lack of it shown by the chart as a whole. Can be extremely destructive in an unevolved chart, causing dissipation and obsessive behavior. Strange kinks in the character often caused by intruding psychic forces. Confusion and restlessness in the nature, seeking in the senses what can only be found within. Neptune dissolves whatever planet it contacts, but works in a subtle unperceived way. Often its damage is not recognized until it is too late. Neptune dissolves the animal self and this death can be painful. Self delusion is strong. The individual with this configuration must be absolutely honest with himself as well as with others. Must be willing to accept responsibility and the disciplines of life. In the advanced type this conjunction would give them mystical tendencies and the religious life is often chosen as a career.

♂ △ or ⚹ ♆ : The practical idealist. Able to dream true for the dreams are backed by action. Integrity and compassion strong. Can work with psychic forces and be in no danger from any adverse influences. Any deception from others will not avail with this aspect. There is hidden protection and earned increment in the spiritual bankbook from other lives and this individual will triumph over any hidden enemies.

♂ □ ♆ : Unless the individual learns to be honest and sincere with himself as well as others this aspect can bring difficulties. Deceit and deception must be avoided. Person with this aspect should not be involved with seances or psychic forces for obsession could be the result. Misuse of psychic and spiritual forces in a past life need redeeming in this one. Alcohol and drugs would be very detrimental to anyone with this aspect. The house ruled by Neptune will show the area where deception and disillusionment could manifest.

♂ ☍ ♆ : Difficulties will come from others rather than the individual. Some lesson to learn involving deception where others are concerned. Houses involved will show where discrimination and emotional control are needed. For instance, if Neptune is in the second house there would be loss of money through deception. If it were in the seventh house the difficulty could come through a marriage partner. Wherever Neptune is placed some sacrifices would have to be made and Mars would show the area that would instigate the activity. Oppositions work through others. Projections of our own come back home for transformation. A ride on a rainbow describes this aspect. It promises so much more than it delivers.

Ed. note: For Mars–Pluto aspects, see pp. 315–316.

CHAPTER 25
Aspects to Jupiter, Saturn, Uranus and Neptune

♃ ☌ ♄ : This is a "New Start" lifetime. Individual free to act without the burden of the past weighing him down. Not a difficult life, especially if there are no afflictions to this conjunction. Jupiter is the soul rushing out to experience life; Saturn, the soul inturning to assimilate the experience gained. In a certain sense, one energy nullifies the other. Because life isn't challenged enough, this individual can rest on his psychological "oars" and not be in the mainstream battling the current. Pleasant life but ineffective unless other energies in the chart are challenging.

♃ △ or ✳ ♄ : Judgment and practicality work together. The inner and outer selves can work together as a team. Able to project goals and objectives, and bring them to completion. Worldly ambition is there but behind it a truly philosophical and religious spirit. Achieves success because of willingness to work for what is wanted. Is honest, sincere and practical in approach to life.

♃ □ ♄ : This is what Marc Jones calls a "last chance" lifetime. The individual has to learn to follow through and grow himself a soul. Has the power to do so but often cops out and evades responsibilities. Will be defeated by life if talents and powers are not used. A physical muscle atrophies when not used; so do the spiritual muscles. Powers and talents, of which there are many, will atrophy as well. Later years will be years of regrets over unused opportunities. Judgment not good for inherent selfness stands in the way. Will have responsibilities where older people are concerned at some period of life.

♃ ☍ ♄ : Two lifetimes in one. One half, Jupiterian in nature; the other half, Saturnian. Cleavage between early life and later life would make the individual feel he had lived two entirely different life paths. The position of these two planets by house would show in what part of life the changeover would take place. Usually it is in the early forties. There is a pull between outgoingness and the desire to retreat from participation in the world. Whichever planet is the stronger will show which tendency is the stronger. These two energies can polarize each other and be a help to the individual if he will cooperate with them both; facing the responsibility of Saturn through the understanding of the higher law of Jupiter.

♃ ♂ ♅ : Intuition and judgment work hand in hand if this aspect is not afflicted by Mars and Mercury. Religious tendencies strong but not orthodox. Would be a strong individualist with concepts and opinions that were his own. Very inventive with creative power. This can be a genius aspect. This person should trust their intuitive powers and act on them if this aspect is not afflicted by Neptune. First impressions would be the true ones. Extensive and unexpected travel. Changes in the life will come in seven year cycles and could come suddenly and unexpectedly. Uranus always acts with no advance notice and always operates through other individuals or circumstances outside the person's control.

♃ △ or ✳ ♅ : This is one of the most fortunate aspects from the worldly point of view. Gives an unusual life, filled full of unexpected and out of the ordinary happenings. The sextile gives the opportunity to have an unusual life but the individual must take advantage of the opportunity. In the trine things happen without the individual having to do anything about it. This is the difference between the trine and the sextile. Finances are not a problem with this aspect though the wrong inner attitude toward money can make a multimillionaire a pauper. Has truly religious outlook. Advanced type of consciousness if the chart shows evolvement. Philosophical depth and capable of keen and accurate judgment. Brings development and success in middle life. Powerfully magnetic personality.

♃ □ ♅ : Conflict between the "status quo" and the desire for freedom and independence. Apt to be strong-willed. Judgment not always sound. Has the same liberal and religious outlook as the trine and conjunction but is more direct, forceful and expressive in promulgating their ideas. Needs to cultivate patience and forethought, for their reflexes are fast and their minds keen. Are apt to be impatient and irritable with the slower thinking individual. Needs to use discrimination where choice of friends are concerned. Could be financial loss through them.

♃ ☍ ♅ : Independent person with strong determination and will power. If judgment cooperates with intuition all will be well. The sign and aspects of Jupiter will show whether the judgment can be trusted or not. Individual will break away from orthodoxy and dogma but will continue to search for religious values that will be meaningful for him. This individual can act as a "cracker of shells" to those locked in attitudes that are stultifying and imprisoning. Great similarity between the opposition and the square where these two planets are concerned.

♃ ♂ ♆ : Clouds the judgment because emotions get in the way of logic. Imagination apt to play tricks where facts are concerned. Generous and sympathetic nature. Hates injustice and will sacrifice self in effort to irradicate it if the rest of the chart shows strength. If the chart is a weak one there will be compassion but there will be lack of

courage to act. Any aspect of Jupiter and Neptune can give difficulties with the liver; essential to use caution where diet, drugs, and alcohol are concerned.

♃ △ or ⚹ ♆ : The inner assumptions and the outer judgment are in harmony. Receptivity and openness bring benefits outwardly as well as inwardly. Individual is intuitive and psychic and should follow his inner leading. Courteous, kindly and sincere person. Religious tendencies strong. Can be mystical and drawn to religious and philosophical groups.

♃ □ ♆ : The tendency to exaggeration and confused emotions can cause difficulties in whatever areas these two energies are placed. Can cause person to be deceived or deceive, according to its house position. Not apt to see straight. The schemer and the dreamer who can be unstable as water, constantly veering and changing course. Apt to be unreliable and lacking in emotional control. Can be a weak character but seldom a mean or cruel one. Can be dominated by a stronger mind due to suggestibility.

♃ ☍ ♆ : Similar to the square but not as enervating and energy dissipating. Deception could come through others due to past karma. When either ends of this opposition are afflicted by strong planetary transits there could be financial loss through underhanded methods. Anyone with this aspect should scrutinize all documents and agreements very carefully before signing on the dotted line. Diet is important for there is apt to be trouble with the liver and also the lower back. Advanced methods of healing, rather than drugs, would be much better for this individual than medicine. Osteopathy, massage, light, heat and natural foods could be of great help if there were physical difficulties.

♄ ☌ ♅ : All aspects between Saturn and Uranus signify a rebellious spirit, strongly centered in the will to be free, and the unwillingness to accept any authority but its own. A battle between the world as it is at any moment in time, versus the world as it should be if everyone passed through (not around) the self discipline that would make that world possible. Uranus breaks the crystallization of Saturn, often painfully, to those who have this conjunction. When Saturn, by transit, stimulates this conjunction, the conservatism and conforming of the character would be apparent. When Uranus stimulates this aspect a completely different aspect of the personality would emerge. The rebel, who resents any restraint or restriction, would come to the surface and act precipitously and erratically and everyone around the individual would wonder what happened. An aspect that causes energy to simmer undercover for a long period of time, and then erupts explosively and erratically and blows all that has been painfully acquired to pieces.

♄ △ or ✳ ♅ : People born with this aspect have been born at this time in order to act as bridges between the age that is dying and the age that is coming to birth. They are able to balance both energies within themselves and thereby help others to understand what is happening. They do not destroy the ladder by which their brother climbs until he is ready to accept another way. Respecting the rights and traditions to which others cling, but inwardly free themselves, they are able to be effective agents in social sciences, humanitarian efforts and in all work that has to do with the communications media. Periodically Uranus will break the established pattern and set them free to work in other fields. Always it will be a better opportunity and a freer field of activity.

♄ □ ♅ : Trouble with those in authority and those who want to keep the status quo because it is safe. This battle rages within as well as without. Person bucks and resists changing for self will is strong and no one is going to tell him anything. Saturn wins in the outer world of appearance (the personality) because that is his domain. Uranus rules the spirit and the spirit is always free. Nothing can harm it yet it can not operate in the outer world without a form or mold to contain it. No one can break a cosmic law but they have the privilege of breaking their own neck trying. This is the lesson for those who have Uranus and Saturn in discordant aspect. Learn that freedom lies on the other side of Saturn, the planet of necessity and responsibility.

♄ ☍ ♅ : Partly selfishness and partly lack of practicability and common sense can cause difficulties. Torn between the necessity to conform because of wanting to feel safe and secure, and the desire to launch out into more expanded horizons and feel free. Must not act impulsively where business or partnership deals are concerned or there could be considerable loss. Needs to consult with those who would be wiser before coming to decisions.

♄ ☌ ♆ : Difficult aspect for Neptune dissolves the ability to see the outer world as it is. The impractical dreamer who would rather retreat from the world than relate to it. Has a mystical temperament with a deep passivity. Apt to be negative in outlook and subject to moods of depression and futility. Is fearful but never sure of the reason for fears are deepseated. Needs to analyze situations through reasoning power, not through emotions. When this individual gets into emotional situations reason flies out the window. Apt to lack judgment in business matters for the material world is of little concern unless the conjunction is in an earth sign. Then, if afflicted by other planets, there would be secretiveness, shrewdness and deviousness in business dealings. There could be undercover dishonesty.

♄ △ or ✳ ♆ : Brings in spiritual power and philosophical understanding. The inner assumptions and the outer facts are not at variance. The practical dreamer who can bring his ideas into concrete expression. This aspect often found in charts of those who could be initiates in this lifetime. Can investigate the inner planes of consciousness with no unpleasant repercussions.

♄ □ ♆ : Emotional fears that are hard to eradicate for they are so deeply embedded in the unconscious levels. Feelings of loneliness and isolation can be strong. Partly due to person's inability to relate to people in the outer world. Not enough understanding or empathy projected toward others. Feeling of insecurity and uncertainty only vaguely conscious but it is damaging to the personality. Should stay away from seances or anything that would open up the psychic senses. Could bring in obsessing forces. Look for the trines to Saturn or Neptune as the way out of the impasses where these energies are concerned. Any discordancy in a birth chart can be overcome if the individual recognizes that the world without is a reflection of the world within him. Look to the houses from which trines to the planets operate for they will give clues as to the path that can lead them out of the shadows into the Light.

♄ ☍ ♆ : Choice between hanging on to the ego structure and materialism, or letting go and trusting the inner spirit to direct and guide the life. Responsibility vs. escapism; materialism vs. spirituality; selfishness vs. sacrifice. The choice is there but choice there must be. No one on earth can get beyond influence but they can choose what will influence them. With this aspect the choice is very important. Difference between an integrated life or a disintegrated one.

URANUS AND NEPTUNE

Aspects between these planets operate for some time so many individuals are born with the same aspect. These two energies come from outer space, beyond our zodiac, to step up the vibration of the planet and bring it to a higher state of evolution. Mankind always responds negatively to new energies before he learns to respond positively to high forces. Therefore, for many people aspects between these two planets can be dumb notes or can be destructive. They are of importance when placed in the 1st, 4th, 7th or 10th house, or in relationship to the Sun, Moon or Mercury. In the angular houses, especially the conjunction or opposition, can cause great difficulty. It is too high a voltage for the average person to assimilate and can bring rebellion and self will and chaotic emotional conditions into the life.

Good aspects between Neptune and Uranus will be indicative of an advanced soul who has come to earth to serve the planet in some philosophical or religious way. Not at all orthodox in their approach to life. A new concept and new seeds would be sown in this life by this individual.

Brings into incarnation the spiritually intuitive people able to grasp first hand knowledge of spiritual truths. Uranus in good aspect to Neptune can make the person a spiritual psychic. In square or opposition can give psychism and intuitive powers but can become the dark occultist if he uses the power for self. The White Magician is used by the power to serve others. The Black Magician uses the power to serve himself and brings about his own downfall.

Those born with Neptune afflicted have attained spirituality in other lifetimes but have lost their equilibrium through not balancing their emotional or devotional fanaticism with mental poise and logic. In square or opposition can give psychism and intuitive powers but can become the dark occultist if he uses the power for self. The White Magician is used by the power to serve others. The Black Magician uses the power to serve himself and brings about his own downfall.

Ed. note: For Jupiter–Pluto aspects, see pp. 316–317; for Saturn–Pluto aspects, see pp. 317–319; for Uranus–Pluto aspects, see pp. 319–320; for Neptune–Pluto aspects, see p. 320.

CHAPTER 26
Birth Chart Calculation

LATITUDE AND LONGITUDE:

Before a horoscope can be set up for the place of birth, the latitude and longitude of the birth place must be found. Latitude shows how far in degrees the birth place is north or south from the equator, and longitude how far in degrees the birth place is east or west of Greenwich Observatory, England.

On the map, latitude is measured by lines running east and west parallel with the equator, and longitude by lines running north and south at right angles to the equator. The degrees of latitude are shown by numbers on the sides of the map at the points where the lines of latitude meet the margin. The degrees of longitude are shown at the top and bottom of the map in a similar way.

METHOD FOR DETERMINING TRUE LOCAL (OR SUN) TIME:

Previous to the establishment of the standard time system, each town and hamlet measured its time according to the sun. After the advent of the railroad, the telegraph, the telephone, etc., the sun time system proved inadequate and confusing.

At 12:00 o'clock noon, November 18, 1883, the United States was, therefore divided into four time belts called Eastern, Central, Mountain, and Pacific respectively.

Each of these belts is approximately 15 degrees of longitude in width and through the center of each runs what is called the standard time meridian for that belt.

The standard time meridian for the Eastern belt is the 75th degree of longitude; for the Central belt, the 90th degree of longitude; for the Mountain belt, the 105th degree of longitude; and for the Pacific belt, the 120th degree of longitude.

On these time meridians — 75, 90, 105, and 120 degrees, standard time and true local (or sun) time exactly agree. All the clocks for any time belt are arbitrarily set from its standard time meridian.

The heavenly bodies in their revolutions recognize no such manmade division of time, however, and unless the birth place be exactly on a standard time meridian, the astrologer must correct the standard (or clock) time back to its true local (or sun) time equivalent.

If the person for whom the horoscope is being set up was born previous to 12:00 o'clock noon, November 18, 1883, no such correction is necessary; for previous to that date all time was true local time and the following calculation may be omitted.

The method being used is the Simplified Calculation Method. It can be done through the use of logarithms if the student wishes. The simplified calculation method is an easier method giving the same results. The tables at the end of the chapter are not needed if the student has the Swiss Ephemeris that goes from 1890 to 1950. The tables in the back of that ephemeris are very concise and exact.

HOW TO CALCULATE BIRTHCHARTS

EQUIPMENT NEEDED:

Ephemeris for the year needed. There is a yearly ephemeris put out by an English firm called Raphaels Ephemeris. It is published about six months ahead of the year needed.

There is a Swiss Ephemerides that is excellent for students who will be working in the astrological field. It gives planetary positions from 1890 to 1950 and they are given for Noon Greenwich Mean Time (G.M.T.) This ephemeris has the planetary tables in the back of the book. If you have this book the planetary tables at the end of this chapter will not be needed.

There is a German Ephemeris that goes from 1850 to 1890 and another one that goes from 1890 to 1930. The 1930 to 1950 ephemeris goes from 1930 to 1950 and is based on Midnight G.M.T. This confuses the student for he must remember to figure from midnight and not from noon. The Rosicrucian Fellowship has an ephemeris that goes from 1950 to 1960, based on Noon G.M.T. There are two other ephemerides that will complete your equipment. They are put out by an English firm. They go from 1961 to 1965 and 1965 to 1969. Another very important booklet to own is one that is called "Geocentric Longitudes and Latitudes" by Raphael. It is inexpensive and gives the major planetary positions from 1900 to the year 2,000.

LONGITUDES AND LATITUDES FOR THE U.S.
LONGITUDES AND LATITUDES FOR THE WORLD

These books will eliminate the necessity of using an atlas to find longitude and latitude of the place of birth. It will give the True Local Time and the difference in that time to be added to give Greenwich Mean Time.

DALTON'S TABLES OF HOUSES

This is the book that will give the cusps of the houses for the degrees of latitude. The six signs from the 10th house Meridian to the third house cusp are given; the houses opposite to the first six signs will be the same degrees only in opposite signs. Example: 24' Sagittarius on the tenth house — the opposite house, the fourth house would have 24' Gemini on the cusp.

TIME CHANGES IN THE U.S. BY DORIS DOANE

This book is a "must" for the student for the Daylight Saving Times in the different states are not uniform. From February 1942 until the war ended the whole nation was on Daylight Saving Time all through the year. Often in different states the years had different daylight time changes.

These books may be ordered through Fellowship House Bookshop, 35 Maple Street, Watertown, Massachusetts 02172, or through any astrological supply house. Prices will be quoted on request.

STEP 1: Find the birth date in the ephemeris for the year wanted. The Sidereal Time for that day is shown. Take the Sidereal Time for the **NOON PREVIOUS** to the birth time. If it is an A.M. birth it will be the Sidereal Time for the day before. If P.M. it will be the same day. If A.M. birth go back to previous noon adding 12 hours (noon to midnight) and then add True Local A.M. Time to the 12 hours. If using a midnight ephemeris the process would be reversed, and the 12 hours would be added to the P.M. birth instead of to the A.M. time. **Example:** if the person was born at 7:08 A.M. in Boston you would take the Sidereal Time of the day before, adding 12 hours from the noon of the day before, to the 7:08 A.M., giving 19 hours 8 minutes before you add the true local time (T.M.T.). The 16 minutes that must be added to any Boston birth would make it 7:24 A.M. and that would be True Local Time.

STEP 2: From the **LONGITUDE AND LATITUDE BOOK** find the correct longitude and latitude for the place of birth. This will be given after the City and County. Boston, Massachusetts is on Page 46; Long. 71W4, Lat. 42N22. It is not necessary to use the 4 or 22. Los Angeles, California would be found on Page 9 and is 118W and 34N. There is a correction of 10 seconds for every 15 degrees of Longitude. This is very easy to calculate by multiplying the Longitude by 2 and dividing by 3. The answer will be in seconds.

 Example: 71 x 2 — 3 = 47 seconds correction for Boston.

 118 x 2 — 3 = 78 seconds. 1 minute 18 seconds for Los Angeles.

 This would be added to the Sidereal Time.

STEP 3: **TRUE LOCAL TIME OF BIRTH:** In the Longitude and Latitude book in the third column that has a heading "L.M.T. Variation from Standard Time," the time (in minutes and seconds) that should be added or subtracted to Standard Time is given. Also if it is **Daylight Saving Time** one hour must be subtracted.

Example: True Local Time for Boston add 15 minutes 44 seconds. To simplify matters, anything over 30 seconds can be called one minute. So add 16 minutes to Standard Time for a Boston birth time. This will be true local time for Boston. The time to be added to find out the Greenwich Mean Time is given in the last column. Add 4 hrs. 44 mins. to True Local Time for a Boston birth and it will give you 5 hours. This is the difference in hours between England and Boston. When it is noon in England it is 7 A.M. in Boston. When anyone is born at that time in Boston the planetary positions do not have to be figured. They can be taken directly from the ephemeris.

STEP 4: Correction of 10 seconds for every hour of True Local Time. This can be simplified by multiplyiing the hours by 10 and divide the minutes by 6. Every 6 minutes is a 1 second correction. Be sure that the answer is in seconds; if it goes over 59 seconds it must be reduced to minutes and seconds.

STEP 5: When all these figures are added together you will have the Sidereal Time at Birth Place at Birth Hour. In the Dalton Table of Houses find the nearest Sidereal Time to that sum. The Latitudes run vertically down the page. You will be given the signs and degrees for the houses that run from the 10th house to the third house cusp. The opposite signs with the same degrees must be inserted. The decimal points do not need to be put in the chart except for the first and seventh house cusps. Be sure you check the column for the degree number and not the number that is the decimal. **Example:** Page 5 — Lat. 48 — the 11th house cusp. The degree is not 6; that is the decimal point. It is 25.6 but the .6 can be left out. Students often fail to do a correct chart because of this error.

This calculated Birthchart can be used as a sample chart. Do it yourself and then compare it with the one given here.

Person born at Boston, Massachusetts, on July 27th, 1968 at 7:32 A.M. Long. 71, Lat. 42, Daylight Saving Time. There would be an hour subtracted, making it Standard Time — 6:32 A.M.

SIGNS

♈ Aries	♎ Libra		
♉ Taurus	♏ Scorpio		
♊ Gemini	♐ Sagittarius		
♋ Cancer	♑ Capricorn		
♌ Leo	♒ Aquarius		
♍ Virgo	♓ Pisces		

PLANETS

♂ Mars	☽ Moon		
♃ Jupiter	☿ Mercury		
♄ Saturn	♀ Venus		
♅ Uranus	☉ Sun		
♆ Neptune	♇ Pluto		

MID-HEAVEN
South

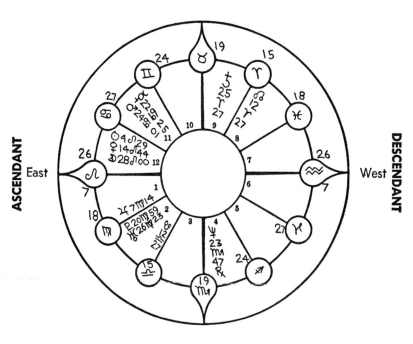

North
NADIR

THE ASPECTS

Star of Destiny ☉
Moon's North Node ♈
Moon's South Node ♎

3	Cardinal ♄ ☿ ♂
4	Fixed ☉ ♀ ☽ ♆
3	Mutable ♇ ♅ ♃
4	Fire ☽ ☉ ♀ ♄
3	Earth ♇ ♃ ♅
3	Water ♆ ☿ ♂
0	Air

SAMPLE CHART
July 27, 1968 — 6:32 A.M. S.T.
Boston, Massachusetts. 41 Lat. 72 Long.

	H.	M.	S.
Sidereal Time for Noon PREVIOUS to birth.	8	16	58
Correction of 10 seconds for every 15' of Long. (L. x 2 ÷ 3)			47
True Local Time (from previous noon) 6:32 plus 16 mins. plus 12 hrs. =	18	48	
Correction of 10 seconds every hour of LMT= 188 seconds.	+	3	08

	H.	M.	S.
	26	67	113
—			60
	26	68	53
—		60	
	27	08	53
—	24		
	3	08	53

These figures must be reduced for there cannot be more than 59 seconds without going over into the minute column. 60 minutes equals 1 hour and must be transferred to the hour column. You will be able to do this reduction mentally but in order to show you it will be done in detail. If the sum goes over 23 hrs. 59 mins. subtract 24 hrs. for there cannot be more than 24 hours in a day. This is the Sidereal Time at Birth Place at Birth Hour.

To find the Nearest Sidereal Time in Table of Houses look at the column nearest in numbers where it says "Upper Meridian, Cusp of 10th house." In this chart it will be found on Page 10 — the last column. Nearest Sidereal Time is

	H.	M.	S.
	3	06	10

This sidereal time gives you the cusps of the houses for the individual born in Boston, July 27th at 6:32 S.T.

In the first column under Latitudes find the Latitude 42. The 10th house will have 19 ♉ on the cusp. 11th house will have 24 ♊ on the cusp; 12th will have 27 ♋ on its cusp. The 1st house cusp will be 26 ♌ 7, the second house 18 ♍ and the third house 15 ♎ . The opposite houses will have the opposite signs with the same degrees. The birth chart will look like this one.

You will be able to know if your mathematics are correct by the position of the Sun. If it falls in the 8th house and you have a morning birth you will know your calculations are wrong. The chart showing the comparative position of the Sun (it varies slightly with the seasons of the year) is a big aid to the beginning student. It is a check on the calcutions.

The Sun must fall in or near the houses that show the time of day the person is born. If it doesn't fall in its rightful section go over your calculations for there is an error in the mathematics.

FINDING THE PLANETARY POSITIONS

As the ephemeris for the positions of the planets is calculated for Greenwich, England it is necessary to translate the true local time at the birthplace into its Greenwich Mean Time equivalent in order to discover the planetary positions.

The calculation appears as follows: add the figures shown in the last column of the Longitude and Latitude book to obtain G.M.T. Adding correction of 4:44 hours to 6:48 Boston True Local Time gives 11:32 A.M. G.M.T. If it were 1:30 P.M. it would be 1:51 L.MT and adding 4:44 would make it 6:30 P.M. in England.

When a correction is added to a P.M. birth, it very often results in changing the day; do be sure not to overlook these changes.

G.M.T. is the only time equation used in calculating the planetary positions, for by this correction we have, so to speak, moved the birthplace to Greenwich, England.

Use the tables provided at the end of this chapter, or in the Swiss Epherides from 1890 to 1950 for a rapid calculation of the planet's place in the chart.

FINDING THE MOON'S POSITION

Turn to the ephemeris for the day of birth. Note the position of the Moon for the coming noon and subtract it from the previous noon to find the travel of the Moon for 24 hours.

Taking our sample chart (July 27, 1968 at 11:32 A.M. G.M.T.) we find the coming noon position of the Moon to be the same day. It is 28 ♌ 16. The day previous it was 15 ♌ 22. So it's travel for 24 hours is 12 hours 54 minutes. In 28 more minutes it will be noon in Greenwich so we need to find the travel of the Moon for 28 minutes and subtract it from the Noon position. In the table for finding the hourly motion of the Moon and the horizontal line across the top of the page shows the travel of the Moon in 24 hours. The vertical line gives the minutes and hours of its travel in the 24 hour span. Under 12:56 (the nearest to 12:54) we find it travels 16 minutes in 30 minutes. As it is before noon subtract that 16 minutes from the Noon position of the moon; 28 ♌ 16 minus 16 minutes makes it 28 ♌ 00.

Supposing the person was born at 4:30 P.M. in Boston on the same day. You would take the coming position of the Moon (the next day) and subtract the position of the Moon on the day of birth.

Coming Noon	11	22
Previous Noon —	28	16
	13	06

You cannot subtract 11 from 28 so you add
30 to 11, making it 41 and subtract from 41.

Adding 4:44 difference to 4:46 P.M. gives G.M.T. as 9:30 PM The
travel for the Moon in 9 hours 14 minutes. It is just as easy to take stan-
dard time in Boston and add 5 hours for we are always 5 hours ahead of
England. In the Table, find the column under 13:06. Going down the col-
umn to 9:00 you will find it has moved 4 degrees and 55 minutes. In the
Swiss ephemeris the tables are given in clear relationship. It will bring it to
within five minutes. To the previous noon we add to 28 ♌ 16 the amount
of travel (4:55). The Moon will be at 3 ♍ 11. The addition may
bother you for when they are added the sum is 32:71. Take the 60 minutes
off the 71 and add it to the hours making it 33:11; one can't go over 30
degrees so subtract the 30 (bringing it into the next sign) and you have
3 Virgo 11. The Moon's position in the birthchart will be 3 Virgo 11 and
should be inserted in its proper place.

If you are like the author you will be ready to throw up your hands
when you are studying the mathematics involved. But don't quit. Like
driving a car, it becomes an automatic process after it is learned. The
ones who have the most difficulty with the mathematics are always the
best interpreters of the chart. Because I found logarithms and all the
complications entailed in setting up charts difficult I searched until I
found an easier way that would give the same answers.

Finding the positions of the planets is done is the same manner only
using the Table for the Hourly Motions of the planets. It is not necessary
to travel the heavy planets. Mercury, Mars and Venus can be traveled for
they move quickly. After a short time you will be able to interpolate
and travel planets mentally. For instance: Mars moves 39 minutes be-
tween the 27th and 28th of July. 1968. In 12 hours it would move 20
minutes and in six hours approximately 10 minutes. The minutes are sel-
dom used unless it is very close to the cusp of a house or to another planet.
At first it is well to travel the faster moving planets as a means of learn-
ing how to calculate planetary positions. The Sun moves about a degree a
day. The Moon 11 to 15 a day. When the Moon is moving beyond 13 degrees
on the day of birth the person gets out into personality activity in life
earlier than the individual with the slow moving Moon. His reflexes and
responses are quicker.

Taking the calculation of Venus July 27, 1968, for the birthtime in
our sample chart;

Coming Noon Position	14 Leo	44
Previous Noon Position —	13	30
Travel in 24 hours	1	14

In the Table for Planetary Motion, whether you use the tables in the back of the Swiss Ephemeris for 1890 to 1950, or the tables at the end of this chapter the result will be the same. I prefer to use the Swiss tables for they give the times in more minute detail.

In the tables for the hourly motions of the planets you will find 1 15 to be the nearest travel to 1 14. Under that column you will find the travel for 30 minutes (closest given to 28 minutes difference) will be 1 minute 33 seconds. Subtracting 1 minute (because it is before noon) will put Venus in 14 Leo 43.

If the birth that day was at 11 P.M. G.M.T. (that would be 6 P.M. in Boston) you would find 11:00 on the vertical line and find under 1:15 that the motion for that amount of time would be 34 minutes and 22 seconds.

Previous Noon	14 Leo 44
Motion	+ 34.22
	15 Leo 18.22

Paste the Moon's Motion Tables in the front of the Table of Houses one on each page, facing each other; put the planetary Motions in the back of the Table of Houses and they will be at hand for reference whenever a chart is calculated.

A TABLE FOR FINDING THE HOURLY MOTIONS OF THE PLANETS

Part 1.

Hr. Min.	10'	15'	20'	25'	30'	35'	40'	45'	50'	55'	60'	1005'	1010'
	′ ″	′ ″	′ ″	′ ″	′ ″	′ ″	′ ″	′ ″	′ ″	′ ″	′ ″	0′ ″	0′ ″
00:30	012	018	025	031	037	043	050	056	102	108	115	0 121	0 127
1:00	025	037	050	102	115	127	140	152	205	217	230	242	255
1:30	037	055	115	133	152	211	230	248	307	326	345	403	422
2:00	050	115	140	205	230	255	320	345	410	435	500	525	550
2:30	102	133	205	236	307	338	410	441	512	543	615	646	717
3:00	115	152	230	307	345	422	500	537	615	652	730	807	845
3:30	127	211	255	338	422	506	550	633	717	801	845	928	1012
4:00	140	230	320	410	500	550	640	730	820	910	1000	1050	1140
4:30	152	248	345	441	537	633	730	826	922	1018	1115	1211	1307
5:00	205	307	410	512	615	717	820	922	1025	1127	1230	1332	1435
5:30	217	326	435	543	652	801	910	1018	1127	1236	1345	1453	1602
6:00	230	345	500	615	730	845	1000	1115	1230	1345	1500	1615	1730
6:30	242	404	525	646	807	928	1050	1211	1332	1457	1615	1736	1857
7:00	255	423	550	717	845	1012	1140	1307	1435	1602	1730	1857	2025
7:30	307	441	615	748	922	1056	1230	1403	1537	1711	1845	2018	2152
8:00	320	500	640	820	1000	1140	1320	1500	1640	1820	2000	2140	2320
8:30	332	519	705	851	1037	1223	1410	1556	1742	1928	2115	2301	2447
9:00	345	538	730	922	1115	1307	1500	1652	1845	2037	2230	2422	2615
9:30	357	556	755	953	1152	1351	1550	1748	1947	2146	2345	2543	2742
10:00	410	615	820	1025	1230	1435	1640	1845	2050	2255	2500	2705	2910
10:30	422	634	845	1056	1307	1518	1730	1941	2152	2403	2615	2826	3037
11:00	435	653	910	1127	1345	1602	1820	2037	2255	2512	2730	2947	3205
11:30	447	711	935	1158	1422	1646	1910	2133	2357	2621	2845	3108	3332
12:00	500	730	1000	1230	1500	1730	2000	2230	2500	2730	3000	3230	3500
12:30	512	749	1025	1301	1537	1813	2050	2326	2602	2838	3115	3351	3627
13:00	525	808	1050	1332	1615	1857	2140	2422	2705	2947	3230	3512	3755
13:30	537	826	1115	1403	1652	1941	2230	2518	2807	3056	3345	3633	3922
14:00	550	845	1140	1435	1730	2025	2320	2615	2910	3205	3500	3755	4050
14:30	602	904	1205	1506	1807	2108	2410	2711	3012	3313	3615	3916	4217
15:00	615	923	1230	1537	1845	2152	2500	2807	3115	3422	3730	4037	4345
15:30	627	941	1255	1608	1922	2236	2550	2903	3217	3531	3845	4158	4512
16:00	640	1000	1320	1640	2000	2320	2640	3000	3320	3640	4000	4320	4640
16:30	652	1019	1345	1711	2037	2403	2730	3056	3422	3748	4115	4441	4807
17:00	705	1038	1410	1742	2115	2447	2820	3152	3525	3857	4230	4602	4935
17:30	717	1056	1435	1813	2152	2531	2910	3248	3627	4006	4345	4723	5102
18:00	730	1115	1500	1845	2230	2615	3000	3345	3730	4115	4500	4845	5230
18:30	742	1134	1525	1916	2307	2658	3050	3441	3832	4223	4615	5006	5357
19:00	755	1153	1550	1947	2345	2742	3140	3537	3935	4332	4730	5127	5525
19:30	807	1211	1615	2018	2422	2826	3230	3633	4037	4441	4845	5248	5652
20:00	820	1230	1640	2050	2500	2910	3320	3730	4140	4550	5000	5410	5820
20:30	832	1249	1705	2121	2537	2953	3410	3826	4242	4658	5115	5531	5947
21:00	845	1308	1730	2152	2615	3037	3500	3922	4345	4807	5230	5652	10115
21:30	857	1326	1755	2223	2652	3121	3550	4018	4447	4916	5345	5813	10242
22:00	910	1345	1820	2255	2730	3205	3640	4115	4550	5025	5500	5935	10410
22:30	922	1404	1845	2326	2807	3248	3730	4211	4652	5133	5615	10056	10537
23:00	935	1423	1910	2357	2845	3332	3820	4307	4755	5242	5730	10217	10705
23:30	947	1441	1935	2429	2922	3416	3910	4403	4857	5351	5845	10338	10832
24:00	1000	1500	2000	2500	3000	3500	4000	4500	5000	5500	6000	10500	11000

Part 2.

Hr. Min.	1015'	1020'	1025'	1030'	1035'	1040'	1045'	1050'	1055'	2000'	2005	2010'
00:30	0 133	0 140	0 146	0 152	0 158	0 205	0 211	0 217	0 223	0 230	0 236	0 242
1:00	307	320	332	345	357	410	422	435	447	500	512	525
1:30	441	500	518	537	556	615	633	652	711	730	748	807
2:00	615	640	705	730	755	820	845	910	935	1000	1025	1050
2:30	748	820	851	922	953	1025	1056	1127	1158	1250	1301	1332
3:00	922	1000	1037	1115	1152	1230	1307	1345	1422	1500	1537	1615
3:30	1056	1140	1223	1307	1351	1435	1518	1602	1646	1730	1813	1857
4:00	1230	1320	1410	1500	1550	1640	1730	1820	1910	2000	2050	2140
4:30	1403	1500	1556	1652	1748	1845	1941	2037	2133	2230	2326	2422
5:00	1537	1640	1742	1845	1947	2050	2152	2255	2357	2500	2602	2705
5:30	1711	1820	1928	2037	2146	2255	2403	2512	2621	2730	2838	2947
6:00	1845	2000	2115	2230	2345	2500	2615	2730	2845	3000	3115	3230
6:30	2018	2140	2301	2422	2543	2705	2826	2947	3108	3230	3357	3512
7:00	2152	2320	2447	2615	2742	2910	3037	3205	3332	3500	3627	3755
7:30	2326	2500	2623	2807	2941	3115	3248	3422	3656	3730	3903	4037
8:00	2500	2640	2820	3000	3140	3320	3500	3640	3820	4000	4140	4320
8:30	2633	2820	3006	3152	3338	3525	3711	3857	4043	4230	4416	4602
9:00	2807	3000	3152	3345	3537	3730	3922	4115	4307	4500	4652	4845
9:30	2941	3140	3338	3537	3736	3935	4133	4332	4531	4730	4928	5127
10:00	3115	3320	3525	3730	3935	4140	4345	4550	4755	5000	5205	5410
10:30	3248	3500	3711	3922	4133	4345	4556	4807	5018	5230	5441	5652
11:00	3422	3640	3857	4115	4332	4550	4807	5025	5242	5500	5717	5935
11:30	3556	3820	4043	4307	4531	4755	5018	5242	5506	5730	5953	10217
12:00	3730	4000	4230	4500	4730	5000	5230	5500	5730	10000	10230	10500
12:30	3903	4140	4416	4652	4928	5205	5441	5717	5953	10230	10506	10742
13:00	4037	4320	4602	4845	5127	5410	5652	5935	10217	10500	10742	11025
13:30	4211	4500	4748	5037	5326	5615	5903	10152	10441	10730	11018	11307
14:00	4345	4640	4935	5230	5525	5820	10115	10410	10705	11000	11255	11550
14:30	4518	4820	5121	5422	5723	10025	10326	10627	10928	11230	11531	11832
15:00	4652	5000	5307	5615	5922	10230	10537	10845	11152	11500	11807	12115
15:30	4826	5140	5453	5807	10121	10435	10748	11102	11416	11700	12043	12357
16:00	5000	5320	5640	10000	10320	10640	11000	11320	11640	12000	12320	12640
16:30	5133	5500	5826	10152	10518	10845	10211	11537	11903	12230	12556	12922
17:00	5307	5640	10012	10345	10717	11050	11422	11755	12127	12500	12832	13205
17:30	5441	5820	10158	10537	10916	11255	11633	12012	12351	12730	13108	13447
18:00	5615	10000	10345	10730	11115	11500	11845	12230	12615	13000	13345	13730
18:30	5743	10140	10531	10922	11313	11705	12056	12447	12838	13230	13621	14012
19:00	5922	10320	10717	11115	11512	11910	12307	12705	13102	13500	13857	14255
19:30	10056	10500	10903	11307	11711	12115	12518	12922	13326	13730	14133	14537
20:00	10230	10640	11050	11500	11910	12320	12730	13140	13550	14000	14410	14820
20:30	10430	10820	11236	11652	12108	12525	12941	13357	13813	14230	14646	15102
21:00	10537	11000	11422	11845	12307	12730	13152	13615	14037	14500	14922	15345
21:30	10711	11140	11608	12037	12506	12935	13403	13832	14301	14730	15208	15627
22:00	10845	11320	11755	12230	12705	13140	13615	14050	14525	15000	15445	15910
22:30	11018	11500	11941	12422	12903	13345	13826	14307	14748	15230	15721	20152
23:00	11152	11640	12127	12615	13102	13550	14037	14525	15012	15500	15957	20435
23:30	11326	11820	12313	12807	13301	13755	14248	14742	15236	15730	20233	20717
24:00	11500	12000	12500	13000	13500	14000	14500	15000	15500	20000	20500	21000

A TABLE FOR FINDING THE HOURLY MOTION OF THE MOON
Part 1.

Hr. Min.	1103°6'	1104°6'	1105°6'	1200°6'	1201°6'	1202°6'	1203°6'	1204°6'	1205°6'	1300°6'	1301°6'
00:30	014	014	015	015	015	015	016	016	016	017	017
1:00	028	029	030	030	030	031	031	032	032	033	033
1:30	043	044	044	045	045	047	048	048	049	049	050
2:00	058	058	059	100	101	102	104	104	105	105	106
2:30	113	113	114	115	115	117	120	120	121	122	123
3:00	127	128	129	130	130	133	135	136	137	138	139
3:30	141	143	144	145	146	149	151	152	153	155	156
4:00	156	158	159	201	203	204	206	208	210	212	213
4:30	210	213	214	216	219	220	221	224	226	237	238
5:00	225	228	229	231	233	236	237	240	242	242	243
5:30	240	242	244	246	248	252	253	255	258	259	300
6:00	254	257	259	301	304	306	309	311	314	315	316
6:30	308	312	314	316	320	321	325	327	330	332	334
7:00	323	326	329	332	334	336	340	343	346	348	352
7:30	338	341	344	347	349	353	356	359	402	405	409
8:00	352	356	358	402	405	409	412	415	418	422	426
8:30	406	410	413	417	420	425	428	431	435	439	442
9:00	421	425	428	432	436	440	443	447	451	455	459
9:30	435	440	443	447	452	455	459	503	507	511	515
10:00	450	455	458	502	507	511	515	519	523	527	531
10:30	505	509	513	518	532	527	531	535	540	544	548
11:00	519	524	528	533	537	542	546	551	556	600	605
11:30	534	539	543	548	552	557	602	607	614	616	621
12:00	548	554	558	604	608	613	618	623	628	632	637
12:30	602	608	613	619	624	629	634	639	644	649	654
13:00	617	623	628	633	639	644	649	655	700	706	711
13:30	632	637	642	648	654	659	705	711	716	722	728
14:00	646	651	657	703	709	715	721	727	732	738	744
14:30	701	706	712	718	725	731	737	743	749	755	801
15:00	715	721	727	734	740	746	752	759	805	811	817
15:30	729	735	742	749	756	801	808	815	821	828	835
16:00	744	750	757	804	811	817	824	831	837	844	852
16:30	759	804	812	819	826	832	839	846	855	901	908
17:00	813	819	827	834	842	848	855	902	912	917	924
17:30	826	834	842	849	857	903	911	918	927	933	941
18:00	842	848	857	904	912	919	927	934	942	949	957
18:30	856	903	911	920	928	935	942	950	958	1006	1014
19:00	911	919	926	935	943	951	958	1006	1014	1022	1030
19:30	926	933	941	950	958	1007	1014	1022	1031	1039	1047
20:00	940	948	956	1005	1013	1022	1030	1038	1047	1055	1104
20:30	954	1004	1011	1020	1029	1037	1046	1054	1103	1112	1122
21:00	1009	1019	1026	1035	1044	1053	1101	1110	1119	1128	1139
21:30	1024	1033	1041	1050	1100	1108	1117	1126	1135	1144	1155
22:00	1038	1047	1056	1105	1115	1124	1133	1142	1151	1200	1210
22:30	1053	1102	1111	1120	1130	1140	1149	1158	1208	1217	1227
23:00	1107	1117	1126	1136	1145	1155	1204	1214	1224	1233	1243
23:30	1121	1131	1141	1151	1200	1210	1220	1230	1240	1250	1300
24:00	1136	1146	1156	1206	1216	1226	1236	1246	1256	1306	1316

A TABLE FOR FINDING THE HOURLY MOTION OF THE MOON

Part 2.

Hr. Min.	13026′	13036′	13046′	13056′	14006′	14016′	14026′	14036′	14046′	14056′	15006′
00:30	016	017	017	017	017	018	018	018	018	018	019
1:00	033	034	034	035	035	036	036	036	037	037	038
1:30	050	051	051	052	052	053	053	053	055	056	057
2:00	107	108	109	110	110	111	112	113	114	115	116
2:30	124	125	126	128	128	129	130	131	132	133	135
3:00	141	143	144	146	146	147	148	149	151	152	153
3:30	157	159	201	202	203	205	206	207	209	210	212
4:00	214	216	218	219	221	223	224	226	228	229	231
4:30	230	233	235	236	238	240	242	244	246	148	250
5:00	247	250	252	254	256	258	300	302	305	307	309
5:30	304	307	309	311	313	316	318	320	323	325	327
6:00	321	324	326	329	331	334	336	339	341	344	346
6:30	338	341	343	346	349	352	354	357	359	403	405
7:00	355	358	401	404	407	410	413	416	418	422	425
7:30	412	415	418	421	424	437	431	434	436	440	443
8:00	429	432	435	439	442	445	449	452	455	459	502
8:30	445	449	452	456	500	503	507	510	513	517	521
9:00	502	506	510	513	518	521	525	528	532	536	539
9:30	519	523	527	530	535	539	543	546	550	554	558
10:00	536	540	544	548	552	557	601	605	609	613	618
10:30	552	557	601	605	610	614	619	623	627	632	636
11:00	609	614	619	623	628	631	637	641	646	651	655
11:30	626	631	636	640	645	649	655	659	704	709	714
12:00	643	648	653	658	703	708	713	718	723	728	733
12:30	701	705	710	715	720	725	731	736	741	746	751
13:00	719	722	727	733	738	743	749	754	800	805	810
13:30	734	737	744	750	755	801	807	812	818	823	829
14:00	750	756	802	807	813	819	825	831	837	842	848
14:30	807	813	819	824	831	837	842	849	855	900	907
15:00	824	830	836	842	849	855	900	907	914	918	926
15:30	840	847	853	859	906	913	918	925	932	937	945
16:00	857	904	911	917	924	931	937	944	951	957	1004
16:30	914	921	928	934	941	949	955	1002	1009	1016	1023
17:00	931	938	945	952	959	1006	1013	1020	1028	1035	1042
17:30	947	955	1002	1009	1016	1024	1031	1038	1046	1053	1101
18:00	1004	1012	1019	1027	1034	1042	1049	1057	1104	1112	1120
18:30	1021	1028	1036	1044	1052	1100	1107	1115	1122	1130	1138
19:00	1038	1045	1054	1102	1110	1118	1126	1133	1141	1149	1157
19:30	1055	1102	1111	1119	1127	1135	1144	1151	1159	1208	1216
20:00	1112	1120	1128	1137	1145	1153	1202	1210	1218	1227	1235
20:30	1128	1137	1145	1154	1202	1211	1220	1228	1236	1245	1254
21:00	1145	1154	1202	1211	1219	1229	1238	1246	1254	1304	1313
21:30	1202	1210	1220	1228	1237	1247	1258	1304	1313	1322	1332
22:00	1219	1226	1238	1246	1255	1305	1318	1323	1332	1341	1351
22:30	1235	1244	1255	1304	1313	1322	1334	1341	1350	1400	1410
23:00	1252	1302	1312	1321	1331	1340	1350	1359	1409	1419	1429
23:30	1309	1319	1329	1338	1348	1358	1408	1417	1427	1437	1447
24:00	1326	1336	1346	1356	1406	1416	1426	1436	1446	1456	1506

CALCULATIONS FOR THE SOUTHERN HEMISPHERE

Charts for the Southern Hemisphere must be calculated the same AS FOR THOSE IN NORTHERN LATITUDES, but twelve hours must be added for Southern Hemisphere. By adding 12 hours to the Sidereal Time and taking the opposite sign you will get the Ascendant for the Southern Hemisphere. The 10th house sign will be on the 4th house; the 11th house sign and degree will be on the 5th house, etc.

Example: Birthdate: May 16, 1966 at Sydney, Australia at 3:50 p.m. 34 S. 151 E.

	H.	M.	S.
Sideral Time for Noon Previous			
Correction for each 15' of Long. subtracted due to it being East of Greenwich L x 2 ÷ 3 = 1 min.	3	35	03
40 seconds.	—	1	40
	3	33	23

This sum was arrived at by borrowing 60 seconds and adding it to the last column.

		H.	M.	S.
True Local Time		3	33	23
Correction of 10 seconds for each hour.		3	54	
	+			39
		6	87	62
Sideral Time at B.P. at B.H. equals		7	29	02
Add 12 Hours.	+	12		
		19	29	02

The nearest Sidereal Time is 19. 30. 49.

When inserting the cusp signs the houses must be reversed, putting the 10th house sign on the 4th house, the 11th on the 5th, etc.

Reverse the cusps, putting 21' Capricorn on the 4th House, 15' Aquarius on the fifth house, 20 Pisces on the sixth house, 4 Taurus on the seventh house, 5 Gemini on the eighth house and 28 Gemini on the ninth house. It is just the reverse to the Northern Hemisphere.

The Longitudes and Latitudes for the World is a necessary book to have for those students who are doing charts outside the United States.

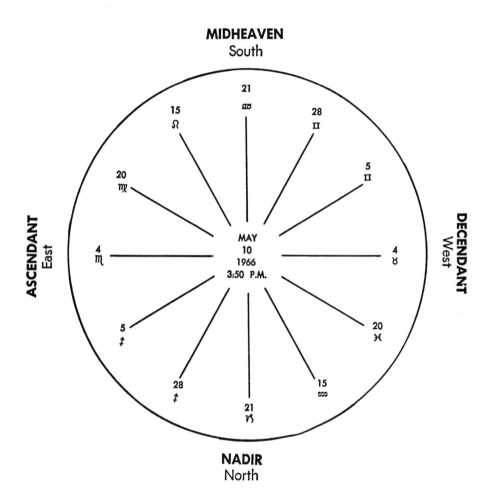

SOUTHERN HEMISPHERE

SYDNEY, AUSTRALIA

CHAPTER 27
Some Information About Transits

Transits are the day by day positions of the planets as they affect the natal chart. The natal chart never changes but changing energies (transits) playing on the magnetic field of the earth affect us, either for good or ill, according to our response to those energies. We do not have to respond negatively but the average person doesn't know that he can control his stars and not be controlled by them. The faster moving planets — the Moon, Venus, Mars, Sun and Mercury effect the personal everyday affairs of an individual's life. The slower and heavier planets are the ones that bring the big changes into our lives. Transits are the outside world affecting us. Progressions are the changes of consciousness within, bringing corresponding changes of environment without.

Why are we more relaxed and better natured one day than another? Perhaps we have a transit of Venus over our Sun or Moon. We respond to it unconsciously. Are our nerves on edge? Mercury may be transiting Mars. Mercury transiting Saturn may give us a day or two of depression if we accept it negatively or more responsibility than usual if we have learned how to work with Saturn. Saturn transiting Mercury will be much longer lasting and calls for more patience because Saturn is slower in motion and usually goes forward, retrogrades and then goes forward again.

The transits are stronger when applying by conjunction or opposition; next in strength are the squares and trines. If the basic meaning of the planets is understood it will not be difficult to know their influences by transit or progression.

The longer the transit the more profound and far-reaching the effect of it. The slower moving planets create effects that affect the life and the personality more deeply and more permanently than the faster ones. Neptune and Uranus are the slowest in motion, Saturn is next and then Jupiter. The Moon, Sun, Mars, Mercury, and Venus are faster in motion.

The transiting planets' aspects are felt as they are applying by transit to the natal planets. By the time they have reached the exact degree their work is done. If a planet stops on a natal planet that energy will be very important and have a strong effect. In the summer of 1968 Saturn came to 25 degrees of Aries. Anyone with planets in 25 degrees of the signs would have felt that influence strongly. If it conjuncted a planet it would be a difficult transit for it would block, delay, test and try the soul. If it opposed a planet then others would be the cause of the difficulty or blockage. If it trined any planet in 25 degrees the person would be re-

Ed. note: For discussion of the transits of Pluto, see pp. 321–328.

warded for work done in the past and the responsibilities accepted would prove beneficial in the outer world. Expect the energy to operate 3 to 5 degrees ahead of its exact conjunction to the planet.

Always look to the birth aspects of the planets involved to know how the transits will work. If they are in harmony at birth and afflicted by transit there will be difficulties but they will be much easier to handle than when the planets involved were afflicted at birth. We cannot escape influences but we can decide what we will allow to influence us. The transits show how the tides are running and what kind of a cycle is operating so we can take advantage of the Cosmic tides or fail to grasp the moment and not use it to our advantage.

The position of transits of the heavier planets by house are important.

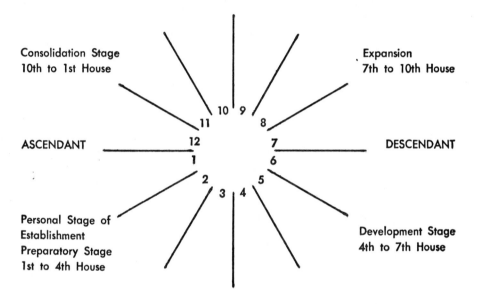

In first to fourth house, matters are in a preparatory stage; move slowly. Not a quick turnover position. Whatever is attempted should be with a long view or long term goal in mind.

In fourth to seventh house energies are being reorganized to take full advantage of expansion.

In seventh to tenth house there are opportunities to bring things started into full expression.

When the heavy planets are coming from the 10th house to the Ascendant it is time for consolidation; consolidating on inner levels and learning to handle sensitivities and feelings in terms of the self. From the 7th to 10th house it is outer activities that are important. From the 10th to the 1st house it is what's happening on the inside that is of deep importance.

When the heavy planets are going from the first to the fourth house it is a period of withdrawal, of retreat from outer activities, and heralds a period of re-evaluation and reassessment. It is not the time to institute new action if Saturn is the planet transiting from the first through the third house.

For example: When Saturn would be transiting the 2nd house build to make resources permanent, whether they be skills or finances, and try to establish the affairs of that house. Saturn is the necessity principle. Stabilize finances and demonstrate that you can handle your material affairs wisely.

Jupiter represents outside opportunity wherever it is transiting. Neptune, wherever it is by transit, stick to what you know. Not what you feel or think or imagine but what you know. Wherever Uranus is transiting look for unexpected and sudden changes. These changes will come through the actions of others. Your reactions will be all important. Uranus will be transiting a house for a long time. It will be when it affects a planet in the house or the ruler of the cusp that it will be activated. Where Neptune, by transit is affecting the chart there is an element of sacrifice. Uranus is sudden, direct, forceful and out in the open. Neptune is subtle, pervasive and undercover. It works under the surface to melt the ego down and dissolve barriers. In a negative way it would be similar to the termites that live and work in wood a long time before their damage is known on the outside or the cancer cells that are doing damage long before they appear on the surface.

Mars is the activating principle. Wherever it is transiting in the natal chart there is action. The energy must be used constructively or there will be strife and contention. Example: when Saturn by transit conjuncts natal Mars in the third house it becomes a necessity to change the mental attitude about things or people in the environment. It will be easier to handle if Mars and Saturn are in harmony in the natal chart. Saturn transiting Mars can be aggravating but activity plus common sense can bring in a new cycle.

The New Moon as it transits in a house stirs up activity in the area where it falls. If it conjuncts or opposes a planet it stirs up activity of the nature of that planet. It will be activated from the New Moon to the Full Moon. If new activity is initiated it should be started after the New Moon. If it is started in the last quarter of the Moon, especially the last three days of the old Moon, it will fail to come to fruition. Take a job on the dark of the Moon (the last three days) and you will not stay in it. It is the time to plan but not to instigate. Nature has an ebb and flow like the tides in the ocean. The tides can be used or neglected. Everything in nature is on the upswing between the New and Full Moon; when its energy starts to recede and is ebbing, the tide is at its greatest passivity before the New Moon. Note the lack of pep and vitality in people in the last phases of the dying Moon. Everything is dragging and only those interested in Cosmic laws know why it is so.

Venus transits ease the way and bring social contacts and happy

times. In planning a party use trines or conjunctions of the Moon and Venus and the party will be successful. Venus transits are only a matter of a few days, but if one of the larger planets transit the natal Venus it will be longer lasting and much more potent. If Uranus comes to an aspect of Venus it can have a tremendous impact on the love consciousness. If the person is looking for a romantic sizzle this can be it. If it is a trine aspect it can bring a sudden marriage or union; if it squares or opposes Venus the romance can come but when Uranus passes the romance can go with it. However Uranus never leaves an individual where it finds him and there is a recognition and a deeper insight into the meaning of love. If the person is in a marriage when Uranus transits Venus they may want to break the ties but it would be a poor time to do so. After the transit is over they may regret their decisions. Often a new relationship looks far more attractive than the old one but there is an erraticness and an instability in Uranus aspects to Venus that need to be taken into consideration. Uranus contacts to Mercury are very important for it changes consciousness; new insights and illuminations change the values forever. When the transiting Mercury afflicts natal Uranus be careful what is said or put in writing. Don't speak out of turn even if it is the truth. If the other fellow talks disagreeably pass up the tendency to retort in kind.

A Mercury transit is not long lasting but when it afflicts Saturn, Neptune or Uranus scrutinize all papers and documents that need your signature. Be careful what you write or what you say. Good aspects to Uranus bring unexpected freedom and favorable news. Excellent for writing, catching up on correspondence. Mail will be important and contact with relatives beneficial. Mercury square to Neptune will be a short transit causing mental confusion. Don't gossip or listen to it. Neptune transiting in affliction to natal Mercury is longer lasting and much more difficult. Gives mental and emotional confusion, inaccuracy of thought and errors of judgment due to irrational reasoning. Sacrifice of self for relatives or troubles with them can present problems. Excessive use of alcohol or drugs can destroy the nerves and brain cells. The tendency to procrastinate and day dream rather than doing will be great. Mercury transiting in affliction to Saturn is a matter of a few days. The mind is apt to be depressive and tired and everything seems to be too much effort. This can be offset by getting more rest and realizing it is a time to be quiet and reflective rather than hurrying and scurrying. When Saturn conjuncts Mercury use this transit to deepen your mental process by studying and working to develop powers of concentration. Work and responsible action will do much to minimize the tendency to futility and depression. If we use aspects constructively they will not use us. With Saturn (the planet of necessity) in relationship to Mercury (consciousness) tests, especially where relatives or your people are concerned, will be presented for cleansing and redeeming purposes. Before a transit of Saturn comes into orb of natal Mercury it is wise to make sure the nervous system is in good condition. If work has been done on positive thinking it will pay divi-

dends at this time. If the individual has allowed negative and depressive attitudes to take over the price can be (but doesn't have to be) a mental breakdown. Knowledge of the tides and currents can be gained a long time before they are flowing so the individual can build in (of his own volition) the necessary ingredients mentally, emotionally and physically. When the time for testing comes he can pass it for he has done the necessary work ahead to time. He uses his energies. They do not use him. This is the proper use of astrology. The trines and sextiles in the birth chart bring good without having to do anything about them. The other aspects are challenges and obstacles that will test our weakness and show us where we need to build in different mental and emotional attitudes. When attitudes are handled correctly the physical body — the end terminal of inner thoughts and feelings — will be healthy. All dis-ease is first within before it manifests in the physical body.

When Saturn transits the Moon in the natal chart, the physical and emotional energy is at a low ebb. The person is touchy, supersensitive and afraid of being hurt. May be suspicious of other people's motives. Saturn cleans up the emotions and shows the physical weaknesses as well as the inner weaknesses that need correcting. Person is dissatisfied and bored with everything in the surroundings. If the individual quits and runs away from his circumstances it does no good. The difficulty is within, no matter how much it seems to be on the outside. In a female chart this aspect has a direct bearing on health. In a male chart the difficulties will come through feminine influences in his life. "This too shall pass" is an excellent motto when Saturn is afflicting the Moon.

Saturn afflicting Jupiter holds zest and enthusiasm down and brings lessons that come because the person has expanded too far through lack of good judgment. It is not a good time to plunge into new business ventures, travel or go into investments. Saturn conjunct Jupiter is saying "Slow up. Wait. Be sure you are well prepared for what you want to do." Jupiter conjunct Saturn is just the opposite effect. It releases the energy and frees one from limitation and restriction. Oppositions in the chart work differently than squares and conjunctions. The opposition comes from outside circumstances and from other people. Walt Whitman said: "Have we not learned great lessons from those who pitted their strength against us and disputed the passage with us?"

Saturn afflicting Venus brings emotional problems due to prior selfishness. It can bring a broken union or disrupt a marriage. Fear of getting hurt where affections are concerned is very strong. Disappointments and separations are of karmic origin when Saturn is strong. Our own selfish attitudes of the past, whether this life or a prior one, are coming home to roost. In the material world this transit, if afflicted, will bring financial difficulties.

A Saturn transit afflicting Mars or in conjunction with it can be difficult if the person hasn't equated his energy output with common sense and practicality. Individualism and energy runs into obstacles Usually calls for added responsibility and hard work, with less energy with

which to cope with it. It is necessary to accept life as it is, not as we would like it to be. If the individual is more martian than saturnian this transit will be difficult. It will cause combativeness and irritation and often the body isn't in good health and the person finds it hard to restrain his martian tendencies. It is necessity versus impulse and necessity needs must win if this individual wants to stay out of trouble. Mars represents the engine and Saturn the brakes. This is the time to apply the brakes, mentally, emotionally and physically.

Mars afflictions tend to physical infections for it rules the bloodstream and when afflicted it gives fever. This is nature's way of burning up toxics in the bloodstream. Emotionally Mars stirs up the passions. There is a tendency to rashness that can cause accidents. The person with an afflicted Mars at birth needs to guard against anger and impulsiveness when Mars or Saturn are transiting the birth planets. If the magnetic field of the individual is free of disharmony or discord there would be no accidents for there would be nothing in the magnetic field to draw it into orbit.

For the inwardly angry person Mars transiting the natal Sun or Moon can bring disputes, strife and accidents. To the one free from discord this transit of Mars can give renewed energy and revitalization of any project in which he is involved. We do not have trouble if we learn how to avoid it.

Mars transiting or afflicting the Moon can give trouble with the feminine sex or with the public if the person is rash and pugnacious and speaks out of turn. He does not have to let the animal self loose. We are all keepers of a zoo and all the animals in the animal kingdom are within us as qualities. In Genesis we were given dominion over those animals. As long as we keep them under control we are safe. They are there and must be tamed.

Mars transiting natal Mercury sharpens the tongue as well as the pen and both need restraint. If these two planets are afflicted at birth this transit can set off verbal explosions. Nothing will be gained and much will be lost.

Mars afflicting Venus is lust versus love. If these two planets are in harmony at birth this aspect can release harmony. If they are afflicted this will increase lust and greed, negate any lovingness until lust is lost and givingness replaces greediness.

If Mars afflicts the Sun it makes self will and aggressiveness too strong. Active and combative combination that needs handling. Quarrels can arise. Physical energy high. Take it easy. Use this energy do not abuse it. Mars afflicted to the Moon involves relationships with the female sex and causes disputes.

Jupiter afflictions come through lack of good judgment and through extravagance and dissipation. Jupiter rules the liver and when afflicted at birth and by transit there can be difficulty where the liver is concerned.

One of the most disruptive, explosive and violent aspects is Uranus adverse to Mars, either by birth relationships or by transit. J.F. Kennedy

had this aspect at birth and when it was aspected by heavy transiting afflictions he was assassinated. His brother had Mars, Saturn and the Sun in Scorpio afflicted to Neptune in Leo at birth. When Neptune by transit afflicted the natal planets (in fixed signs) he too left the body violently. Does violence have to happen? After thirty years in studying Cosmic law I would say "No, it does not." To escape the birthchart afflictions the negative aspect must be known and changed by changing the discordancy within, thereby eliminating the discordancy in the outer world. If we live in the personality — the unlit self — then we cannot overcome the tensions or tides. We live the Moon side and not the Sun. When the Real Self is allowed to control the life and the personal will is given to the Will of the Spiritual Self, (God in us) then the birthchart no longer operates negatively. The astrology of the new age will teach these truths. Predictions will be understood in their rightful context. The future is a direct result of today's actions. Our situations of today are a direct result of our actions and reactions of the past. When we are truly in tune, energies will be released positively and there will be only good results from any aspect, whether it be square or trine, conjunction or opposition.

Mars in affliction to Neptune or afflicted by a Neptune transit gives self deception and fogs the mind and emotions. If the person takes drugs or alcohol there will be danger of obsession. Psychic invasions can take place for the etheric field could be damaged and devitalized. The protective web that acts as a protective shield could be ruptured.

Neptune transits are the slowest of all the transits except those of Pluto. They are more subtle and more hidden for they operate in such a way that their effect goes unnoticed at the time. Interpret rightly the natal Neptune and the influence it will exert by transit and you will have the hidden key to the personality and direction of the life. The nature of the planets he passes over plus the time of life at which the contact occurs will provide valuable clues to the inner and outer development of the character. Not everyone feels Neptune in the same way; some not at all outwardly but the vibrations are there in the unconscious working silently to dissolve the ego and set it free.

Our dreams and ideas change as the years come and go. This is Neptune working underground. Neptune, ruler of the 12th house of self-sustainment or self-undoing is one of the lords of Karma. The more one tries to hang on to the self the less self there is. The more one gives oneself away the more self there is to give. Until the personality is willing to be nothing it will not be anything. Neptune is the planet of obligation or sacrifice. Where Uranus rules the Will, Neptune rules the willingness to give it up. Neptune is the Cosmic Santa Claus for everything that is freely given "UP" comes back a hundredfold. Only the givers to life have found this secret. The more given, the more received. This is the law of the Universe; everything sent forth, whether thought, feelings or deeds, returns to bless or burn.

Neptune is not one of the earth planets. On the material levels it is a trouble-brewer. It gives emotional fog when tied with Venus. The mind

is fogged when Neptune is configurated to Mercury. When related to the Moon the personality must become sacrificial for the good of others. When it is related to the Sun the will and the ego must be dissolved. In its transits these conditions will be met. How we handle them depends on our degree of understanding.

Uranus configurated with Jupiter in a harmonious fashion brings unexpected and unusual benefits through other people. Person often gets an unexpected inheritance through the transit of Uranus over Jupiter. In square or opposition it often takes benefits away, either through others or the person's own lack of judgment.

Uranus transiting in conjunction to Saturn often sets the person free of some bondage or confinement and gives him a larger world in which to operate. Saturn transiting Uranus often binds the person's freedom in some way; added responsibility often coming through older people can be required.

Those with Jupiter well placed and aspected are those who appear to have a charmed life and protection around them. They do for they have earned it. They sowed the right seeds (compassion, generosity, love) in a past incarnation and they are reaping the rewards in this life.

Venus in conjunction with Jupiter is extremely fortunate, especially in a sign in which they work together harmoniously. It is a harmonious aspect between Jupiter and Venus that brings what the world calls "luck" into the life. Only when the Cosmic Laws are understood is there a recognition that we all receive exactly what we have given; no more no less.

When Uranus is afflicted we want freedom more than anything else but are bound and do not have it simply because we have hampered others and given them no freedom in the past. Mars afflictions are greed for possessions but Uranus is interested in human beings under his influence. Self-will is exceptionally strong when Uranus is afflicted. It must be given up thereby releasing others into their freedom. Authority is one of the subtlest tests for it involves the use of power. Only when we become channels for the power and do not usurp it are we safe.

In reading planetary transits notice their effect as they change houses. If the birthtime is correct this will give a new trend or direction depending on the planet and the house it is entering. Uranus going over the Ascendant (First House) always brings a big personal change into the life; it upsets the status quo and brings in new concepts, new directions and a new life opens up for the individual. Sometimes a birthchart time may be corrected by noting the time Uranus crossed the Ascendant. If no event occured the birth data given is not correct. One of the most difficult times in the individual's life is when Saturn transits the Ascendant. If the individual hasn't taken care of his health the physical body will suffer. The individual goes through experiences that are difficult and test the soul. Often there is an enforced retreat from outer activity and the person is faced with circumstances that will call for fortitude and courage. Saturn going over the ascendant takes weight off the physical body. Jupiter puts it on. Jupiter transiting the first house brings travel, expan-

sion and happy conditions into the life. Any contracts or marriages taking place at this time will prove to be beneficial and harmonious. Marriage at the time Saturn transits the Ascendant brings restrictions, responsibilities and lessons that are painful.

It is necessary to make adjustments, to accept tests and not run out on any responsibilities in the area Saturn is affecting by transit. If it moves into the sixth house it necessitates an adjustment where work is concerned. If there is a health problem negative thinking and wrong emotions are at the root of the difficulty. Don't change a job even though you would want to do so while Saturn is transiting the sixth house. With Saturn entering the seventh house a marriage is possible but it will be for security and material reasons. If one accepts the responsibilities that go with this type of marriage it can work. Often it does not work because later the person finds that love is the only quality that gives a solid relationship.

Transiting Jupiter in the seventh house can bring a good marriage. Often it is to someone who has had a previous marriage. Chances of an inheritance are strong when Jupiter is transiting the eighth house. With Jupiter in the eighth house there is an opportunity to cash in on work already done, and service already given. It would be a good time to seek credit or backers for any venture.

In this textbook only some of the transiting conditions are given. If the student has a basic grasp on the principles involved where planets and signs are concerned it will not be difficult for him to know what is likely to happen as the transiting planets come and go. By knowing ahead what kind of cycle or trend will be operating the individual can go with the tide and not resist it. There is a time to launch a boat and put it into the deep for the tide is flowing and the conditions are right. When the tide is out, wait for it to turn. Otherwise your boat can flounder on the mud flats. Go with the tides, not against them. This is the right use of astrology.

One of the best ways for the student to gain experience in interpreting charts is to collect the charts of his family and friends. Study them carefully and see why they respond to life as they do. Ask them for the times in their lives when important events happened to them. See what transits were operating at that time. This is the way to understand how planet energies operate. Good sailing!

CHAPTER 28
Progressions

The progressed chart shows the life patterns and trends for any particular year, as they effect the consciousness from within. The coiled up energy locked up within the individual is released at a ratio of a day for a year. The last chapter on "Transits" shows how the daily motion of the planets affect the person from the outer world. They operate through the environment and relationships in the world of appearance. The progressed chart works from within showing the changes of consciousness occuring in the individual, bringing changes in the outer world. It is a symbolic picture of what is going on in the individual's thoughts, feelings and attitudes toward life. Attitudes are of the greatest importance. The outer world is not a creative world. It is the world of manifestation. The creative world lies on the inner side and truly man creates his own destiny. He is connected to everything that happens to him. Only by changing his consciousness and his attitudes will he change the outer world around him. Progressions help us to understand what is going on within and if it is a negative condition man has the power and privilege of changing it before it manifests in the outer world.

Always the transits and the progressions must be related to the natal chart. Progressed planets to progressed planets are not effective. If there are good relationships between the planetary energies at birth, discordant transits and progressions need not work harm. They often release the harmony shown at birth. If there is strong discord at birth between two planets, and the person has not rechanneled that negative energy into harmony, then difficulties will arise when that energy is stimulated by the progressed chart or by transits. Sometimes a progressed trine or square stimulates the birth aspect releasing the energy to operate in a negative fashion for the person has failed to learn the lesson hidden in the affliction at birth. Energy always follows the line of least resistance. It is essential to have a thorough understanding of the birthchart before it will be possible to understand how the progressed chart operates.

There are two methods of Progressions most frequently used by the modern astrologers. They are called Primary and Secondary Progressions. Both are valid as a symbolic picture of the year ahead. The secondary progressions work from within and show the growth and development of consciousness. Primary directions seem to operate more in the outer world and bring changes to the individual. Some astrologers use Primary Directions to rectify a chart for any important event in the life does show in the Primary Direction chart. One of the greatest difficulties in astrological counseling is getting the right birth data. So many times the time given

as the birth time is not correct. In the Aquarian Age more and more individuals will demand that the exact time of the first breath be clocked in the delivery room and written down at that time. Time given by hospitals may be off anywhere from 30 to 40 minutes. This has been proven by a birth clocked in the delivery room at the exact moment of the first breath. Later a letter was written to the hospital asking for the birth time. The correct time was 7:29 a.m., the record in the hospital was written in as 8 a.m.

For the Progressed chart for any year of life, counting from the day after birth, count as many days as the person's years of life. Set up the chart for this day in exactly the same way as the one for the day of birth, using the same time of day. Use the longitude and latitude of birth. Then place the progressed midheaven, the progressed Ascendant and the progressed planets on the outer rim of the natal chart This method is called Secondary Progressions.

SECONDARY PROGRESSIONS

Set up a chart for the same birth time on the Progressed Date to get the house cusps. Only the Progressed Midheaven and Ascendant will be used. Count a year for a day to find the Progressed Birthday. If the progressions for the 20th year were to be calculated, by adding 20 days to the birthday the student would have the Progressed Chart for that year. To be enabled to copy the planetary positions directly out of the ephemeris it is necessary to find the Adjusted Calculation Date.

FORMULA FOR FINDING ADJUSTED CALCULATION DATE:

1. In the Longitude and Latitude book (in the last column) find the time that must be added or subtracted to get Greenwich Mean Time.

2. Find the number of hours from the G.M.T. to the following noon.

3. Whatever the number of hours, add this amount to the noon Sidereal Time on the day of birth.

4. If the G.M.T. is PM or AM of the following day, count backward or forward in the ephemeris until you find the day that has the corresponding Sidereal Time.

Example: July 8th, 1968. Born at 1:16 True Local Time. 42 Lat. 71 Long.
To find the Progressions for the tenth year of life. Counting ten days after birth will give July 18, 1968. This will give the progressions for the year 1978. Using the same birth time, set up a chart for July 18, 1968, using the same longitude and latitude. The cusps of the Midheaven and Ascendant will be the only ones of importance.

MID-HEAVEN
South

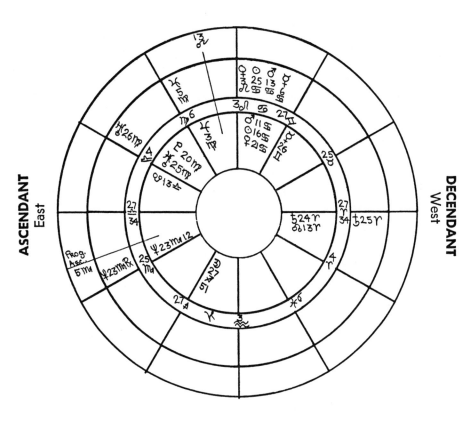

ASCENDANT
East

DECENDANT
West

NADIR
North

Outer Rim — Progressions for 10th Year
Adjusted Calculation Date: April 8th

7:06:00
.47
1:16
.13
‾‾‾‾‾‾‾‾
8:22:60
S.T. 8:23:00

To find the adjusted calculation date:

G.M.T. 1:16 4:44 6 P.M.

Number of hours to **following** noon. 18 hours.

```
Sidereal Time on Birthday:     7:  06:  00
    Add  hours            +  18:
                            _____
                             25:  06:  00
                           — 24:
                            _____
                              1:  06:  00
```

It is a P.M. birth so counting backward the corresponding sidereal time is on April 8th. Put this date in the corner of the birthchart as A.C.D. (April 8th). In this example you would copy the progressions for July 18th directly from the ephemeris, except for the Moon. When the G.M.T. is A.M. reverse the above procedure and count forward in the ephemeris.

As the Moon travels from 11 degrees to 15 degrees in a day's time it is necessary to calculate it. It is necessary to pinpoint the month when the lunar aspects become exact. In 24 hours the Moon travels on an average of 12 or 13 degrees. 24 12 2. Every two hours travel equals one month in the progressed chart.

```
Moon's Position for coming Noon (July 18th)   20:  02 Taurus
    Previous Noon                            — 8:  11
                                            _____
Moon's travel in 24 hours                     11:  51
```

Referring to the Moon Tables we find that the travel of the Moon for two hours is 59'. This is the equivalent of one month's travel in the Progressed Chart. The position of the progressed Moon for the year will be shown by the progressions for July 18, 1968.

LUNAR POSITIONS — YEAR 1978

April	8, 1978	8:11 Taurus
May	8, 1978	9:10 Taurus
June	8, 1978	10:09 Taurus
August	8, 1978	12:07 Taurus
September	8, 1978	13:06 Taurus
October	8, 1978	14:05 Taurus
November	8, 1978	15:04 Taurus
December	8, 1978	16:03 Taurus
January	8, 1979	17:02 Taurus
February	8, 1979	19:01 Taurus
March	8, 1979	19:00 Taurus
April	8, 1979	20:00 Taurus

The progressed Moon operates on the personality level and has a great deal to do with the everyday circumstances and the environment. Its house position is important for it highlights the particular area through which it is passing. It is strongest when it is going through the house it rules (the fourth house). When it goes over the fourth house cusp it often brings a move or a home change.

In the chart for July 8th, 1968, the Progressed Moon is going through the seventh house. The only aspects it makes in the year is a sextile to the natal Mars in July, 1978, and a sextile to the natal Sun in December of the same year. This is a mildly good condition that would energize his body and would bring some beneficial action through the father.

Note that in the Progressed Chart the natal Venus has progressed to the natal Midheaven. This would bring a beneficial change in the life due to financial betterment where the father would be concerned. There could be a move to a new environment that would be of benefit to this individual.

If the Progressed Sun comes to a conjunction or opposition to the natal Saturn check the relationship between these planets at birth to know how this energy would be released. There will be tests, trials and plans and projects may be delayed. It can cause health problems due to depletion. If the individual will realize the tide is out and not try to start new ventures or change the "status quo" he can come safely through this cycle. Saturn is saying "Wait. The tide is out. This isn't the time to launch out into the deep. Let patience have its perfect way with you." "Patience is dwelling, understandingly, in the Now with a vision of the Plan."

If the Progressed Sun comes to a conjunction of Jupiter launch your boat out into the deep for the tide is with you. Everything is on the upswing. If the Sun is afflicted to Jupiter at birth, don't let the ego get out of hand. Arrogance and egotism can be loosed that will be damaging to the person's success. If this progression releases the constructive side of Jupiter this is an excellent time for general prosperity and advancement. Gain can come through speculations and investments. This is an excellent time for expanding the horizons, either by outer travel or inner travel on the higher planes of consciousness. If the Progressed Sun opposes Jupiter there can be financial loss and loss through expanding too far. Judgment is apt to be impaired so it would be wise to seek wise counsel before making any changes.

If the Progressed Sun conjuncts or opposes Neptune it would be necessary to consider the chart as a whole before passing judgment. The individual's evolvement or the lack of it must be known. Neptune is not of the earth, and to the materialist would confuse, delude and deceive him for the time this cycle would be in opposition. The individual would be "lost in a fog" and not able to see the way clearly. To the "twiceborn" and those of mystical inclinations this could bring spiritual development and the chance to sacrifice the personality, gladly and joyously, for a greater ideal or cause. The ability to penetrate the higher levels would be enhanced. To the unevolved, danger could come through drugs, alcohol

and obsessive compulsions. It would be necessary to be absolutely honest in all dealings with others.

If the progressed Sun comes to a conjunction or opposition of Uranus, unexpected changes are in the air. Sudden and unusual happenings change the course of the person's life. It is an unpredictable aspect. It can mean the closing out of the past completely and entering into a new phase of livingness. The birth aspects between these two energies will be important. If the Sun and Uranus are well aspected at birth it can release the constructive use of the will and give the power to handle the high voltage. If afflicted, the release of this energy can be extremely destructive if the individual has not learned self control. A desire for freedom and to shy away from every restraint will be strong. It is not a time to break a marriage though there may be a strong compulsion to do so if this aspect is tied to the seventh house. Other fields look greener, but when this aspect passes the person usually finds out the grass was really greener in his own back yard but often it is too late to go home.

Aspects of the progressed Sun to Mercury stir up the mental faculties and the person has the urge to study. Contacts with relatives and young people will be stimulated. Mercury is never afflicted to the Sun in the birthchart. How can the soul (consciousness) and spirit be at odds? Whenever Mercury by progression conjuncts the natal Venus, a refining process ensues. The individual becomes more interested in cultural and artistic endeavors. When the Progressed Mercury conjuncts or opposes the natal Mars, if afflicted at birth, the tendency to become argumentative, combative and tactless in the use of speech will be enhanced if the person has not learned to control his animal instincts. If the birthchart aspect is a trine or sextile it will give added energy, vitality and keenmindedness.

Only one degree orb is used in Progressions. Never use more than one degree applying and one degree separating from the aspect. Progressed Sun aspects are of two year's duration. The Progressed Sun travels one degree in a year. They are the slowest influence in progressions for they affect the person's Will and Consciousness. The Progressed Moon aspects are of one month's duration, and will affect outer circumstances. the emotions and the personality. The Progressions must be related to the birthchart, not to each other or to the transits. Conjunctions and oppositions are of major importance. Trines, sextiles and squares are of lesser importance. The faster moving planets are the important planets in progressions; Sun. Moon, Mercury, Mars and Venus. The heavier planets change but little in a progressed chart. When the planets, especially the Sun, change signs they bring marked changes in consciousness though they may not be apparent in the outer life for some time. The Sun changing signs brings marked changes in consciousness. If a person had their natal Sun in 25 Leo, at 5 years of age it would go into Virgo. At 35 it would leave Virgo and go into Libra. The years that the Sun would be in Virgo would bring health problems, a tendency to an inferiority complex and shyness, and working conditions could be difficult. In Libra there would be more contact with people, and associations would

increase. The worries of Mercury ruled Virgo would be replaced by Venus and there would be greater ease and harmony in the life. Cultural opportunities would come that would bring a change in consciousness. Knowing the meaning of the Signs and the lessons and opportunities they bring will enable the student to know what the Progressed Chart is bringing into the consciousness.

Conjunctions and oppositions are the strongest aspects in the Progressed Chart. It would be impossible in any textbook to give all the combinations possible in a birthchart or a progressed chart. There are infinite combinations due to houses, birth aspects and signs. A general indication can be given, but the student must learn to synthesize and blend the patterns for himself. If he learns the basic principles thoroughly he will be well equipped to interpret the Progressed Chart.

Some of the combinations will be given. The happiest and most love-filled year, is the year when the Progressed Sun conjuncts the natal Venus, or the Progressed Venus conjuncts the natal Sun. If the person is of marriageable age, and even if they seem to be beyond it, this can bring love into the life. This aspect opens up the love consciousness on the inner levels and its attracting power draws an outer manifestation of that love into the person's orbit. If we knew how to use our Love potential we would not have to wait until this kind of aspect operated. It is all too true that most of God's children do not know the attracting power of the Love consciousness locked up within them crying for release.

If the Progressed Sun comes to a conjunction or opposition of the natal Mars there can be renewed vitality and increased energy. It is a time when the person would have more independence and more courage. It would be necessary to note the aspects between the Sun and Mars at birth. If they were afflicted there would be great need for caution against over-impulsiveness, combativeness, violence and accidents. This conjunction or opposition could be very detrimental to the one who had not learned to control his passions and his temper, but would be beneficial to those who had the Sun trine or sextile Mars at birth.

The year when a planet, by progression, goes direct or retrograde will be very important. There will be a change of direction where that principle or energy is concerned. If it is Mercury there will be a strong change in consciousness. A retrograde planet is not an affliction It merely makes the energy more subjective. It operates more in the inner world than the outer one. When the planet turns direct it gives access to the energy and the person is better able to project it into his outer world.

The people who live completely in the personality will not respond to the progressed chart as will those who are more awake and aware. To the spiritual student the progressed chart can be very important. It shows the opportunity and challenges stemming from within. If handled rightly they manifest harmoniously in the outer world, regardless of whether they are afflicted planetary configurations or not.

Man was meant to use the knowledge of astrology to understand the work to be done, the opportunity to do it, the times when he could use

the energy to his advantage and the times when he should let the energy use him. As long as we respond negatively to any configuration we have not lived the real Self. Man was meant to rule his stars, not be ruled by them. The measure of his dominion over the world of appearances will be shown by his reactions to the energies flowing through time and space.

CHAPTER 29
Medical Astrology

The medical field is an area that could be greatly benefited by an understanding of Astrology. The correlation of the signs with the parts of the body and the rulership of the planets where the endocrine system is concerned is of deep import. The physical dis-ease (lack of easiness) is the end terminal of conflicts that occur in the emotional and mental levels before they finally terminate in physical disease. Psychosomatic medicine has shown that the relationship of the person in the body and the body is tied up with physical ills.

Research has shown that arthritis is tied with repressed antagonisms. Those who are strong willed and rigid in their thinking, those who are self-righteous and set in their judgments, are those who have the predisposition and tendency to attract this disease. They have failed to learn to flow with the rhythm of life and their joints become calcified.

The same aspects that show repressed fear, hidden selfishness and resentment are the aspects in a chart that show predisposition toward and the tendency to attract cancer. Diet is very important and can be of very great help in negating any disease but the mental and emotional qualities are equally important. Diabetes in the physical body is often the result of bitterness in the emotional vehicle. Sugar has always been the symbol of sweetness and an upset in the sugar balance in the physical body is the result of holding bitter thoughts and feelings. Sometimes it is on the unconscious levels and one must learn to love and reeducate that little self that lives inside the conscious self. One of the best books to get in tune with this hidden self is *Secret Science at Work* by Max F. Long. It may be ordered through New Pathways, 103 Goldencrest Ave., Waltham, MA 02154.

Paralysis of any kind is an overcrystallization of the will, either in a past lifetime or this one. This difficulty, like arthritis, is tied with fixed signs and Uranus afflictions.

In heart trouble the drive for significance has not been fulfilled and a feeling of not being loved is deep within. This does not mean the individual may not be important and is not loved. It means the person has not the ability to assimilate the love or have a feeling of importance. A man can be sitting at a banquet table loaded with food, but if he can't reach out, accept it and assimilate it he can starve. This difficulty showns in the chart by afflictions to the Sun and to the fifth house.

Back difficulties are always tied with the misuse of the will. Often egotism and pride are outpictured by difficulties with the back. Obsessions and psychic difficulties are shown in the chart by Neptune afflictions.

The signs are correlated with the parts of the body. Planets are correlated with the endocrine system and the ductless glands. Each ductless gland has a psychic center behind it. Every gland secretes a hormone into the bloodstream. The bloodstream circulates energy from one organ to another. The proportions of the glandular secretions make a man what he is; thoughtful, combative, sympathetic, moody, energetic or passive. Man, by changes of consciousness, can accentuate or restrain natural tendencies. The bloodstream, like the Sun's radiations, extends through the whole system. No part of the body is too distant to be vitalized by the bloodstream. As the Sun's light and heat shines through all the planets supplying them with heat and light so the bloodstream serves the same purpose in the body. From Aries to Pisces, from head to feet, it circulates and flowing circulation brings health. Where circulation is impeded dis-ease manifests. Each of the houses in a birthchart represent external environmental factors that can affect the health in a constructive or negative manner.

The Ascendant is an important factor for it rules the physical body and the sign on the Ascendant shows the kind of conductivity or resistance which the physical body offers. The fire signs on the Ascendant show the greatest ability to conduct the life force and vitality. Next in conductivity are the air signs but they are nervous signs. Being intellectual in nature, the mind often wears the body out. Water signs on the Ascendant, especially the sign Cancer, give an over-active lymphatic system. There is too much retained liquid in the system. The earth signs are resistors and are not good conductors of the vitality flow. A child with a Capricorn ascendant is rarely physically strong in childhood (Saturn slows circulation) but they grow more vigorous as they grow older. Saturn has staying power. Though Capricorn ascendants have difficulties with ability to assimilate food in infancy they are much healthier when they go past their first seven years. Gemini is a ready conductor so people with this sign on the horizon are active, restless and in constant motion. Cancer ascendants are healthy or unhealthy depending on their environment for they take on the conditions around them. They are emotional blotters, absorbing everything in the psychic side of life around them. Taurus is the most static and resistant and does not let the vital force flow easily.

There is a tieup between the opposing signs that is important to understand. As an example: Aries people are subject to headaches and if they persist there should be a checkup of the kidneys. Libra is the opposite sign to Aries and by reflex could be causing the headaches. Taurus rules the throat and Scorpio rules the generative system. A boy's voice changes when his power to create on the physical plane comes into activity. When a feminine has trouble with constant sore throats the generative system is often the seat of the difficulty. The tieup of cancer of the lungs, ruled by Gemini, to cancer in the leg or thigh (Sagittarius) is well known. The heart (Leo) and the circulation (Aquarius) are intertwined.

SUN rules the constitutional strength for it is correlated to the prana or etheric energy that flows into the magnetic field. An individual with a strong Sun has the power to overcome many ills that the person with a poorly placed and afflicted Sun cannot overcome. The dominant note of the Universe is the Sun for it vitalizes all life and is the cause of life. The planets are agents of the Sun for it is the Sun force that flows through the planets much as a prism picks up light and breaks it into different colors. It is through the planetary receiving sets that the different functions of the body are sustained and regulated.

MOON rules the form side and is related to the functional strength of the body. An afflicted Moon with a strongly placed Sun can have many bodily ills during a lifetime, but the etheric energy or prana can keep the body operating much longer than anyone would expect. The Moon is associated with the lymphatic system and the pancreas. The Moon in partnership with the liver controls the digestion of food. This explains part of the reason Jupiter is in its exaltation in Cancer. Another astrological statement is that the Moon is an antidote for an afflicted Mars. One part of the pancreas secretes insulin, promoting storage of sugar and works against the adrenals (Mars) to quench or dampen too much adrenal activity. Hidden in the functions of the body are all the cosmic laws if the student digs deeply enough. The Moon effects the body tides where the lymphatic system is concerned. It puts the fire out. Isn't Mars in its fall in Cancer? An individual cannot use the Moon force — nurturing, sustaining, and caring — and be combative, aggressive, and antagonistic at the same time. The Moon type of person is moody, passive, introspective, the watery emotional type, fluctuating like the phases of the Moon.

MERCURY controls the king gland in the body: the thyroid gland. It controls breathing and the speed of the metabolism, like dampers on a furnace that regulate heat and speed. The relationship between breath and the person in the body is well understood. In fright or sudden shock the breath is effected. When an individual is upset if he will slow down his breathing deliberately he can calm down and control any situation. The more active the thyroid works, the quicker and more keyed up the person. Iodine, in the form of sea salt and kelp, acts like the weight hung on the damper door to keep it from bursting open and burning up the fuel in the furnace. The Mercurial type is impulsive, usually thin, restless, impulsive and often inexhaustible but exhausts everyone around him.

VENUS rules the parathyroids. It has a great deal to do with tissue building and increase in bulk. Venus also rules the veins and the venous circulation, the return flow of circulation to the heart.

MARS AND SATURN are correlated to the adrenal glands. There are two parts to this gland. The medulla hormone, produces a secretion that can cause fear or flight. This part of the adrenal gland is ruled by Saturn.

The shell or cortex secretes another hormone giving pugnaciousness and combativeness. These are glands more directly connected to the impulse of self-preservation and the animal nature. The antidote for an afflicted Mars is the Moon (maternalness) and the antitode for an afflicted Saturn is Venus (love). Changes of consciousness bring corresponding changes in the secretions of the glands. Every physical effect has a psychological basis. For instance: Mars and Saturn in Leo can cause heart block. The inner reason is that the person has defied and rebelled against authority and has misused power (vitality) in a past life. It is a frustrating aspect but if the individual accepts the frustration (the house it is in would show the area in which he would feel limited) he would save himself much physical distress and live longer. Mars is energy; Saturn, the brakes, the blockage. He would have to learn to equate the energy with the brakes, and not overdo. The resolving of all indecisions and anxieties would come through acceptance of the "as is" as necessary for growth and development. Mars in the body is the fighter. It gives the capacity to fight infection. Saturn has an influence over the skeleton and the bony structure and is apt to impede and obstruct circulation wherever it is placed by sign and house.

JUPITER, the largest planet in the solar system, rules the largest organ in the body, the liver. It also rules the arterial circulation. When Jupiter is in Leo the heart is enlarged. When Saturn is there circulation is impeded and the heart contracts. If the student understands the principles involved where each planetary energy is concerned he can read the chart accurately on the three levels — physical, emotional and mind levels. Every energy operates on three levels. Sagittarius, sign ruled by Jupiter, rules the sciatic nerve that branches off from the lower back and goes down both limbs. When Jupiter or Uranus are afflicted in Sagittarius, trouble can come through lower back pain. A good osteopathic physician can do more to relieve it than medicine.

URANUS rules the pituitary and shares that rulership with Saturn. There are two lobes to the pituitary gland. One hormone is closely connected with the function of abstract thought and reason. The anterior pituitary type is long boned with a strong body. Its over-secretion results in abnormal growth of the body, especially the extremities. This person is a strongly Saturnian type with the ability to have self-control and rule his own life.

Rodney Collin believes that Uranus rules the sex glands and gonads. He makes this statement: "Sex must be separated from the Venusian sensuality of the parathyroids, the martial passion of the adrenals, the material affection of the posterior pituitary and the Saturn domination of the anterior pituitary. It must be connected with the ultimate principle of two sexes, and their joint power of creation. It will include all the deepest emotions which arise from this interaction, which includes, be-

sides children of the body, music, poetry, the arts and the whole aspiration of man."

It is interesting to know that Uranus is in its masculine phase for 42 years and is in its feminine phase for 42 years. It went into its feminine phase in 1945. Does this explain the increase in homosexuality on one hand and the reason why boys are looking more and more like girls? With the long hair and both sexes dressing alike it is hard to tell one from the other. In 1987 Uranus enters its masculine phase and there will be a radical change where male characteristics are concerned.

NEPTUNE rules the pineal gland; it is single in form unlike the other glands that operate in pairs. It is the gland of illumination. Neptune is the planet of obligation and sacrifice. Only when the personality is offered as a sacrifice and as a server in the Temple of Wisdom, where the High Self resides, does the pineal gland become operative. It is the third eye. "If your eye be single the whole body shall be filled with Light."

There is much to be learned in the field of medical astrology. It is the author's hope that this chapter will whet the appetite of the student so he will study deeply into the relations of the physical body to the Cosmos. There is no disease that cannot be healed but there are people incapable of being healed. They impede the flow of vitality from the spiritual level, often unwittingly. I have seen cancer cured in one healing meditation when the individual didn't know he was held in prayer. I have seen and experienced miracles. When the self doesn't stand in the way, the Power can work. What it needs are dedicated channels, emptied of self-seeking, through which the Power can flow. Every true astrologer can be a healer. The chart shows where the blocks may be but the spiritual orientation of the astrologer will enable a higher Power to flow that will overcome the resistances on the personality level. Only the dedicated astrologers will be the successful ones in the days that lie ahead. This fiat has gone forth from the invisible forces of Light and Love. So be it.

* * * * *

PLUTO

In this textbook so far there has been no mention of Pluto.* It is my opinion that too little is known of this planet and too many people are attempting to delineate its effects before sufficient research has been done on it. Its effects are so subtle and so hidden that what it has done when it transits a natal planet will not be apparent until much later. It rules the underworld of the subconscious; what Jung calls the collective subconscious. Undoubtedly it is related to Scorpio, but with most charts Mars will continue to be the ruler of Scorpio for a long time to come. Pluto stays from 12 to 30 years in a sign. It was discovered in 1930 and ushered in a great deal of chaos and confusion. It has more to do with civilizations than it does with personal matters. It is a dark planet and ushered in an era that brought war, the atomic bomb, the

*For a full discussion of Pluto, see Chapters 32–39.

dictators and opened up the astral plane and allowed many entities to come into incarnation that were not of Light. They were given the opportunity of redemption if they so chose. To many of the earth children Pluto is a dumb note and it is better so. The invoking of this energy through too much concentration on it will bring trouble in its wake.

When Pluto is in an angular house it can be effective for good or ill depending on the evolvement of the individual. Marc Jones calls it the planet of obsession. He is not wrong. It can be a magnificent obsession or one that is detrimental. Pluto can be a transforming force or a very destructive one. The person with a prominent Pluto must serve the Universe, not his own self. He will be used; whether by constructive forces or destructive ones, he will be used. His is the choice, but choice there must be. Nuclear fission and the new sciences are related to Pluto. These energies can bless or burn the world to cinders. The power to use these energies lies in the hands of human beings. No one can say what the end will be. Pluto shows the power to realize untold forces for good or ill.

Study its effects in the world conditions since 1930 but be cautious when attempting to interpret it in the personal chart, for it will remain a dumb note (and luckily so) until the person has developed enough power to be a force in the world. When it conjuncts a planet there will be a subterranean effect on the planet involved that will not be apparent on the surface. That energy will be transformed or redeemed or will bring the individual to disintegration and destruction.

It truly is a dark planet. Clairvoyant investigation shows it to be a prison house for those who have refused, over eons of time, to take the path of evolution. Behind Pluto stands another planet, little known by the children of earth; Minerva, the goddess of wisdom.* Some there are who have to go down into the darkness to find her. Pluto's action is a long term action and is not recognized at the time it is operating. Much of what is said about Pluto and its effects relate to Mars in the chart.

Pluto, coverup for Minerva, goddess of Wisdom, in its highest meaning relates to the Universal Consciousness. It is completely impersonal and works subjectively. In its underworld aspect, ruler of Hades, it represents degradation and disintegration.

Know that in the house Pluto is placed there must be transformation and redemption, but do not delineate it in a personal way. Let wisdom guide you when you deal with this planet in the birthchart. A word to the wise is sufficient.

*When this was written, Pluto's "twin moon" had not yet been discovered. Isabel Hickey's idea anticipated the reality that Pluto is now considered to be a "double planet."

CHAPTER 30
The Art of Interpretation

The art of interpretation — and it is an art — depends on the ability of the student to get a mental grasp of the nature of the energies involved as well as an intuitive feeling of their meaning. Those who meditate on the symbols can pierce through the symbol to the energy or actuality that the symbol represents. The astrologer must be able to have some idea of where the client stands on the path of evolution in delineating the birth-chart and counsel him at that level. If the individual is involving himself in matter, and building a personality he will be very different to the one who is evolving out of the personality and building a soul.

When most of the planets are in the first six signs and the higher octave planets are not angular or configurated with Sun, Moon or Mercury, the person is involving himself with the world of appearance and the personality. When the last six signs have many planets in them and the higher octave planets are prominent, the soul is more advanced and the person will be evolving out of personality orientation. His life, though more difficult, will be more effective. This planet is a school and the different grades are different stages in growth and development. The life of the kindergartener and those in the early grades of school are comparatively uncomplicated. In the higher grades studies are harder and more work must be done and more tests taken. The stronger the soul the more squares and oppositions in the chart. It takes great strength to meet the bigger challenges of life. There is no affliction in the chart that cannot be changed and unredeemed. It starts with a change of attitude or consciousness. The world outside is the world of manifestation; not the world of creation. Everything is created inwardly and then projected into the world of manifestation. If this cosmic law was fully realized the key to the secret of this universe could be used in the outer world. Change your attitude, release the tension and allow the true nature of the planets (energies) to work, seeking to be but a channel through whom the energies can flow. You then can flow with the rhythm of life and know the true meaning of joy.

The astrological pattern is meant to be a guide to show how the tides are flowing at any particular time. The wise person uses these tides and makes allowances for them. He cannot escape their influences but he can use them and does not allow them to influence him negatively. Each birthchart marks a step in the evolution of the soul and represents the character of the Self in the body and shows the environmental conditions necessary for the next step forward in consciousness. He can dilly dally if he chooses. He can pass by or pass up his opportunities; then he fails to

pass his grades and is held back to do that grade over again until he is able to go on to the next grade. The choice is his. God is patient. God is also pressure and pressure is the inexorable force that cannot be evaded except for a certain length of time.

The planets are symbols that convey eternal truths to those ready to receive them. They have preserved the Cosmic law since the beginning of time. As far back as there is any planetary history the symbols have been found.

For centuries astrology fell into disrepute because, like so many things on earth, it fell into the wrong hands and was used as fortunetelling and was exploited by those seeking to gain through it instead of seeking to give through it. The Light was withdrawn and the inner truths behind it were not given to the profane. With the dawning of the Aquarian Age there are those who have come to earth to restore astrology as a sacred science. Many there are who are doing this work, and many there will be who will do it. Many there are who may use it for their own ends and deride those who work to raise the level of consciousness of those who seek understanding. Ever it has been and ever it will be for this is a world of duality and "choose ye this day whom ye will serve" is as true today as it was 2,000 years ago.

It is particularly important in astrological counseling to study the chart well before talking about it. If the chart has mutable signs on the angles the individual will remember every negative comment and forget every positive statement. He is a worrier and full of fear. In every diagnosis of the afflictions give an antidote that will clear up the conflict. No physician diagnoses a disease without giving the remedy that can cure it. If the person is emotionally oriented it is through his feelings he can be helped. If he is intellectually oriented he can be reached through reason. If he is strongly materialistic he will be the one who will say "I'm not interested in anything except finances" and "what I'm going to get out of this or that situation." Then it's up to the astrologer to talk, first about finances, and then (lovingly) show the individual how what happens to him outwardly cannot be detached from the person he is on the inside. The body cannot be detached from the person living in it and have any life power or energy. The truly inspired astrologer is the one who is oriented spiritually and really cares about every individual that comes, whether they come out of curiosity or a real need. Unless the astrologer has become soul-oriented how can he help another soul. Unless the astrologer has known pain, suffering and loneliness how can he help someone who is suffering. Pain is the breaking of the shell of selfishness and only through pain (not around it) can one feel the pain of others and be able to say in great love "I know." The true astrologer will be a healing agent and will know he is only the channel through which the Power flows. Then, added to his knowledge gained through study, will come that plus factor that is not of this dimension but comes through from the Love that eternally sustains the universe. Come to your study of astrology in rev-

erence for the wonder of life and a desire to understand yourself and change what is manifesting negatively in yourself. Then you can help others and your service to them will be appraised and based on loving understanding. When you know Love and Joy it can be transmitted through you to others.

CHAPTER 31
An Allegory

I leaned from the low-hung crescent moon and grasping the west pointing horn of it, looked down. Against the other horn reclined, motionless, a Shining One and looked at me, but I was unafraid. Below me the hills and valleys were thick with humans, and the moon swung low that I might see what they did.

"Who are they?" I asked the Shining One. For I was unafraid. And the Shining One made answer: "They are the Sons of God and the Daughters of God."

I looked again, and saw that they beat and trampled each other. Sometimes they seemed not to know that the fellow-creature they pushed from their path fell under their feet. But sometimes they looked as he fell and kicked him brutally.

And I said to the Shining One: "Are they ALL the Sons and Daughters of God?"

And the Shining One said: "ALL."

As I leaned and watched them, it grew clear to me that each was frantically seeking something, and that it was because they sought what they sought with such singleness of purpose that they were so inhuman to all who hindered them.

And I said to the Shining One: "What do they seek?"

And the Shining One made answer: "Happiness."

"Are they all seeking Happiness?"

"All."

"Have any of them found it?"

"None of those have found it?"

"Do they ever think they have found it?"

"Sometimes they think they have found it?"

My eyes filled, for at that moment I caught a glimpse of a woman with a babe at her breast, and I saw the babe torn from her and the woman cast into a deep pit by a man with his eyes fixed on a shining lump that he believed to be (or perchance to contain, I know not) Happiness.

And I turned to the Shining One, my eyes blinded.

"Will they ever find it?"

And He said: "They will find it."

"All of them?"

"All of them."

"Those who are trampled?"

"Those who are trampled."

"And those who trample?"

"And those who trample."

I looked again, a long time, at what they were doing on the hills and in the valleys, and again my eyes went blind with tears, and I sobbed out to the Shining One:

"Is it God's will, or the work of the Devil, that men seek Happiness?"

"It is God's will."

"And it looks so like the work of the Devil!"

The Shining One smiled inscrutably.

"It does look like the work of the Devil."

When I had looked a little longer, I cried out, protesting: "Why has he put them down there to seek Happiness and to cause each other such immeasurable misery?"

Again the Shining One smiled inscrutably: "They are learning."

"What are they learning?"

"They are learning Life. And they are learning Love."

I said nothing. One man in the herd below held me breathless, fascinated. He walked proudly, and others ran and laid the bound, struggling bodies of living men before him that he might tread upon them and never touch foot to earth. But suddenly a whirlwind seized him and tore his purple from him and set him down, naked among strangers. And they fell upon him and maltreated him sorely.

I clapped my hands.

"Good! Good!" I cried, exultantly. "He got what he deserved."

Then I looked up suddenly, and saw again the inscrutable smile of the Shining One.

And the Shining One spoke quietly. "They all get what they deserve."

"And no worse?"

"And no worse."

"And no better?"

"**How can there be any better?** They each deserve whatever shall teach them the true way to Happiness."

I was silenced.

And still the people went on seeking, and trampling each other in their eagerness to find. And I perceived what I had not fully grasped before, that the whirlwind caught them up from time to time and set them down elsewhere to continue the Search.

And I said to the Shining One: "Does the whirlwind always set them down again on these hills and in these valleys?"

And the Shining One made answer: "Not always on these hills or in these valleys."

"Where then?"

"Look above you."

And I looked up. Above me stretched the Milky Way and gleamed the stars.

And I breathed "Oh" and fell silent, awed by what was given to me to comprehend.

Below me they still trampled each other.

And I asked the Shining One.

"But no matter where the Whirlwind sets them down, they go on seeking Happiness?"

"They go on seeking happiness."

"And the Whirlwind makes no mistakes?"

"The Whirlwind makes no mistakes."

"It puts them sooner or later, where they will get what they deserve?"

"It puts them sooner or later where they will get what they deserve."

Then the load crushing my heart lightened, and I found I could look at the brutal cruelties that went on below me with pity for the cruel. And the longer I looked the stronger the compassion grew.

And I said to the Shining One:

"They act like men goaded."

"They are goaded."

"What goads them?"

"The name of the goad is Desire."

Then, when I had looked a little longer, I cried out passionately: "Desire is an evil thing."

But the face of the Shining One grew stern and his voice rang out, dismaying me.

"Desire is not an evil thing."

I trembled and thought withdrew herself into the innermost chamber of my heart. Till at last I said: "It is Desire that nerves men on to learn the lessons God has set."

"It is Desire that nerves them."

"The lessons of Life and Love?"

"The lessons of Life and Love!"

Then I could no longer see that they were cruel. I could only see that they were learning. I watched them with deep love and compassion, as one by one the whirlwind carried them out of sight.

— Anonymous —

PART TWO

Pluto
or
Minerva

The Choice is Yours

Dedication

To Thomas A. Jackson whom we love and respect for his support and encouragement and friendship through all the years we have known him.

Acknowledgements

We are grateful to all who encouraged us to gather together the ideas and the experiences gained from our counseling and research activities. We have been challenged to share our information to date. In no way are these thoughts the final and definite answer to the understanding of Pluto. We hope serious students of astrology will also share their knowledge and new experiences with Plutonian activities, so that cooperatively and collaboratively we all may benefit.

We sincerely thank all of the clients, students, and fellow astrologers who have shared charts and information with us and who thus have contributed significantly to this book.

Our thanks go to two other individuals who contributed their talents to assure the coming into being of our book: Edna Layton, our patient, diligent typist, and Helen K. Hickey, whose editorial skills added to its readability.

May the blessings you have shared come back a thousandfold.

Sincerely,
Isabel M. Hickey

Introduction

In this book we are sharing with you only the beginning glimmerings of what the planet Pluto represents.* All astrologers and students have the responsibility to do much more research before there can be more definite rules about its innermost meaning. Pluto, the most invisible of all planets, represents the energy in us which is unknown on the surface but which works ceaselessly in the depths of our being. It rules the underworld in us as well as the highest part of us. In its lowest aspect it can be working silently and unknown under the surface and then erupt with violence. Thus it can be compared to an earthquake or a volcano. There may be rumblings that pass unheeded and then comes the eruption. Long before the outer event is manifested the energy was stirring in the hidden depths. It is strange but the highest aspect of Pluto (Minerva) works in a different fashion. It changes the individual from within and comes imperceptibly like the dawn of a new day. It changes the individual so he is never again in the same state of consciousness. Purged of the dross he is refined and regenerated.

For some people Pluto remains apparently a non-functioning influence. Because they are sleeping souls neither their heights nor depths have been stirred. This is one reason for the lethargy and apathy seen in so many humans on earth today. Only those matters which concern them personally are of meaning or consequence to them. If you consider Pluto as important in the horoscope of those who are young souls you will not interpret the natal chart correctly. These young souls know nothing of the potential of their heights and depths and so they slumber on.

Pluto's transit through the signs is too long to be meaningful in a personal way. It affects the collective unconscious of a generation as it transits a sign. By house position and aspects to the other planets it affects the individual. Pluto by house position can be extremely important to the individual. The house in which Pluto is placed indicates the area where a purging must take place. One wonders if the person who named the laxative "Pluto Water" knew something about the planetary energy we call Pluto! Its little red devil as a trademark is a symbol of the Martian force expressed in a cleansing and purging way. Interesting, isn't it? Until Pluto's undercover work is done, and the dark side of ourselves is known and understood, we will not be able to know its true effect.

*When *Astrology: a Cosmic Science* originally was published in 1970, Isabel Hickey felt that further understanding was needed of Pluto's deeper meanings. After she had gathered more research on Pluto, in 1973 she published *Pluto or Minerva: the Choice is Yours,* which is now incorporated into this edition of *Astrology: a Cosmic Science.*

Pluto rules Scorpio. Minerva, goddess of wisdom, rules the highest aspect of Pluto. Every growth begins in the darkness and grows toward the light. Before the higher aspect can be reached, the personality has to be dissolved in the universal solvent. Sacrifice is the secret of Neptune. The cross is piercing the Moon, the personality. In the Minerva aspect of Pluto, the symbol is the cross below the chalice (♀) and the symbol of the Sun (☉), the eternal spirit, has risen above the cross where it is cradled by the Moon. It is our belief that there is a strong connection between Neptune and Pluto. Pluto's exaltation will be found to be in the sign of Pisces. The highest aspect of Pluto can be realized when the personality has been dissolved in the universal solvent of Pisces.

Study the following two charts of the houses that relate to Pluto and Minerva. Note that the evolved signs are on the night side of the chart with Scorpio on the ascendant. For the higher side of Pluto Pisces is on the ascendant. The evolved signs are on the day side of the chart. There is food for thought here.

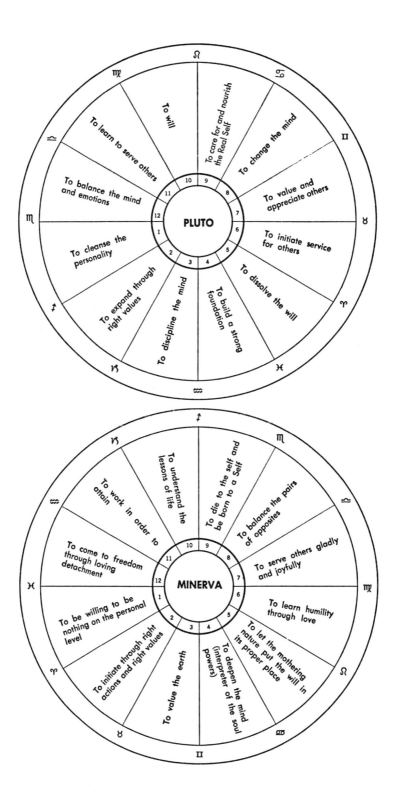

CHAPTER 32
Pluto Discovered

Myths that have come down through the ages represent great truths. The ancients knew those who were illumined would know the inner meaning of the myths while other would think of them as fairy tales. In mythology, Pluto was one of the twelve great Olympian gods who dwelt on Olympus. Zeus (Jupiter) was the chief. The oldest of the brothers was Saturn. To him was given the rulership of the earth and all that dwelt on it. He represents the first law of manifestation — the law of limitation. We all have to pass the tests of Saturn before we are free of the unlit self, the personality. Every one of us on earth is under Saturn's dominion as long as we are bound by the personality. The symbol shows the Moon, the unlit self, held down by the Cross, which is the symbol of earth living. In the Piscean Age this part of us had to be crucified. Not so in the Aquarian Age. The Avatar of this age will not be crucified. The personality will become the servant of the real Self, and take its proper place as a channel through which the power of the Essential Being can flow.

One of the Olympian gods was Poseidon, another name for Neptune, which rules a water sign. The three water signs are Cancer, ruled by the Moon; Scorpio, ruled by Pluto; and Pisces by Neptune. It is our belief that there is a very strong relationship between the higher aspect of Pluto, which is Minerva, and Neptune. The symbols are worth pondering. Ψ — This symbol is the Moon (personality) pierced by the Cross (symbol of earth living). \male — Minerva, the higher symbol of Pluto is the symbol of spirit above the chalice, the Moon uplifted above the cross of earth manifestation. It is very possible that the exaltation of Pluto will be given to Pisces. The lower aspect, Pluto, is symbolized by L , the Moon in the quadrant of the cross that denotes the eighth and ninth house in the chart. Pluto is the death of the separated self. Minerva is the regeneration and rebirth that brings us to the wisdom that is inherent in every child of earth.

Pluto, one of the brothers of the Olympian gods, was given the rulership of the underworld — all that was buried in the earth. It rules Scorpio, the sign of the death of the personality and the birth of the soul. Every seed must be buried in the darkness of the earth before it can break out of its shell and come up into light. All growth must begin its life in the dark. Every seed, even a human seed, needs that darkness before it is ready to reach toward the light. Pluto represents that life in the dark. Minerva represents the light that is reached when the life force in the seed breaks its shell and pushes through the earth and grows toward that light.

Pluto is a dark planet, and it is part of an inferior solar system. The vibration of the earth is speeding up, and there will be those who cannot take the increased vibrations that are bombarding the earth to raise its vibratory

keynote. All the evils that have been submerged and hidden for so long are being brought to the surface to be faced, cleansed, and changed. It is the Plutonian energy at work behind the chaos and confusion that is sweeping the planet. The ancient wrongs and evils must be eliminated. There is always the darkness before the dawn. The light that lies behind the outer aspect of Pluto will reveal itself if the individual will let it through.

Every energy that challenges us has two poles that act as attracting forces. As individuals we are pulled by both of them until we find the balancing force in the third force which is the center between the two opposing pulls. Pluto represents the underworld of the unconscious. It is an extremely powerful force which has rulership over the instinctive forces that lie buried deep in the unknown part of ourselves. Pluto wears a helmet, symbol of invisibility. Minerva also is pictured as wearing a helmet, and she sprang full grown from the head of Zeus. (Jupiter — Zeus — is the symbol of the Superconscious self.) There is a very negative side to Pluto. That side is as low as its higher aspect is high. When mob rule takes over, the negative side of this energy causes individuals to act far more viciously than any one of them would act by himself. In today's world the Hell's Angels and the Mafia are representative of this negative side of Pluto.

When we strike the highest vibration in our consciousness, there is an equal and opposite vibration struck in the deepest and lowest sub-basement of ourselves. The beast stirs and comes up for transmutation. This is the lower Scorpio aspect of Pluto, and shows the necessity of cleansing the swamp waters of the lower emotions. This explains why, after a spiritual retreat or a spiritual mountain-top experience, we have to come down to the valley and be plunged into earth matter to face the muck and mud in ourselves so that the light of Minerva (the insight we have gained) can dry it up. This is illustrated so well in the scriptures in the story of Moses. He had been on the mountain-top with God. Mountains are always the symbol of high peaks of spiritual consciousness. He came back to the valley and wondered what he was going to do with the wisdom he had gained. He heard the voice of God say, "Take off your shoes. The place on which you stand is holy ground." Shoes represent the covering of the understanding. He was being told that where he was at that moment was where he must work, and where he must bring in the light he had gained. Only by using the light we have gained right where we are functioning can we move on to greater opportunities and greater accomplishments.

Astrologers had known of the existence of Pluto since earliest times. The priest-astrologers of antiquity gave Pluto rulership of the land of the dead, Hades, and all the wealth beneath the surface of the earth. Astrologers were so certain of Pluto's existence before the announced discovery that there was little left to do except to study its physical characteristics and determine its place of rulership.

The search for the planet Pluto began when disturbances in the orbit of Neptune were recorded by astronomers. (It was when eccentricities were noticed in the orbit of Uranus that the search for Neptune began.)

The announcement of the discovery of the planet Pluto was made on March 12, 1930, from the Lowell Observatory at Flagstaff, Arizona. From the very

beginning its affinity with the planet Neptune was very obvious. The discovery of Pluto was the result of research begun by Dr. Percival Lowell, in 1905. The planet was first noticed on a photographic search in January 1930. Once recognized, its course was followed on numerous photographic plates until the time of the announcement, made by Clyde Tombaugh, a member of the staff at the Lowell Observatory.

Pluto's statistics have raised more questions in scientific circles than they have answered — a Scorpio trait indeed! It is the farthest out (3.64 million miles) from the Sun, and it is the last planet added to those already known in our solar system. Even with the assistance of the most high-powered telescopes, Pluto cannot be seen with the naked eye. It appears only as a tiny dot on photographic film used in the highest powered and most advanced telescopes. In essence, only those who can respond positively to Neptune and its highly spiritual rays can hope to understand and respond rightly to the Minerva aspect of Pluto.

Pluto broke up a similarity that previously existed in mathematical proportions. With the exception of Mars (lower octave of Pluto), planets from the Sun out to Jupiter (largest planet in our system), increased in size proportionately. From Jupiter out to Neptune, they decreased in size proportionately. Pluto's size, about half the size of our own Earth, was too small to fit the formula. The distance from the Sun also followed an almost perfect mathematical progression, until the addition of Pluto. The orbits of the other planets follow a pattern in that they are almost parallel to each other. Pluto, on the other hand, differs from them in that it is more elliptical, and is tilted the greatest number of degrees with respect to the Earth's orbit. Pluto is the only planet which passes within the orbit of another planet. At perihelion it is closer to the Sun than Neptune is at its aphelion. Pluto does not seem to turn on its axis as do the rest of the planets. This is just one more aspect of its seeming lack of conformity to the natural laws of our solar system.

The above facts have led scientists and astrologers to believe that Pluto is not a natural planet in our solar system. They are correct. The planets beyond Saturn were given to us to speed up our earth's evolution. The term "Prisoner" or "Captive Planet" used in some discussions of Pluto may also be correct. As stated in Chapter 29 (p. 274): It is truly a dark planet. Clairvoyant investigation shows it to be a prison house for those who over eons of time have refused to take the path of evolution. The fact that at its perihelion (the closest point to the Sun in her orbit) Pluto is closer to the Sun than Neptune at its aphelion (furthest position from the Sun in its orbit) gives food for thought to the spiritually curious student. If compassion and empathy (the very essence of Neptune) are as far away from the individual as is possible, a regeneration (Pluto) is necessary. Pluto, cover-up for Minerva, goddess of Wisdom, in its highest meaning relates to Universal Consciousness. Some there are who have to go down into the darkness to find her. The descent into Hell (or Hades) of Dante's *Divine Comedy* gives a clue to the meaning of Pluto. There is always a descent into the darkness of the underworld of ourselves before we can ascend. At the beginning of Dante's *Divine Comedy*, he finds himself in a dark forest and very dejected. Then he sees a hill illuminated by the Sun, and meets Virgil who is the symbol of human reason. Dante sets out

to climb the hill, but wild beasts, representing the unconscious darkness in himself, bar the way. He must first make the pilgrimage through (not around) Hell, or the depth of his own underworld.

CHAPTER 33
Pluto's Meaning

Pluto is the slowest moving of all the planets, and its journey through the twelve signs of the Zodiac takes 247.7 years. It stays in the sign Taurus longest, taking 30 years to complete the transit, and the least amount of time in Scorpio. It stays in its own sign only 12 years.

When a new planet is added to the hierarchy of our solar family, it is a sign of a new step in the evolutionary process of man. From the beginning there has been division of opinion where Pluto is concerned. Whether it is malefic or benefic; whether it rules Scorpio or Aries; whether it is of our own solar system or a planet captured or borrowed from another system are questions still being discussed. Answers have come psychically and in truly Scorpio fashion, and from the subconscious in true Plutonian fashion.

The naming of the planet is a perfect example. At first it was quite simply called Planet X. When one investigates the letter X occultly, we find that it denotes adjustment on the emotional plane. X is of an emotional and dual nature. It carries within its vibration psychic ability and heralds the awakening of intuition. The Flagstaff Observatory asked people all over the world to send suggestions for a name for the new planet. An eleven year old girl, Venetia Burney, of Oxford, England, proposed the name Pluto for the new planet. Eleven is a Neptunian vibration signifying psychic ability. Hers was the first proposal to be received at the Flagstaff Observatory, and was accepted. "And a little child shall lead them."

During the time since the discovery of Pluto the world has experienced wars, assassinations, a resurgence of violence, and gangland type organizations who parasitically live off the labor of the common man. There were those who quickly took note of the negative use of this energy and branded Pluto malefic, dark, and destructive. This is only partially true. Because it is dual there is also positive use of the same energy. If he so chooses man can use the line of least resistance and bring himself destruction and misery. When dealing with this most powerful radiation with wisdom and reason, the Minerva aspect of Pluto is in evidence, and the end result is a big step forward for mankind.

Coinciding with the discovery of Pluto was the famous kidnapping of the Lindbergh baby. Pluto was given rulership over kidnapping. However, only those spiritually tuned in could see the Minerva aspect at work. Up until this time, there were no federal laws that were enforced against kidnapping. Through that kidnapping, the legislature was able to get laws passed which henceforth would protect all children.

The great work of Dr. Sigmund Freud, and later that of his student, Dr. Carl Jung, opened the realm of the unconscious for investigation. Pluto's

discovery heralded a new day for man's thinking and feeling processes. The recognition that our fears were projections of our own unconscious served as an impetus to cause people to come to terms with the hidden side of themselves.

Scorpio, ruled by Pluto, can be either saint or devil. In its negative manifestations there is utter emotional confusion and subterranean destruction. There is conflict and instinctual self-defeatism. The negative Plutonian rays can be the most violent of any planetary radiations now known to man. Growth comes through painful experiences. Its positive manifestation is symbolized by Minerva, goddess of wisdom. It unites the head and the heart. The higher side of Pluto can bring illumination and Cosmic Consciousness. The scorpion who would sting himself to death rather than forego the pain and pleasure of stinging is the symbol of the lower aspect of Pluto. The phoenix bird, rising from the ashes of its dead self, is the Minerva aspect of Pluto.

KEYWORDS

Positive Expression	Negative Expression
Consecration	Desecration
Rebirth	Death, Annihilation
Transformation	Tribulation
Construction	Destruction
Free Flowingness	Intensity
Submission	Submersion
Transmutation	Instinctive Force
Wisdom	Struggle
Illumination	Obsession
Light	Darkness
Heaven	Hell
Willingness	Willfulness
Grace	Karma
Integration	Disintegration

CHAPTER 34
Pluto in the Signs

Because of the eccentricity of Pluto's orbit, a very different interpretation must be made of Pluto than the traditional interpretations of the other planets. So much is being interpreted about Pluto that isn't true. Its influence is a long time underground before it comes up for redemption. Pluto in the signs has a collective effect rather than a personal one. It stays from 12 to 30 years in each sign. Pluto was in Gemini from 1884 to 1914; in Cancer 25 years, 1914–1939; in Leo 18 years, 1939–1957, and in Virgo 15 years, 1957–1972. It transits through Libra from 1972 to 1984, and through Scorpio from 1984 through 1996. In the signs it affects civilizations and generations. The collective unconscious is affected and new energies begin to emerge from the invisible side of life.

PLUTO IN GEMINI:

When Pluto was in Gemini, 1884–1914, its eighth house relationship to Scorpio was outgoing and positive in expression. In that cycle, family ties were of great importance. There was insulation of the family group largely because of the lack of transportation. One travelled by horse and buggy or by trains. Communication between peoples of different cultures or different races had not yet been possible thus it was not developed. There was little group interaction except for those involved with family ties. Air deals with the mind, and air is much more impersonal than the other elements. It does not get involved. It is the spectator. The inventiveness and ingenuity of Gemini was bringing change (Pluto) into the world. Those brought up in the era before 1914, when the First World War broke out, were part of that world and saw the death of a world that would never again be the same. The airplane was invented. That would bring changes that no one could even begin to perceive at that time. The first use of planes was to bring death and destruction during the First World War. This started at the end of the time Pluto was in Gemini. Ever has it been that mankind has used the energy of any planet violently and destructively before using it constructively.

PLUTO IN CANCER:

Pluto in Cancer, 1914–1939, began to bring emotions and feelings to the forefront. Sentimentality was the keynote. Emotions and feelings were stirred up by the demagogues and the munition makers who wanted a war to sell

Ed. note: Written in 1973, this material on Pluto in the signs reflects Isabel Hickey's view at that time of current events and future trends.

their products. Blind patriotism was played up to an unbelievable degree. "Make the World safe for Democracy" was the keynote for the first decanate. Bands played, huge crowds gathered at railroad stations as our boys went "Over there." It was a lark for there had been no wars for many years, not since the Civil War. Then came the awakening. Poison gas was used. The trenches and "No-Man's Land" became realities. Pluto in Cancer was operating. The songs of the period emphasized the emotional side of that era. "I didn't raise my boy to be a soldier; I didn't raise my boy to go to war" was considered treason. The Kaiser's effigy was hung in the squares of the town and cities. Even though they had made their homes in America for years and become good citizens, those of German descent in this country were hounded and persecuted. In the second decanate the boys were home and disillusioned by the war. There were no jobs and the world was in a depression such as it had never known. It was the Scorpio decanate, and Pluto had full sway. The intensity of the suffering had its redeeming side. Pluto's higher aspect, Minerva, was operating. Where there is deep suffering, there is growth. Everyone shared whatever he had, however little it might be. The common denominator — everyone was on the same level — brought more true caring (Cancer) and more desire to share than ever before. The third decanate of Cancer, Pisces, was operating. Pluto in Cancer wants to mother or be mothered.

PLUTO IN LEO:

Pluto in Leo, 1939–1957, was when the dictators came into operation. The New Deal was born. The Second World War started in September of 1939. This was devoid of the glamour of the First World War. No more flags flying and bands playing. The soldiers were shipped out quietly in the middle of the night. No lights on at night unless the windows were draped with heavy shades so that no lights could be seen. Broadway was no longer the Great White Way. Wardens were out every night to see that there were no violations of "lights out." The first decanate of Pluto in Leo (ruled by the Sun) saw the dictators in full sway. The four Lords of Karma were in incarnation. They are tied with the fixed signs. Do you think it was happenchance that Hitler was a Taurus, Mussolini was a Leo, Hirohito a Scorpio, and Franklin Roosevelt an Aquarian? Pluto in Leo (its eighth house relationship to Scorpio) shows the need for the individual to balance his ego drives with respect for the needs of others. The dependency need of Pluto in Cancer was now replaced by the authoritarian desire (Leo) to have complete control over others (the 10th house position of Pluto). Being in a positive and outgoing masculine sign, Pluto in Leo dominates and uses others for their own needs. By manipulation and the ruthlessness of the lower side of Pluto, the dictators did use others. Because the undercover and subversive side of Pluto was present in Leo, a Fire sign, the dictators did what they wanted. For those born with Pluto in Leo there would be a tendency to want to dominate and there would be struggles with children. The strong will of the parents would mean that they would bring in offsprings with wills just as strong.

The first decanate brought in the struggle for power that ended in 1945. The second (Sagittarius) decanate, ruled by Jupiter, 1945–52, saw World War II ended, and the dictators either dead or dying. The division of the spoils changed the map of Europe forever. Russia, that had done so little for the Allies, though her defense of her own country was magnificent, was to reap the greatest benefit. Stalin, a Capricorn, knew how to manipulate and he did. He knew how to play Churchill and Roosevelt against each other, and he did so at the Yalta Conference. 1951 to 1957 saw the rebuilding of all that had been torn down. The egos born in this Aries decanate have a burden to carry. Mars with Pluto gives a tendency toward violence and rebelliousness that can be ruthless and cruel. Many of the Storm Troopers of Germany incarnated very quickly, bringing over the ruthlessness and violence they had been trained to execute. This explains why some of the young people of today have no conscience about mugging, killing, or raping. To counterbalance these types, many, many, souls born in the same generation represent the Minerva aspect of Pluto. They are spiritually oriented and tuned to a wisdom and understanding that is truly beautiful. They are developed souls who have chosen to incarnate at this time to bring the Ark of the Covenant into the New Age. They are the hope and the glory of this incoming age.

PLUTO IN VIRGO:

From 1957 to 1972 Pluto was in Virgo. These fifteen years saw tremendous strides where the rights of the worker and the "little man" have been concerned. Interest in health brought in the use of vitamins and interest in organic foods. The young people became health conscious. Health stores and macrobiotic restaurants sprang up in all the cities. New methods of healing in natural ways came into existence. Tremendous research in medicine began. Important breakthroughs occurred and the relationship between the mind and the body was recognized. Gestalt therapy came into being to break up the repressions, insecurity, and inferiority that Virgo all too often represents. Computers (a truly Virgoan product) mushroomed and have increased in every area of the business, scientific, educational and health world. Computers for chart calculation in astrology were born. The higher aspect of Pluto is involved here. With time saved and work cut down, the individual has time to tap into his inner resources, and to develop his spiritual potentials so the light and wisdom within him can be released. The negative side of Pluto in Virgo is the tendency to be overcritical and to sit in judgement where others are concerned. If the Minerva aspect of Pluto proves to have its exaltation in Pisces, as we think, then Pluto in Virgo will be in its fall. Virgo gets caught in detail and the "nitty gritty" side of life. Virgo can be unloving and self-centered and is not too keen about sacrificing for others. If those with Pluto in Virgo will use its highest aspect they will be truly great servers on the planet. They will make excellent nurses, doctors, naturopaths, physical therapists, and healers.

PLUTO IN LIBRA:

In the sign of Libra (1972–1984), Pluto's energy affects relationships, marriages, unions and partnerships. Here the lessons of cooperation and compromise have to be learned. Global responsibility (Saturn exalted in Libra) must be faced. As Libra is the 12th house sign of Scorpio either we must learn to understand those alien to our way of thinking or we bring about our destruction. Events are now soul size and planetary size. Every aspect of legislation and law and those who administer those laws will be challenged. The turning point in evolution has been reached in Libra for that is the nadir of involution. The first six signs represent the lessons of personality mastery. Libra represents the turning point similar to the marking buoy in a boat race. We are turning back to where we started and if we have mastered the lessons of the course up to this turning point, the rest of the course will be relatively easy. We have to be involved before we can evolve. We are now touching the depths in all of us. This means going down to uncover the basic elements and values deep in the earth of us that are not apparent on the outer side of the personality. Depth is reaching into the center. The nucleus is the core of the atom. Beyond the world of appearance and the outside aspect of life lies power. Beyond all the superficial aspects of life lies the Universal Mind where the unity of all life is known. The ability to contact this Universal Mind has been known to all the sages, initiates, and those great ones that knew the truth, and the truth set them free. Knowing an initiate teacher in this lifetime called Brother Philip has given an insight to what this means. An uneducated man in a formal sense, he could talk to a medical man in his terms, a scientist in his terms, a geologist in his terms and know all he needed to know about their fields. Asked how he could do this (after seeing him do it), he smiled, and said, "In the Universal Mind is all knowledge of everything, for it is the totality of all that is. I tap into it and know when I need to know it." This is Plutonian power at its highest. This is the wisdom of Minerva personified.

The brain (Mercury) is like a radio. It transmits as well as receives. Mercury represents our ability to assimilate (Virgo) that of which our brain becomes aware (Gemini). The state and quality of that radio is shown by Mercury in the birthchart.

Pluto does not, as a rule, deal with immediate life situations and personal requirements. It is how the individual is affected in the depths of his being. It is not what happens to him but the effect of the happening upon his consciousness, for good or ill. The challenge of Pluto is what group or what ideology are we going to serve. One World — that is what Pluto is saying — and each individual has to come to realize the unity of life. We rise or fall together.

In Libra, Pluto teaches us to understand the other fellow and think in terms of that 'other' out there. The process of decision-making takes on great importance here, with long-reaching results. Libra represents the law of relationship. Two poles are brought together to create a third force whether it be male and female, parents and child, spirit and matter, or positive proton uniting with the negative electron to produce electricity. Pluto in Libra brings up

to the surface the evils that have been hidden and kept out of sight. These evils have to be recognized and redeemed.

Marriage as it has been known in the past is on its way out. Young people are living together without benefit of clergy. They are writing their own marriage vows and contracts when they do marry. There has been loss of faith in dogma and creed. The legal laws and religious laws are being challenged as never before. Pluto brings destruction of all outmoded legalities and hypocrisies. We are seeing the darkest side of Pluto in Libra operating as a supposed agent of light when a well-known Christian leader condones and calls for capital punishment and castration to be brought back as laws. Where in all of the New Testament did the Piscean Master advocate killing or death for any offense? Does one murder cancel out another? Is it any wonder so many intelligent young people turn from Christian orthodoxy? Hypocrisy, indecision and failure to speak up and be counted is our greatest enemy with Pluto in Libra. When only 52% of the population voted in a national election, the results can be placed squarely on the shoulders of those who didn't care and who abdicated their rights and responsibilities. How can we complain about adverse conditions when we sit back and do nothing to change them? Whatever we fail to sow during this period reaps its harvest while Pluto is in Scorpio.

Libra is an Air sign, and Pluto in Libra seeks to clean and clear the air in more ways that one. Pollution of the mind through air waves will cause investigation and reexamination of television programs. Corruption of youth through violence and crime on television programs will be recognized and brought to the attention of the public. Recently there was a report in a newspaper of a youth who saw a murder of an elderly lady on television and repeated the crime in real life just as it was acted on TV. At this writing there are several groups spearheading movements to clean up the airwaves.

Smog and radioactive matter carried by the wind will do so much damage that laws will be passed outlawing nuclear tests and outlawing gasoline fumes. New kinds of fuel will be used in motors of all kinds. There will be very definite proof of what pollution is doing to human beings. 1975 to 1984 are reaping years. Nature will be protesting the misuse of her resources and the weather will prove this point. The effects of Pluto in Libra will take our minds well beyond what our prior human capacity could conceive.

The souls that came into incarnation with Neptune and Saturn in conjunction in Libra at their birth will be active and at work to usher in a new consciousness when Pluto goes over that conjunction. Many advanced souls have come in since 1945, and they will be the new leaders and statesmen. They have chosen to come in and clear the planet of the demagogues and the greedy materialism which such persons represent. A purifying, albeit painful process will be at work on the planet. The Avatar of the Aquarian Age is about His Father's business. His activity started on the outer levels with the entrance of Pluto into Libra. Would you be surprised to find out he is already functioning and has chosen a black body in which to dwell! How many will recognize Him? How many recognized the greatness in a Jewish carpenter?

Wherever Pluto is placed by house is the area where the deepest and darkest side of our nature has to be understood, brought up into the light and

changed. That area of our being must be purged and purging can be a painful process. So many astrologers speak of Pluto as a very negative planet. Any energy can be used constructively or destructively but the energy is pure. It is how it is used that labels it. There is tremendous strength in Pluto as there is in Scorpio. With that strength, and will, we can tap the highest in us or the lowest. The highest aspect of Pluto in Libra will be the ability to recognize Love as a principle, not as an emotion.

PLUTO IN SCORPIO:

Pluto will be in Scorpio from 1984 to 1996. One can have some idea of how this will affect us by knowing the meaning of the sign Scorpio, and its relation to the other signs by house position. The house positions are far more important than we realize. The houses came into prominence first rather than the signs. Pluto in Scorpio is in its first house position. It is more powerful in that sign than in any other. Scorpio deals with generation, regeneration, and degeneration. Of all the signs it is the strongest for good or ill. It represents concentrated power. If misused, it is unbalanced force and power out of control. Its intensity is due to Pluto's rulership. Its painful effect is due to our crystallizations and our unwillingness to face the dark side of ourselves. We all have that dark side. Pluto's work is to cleanse and redeem the murky swamp waters in the depth of our subconscious and instinctive self. Minerva is the end result of our Plutonian experiences. While we are going through a purging experience this may be difficult to realize. Only after the experience is over do we realize and know the good that has been done. There is no doubt that our egos are crumpled, our illusions are finished, and we are forced to face reality. The shell of our understanding is cracked and we are set free. This is what Pluto in Scorpio will do to everyone on the planet Earth, between the years 1984 and 2000.

Pluto in Scorpio will revolutionize medicine and bring in new methods of healing. New birth control measures will be taken that will not harm the body as the pill of today has. Cures for cancer will be found. Because the veil between the planes is already getting thinner many children will be born with highly developed extrasensory powers. There will be great changes in educational methodology. Astrology will be taught in most of the schools and colleges. The emphasis in education will be directed towards helping young people develop their own potentiality rather than pouring a great many facts into their heads that they will not use in life. When Pluto is in Scorpio, its power will be at its strongest. This planet will undergo a purging such as the world has never known. Those who are born with Pluto in Scorpio will be the souls who, when grown, will have the power to usher in a new heaven and a new earth. The ancient evils that have been under cover for so long, will be exposed, cleansed, and redeemed. The strength so apparent in Scorpio will be recognized as Plutonian power that can act viciously, or if operating at the highest level, the power can redeem and raise levels of consciousness for those who are ready. There will be severe punishments for crime that will deter the criminal. A tremendous cleansing will take place where politicians and corrupt government is concerned. Corruption is coming to the surface.

There will be violence and resistance but nothing will stop the inexorableness of Cosmic Law. Although some there are who do not believe it, there is strict and undeviating justice in the Cosmos.

The lost continent Atlantis will rise, and part of it will come up as intact as it went down. It will be coral-encrusted, and artifacts will be found that will give people ideas of what civilization was like. Every outer event has its correspondence on the inner side of life. The inwardly connected souls knew that when the top of Mt. Everest was reached, we could reach higher spiritual heights than had ever been known before. When the astronauts reached the Moon, it told us that the subconscious would no longer be a mystery, and we would explore the Moon part of ourselves. Books on the subconscious and its powers began to fill the bookshops. Groups of all kinds were using techniques that helped people to understand their hidden feelings and their dark side.

When Atlantis rises out of the sea, the collective unconscious in us will be brought out of the depth of ourselves and will show the unity of life as never before. Ego has to go, and love must take its place. Those who cannot take the heightened vibration will, in mercy, be withdrawn and take an incarnation on a planet of slower vibration. From 1975 to the year 2000, earth changes, personality changes, spiritual awareness and illumination will be the order of the times. The decision of mankind will determine what happens. Because those decisions are in the hands of mankind, even the Masters do not know what will befall the planet. The pattern can change from day to day. Each of us should be willing to flow along with the tide and not set up resistance against anything that comes. This is necessary so that growth and redemption can occur.

CHAPTER 35
Pluto & Minerva Through the Houses

Pluto in the signs refers to a generation as a whole and shows the lifestyle of a period. It has no really individual meaning for millions of people are born with Pluto in a particular sign.

It is Pluto in the houses that is important to the individual. The house in which Pluto is placed is important. It shows where and how the person can best meet the challenge of his destiny in regard to his humanity and his relationship to the group consciousness. It is different in different houses. Pluto's placement in the birthchart represents the path that could lead to Cosmic Consciousness. It shows how one can best help or hinder the great tide of human evolution.

Pluto shows the highest attainment the person can reach in this lifetime or the lowest to which he can descend. Always the choice is there. Pluto is power but so often unbalanced power. As far as mass consciousness is concerned (for it is asleep spiritually), only the negative aspect of Pluto is working. In the solar system the Sun is the power planet. The planets transmit this power to the magnetic field of the earth. Any planetary energy manifesting discordantly can become a source of energy out of control. All planets but Pluto revolve around the Sun in the plane of the ecliptic. Pluto's orbit is different from all the rest. It is steeply inclined to the ecliptic, and its orbit is a long way from being a circle; it is a flat ellipse. Pluto's position within the solar system is different from all the other planets. This fact must be taken into consideration where its house position and relationship to the other energies is concerned for it cannot be interpreted in the traditional way.

As Pluto's energy is underground and invisible, there has not been enough study of it for us to fully understand it. We have touched only the fringes of its meaning. Pluto's influence as it conjuncts a planet is very important, especially if Pluto is in an angular house, or is, at birth, in conjunction with the Sun, Moon, or Mercury. When it is in a cadent house with very few aspects, it may have very little influence of the person.

Pluto has more duality and ambivalence than any other planet. It has contradictions in its actions that the unillumined individual will not understand. Its effect is undercover for a long time before its influence is felt by the personality. And why not? It rules the underworld and all that is invisible. Its highest keynote is "CONSECRATION." Its lowest aspect is "DESECRATION."

In this book we are giving its influence (as we have observed it) in its Minerva and Plutonian aspects. The only way one can learn the effect of Pluto in the houses is to watch its position by house and see how it affects the individual. The house Pluto is in will be a difficult one until the individual has transmuted his ego and tapped into the wisdom of Minerva. Here is where

his weaknesses are unknown and unrevealed to his conscious self. Here is where he has to deal with his subterranean forces, letting them emerge into the light of day. The sign on the cusp of the house that Pluto is in will be important. Its influence changes according to whether the sign on the cusp is positive or receptive. If the sign is masculine, Pluto's energy would be positive, outgoing, and dominating. It would use others rather than be used. If it is a feminine sign, it is a passive and receptive force allowing itself to be used. For instance, Pluto in the first house will have a different effect when it's in the sign of Leo, than it will have in Virgo. If you have studied the characteristics of the signs, you can see why this would be. Leo is positive, assertive, and independent with organizing ability. There would be a power struggle (the Sun force in Leo) for the Sun reaches out for power and Pluto, being hidden, is an energy tuned inward. Virgo, as a rule, does not want power. It wants to get on with the details of everyday living, and do "its own thing."

Astrology is a symbolic language, and if we learn the basic keywords and put them together our understanding of the meaning of the energies will be greatly increased. The houses the planets are in are very important. The houses came first, and the meaning of the signs was derived from putting Aries (the divine spark descending into matter) on each one of the twelve houses. The character of the sign came from the position of Aries on each house cusp. Try this method out for yourself, and you will see it. As an example, why is the person with a Sagittarius ascendant very friendly but apt to be far from generous with his finances or resources? Capricorn, ruled by Saturn, is on the second house. Why is the person with a Scorpio ascendant far more generous, and very quiet about it? Sagittarius is on the second house, and Jupiter, the planet of expansion and givingness, rules it. Uranus, planet of intuition, higher octave of Mercury, rules astrology. By studying the signs on every house cusp much will be revealed to you.

PLUTO IN THE FIRST HOUSE

Here is the necessity for understanding the instinctive side of the nature. When Pluto is in Virgo or Cancer, there will be a deep-seated inferiority complex. The individual does not have control or mastery over his instinctive forces. Somewhat like the person with Neptune in the first house, he is never sure of his own identity. Many people with Pluto in this house are timid and unsure of themselves. They are usually gentle and very sensitive on the surface. If they panic or get upset they can erupt like a volcano, and everyone is surprised at the amount of anger that comes to the surface. If Pluto is in Leo and afflicted, especially to the Sun, the individual hides his insecurity by appearing bombastic and arrogant. It is a cover-up for his lack of confidence in himself.

The personality needs regeneration. If too withdrawn, the person has to learn to come out into the world and participate, instead of retreating. If too aggressive, and the urge for power is overemphasized, then the self must come to the realization it can be used by the power, but not be the power. In the house where Pluto is posited there is great strength that can be used in a destructive or constructive way. The desire to use power must be overcome.

Reactions to the upheavals Pluto brings will be very important. The negative Plutonian tendencies of brooding, holding on to hurts whether imaginary or real, the need to retaliate (vindictiveness) will react on the physical body as well as on the emotional vehicle.

Moderation is a good keyword for this position of Pluto. To retire into one's self refusing to share ideas, motives, dreams and ambitions can be just as damaging to the personality as the giving of one's self totally to whatever idea or cause one is moved by.

The Minerva aspect of Pluto in the first house is as constructive as the lower aspect is destructive. There is a perfect willingness to be a channel for healing and to be used by the forces of light. The personality is dissolved, and the light streams through the vehicle blessing all with whom it comes in contact. This aspect of the self comes through. The personality is dissolved in the solvent we call understanding. Pisces rules the feet in the physical body. Feet have always been the spiritual symbol of understanding. When Jesus washed the feet of the disciples it had a twofold meaning: the willingness to serve in perfect humility; and the cleansing of their understanding. On the wall of the Hall of Learning on the inner levels the Piscean Mantram was, "The disciple can stand in the presence of the Master when his feet have been washed in the blood of the heart." On the Aquarian Hall of Learning the Mantram is "The disciple can stand in the Presence of the Master when he can hear every bitter word as a cry for help and answer from the heart of love unstintingly."

PLUTO IN THE SECOND HOUSE

Here is the house of values and resources. Here one confronts one's appetites and learns to control them. Money and the things it can buy will be important. If the negative side of Pluto is working, the method of attaining money could be less than honest. In some charts with Pluto afflicted in this house the individual has been connected with gangsters, and the underworld of crime. This position of Pluto can bring great wealth, usually from metals, mining, or oil — things that lie beneath the surface of the earth. Worldly possessions are important and often obtained legitimately if there are good aspects to Venus or Jupiter.

With heavy afflictions to Pluto in the second house, money may be acquired, but it could vanish very suddenly and unexpectedly. Gambling and speculation could cause loss when a heavy transit conjuncts or opposes Pluto in this house. With constructive aspects, money could come through inheritance. If the Minerva aspect was functioning, the individual would consider himself a steward of his wealth, and use it to lift the burdens of those that need help. There would be a spontaneous outgoing expression of the desire to share. Pluto is a planet of extremes going to the farthest pole whether it be desecration or consecration. If there is a particular pattern shown in one area of the chart that is a strong characteristic, it will be shown not only by one aspect, but over and over again in many different ways. If it is shown only once, it will be of little importance in the character formation. When some quality of character is emphasized in several different ways, the astrologer knows that it is of great importance in the individual's life. The house in

which Pluto is placed shows the karmic hangover from the past as far as instinctive reactions are concerned. In the second house, Pluto has to do with values, appetite, sensuality, and over-possessiveness. It can swing from one pole to another. There may be an austerity that passes severe judgements on anyone indulging in weaknesses. Our latest learned lessons usually involve the qualities of which we are most intolerant in other people. For instance, the alcoholic or drug addict of a past life is the one who comes into embodiment with no desire for liquor or drugs in this lifetime. The lesson has been learned where others are concerned, but the dues have not been paid. So, before incarnation, the soul chooses to come into a family or situation where someone will be an alcoholic or a drug addict. It is possible it will be a mate. The same treatment once passed out to others returns to its source. This is how we learn. We reap what we have sown. The right attitude in these situations proves whether we have learned the lesson or not. Pluto is the underworld in ourselves. Aspects from Pluto, by transit or direction to the ruler of the second house or planets in it, can make a prince of the pauper, and a pauper of the prince. The tests lie in one's positive or negative reactions to these events. Keen judgement, endless energy, and great patience are all necessary ingredients for financial success in life. The tendency to view persons, especially those with whom one is romantically involved, as possessions must be avoided. Efforts to remake those in one's personal world, or to force one's set of values upon others will meet with unhappy results. As natural ruler of the 8th house, Pluto posited in the house of values demands a sane attitude toward sexual appetites if peace of mind is to be acquired. Man's chance to use the Minerva aspect can give him god-like powers to create and reproduce. His abuse of this gift called forth the destruction of Sodom and Gomorrah.

PLUTO IN THE THIRD HOUSE

Planets in this cadent house affect the individual through the mind and the nervous system. Pluto in this house does not bring the drastic outer events into the life as it does in the angular houses. It works in a hidden and more subtle way. The backdrop of this house is Mercury, natural ruler of the third house, and Saturn, ruling Capricorn, third sign from Scorpio. There will be caution, seriousness, and depth to the mind. At times a tendency toward depression and negative thinking has to be overcome. The aspects between Pluto, Saturn, and Mercury will be very important for they will indicate whether this energy will be used positively or negatively. This position of Pluto can be used to probe the secrets of the universe or be used to uncover secrets of a more personal nature. The individual could be a good researcher in medicine, or a geologist dealing with the earth. Metallurgy would be a vocation with appeal. If Mars is highlighted in the chart there will be ability in police work or as a private investigator.

There can be great turmoil in the mind and if it is suppressed the results will not be good. If difficulties cannot be talked out with a confidant, then they must be expressed either through writing or painting. Often painting or writing out one's feelings can act as safety valves and save the nervous system from too much pressure. After the thoughts and feelings have been expressed,

either through color or writing, they should be destroyed. Elimination of what has been expressed provides a mental catharsis, and the health will not suffer.

In the early home life there may be unusual conditions where relationships with brothers and sisters are concerned. How this will operate has to be judged by the aspects to this house from the rest of the chart. The Minerva aspect of Pluto in this house would illuminate the mind, and the individual could be a teacher of spiritual law and bring light to others. Little escapes the awareness of persons with a third house Pluto. They are able to evaluate situations and people with great accuracy. For that reason they make great counselors and psychologists.

PLUTO IN THE FOURTH HOUSE

This is the midnight part of the chart and shows the quality of the soul operating in the depths of the individual. Energies in this house are not apparent on the surface as Pluto is the most invisible of all the energies. This house portrays the foundation of the character inherited from other lives as well as the genetic patterns inherited from the parents. The energies of this house come to the surface in the latter part of life.

Success can come in the outer life through real estate and property. This is especially true if there are many earth signs in the blueprint. Imagination is very active and intuitive faculties are good. Interest in the inner side of life will manifest as the individual matures.

There is a very strong desire to have a home life where there is love and security. However, this has not been earned if Pluto is afflicted in this house, especially if afflicted to the Moon. From a study of many charts it seems as if Pluto, in whatever area posited, denies us what we want until we are willing to relinquish it. A purging has to be undergone before the Minerva aspect of this energy works. In the natural zodiac this house is ruled by Cancer. It is the most dependent sign in the zodiac. Home and mother play a very big role, either for good or ill, where any planets in this house are concerned. If Pluto is here this is particularly true.

Minerva, another name for the feminine principle, the Divine Mother, is the Forgotten One between Heaven and Earth. If there is a Father and a Son, doesn't there have to be a mother, too? Caring is the way to bring her in. In order to do so we have to be purged of selfishness. This is what Pluto in this house means.

PLUTO IN THE FIFTH HOUSE

This position is similar to the Sun in conjunction with Pluto. In the natural zodiac the fifth house is ruled by Leo. Here the ego has to be purged of any self-conceit or tendency to arrogance. If the heart center is open, the creativity and wisdom of Minerva is at its disposal. The serpent force, the kundalini fire at the base of the spine, is active and can be used creatively. If sex is over-emphasized, this Plutonian energy can raise havoc, emotionally, mentally, and physically. This does not mean to suppress the sexual energies but to use them wisely and always lovingly. In the use of any power Pluto in the fifth

house makes two demands. Is it loving? Does it hurt anyone? When Pluto's power is used constructively, the individual can express his creativity through any channel he chooses. A well aspected Pluto in this house can bring fortune through speculation. Pluto often brings great wealth through the areas it rules as well as its aspects. If it is afflicted, the person can attract wealth and then lose it.

If there are children promised in the chart, they will be unusual and not run-of-the-mill types. Selfishness will be overcome through the responsibility that has to be accepted as a parent. There are children of the mind and emotions as well as of the body. In this house power cannot be appropriated by the self. Illumination (light) comes by a willingness to be a channel not the power. Pluto's keynote in this house is "Be willing to be nobody — then you will be truly somebody." When that consciousness is reached (usually through sacrifice), Minerva will use the individual to bring light into a world sadly in need of it.

PLUTO IN THE SIXTH HOUSE

Pluto in the house of adjustment means a purging of the motives and of the mind. A healer or a hypochondriac? The choice is there. If one loses one's self in service one hasn't time to be sick. With a Virgo background Pluto in this house can be the "nitpicker." Being critical and sitting in judgment are signs of deep feelings of insecurity and inferiority. Pluto represents large groups and corporations, and a person with Pluto in this house may feel submerged as an individual in such an impersonal materialistic environment. There is an adjustment necessary where employment and fellow workers are concerned. If Pluto in this house is afflicted (especially to Mercury) nerves are a problem that could cause difficulties which are not easily diagnosed. There can be trouble stemming from wrong reactions where others are concerned. There could be instability and criticalness which are unexpressed, but which are still felt by others. The individual thinks that because nothing was said the other fellow is not aware of the criticalness. Because the veils between the planes are thinner than they have ever been before, what is thought radiates, and the antenna on the unconscious side of others is picking up the thoughts and reacting accordingly.

If the individual forgets himself in service to others, the Minerva aspect of Pluto brings on tremendous healing power. The ability to be a channel of healing comes naturally to the person with Pluto in this house. Nursing, the medical field, psychology or counseling as well as the ability to work with the earth and treasures hidden in it are the fields in which there could be great success. Take note of the relationship between Pluto and Mercury when Pluto is in the sixth house. It is important. There is high tension in the nervous system, and it must be understood and used rightly. The lack of ease created by unused energies can play havoc with the psychological well-being of the individual.

PLUTO IN THE SEVENTH HOUSE

The seventh house represents relationships in the outer world and how others react to the individual. The most personal of relationships is marriage. Pluto has a purging effect in any house of the birthchart but its effect is particularly strong in this house. It is a very impersonal energy in an area where personal attachments are very strong. It is difficult for the person to have a close and strongly emotional relationship. An uninvolvement where personalities are concerned and a deep dedication to Love as a principle is the lesson Pluto brings in this house. A wise choice of a partner in a union or marriage is very important as Pluto will hold the individual to his choice even though he would wish to be free. The stubbornness or stability will hold the individual to the promises he made regardless of the cost to the personality.

The individual's ability to see both sides of a situation makes his judgments unprejudiced and objective. His role as a mediator is unquestioned. Law and legal matters can be of interest and talent does lie in this direction. As Pluto rules large corporations, corporation law can be a natural outlet for the energy. The regeneration of the person with Pluto in the seventh house depends on the willingness to cross out any personal desires and be willing to serve "others" for the sake of service, with no ends of his own to serve. The Minerva aspect of Pluto comes to the fore when love is more important than self. "He who loses himself shall find himself."

PLUTO IN THE EIGHTH HOUSE

This is the true house of education for it is concerned with progress of every kind, moral, mental, and spiritual. The house is always important in charts of those strongly interested in movements of progress and reform. Its gloomy title as the "house of death" is appropriate only because death is the greatest step forward known to us at our present stage of evolution. If Pluto is badly aspected here it makes it easy to choose the path of degeneration, if that is the way an individual can learn the most. It need not be. With Pluto in this house there will be no standing still. One has to die to the old self and undergo rebirth while still in the body. There are no misty flats or drifting to and fro. It can mean a long life if the life force is not wasted. Heavy afflictions could mean the degeneration of the energies through dissipation and sensuality.

This house represents the entrance to the next dimension. It rules the psychic senses and out-of-body experiences. If Pluto is well aspected to Neptune and Mars, the native may be clairvoyant.

No one but the person himself can help the person with Pluto in this house come to victory over his appetites and desires. There must be no desire to control others but a sincere desire to help others find and use their own resources. Financial independence can come through a legacy. The aspect between Pluto and Mars will be very important with Pluto in this house. If one uses others for one's own ends there are drastic and violent repercussions.

With rebirth through regeneration comes the wisdom of Minerva. The death of the personality and the birth of the soul power is the promise of the

higher side of Pluto. One goes into the darkness to find the light. Insight, self-mastery, and the ability to stand alone, if need be, are the gifts of Minerva in this house.

PLUTO IN THE NINTH HOUSE

With Pluto stationed in the house of the superconscious mind there is emotional intensity in the desire to know and understand the purpose of life. The breaking down of all orthodox beliefs and fixed opinions is sometimes necessary before the individual can begin to feel satisfied that there is a meaning and a plan behind all manifestation. When Pluto is in this house, there is a strong desire to be a pioneer in the spiritual realms as part of the individual's traits. To show others the reasons and methods of regeneration is a compelling urge to this individual. This position can bring with it a higher sense perception (clairvoyance) that stems from a much higher level of consciousness. If Pluto is used negatively in this house, it can make one a fanatic where beliefs and religion are concerned. There can be a tendency to force beliefs on others. If Saturn is very strong in the chart, there is rigidity in the viewpoint that indicates the need for the individual to be more flexible in his thinking. As Jupiter is the natural ruler of this house there will be expansion where Pluto is concerned. If the lower side of Pluto is strong, then the negative aspect will be enhanced. If the individual reaches up to his highest ideals and principles, illumination and wisdom will be his birthright.

There is a strong desire to explore far horizons, whether on earth or beyond it. If that urge is followed, the person can bring back to others the knowledge that has been gained. Pluto in the ninth house brings a water element (♏) into a fire (♐) house. This can cause steam, or the water can put the fire out! It's how this Pluto energy is used that makes it steam or sizzle.

PLUTO IN THE TENTH HOUSE

In this house Pluto comes into the area that is controlled by Capricorn and Saturn. A power struggle is operating for the person wants total control. This just cannot be. Saturn represents a conscious drive for power and Pluto represents an unconscious drive for power. Saturn represents the force of conservation and Pluto represents the force of dispersion. It breaks up crystallized conditions. Thus, the sense of balance and of values can be distorted with Pluto in Saturn's house. If Pluto is in a positive sign, the drive for power will be stronger than if it is in a receptive (feminine) sign. The individual's place in the limelight (10th house is Capricorn's home base and Saturn rules lime) is very important to him. If the Pluto energy is used negatively, there will be a climb to the top regardless of how many people are trampled on to get there. The person will find that the position or prominence attained cannot be maintained and many difficulties will ensue. Pluto acts as a purge in this house to cleanse the materialistic selfishness inherent in the drive for power. Diplomacy and patience have to be inculcated into the character if the individual with this position of Pluto wishes to be successful in the world of appearance. The need here is to learn the meaning of "Seek ye first the kingdom of heaven

and all else will be added unto you." "All else" includes peace of mind, abundance, and the right position in life.

These are the gifts Minerva brings to those who know Saturn and Pluto's mission in one's life. The tenth house is the highest house in the chart. Capricorn is the scapegoat and is perfectly willing to bear burdens in order to relieve others and free them from their misconceptions. This is why all the world saviours have been born in Capricorn. According to Manly Hall there have been sixteen of these great saviours.

PLUTO IN THE ELEVENTH HOUSE

This is the house of friendships, goals, and objectives. Therefore the choice of friends and the goals chosen are going to be of the utmost importance. If the wrong choice of friends is made, there can be sudden and unexpected disruptions. Remember that Pluto too often can be unbalanced and uncontrolled power. Great care must be taken in choosing the right groups with which to associate. Great discrimination must be used. Virgo is the 11th house sign of Scorpio. There is great necessity to choose your associates with care. This is shown by the underlying tone of Virgo in this house. Friends will come and friends will go with Pluto in this house. While they are in your life serve them well and you will purge yourself of all the negatives inherent with this position of Pluto.

A well aspected Pluto in this house, especially to Jupiter, Venus, or Uranus gives great devotion to principles and to ideals that further the development of mankind. These people are the leaders who fight for causes that will benefit others. They have charisma and people are willing to follow them. They have many friends, and without friends, goals and objectives are not achieved. Interesting that both Leo Tolstoy and Goebbels, who associated with Hitler, had Pluto in the eleventh house. One took the high road and one took the low road. Both influenced many people. "The high soul seeks the high road; the low soul seeks the low, and in between on the misty flats the rest drift to and fro..." Pluto never drifts any more than Scorpio does.

PLUTO IN THE TWELFTH HOUSE

If we are right about Pluto being exalted in Pisces, then the position of Pluto in the 12th house is going to be very important. This house, as the sign it rules, is the most psychically permeable. Neptune is placed at the meeting point between our solar system and an inferior solar system. It is from this inferior solar system that Pluto draws its primitive force. That is why it is known as a dark planet. Behind it lies Minerva, a planet not yet discovered.* Only the few who are light filled and ego-free will see her and recognize her power. Those completely caught in the personality will see Pluto as a malefic. Those who recognize this planet as a necessary purging process and are willing to go through the purging will see light on the other side of darkness.

Anyone with 12th house planets feels cribbed, cabined and confined by life on earth. It is difficult for him to submit to the rules of the road and to live by

*See footnote on p. 274 regarding Pluto as a "double planet."

these rules. The enemy lies within. This is especially true if Pluto is in the 12th house. The 12th house rules the subconscious, Neptune rules the collective unconscious, and perhaps one day we will find that Pluto will rule the collective conscious Being. The highest side of Pluto in this house means the willingness to be a channel to help those who are limited and afflicted. The willingness to be nothing in order to serve humanity can bring the wisdom aspect of Minerva into operation. As long as the individual tries to live a personal life (in the sense that he chooses to enhance his own personality and his own power) he is confused and can lose his sense of identity. He bogs down in a swamp of self-pity and self-recrimination. Again the choice that is so intimately tied with the 12th house is serve or suffer. The choice is there. Only through service and the dissolving of the personal will, will freedom from the negative use of any energies in the 12th house come.

CHAPTER 36
Natal Aspects

Natal aspects in a birthchart show how Plutonian energy has been used in past lifetimes. We have set the pattern with the use or abuse of that energy. Though the pattern is set we have the ability to recycle that energy and change its direction. Pluto is invisible energy that is deeply ingrained in the instinctive nature. For that reason it represents the qualities in our nature that are unknown to the conscious self. It will be the strongest force in a birthchart when it is in an angular house and strongly configurated with Sun, Moon, or Mercury. One must always relate the Plutonian power to the whole tenor of the birthchart. As has been stated previously, it can never be taken on its own without considering the total personality. Squares and oppositions in charts of persons of strong character seem to strengthen the moral fiber. Sextiles and trines in the charts of individuals who are weak by nature or unbalanced can cause them to take the line of least resistance.

ASPECTS TO THE SUN

Sun Conjunct Pluto ☉ ☌ ♀

The desire for power, authority, and recognition from his contemporaries is deeply imbedded in the individual. Whether this conjunction falls into positive signs, such as Gemini, Leo, or Libra, or in receptive signs, such as Cancer or Virgo, makes the difference in the person's approach. In positive signs the natural inclination is to reach attainment of the objective at any expense. The person rids himself of attitudes and habit patterns as they outgrow their usefulness. This attitude is sometimes extended to other people. In the receptive signs Pluto seems to hold sway and rather than using the energy the person is used by it. The basic solar (ego) drive for significance, and the individual's outer-world ambitions, are likely to be constrained, or steered, by forces beyond one's conscious control. Whether as head of a large corporation, or association, (Sun conjunct Pluto in Leo) or head of a large family (Sun conjunct Pluto in Cancer) this individual quietly assets his authority and is always in command.

Sun Sextile or Trine Pluto ☉ ✳ or △ ♀

In this pattern the individual's desire for advancement and evolvement go hand in hand with the ability to eliminate negative associations and attitudes that would otherwise cause him delay. Philosophic and religious traditions are of interest. The person has creative abilities, and because of personal magnetism and intuition he knows what other people will enjoy. With other

favorable indications in the chart, the individual can look forward to a successful public career. The pioneering instinct is strong and these individuals are fighters. They have great strength and if they use it constructively they can attain great success in whatever field they choose.

Sun Square Pluto ☉ □ ♇

Individuals with this configuration can be arrogant and ruthless with complete disregard for the other fellow. There is too much self-confidence which borders on egotism. However, this may only be a cover-up for a deep-rooted inferiority complex. Pluto square with the Sun, especially if connected with the 10th house, may deprive the person of a father figure. Whether this separation is physical or psychological will be shown by other factors in the chart. The individual's pleasure-seeking attitudes can be the cause of his own undoing and the end result can be confinement. The person with this aspect must go deep to regenerate his negative attitudes as there is a resistance to change along with a very strong self-will.

Sun Opposition Pluto ☉ ☍ ♇

In the opposition pattern the individual must exercise care in his choice of partners as there would be a tendency to choose a partner who would act possessively and be dominating. In a feminine chart, the Sun opposition Pluto would indicate that the animus in the subconscious would have to be understood before the right relationship with a masculine figure in the outer world could be achieved. Emotional upsets through disappointing love affairs are part of the pattern, especially if Pluto is in Leo or Libra. Jealousy and possessiveness are inherent qualities. Additionally, the wrath of the individual can be brutal. This is the person who in previous lives has been tyrannical and despotic. He is now given the opportunity to view the situation from the viewpoint of the other fellow. Now he meets people whose qualities are reminiscent of those he himself once possessed while on the path of evolution. The ego which has been blown out of all proportion must now be reduced to its proper size.

ASPECTS TO THE MOON

Moon Conjunct Pluto ☽ ☌ ♇

In this conjunction we have the individual who is potentially sensitive and emotional especially if the conjunction is in Cancer or Scorpio. There are extremes in the expression of the feelings. There is a tendency to have upheavals and upsets in the person's environment. Yet it may not be obvious that these upsets come through his own conduct. On the level of instinct there is a duality unrecognized by the individual. On one hand there is sentimentality while concurrently there is a strong inquisitiveness and desire to know the reality of what makes things as they are. There is a deep psychological awareness of other people. The need to break away from the family unit and to find one's own individuality is often part of the pattern. Many times there is a strong mother figure in the life. Aspects to the conjunction will show whether this is beneficial or detrimental.

311

The Minerva aspect makes this person an incredible worker. There is great ability to be a success in the world. This individual is a mothering and caring type of person. Because of the supersensitivity in aspects involving the Moon the individual can be too protective on the personality side, and if not careful, dominating. If the higher aspect is operating, this individual is selfless and willing to serve the forces of light.

Moon Sextile or Trine Pluto ☽ ✳ or △ ♀

This represents the individual who is able to take changes and situations that life has to offer and use them beneficially. The native is sensitive and many times is gifted with great psychic ability. Unlike the conjunction, the sextile and trine to Pluto enables the person to separate the wheat from the chaff. The depressions that come with Moon-Pluto combinations are more easily discarded. This individual can sway others subtly because of his psychic understanding of the needs of others. He gathers knowledge and stores it like a sponge, but must guard against a lack of objectivity. He is many times considered lucky and has within his reach the possibility of a deeply rewarding emotional life.

Moon Square Pluto ☽ □ ♀

This individual is the lone-wolf type. Although quite ingenious he may be rigidly set in his own ways. He does not realize that self-imposed isolationism limits his opportunities. The individual is constantly besieged by emotional crises due to the excessive use of his emotions rather than his intellect. If an afflicted Mars is in the chart, the individual is easily excited and a definite lack of self-control is evident.

Moon Opposition Pluto ☽ ☍ ♀

There is a strong psychological tie with the mother, or some other dominant female which has far-reaching results in the person's life. The feelings go deep. The outward expression of the love nature is forceful. There is much static in the emotional life. To others it seems the individual's attitudes are emotionally biased. In some cases the individual with Moon opposition Pluto has been considered eccentric and anything but orthodox. But even though he may not be understood he is liked by people.

The Moon rules mass consciousness. People with aspects between Moon and Pluto are apt to have difficulties dealing with the public. Pluto must affirm or deny what is promised in the natal chart.

ASPECTS TO MERCURY

Mercury Conjunct Pluto ☿ ☌ ♀

Mercury is the instrument by which we have direct contact with the exterior world. It is the connecting link between the inner and outer self. There would be no communication or ability to relate to the world without Mercury.

In its positive expression this conjunction gives the power to excel at research, investigation, and analysis. This can be a mind capable of deep penetration and keen powers of observation. There is an agility to the mind that

can be used either constructively or destructively. There is a desire for intellectual recognition, and this conjunction enables the individual to have the power to influence others. Many times this is done very subtly.

In the negative expression this can cause hastiness, irritability, impatience, and over-estimation of one's ability. It can be an aspect of mental confusion. Because the nervous system is highly geared, circumstances can cause great nervous tension. Afflictions to this conjunction from the ruler of the third house can be indicative of strong karmic ties with relatives.

The Minerva aspect can purge the self-centeredness and instability inherent in this conjunction through a willingness to accept whatever may be necessary for growth and development.

Mercury Sextile or Trine Pluto ☿ ✳ or △ ♀

Originality is the keyword when Pluto and Mercury are well aspected. Here we have the specialist who through discipline and fine intellectual prowess gains recognition from his contemporaries. The person has writing ability and can easily communicate his ideas. His powers of suggestion are so logical that people accept his ideas subconsciously without realizing they do so. He has the ability to easily change his approach to meet all immediate situations. Because of a self-sufficiency the person has a way of using associates to great advantage in his everyday environment. There is self-confidence which in extreme cases can become conceit.

Mercury Square Pluto ☿ □ ♀

This aspect, especially in cadent houses, gives a highly sensitized nervous system. The person is a tireless worker and his health can suffer from overwork. Situations and ideas are grasped quickly yet there may be a pronounced lack of patience where others are concerned, especially with those who may be slow in perception. The individual is a born skeptic and must either prove or disprove to his own satisfaction the knowledge presented. As with the conjunction the individual can become obsessed with his own ideas and carry them to the point of fanaticism. The person's quantitative rather than qualitative avidity for experience can be the cause of mental and physical disorders.

Mercury Opposition Pluto ☿ ♂ ♀

This can be a difficult configuration and one that denotes both inner and outer conflict. The person learns early in life he must seek ways for self-improvement in order to find a measure of contentment. People met in the outer world, especially in close relationships, tend to be undemonstrative. The individual may well feel alone and lonely even in a group. A strong inner restlessness which seemingly desires contentment and tranquility may well serve as the impetus to motivate the person to go on to new accomplishments and success. In receptive signs this opposition causes an individual to be oversensitive. The person needs to think long and well, before being too critical, as this aspect can cause one to be too hasty in judgment.

ASPECTS TO VENUS

Venus Conjunct Pluto ♀ ☌ ♇

Here is the sex-symbol aspect where Pluto holds sway. The sexuality of the person is strong but in an earthy way. There is great depth and intensity to the love nature and strong procreative powers are inherent in this aspect. The individual can be possessive and jealous. When Mars afflicts this conjunction it is apt to emphasize sensuality. There is a tendency to allow irritation and anger to take over. Love of pleasure and self-indulgence can lead the person down the primrose path. If Uranus aspects the conjunction there may be a tendency toward perverted means of emotional satisfaction. This is the person who can be possessed by lust. In unevolved souls Venus-Pluto contacts are often indicative of those who tie sex and money together.

There is a potentiality for universal love when the Minerva aspect is in operation. This is the love principle that is able to transcend ethnic, racial, cultural and social barriers.

Venus Sextile or Trine Pluto ♀ ✳ or △ ♇

The individual with this pattern has a rare magnetism which has a subtle influence on other people. There is the possibility of a deep love union with someone from a past lifetime. There is artistic ability and a deep desire to create what is beautiful. This person looks for the beauty and goodness in people no matter how deeply it may be buried. The rewards are great. This aspect makes one emotionally self-sufficient and a tower of strength in any relationship. There is deep empathy for the problems of others and oftentimes the individual is a champion of the under-dog.

Although there may be many upheavals in the early love life, the end result is good. In connection with the eighth or second house the inheritance of money is a strong possibility. What is little known to the children of earth is that there is a strong tie-up between love and money. The more one loves, the more abundance one will have on every level, including that of finances. With Pluto, god of wealth, in the picture money is easily attained without having to fight for it.

Venus Square Pluto ♀ □ ♇

This aspect must be handled with caution. The individual allowed greed and lust to run rampant in other lifetimes. Lustful and immoral behavior would only continue the pattern causing more trouble for the person. There will be much stress and strain in love relationships until the individual has resolved the conflict. Loneliness can be a cause of great unhappiness until the person learns to be truly loving. Until the realization comes that the problem is within the person rather than in other people, there are many disappointments in the emotional life. One of our students, a nurse, has resolved this problem by working in a hospital for terminally-ill cancer patients. She has helped to bring peace, love, and understanding to those less fortunate than herself. Venus rules Libra, which is the 12th house sign of Scorpio, Pluto's home, and the 8th house sign of Pisces, the sign of Pluto's probable exaltation.

Service of this kind is the most positive use of this aspect with the Minerva wisdom very much in evidence.

Venus Opposition Pluto ♀ ☍ ♇

The main difference between the square and the opposition is the difference between the self and the not-self. In the square the problem is within the individual. In the opposition others in the outer world represent the problems. Here, reactions to others are of paramount importance. The individual can become prey to those who would use and abuse for their own pleasure. There are many unusual love experiences in the life and relationships seem to lack stability. Immoral behavior can only bring the individual tragic consequences. The emotional life can be very unsatisfactory and the individual may experience great difficulty in achieving a feeling of being loved. He must learn not to demand but to give love in order to pay the dues he owes. Until there has been a regeneration of the values, the person experiences many losses of friends and loved ones without realizing that what he has done to others is now coming home to him. Any sub rosa involvement with those not free will bring heartache and disappointment. It will be a dead-end street.

ASPECTS TO MARS

Mars Conjunct Pluto ♂ ☌ ♇

This is a dynamic combination of energies that must be handled wisely. The individual may possess tendencies that can manifest as cruelty and ruthlessness. Force cannot be viewed as a just means to attain one's own ends. The animal self is strong and needs restraint and taming. Whether used in a positive or negative way, a distinct disregard for the rules and regulations of society is in evidence. Both the destroyer and the reformer share the same discontent with the status quo.

The individual can experience periods of irrational upheavals due to untamed impulses. Individuals with this configuration would do well to remember that retribution quickly follows destructive action.

In the map of a spiritually oriented person, the regenerative aspect of Pluto would be at work, helping tame the desire nature of Mars. There could well be great courage and a desire to overcome habit patterns which previously handicapped the individual.

Mars Sextile or Trine Pluto ♂ ⚹ or △ ♇

The Mars-Pluto trine bestows great ambition. The ability to work hard and long, coupled with much self-confidence, enables the individual to reach great heights. Courage is an outstanding quality and no odds seem too great for the individual using these powerful energies in a positive manner. The desire to achieve and conquer can easily lead to the fields of athletic competition and the political arena. With other favorable aspects he will rise to the top of his profession and make his work a mark for all to see. This individual, especially if Venus and Neptune are well placed and aspected, is successful in taming the animal within, and that which previously was personal now becomes uni-

versal. There is a strong interest in occult studies which many times is accompanied by an unusual amount of ability in these areas.

Mars Square Pluto ♂ □ ♀

Pluto was discovered on January 21, 1930, and on that day Pluto and Mars were in exact square. Pluto took the rulership of Scorpio away from Mars. There is intense struggle and violence inherent in this aspect. The intensity will be a long time building in the individual before it erupts on the surface. After studying the workings of this aspect in many horoscopes, it is the authors' opinion that this, more than any other aspect, causes an anti-social attitude in the individual. There are many inhibitions and violent feelings which the person normally controls. When unleashed, it is usually in a violent and destructive manner. Lust rather than love rules the individual's sexual motives. When Saturn joins this configuration by either conjunction to Mars or Pluto or by opposition forming a T-Square, sadistic tendencies are often found in the person.

If an individual is well integrated or spiritually oriented this aspect would not have the destructive side operating. There would have to be control where the desire nature was concerned before peace and tranquility would be attained. Empathy and compassion are the antidote for Mars-Pluto afflictions.

Mars Opposition Pluto ♂ ☍ ♀

This is a very similar aspect to the square. In the opposition we are dealing with the individual's reaction to violence and turbulence in others whom he meets in the world. The individual with this opposition needs to learn to protect himself using his creative imagination and to clothe himself at all times in a robe of light. "I clothe myself in a robe of light composed of the love, power and wisdom of God enveloping me and interpenetrating me, not only that I may be protected, but so that all who see it (the psychic forces), or come into contact with it (the Earth children), may be drawn to God and healed." This prayer is a powerful protection against violence of any kind. With Mars opposition Pluto the individual would be wise to use it.

ASPECTS TO JUPITER

Jupiter Conjunct Pluto ♃ ☌ ♀

This aspect is a coupling of the principles of the eighth and ninth houses of the astrological chart. Through regeneration and self-mastery (eighth house) the individual seeks a belief system (ninth house) to suit the present stage of evolution. The "truth" running like a golden thread through all of the earth's religions may be sought and investigated. The person feels an insatiable desire to understand as much of the infinite as is possible. The leadership inherent in this aspect and the desire to be in the forefront can lead to spiritual ambition. Good aspects to this conjunction from Venus favor financial success where joint finances are concerned. The individual is sensitive and has ability to investigate the motives behind the outer events in life. The planets seem to go well together and oftentimes confer great popularity as well as great recognition. The individual is a leader of men, never a follower.

316

Jupiter Square Pluto ♃ □ ♇

A strong will aspect which is many times coupled with the belief, "Whatever is good for General Bullmoose, is good for the country." Although the native has good critical ability conferred by the pairing of these two mighty energies, a certain amount of deviousness may be present. The power sought many times is no more than a cover up for deep feelings of inadequacy. The individual's outlook on life is based on instinct rather than intellect. Destruction (with the self included) or construction is the dilemma of this individual. He is torn between the desire to remake his personal world and all in it, or to destroy it. Always he imagines himself as the most important figure in this world picture. The destroyer or the builder, he gives himself top billing.

Jupiter Sextile or Trine Pluto ♃ ✳ or △ ♇

In sextile or trine aspect there is a wonderful blending of the extrovertedness and optimism of Jupiter with the caution and subtlety of Pluto. There is charm and vitality, and this individual has penetrating insight. He is able to help himself as well as others overcome obstacles that may well stand in the way of success. Because of this quality this person is often the chosen leader in groups and organizations to which he belongs. There is generosity present as well as empathy and understanding for the problems of the other fellow. Metaphysics and all that it implies may well interest the individual as the cause behind the effect appeals to his highly imaginative consciousness. Yoga and disciplines that call for meditation attract these individuals as vehicles to serve as creative outlets to help in the individual's mastery of self. This is an aspect that may well be found in the horoscopes of those who lead spiritual groups. The aspect can bring the individual abundance through inheritance.

Jupiter Opposition Pluto ♃ ☍ ♇

Anxiety and restlessness are the end result when Jupiter and Pluto oppose each other in the horoscope. The individual has big ideas and grand schemes, but many times the execution of these never come off. His opinion of himself swings from over-confidence to great self-doubt. In his high periods the person will work long and hard on the loftiest ideals of mankind. While in low gear he will concentrate just as earnestly on the most primitive instincts in his animal nature. His outlook can be very dogmatic. Controversy can arise when he tries to force his own attitudes on unwilling people in his environment.

The individual has good intuitive powers as well as great imaginative abilities. Many times the inability to hold these in check will delay realistic attitudes and the social acceptance of his contemporaries.

ASPECTS TO SATURN

Saturn Conjunct Pluto ♄ ☌ ♇

This individual is the deep questioning type of soul whose serious outlook on life gives him an aura of aloofness. There is a distaste for the superficial and time is spent exploring the seeming miracle behind physical existence. Many of the young generation born with Saturn conjunct Pluto in Leo left the

big cities to study rural life and to find meaning for themselves seeking nature's way. The excluding of all modern conveniences is an exaggeration in itself, and it will only be when these souls are able to blend the new with the old that a meaningful, successful lifestyle will develop. Some periods in the life may be marked by extreme self-denial or self-discipline. The individual shuns any activity which will bring upon him the ridicule or disapproval of his contemporaries. His own depth of psychological awareness may be the reason for his periods of despondency. Periods in which he can completely lose himself in some activity may prove to be very beneficial for during this time the individual goes through a self-renewal process.

Saturn Square Pluto ♄ □ ♇

This aspect is never found in the horoscope of a weak ego. Great emotional intensity many times negatively manifested makes the individual vindictive. Periods of great jealousy, lust, and an overdeveloped sensuality can raise havoc with the personal life. A great desire for power and authority are inherent in the person. In the unevolved the means of attaining the heights he thinks he deserves can be less than honest. There are periods of withdrawal from close contacts with others. These will be used well if they are used to understand the primitive side of the individual's nature, so that self-mastery becomes a visible goal.

There is psychic ability and occult interest. Personal ambition can well serve as a stumbling block in these areas. One of the most elusive of character qualities, humility, is the antidote for this intense aspect.

Saturn Sextile or Trine Pluto ♄ ✶ or △ ♇

This is a good aspect for those individuals who work with other people's money. Bankers, insurance salesmen, and public accountants. There is keen judgment coupled with great stamina when working toward a goal. Those individuals have good common sense and are among the reliable persons in the zodiac. Their methods are plain and there is a built-in mechanism against excesses. These individuals are extremely hard workers and have the ability to subject themselves to periods of severe self-discipline when necessary. When these sterling qualities are put into use in any area they mark the individual for leadership. This is not the overnight success story but rather the slow patient climb through hard work and discipline. There is a strict adherence to the moral code of the day which can cause finger pointing at the more liberal egos. It would be well for Saturn-Pluto individuals to remember that it is not for them to judge anyone.

Saturn Opposition Pluto ♄ ☍ ♇

This represents the necessity principle versus the principle of regeneration. This is a difficult aspect which, when worked with, can serve as the impetus to build a strong character. There are karmic conditions involving partnerships which when not handled rightly can seriously affect the happiness of the individual. Only by "sticking to it" and handling the other person with love and understanding can these individuals find peace. To walk out on serious karmic conditions would mean that the problem would just have to be faced and

dealt with through another individual. It would be well to remember that the seemingly difficult treatment being received was once being meted out! As in other tension aspects it is well to follow Saturn. The urge to dissolve and bring death to conditions must be replaced with patience, hard work, and understanding. As in all oppositions there is awareness, but this time on a large scale. When the individual has conquered the dark side of himself (Pluto) he can then teach (Saturn) others to turn on the light.

ASPECTS TO URANUS

Uranus Conjunct Pluto ♅ ☌ ♇

Uranus-Pluto aspects are aspects of a generation. Due to the slow movements of the planets involved many souls are born with these two planets in the same relationship. Only if the configuration occurs on an angle of the horoscope and/or is strongly configured with the Sun, Moon and Mercury can it be delineated in a personal way. Change is the keyword for this conjunction. It can only occur once in a century. The last meeting was in Virgo in 1965. In Virgo, Mercury's home, we can expect the individual born with this aspect to use his great creative energy to bring in new methods of healing, breakthroughs in the fields of science and religion, as well as deep concern for food and its relationship to the physical body. When used rightly this aspect can help move mankind forward on its evolutionary path. An insatiable desire to change the outdated social structures of his time is the cause of the seeming restlessness of this individual. As these changes can be radical, these people are considered revolutionary. Many times they are.

Uranus Square Pluto ♅ □ ♇

This aspect last occurred in the cardinal signs. Uranus was in Aries and Pluto in Cancer. Individuals born with it (1930–1935) have seen the world in a time of great crises. Wars, revolutions, and economic catastrophes have greatly influenced their lifestyles. Women born with this aspect represented the seeming subservient role allotted to them by previous generations and fought for their own individuality. Mrs. John Doe wanted to be considered a person in her own right. She found that only through financial independence could Jane Doe emerge successfully. Yet, these are the same parents who fail to come to terms with the free spirit of their children (many of whom were born with the sextile of Uranus and Pluto). Trying to strike a happy medium between family tradition, responsibility and personal freedom, left many with nervous disorders. They were rebellious by nature and independence was sought.

Uranus Sextile or Trine Pluto ♅ ✶ or △ ♇

These individuals are gifted with great insight regarding the merger of past and present principles to bring about a better future. The intuition is highly developed and is used to create a better understanding among all peoples. The brotherhood principle is both understood and respected. Love becomes universal linking all men together in common causes. Great success can be the result when these people organize to solve what originally may have seemed

to be a hopeless problem of great immensity. The aspect favors scientific studies as well as ability in metaphysics. If the Sun is involved a certain amount of clairvoyance may be present.

Uranus Opposition Pluto ♅ ☍ ♇

This aspect was last in operation at the turn of the century. Uranus was in Sagittarius opposing Pluto in Gemini. The mind signs (Gemini, the conscious mind and Sagittarius, the superconscious mind) were brought to attention. In this aspect the intellectual approach is emphasized, but it is coupled with a desire to perceive what is beyond the finite limits of the mind. With this aspect the individual is not a joiner by nature. When he would join a group or organization he found it hampering and was held back by the very images he helped to create. Working through the seventh (the opposition being a 7th house aspect) it is not uncommon for a husband and wife to be directly opposite in their belief systems and approaches to life. In the spiritually oriented person this gives the opportunity to see and appreciate another's point of view. In the younger soul it can cause great turmoil with total dissatisfaction as the end result.

ASPECTS TO NEPTUNE

During the 20th century Neptune and Pluto have made only one major aspect, the sextile. This generation aspect occurred several times thus far, in the positive signs of Leo and Libra, and later in Libra and Sagittarius. The sextile also took place in the receptive signs of Virgo and Scorpio. When these collective giants aspect each other in the heavens they make a social statement. Individuals born with this aspect have the latent ability within themselves to make the statement a reality.

Neptune Sextile Pluto ♆ ⚹ ♇

Justice is the keyword of this aspect. Evolved individuals with this aspect labor to achieve justice in the courts, decent wages and fair prices, job opportunities, unemployment compensation, needed welfare grants, pension plans, and job training for all their brothers who are in need. They are the liberators fighting against anything that dehumanizes, degrades, oppresses and imprisons men in any way at home and across the world. The objective is the same whether their chosen fields are the arts, sciences, education or labor. This aspect saw the birth of those egos who were to be called the "Flower Children." Deeply ingrained in their spiritual consciousness is "love one another as I have loved you."

CHAPTER 37

Transits

Much of Pluto's action is veiled. Mythology shows this to be true, for Minerva and Pluto wore helmets that made them invisible. What is given in this chapter represents personal research, and is by no means intended to offer a full explanation of how Pluto works. In every case one has to consider Pluto's influence natally.

In dealing with transits of Pluto not enough research has been done for anyone to be dogmatic about its effects. It will take years and probably lifetimes before we will fully understand its true meaning. Chapter 39 on birthcharts and what the transits of Pluto meant to the individuals concerned is a beginning and only a beginning of an understanding of Pluto's effects in personal lives.

Because Pluto in the outer world is unbalanced energy, when it conjuncts any planet in the horoscope, that planet is subject to uncontrolled power and that energy comes under attack. If this position is well fortified, the attack will reveal the weaknesses that need to be faced and regenerated. If the energy of the planet is poorly fortified, the effects can be very destructive.

Due to the fact that Pluto has to be considered in relationship to the total being, we are giving the positive and negative expression of Pluto as it affects the other planets. The higher aspect will be under Minerva's domain. The lower aspect will have to do with the Plutonian underworld in all of us. The energy is always pure. It is man's use of it that determines whether the experience will be positive or negative. When new energy has been precipitated on the planet, always man has used it negatively before he has learned to use it constructively. It has been very difficult to find many people who are tuned to Minerva. Its keyword is "consecration" and only those who are willing to go through (not around) the regeneration necessary can touch the hem of her garment. Pluto does rule Scorpio which is the death sign of the zodiac. What is death? From a higher plane it is the surrendering of the energy in a form. Lest a seed go into the earth and break its shell the new life cannot emerge. We have to go into the darkness of ourselves in order to find the light. "The Light that lighteth every man that cometh into the world. And the light shineth in the darkness and the darkness comprehendeth it not." One doesn't fight the darkness. One turns on the light. Where does the darkness go when one turns on the light?

Sun-Pluto (☉ ♇) Negative Expression

There is a strong resentment against authority of any kind. The will inherent in the Sun can cause an ego flareup that can be destructive to the individual concerned. Indicates a poor time to leave a job, or to refuse to take the

discipline engendered at this time. Self-will can be very strong and can bring difficulties mentally, emotionally and physically. The house it is transiting as well as the sign will show where the difficulties lie. For instance: Pluto transiting the Sun in Cancer in the third house would bring mental disturbances due to the emotions. It could cause ulcers in the physical body. Cancer, ruling the stomach, has to do with digestion. In the psychological body it has to do with digestion of experience. It would be what the person would think about the experience that could cause mental distress in the third house. In the fourth house it would affect home conditions and endings of all kinds. Note the house Pluto is in at birth and the house ruled by Scorpio. They will be involved. The negative side of Pluto can cause the individual to be self-destructive as well as to those around him. Pluto transiting the Sun forces the individual to face himself honestly and squarely or he goes down to defeat. Deviousness and dishonesty will bring quick retribution. In one case on file a young man and two of his friends held up a bank in the spring of the year and seemingly got away with it. Pluto was conjunct his Sun. He had a wonderful summer living luxuriously, playing golf with an embassy official and enjoying life to the fullest. In October with Pluto once again transiting his Sun he was arrested for the crime and was sent to prison for twelve years.

With this transit failure to use proper discrimination can cause the dictates of the lower nature to take control and cause havoc in the life. It is no time to be involved with subversive groups of any kind for everything hidden will be brought to light.

Sun-Pluto (☉ ♇) Positive Expression

This transit can bring regeneration through illumination causing a complete reorientation in the life if the soul is ready. It can begin a new expression of life's purpose and can bring the individual into creative and dynamic leadership along spiritual lines. New pathways can open up and a completely new and impersonal approach to life can come at this time. For the spiritual disciple it can be the cleansing away of the obstacles that have hindered his progress. This can be painful for we hug our chains unwittingly. It is a time for important, far-reaching decisions. Wisdom through willingness to take the high road can be gained in fuller measure than at any other time in the life. The choice is there. The results depend on the willingness to will the will of the Higher Self.

Moon-Pluto (☽ ♇) Negative Expression

This transit can cause a great deal of restlessness and a compulsion to keep moving without any definite purpose or direction. Emotions are not stable and moods are up one day and down the next. Depressions must not be allowed to take over the personality. Sensitivity is greatly increased and the individual is inclined to feel slighted and offended at the least provocation. During this transit half of what one believes is not so. The need to exercise willpower and discrimination will be brought to the fore as this transit brings in experiences which will only serve to satisfy the sensual nature. As in all Moon-Pluto transits one is compelled to choose the higher or the lower way. The animal side must die through malnutrition, and this would be an

excellent time to starve it.

This transit can bring changes in family relationships, especially in regard to the mother or home changes. There is a necessity to watch health for there can be trouble with the bodily functions especially the digestion. During this transit the reputation can suffer if the individual uses this energy negatively.

Moon-Pluto (☽ ♇) Positive Expression

The individual must come to decisions that are vitally important to his future being. It brings emotional intensity and a desire to get at the roots of one's being. It gives a strong desire for one's own home and family. It brings radical changes in work if it affects the 6th or 10th houses. If it is configurated with the 5th house it can bring a new consciousness of love through a love affair. It can cleanse the emotions of self-emphasis and bring in a desire to "mother" the world. A persistent drive to bring benefit to others is brought in. At the same time the individual recognizes the necessity to have times when he must withdraw from the world and have privacy. In a female chart it enhances the femininity and brings out the receptive side of the nature. In the life of a male it could bring into his orbit a female who could be of great help in setting his feet on the path of discipleship.

Mercury-Pluto (☿ ♇) Negative Expression

Pluto transiting Mercury can cause carelessness, superficiality and a tendency to be dishonest in word and deed. There can be a disturbance of the nervous system causing irritability. It is not wise for a person with afflictions in Gemini at birth to tempt fate by smoking when this aspect is in operation.

This transit can bring family relationships to a crisis point. There can be changes or breakups where relatives are concerned. While this aspect is operative it is well to watch the tendency to be too critical and blunt in speech or writing. "For every idle word you shall give account." During this transit all contracts, papers and writings should be scrutinized in detail.

Mercury-Pluto (☿ ♇) Positive Expression

This transit gives the power to tap in on the Universal Mind. We believe Mercury in its deepest meaning represents consciousness — the thinker behind the brain mechanism. It gives good powers of observation and brings a desire to study in depth and to find the meaning of life behind the world of appearances. The power to influence the public through writing, speaking or teaching can come into expression under this transit.

At this time interest in astrology, cosmic laws and metaphysics can bring profound changes into the life. The consciousness is never the same after a transit of Pluto over Mercury.

Venus-Pluto (♀ ♇) Negative Expression

It is not wise to speculate or extend one's self financially while this aspect is operating if other aspects to Venus are adverse in the birthchart. Venus is natural ruler of the sign and house that rules finances.

The Venus and Pluto combination is not subject to tradition or convention. In the unevolved this brings the sexual side of Pluto with its eccentricities

and aberrations to the fore. In our research of charts of prostitutes or homosexuals who used their sexual energies to make money we found Venus and Pluto very much involved. In those whom we contacted they reported the exploitation brought little satisfaction and great loneliness.

In the average person's chart Pluto transiting Venus causes upsets in emotional relations, and the longevity of the relationship is threatened. The only way out (or in) at this time is to hold to the love principle and take the discipline and the purging that is sure to be part of the growth toward the understanding of what love really is. Love is not an emotion but a principle.

If a relationship is terminated without resentment or anger, the lesson is learned, and the karma is over. To start a new emotional relationship with Pluto transiting Venus is not wise. There will be too much suffering involved. Any relationship formed at this time on the personality plane will be of karmic origin.

This tieup can give difficulties on the physical level with lowered resistance to infections. The throat, generative system and the kidneys must be kept in good condition. Clogging the system with starches and sugar should be avoided at this time.

Venus-Pluto (♀ ♇) Positive Expression

This is the greatest opportunity in a lifetime to know what love really means. It will purge the individual of possessiveness and selfishness. To the disciple on the homegoing pathway it can mean the dark night of the soul, but out of it will come greater healing power and greater perception than he has ever known.

It gives greater emotional sensitivity towards others and an impersonal attitude toward one's own self. Marc Jones speaks of Pluto's keyword being obsession. The right use of a transit of Pluto to Venus can be a magnificent obsession. Just as the Minerva aspect of Mercury-Pluto taps into the universal mind so Venus-Pluto taps into the universal love.

Artistic expression as well as inherent creative ability can come to the surface and be appreciated by others as well as being a fulfillment to the self. As Venus, ruler of Taurus, is the polar opposite to Pluto, ruled by Scorpio, it is the choice between self indulgence and self-mastery.

Mars-Pluto (♂ ♇) Negative Expression

This is a difficult transit unless the animal nature has been domesticated. Mars rules the animal energy, and Pluto rules the invisible underworld in all of us. The tendency to be rash in actions and judgment can raise havoc in the personal life. There can be a lack of restraint that causes antagonism within to generate antagonism without. When Pluto is configurated with Mars it is wise to keep one's magnetic field free of anger for it will draw violence into the person's orbit. This is the time to use your "robe of light." The individual using the negative expression of this transit can be too severe and cruel. The antidote for this tendency is to deliberately cultivate the qualities of mercy and compassion. This transit will depend largely on what other energies are operating in the chart. Jupiter or Venus or good aspects to the Sun can nullify much of the violence in this aspect.

In research having to do with mass murders or murderers, Pluto and Mars were strongly configurated at the time of the crimes. In a "sleeping" soul it can foster criminal or antisocial tendencies. In judging any Plutonian aspect remember that only if the total chart at birth shows these tendencies will they be operative. This is a poor time to act too forcefully without regard for other people's feelings.

If an individual is connected with subversive activities such as the underworld of crime this is the time dues will be collected even to the extent of the individual being taken out of his body.

In a feminine chart there can be danger where sexual assault is concerned with the possibility of death at the hands of someone. It is a poor time to hitchhike with anyone not known. In the early spring of 1973 when Mars was in Capricorn afflicting Pluto in Libra there were three murders of university students in Boston who had hitchhiked on their way to school. They were never heard from again until their bodies were found. They had been sexually assaulted before they were killed. Forewarned is forearmed. These things do not have to happen if the person uses discretion.

Mars-Pluto (♂ ♀) Positive Expression

This gives tremendous physical energy. By persistence and confidence the person will be able to attain his goals and objectives. He may work harder than he ever has before but the results will be well worth the effort. In all Martian aspects the energy must be used for it pours adrenalin into the system. If the energy is used constructively on the physical level the adrenalin will not act deleteriously because of over-accumulation.

Because of the right use of Mars-Pluto energy the individual having this transit can inspire those around him with courage and enthusiasm. The positive use of these two energies can build excellent health on the physical level, and courage and stamina on the emotional level, thus bringing about consecration to the highest ideals on the mental and spiritual levels. If the individual has reached the point in evolution where he can raise the animal energy above the belt line, there is the possibility of illumination.

Colonel Lindbergh made a record breaking flight across the Atlantic with Mars transiting Pluto. His courage and initiative overcame all the obstacles. Mars-Pluto can be used magnificently if the person chooses to do so.

Jupiter-Pluto (♃ ♀) Negative Expression

This is not as difficult a Plutonian transit as other transits of this planet may be. Pluto is exalted in Pisces and Jupiter is co-ruler of Pisces so they are friendly to each other even when they disagree.

Pluto brings action and a crises into the life that can make or break one's reputation. There is a desire to be important financially and socially. If this is not achieved the person can be self-destructive. Gambling or speculation is not wise at this time and can cause loss.

There is a necessity to watch one's health. Overindulgence can bring physical difficulties especially with one's liver. Curb impulsiveness and rash judgment while this transit is operating.

There is a strong but hidden desire for material power. There is a gift for

organization but the tendency to exploit the public is hidden behind the facade of "hail-fellow-well-met."

Jupiter-Pluto (♃ ♀) Positive Expression

The positive expression of these energies can be an excellent influence for personal honor and integrity. Public honors can come during this transit. A famous scientist received the Nobel Prize under a transit of Pluto square Jupiter. The intuitive faculties are increased. Help from spiritual sources can be sought and received. Jupiter rules the superconscious realms, and we feel that Minerva is energy from a higher source and is correlated with Binah (Saturn) on the Tree of Life. Wisdom is the keyword in each case. Wisdom and understanding complement each other.

Saturn-Pluto (♄ ♀) Negative Expression

This combination can bring out the weakness hidden in the underworld of the self and if not faced can cause depression and self-destructive tendencies. There will be increases of work and responsibility at a time when physical energies are low. Saturn-Pluto aspects so often cause lowered resistance and fatigue at a time when the work load and responsibility are increased.

With this transit an unevolved individual could become extremely selfish and show a ruthlessness that would be surprising to others. Enforced restrictions, in some cases due to ill health, may have to be accepted. Slow and unsuspected accumulation of poisons in the system could cause the necessity for rest and purification of the blood stream. Pluto always brings a crisis of some sort but needs other transiting conditions in the chart to explode its energy.

Saturn-Pluto (♄ ♀) Positive Expression

This gives the ability to accept whatever test or added responsibility is engendered by Pluto during its transit. It brings the reward of patient and persistent efforts to attain spiritual integration. Through the responsibility to what Saturn teaches, the disciple learns. It is our belief that a true understanding of Saturn and Minerva is going to bring illumination to the person who goes beyond the world of appearance into the reality behind it. Minerva, goddess of wisdom, the highest energy of all the planets, and Saturn (Binah) may prove to be the Divine Mother or the mothering aspect of the creative intelligence that we call God. To those intuitive disciples open to truth, the article on "The Forgotten One" at the end of this book may be the clue to the inner meaning of this aspect.

Uranus-Pluto (♅ ♀) Negative Expression

How the person uses his will will be extremely important at this time. Strong opposition can be aroused if the individual is too erratic and determined to do what he pleases with no regard for anyone else. If he attempts to take the law into his own hands and uses violence to attain the wrong ends, retribution will be sudden and sure. Pluto can represent persuasion on its higher side (Pluto exalted in Neptune's sign) and coercion (force) on the negative side. At the time of this transit it is well to remember you can catch more flies with honey than with vinegar.

If other transits are operating at the same time (especially Mars or Neptune) it is best to use extra precaution to avoid accidents involving electrical equipment or machinery. Whatever happens, good or ill, like all transits involving Uranus, events will be sudden and unpredictable and will change the status quo. No one can safely predict what Uranus will do, and Pluto is an invisible energy working in the depths of the being to purify and redeem the consciousness. Whatever happens the outcome will be forever and always blessed.

Uranus-Pluto (♅ ♇) Positive Expression

This gives a very strong desire for freedom but those attuned to wisdom know freedom only comes when one doesn't care whether he is free or not. He has given up his will and truly wants God's will to operate through him.

There is originality and genius in this combination of forces. There is increased power on the inner levels of consciousness. There can be the development of spiritual insight and intuition. Squares and oppositions by transit can work as effectively as conjunctions if the soul is evolved. Any dogma or orthodoxy will be broken up for flashes of intuition and inspiration reveal truth to those who are ready, and with these two energies affecting each other a process of transformation can take place.

An increase in physical vitality can give the power to go forward to success in a chosen field. The stamina and energy on the physical level plus the flashes of intuition and inspiration coming from the inner levels can bring hidden dream into physical reality. No one does anything on his own that is really worthwhile. Don't forget to say "Thank you" to the Invisibles that work through you. Even Jesus said "I of myself can do nothing." Neither can we.

Neptune-Pluto (♆ ♇) Negative Expression

This transit can lead a person to the depths of degradation, unless he chooses the higher way. The drug addicts of the 1950's and 60's were those afflicted with a Neptune-Pluto transit. If there is instability in the character this is when it will come up for transmutation. At this time all that is locked in the hidden self is brought to the light for inspection. Deciding between what things really are and what they appear to be, becomes of great importance. The individual fluctuates between being over-sensitive and downright gullible. Delusions of persecution can destroy relationships. There is great restlessness, daring, and foolhardiness if this transit is misused. Yet the same energy turned upward can lead to the heights of attainment. The choice is there.

The individual's responsibilities become burdens, and, at the same time, he takes on the burdens of others as his own responsibility. The sense of values can become distorted. What has worth is discarded, and the worthless is cherished as precious. This is a transit that can prove to be the person's undoing as both Neptune and Pluto (both strongly related to the twelfth house and Pisces) work underground and attack the weakest part of the individual's nature.

Everyone does the only thing he can do with the consciousness he has at any moment in time and space. Therefore those who have true Neptunian compassion do not presume to judge those who are unable to face the denseness of the earth vibration and seek to escape the challenges of life.

For those inclined to be critical and sit in the judgment seat, these lines from *The Book of Tokens* can be of great help if built in to the consciousness.

> *Apart from me*
> *There is neither wisdom,*
> *Nor knowledge, nor understanding.*
> *Into every state of knowledge do I enter,*
> *Into false knowledge as well as into true,*
> *So that I am not less the ignorance of the deluded*
> *Than the wisdom of the sage.*
> *For what thou callest ignorance and folly*
> *Is my pure knowing,*
> *Imperfectly expressed*
> *Through an uncompleted image*
> *Of my divine perfection.*
>
> *Woe unto them*
> *Who condemns these my works unfinished!*
> *Behold, they who presume to judge*
> *Are themselves incomplete.*
> *Through many a fiery trial of sorrow*
> *Must they pass,*
> *Ere the clear beauty of my wisdom*
> *May shine from out their hearts,*
> *Like unto a light*
> *Burning in a lamp of alabaster.**

Neptune-Pluto (♆ ♇) Positive Expression

The highest use of this transit can give inexhaustible spiritual energy. This is the time to seek spiritual companions, for advancement along spiritual lines can be greatly accelerated by being in the company of those who are spiritually awake. The Minerva aspect can bring pineal gland activity into operation. No spiritual consciousness can be unfolded without touching the higher aspect of these two energies. A very great sensitivity to the inner worlds can be enhanced by the practice of meditation during this transit. Many come into their spiritual heritage when these two planets are operating in their birthcharts.

This aspect gives an uncanny ability to see through people and circumstances. Depending on how this ability is used it can work in either a constructive or destructive way. If the individual is willing to undergo the necessary purification, and sacrifice the self to the Higher Self, he can be led to the heights of spiritual attainment.

A desire to transcend all boundaries can bring in a great interest in exploring the dimensions beyond the physical plane. If the individual is tuned to his superconscious self (Jupiter), he can explore the inner dimensions with safety. Otherwise he would be wise to stay safely centered on terra firma while this transit is in operation.

*From *The Book of Tokens*, by Paul Foster Case.

Ed. Note: The author did not include any material on Pluto-Pluto transits.

CHAPTER 38
The Perversions of Plutonian Power

- In June 1914 Pluto entered Cancer to stay. One month later when Pluto was in two degrees of Cancer, World War I began. The U.S. entered the war in April, 1917, when Pluto was again in two degrees of Cancer.
- In July 1939 Pluto entered Leo to stay. At the end of one month Pluto was in two degrees of Leo. England declared war on Germany and World War II began.
- In 1957, Pluto was in two degrees of Virgo and the Southeast Asian War was on.
- In 1972 Pluto entered Libra and with Pluto in two degrees Libra the undeclared "World War III" (the Vietnam War) was supposed to have stopped but the American bombing continued. At the time of this writing (June 1973) with Pluto in 2 degrees of Libra it does not look as though the war is ended regardless of what the government tells us.

Violence is often associated with Pluto. It can be representative of organized evil as well as organized good. Organization is one of the keywords applicable to Pluto. It is a strange force. It can activate a group to be far more vicious than any one person would be by himself. The Mafia, Hitler's Storm Troopers, Charles Manson's followers, and the Hell's Angels are manifestations of Pluto. Feeling no attunement to the Forces of Light and their own true identity, they find a sense of belongingness in a group that gives them a sense of importance. They feel they are part of a group that has authority and thus can frighten others into submission. As part of a group they do things they would never do on their own. Singly they are cowards. In mob psychology the mob acts at a far lower level of consciousness than any one person would act by himself. As far as mass consciousness is concerned, the use of this energy is destructive rather than constructive. The atom bomb is the destructive use of Plutonian energy.

Pluto has a special rulership over groups. People with an angular or prominent Pluto have the ability to work with groups. Any planet is prominent if it is in an angular house or configurated strongly with the Sun, Moon or Mercury. When the destructive side of Pluto is dominant then the resourcefulness and power inherent in this energy is turned against society. The individual begins to prey upon society. If powerful enough he becomes the ruthless dictator. Outside the law he operates through mobs. Inside the law Pluto operates through committees and groups dedicated to upholding the law. The Watergate Committee investigation of the undercover activities of those in power at the White House is indicative of Plutonian energy. Pluto always operates as a dichotomy; one group polarizing or opposing another group.

Next to group activity, the conflict of opposing interests is most indicative of Plutonian energies.

A prominent Pluto in a birthchart gives a great sensitivity to the inner planes. These individuals can take the high way or the low way, contacting the forces of light or the forces of evil. Note Charles Manson's chart in the last chapter of this book. The invasion of the wrong forces is clearly shown. It is easy for individuals with a prominent Pluto to develop extrasensory perception and contact the inner planes for good or ill.

Pluto operates undercover, and even astronomically operates eccentrically. It remains out of bounds where the zodiacal limit is concerned. Its orbit is different from the other planets. It moves through some signs in thirteen years, but takes thirty-two to traverse other signs. The average time in a sign is about twenty-six years.

Only as individuals can we change and grow in consciousness and lift the planet to a higher level of Beingness. Then the higher side of Pluto which we call Minerva (Wisdom) begins to operate. The forces of Light and the world servers are connected with the higher aspect of Pluto. All Black Magic is the misuse of Plutonian energy. The dark forces use the Pluto force destructively and thereby bring on their own destruction. It takes strength to be a devil. Most of what we call evil is ignorance. Organized evil is beyond the comprehension of the average person. The forces of Light and their work is just as little understood. Always and all ways we can choose which is right for us.

MY TIGER*

"My tiger is what every man has within him. I don't mean a nasty habit or a degrading passion or anything of necessity vicious. My theory is that every man is given at onset of a life a Beast in the finest noblest sense with whom through Life he has got to settle. It may be an ambition, or a passion, or a temptation or a vice, what you will, but with that Beast he has got to live. Now it's according to his dealings with the Beast whether the man is great or not.

"If he faces the Beast — and the Beast is generally something that a man knows about himself that nobody else knows — the Beast can be used, magnificently used. If he is afraid, pretends the Tiger isn't there, builds up walls, hides in cities, does what you will, then he must be prepared for a life of incessant alarm, and he may be sure that at some moment, or another the Tiger will spring — then there'll be a crisis."

The Tiger is another name for Pluto.

*From *Duchess of Wrexe* by Hugh Walpole

CHAPTER 39
Letters & Charts

The following examples include personal testimonials by clients and students as to their experiences of the effects of Pluto, along with some charts of well-known people with a prominent placement of Pluto. The author's comments are in parentheses, when it is necessary to distinguish them from the individuals' testimonials.

M.K. (No chart)

"In regards to Pluto transits I'll speak of my own experiences, the only ones I know well and have meditated on. So far in my life Pluto has made two major aspects by transit. It went back and forth over my Sun-Venus conjunction. In those few months I graduated from college, met the girl I married and served in the Coast Guard. This was a time of great and concentrated effort in completing my thesis. At the same time I had a transcending love affair which brought with it vast strength and stamina, happiness, sweet dreams and the whole gamut of life's gifts. We were married when Pluto reached exact conjunction for the last time. Six months earlier marriage was the farthest thing from my mind. So it was sudden and compelling. That was the high side of those months. The low side was being enlisted in the service. Here man becomes part of the mass consciousness and loses all trace of individuality. I'd never felt at a lower point in my lifetime. It slowed to a point where I was counting minutes. This was the complete opposite to my timeless romance with all power. In the service I was powerless and devoid of all love, feeling, or even mental stimulation. So you are definitely right about the highest and lowest and it seems that we don't get one without the other. The second conjunction of Pluto was with Neptune. In this case it seemed to be the catalyst that activated my Neptune, Uranus, Mars grand trine. This time it took a couple of years to complete its action starting 3 or 4 degrees before the actual conjunction. Before this occurred I was strictly a materialist, pursuing society's goals and climbing the ladder in New York City. Slowly I became disenchanted with where I was going and decided it was time to stop and reassess my whole life, especially my goals and meaning of life. This time was a period of great inner struggle and a feeling of stepping off into the unknown. It was also a time of being introduced and guided through a series of drug trips. I was very 'lucky' in these experiences because a very evolved person was with me each time and careful planning went into each trip. A series of seven trips was the climax and completion of the Pluto transit and it was then that my rebirth had taken place. It gave me a completely new direction, new reference points, and a new consciousness.

"In both cases the transit has brought great change for the good. Of course the natal planets were in good aspect. At birth Pluto was trine Jupiter. It is now in opposition. However I will only be able to understand its effects in retrospect.

"In summation, I sort of look upon Pluto in my own chart as a powerful force that will in this lifetime (because of its mundane position) cleanse and purify and bring about major changes in my life. Life certainly is a marvelous thing when you can catch small glimpses of the many potentials that lie ahead."

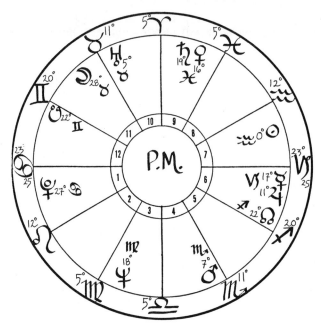

Commentary on the Chart of P.M.

This is the chart of a woman who was left at Long Island Hospital in Boston as a ward of the state. Nothing is known of the circumstances except for the mother's name from birth records.

She was adopted at about two years of age. The adoptive mother died when she was six and she was sent to live with relatives. The father re-married a few years later and she went back to live with him and his new wife. The relationship with this third mother was very unpleasant and today she still has much resentment toward her.

She married a quiet hard-working man in 1957 and had two children. In 1960 she met another man (both of them had their Sun in Leo) and she left her husband. She has never gotten a divorce and seems to find some security in that fact. For the next four years she traveled a great deal, was a prostitute for a while and had two more children, each with different fathers. There has been a tremendous amount of violence in her life both coming to her and from her. She has also been involved in gangland activities.

She has a natural talent for music and is an exceptionally good artist. She can be extremely compassionate to anyone in need of assistance. Most of the art works she has produced have been given away. She is very generous, even though she is now on welfare. If there's a stray, homeless animal in the neighborhood it ends up at her house.

(Pluto in the first house conjunct the Ascendant may be significant in conditions surrounding birth. Note that afflictions in angular houses in fixed signs are very difficult because they are misuse of power and self-will over many lifetimes. When she was two years old Pluto in Leo by transit had made

the T-square involving Sun, Mars and Uranus, a cosmic cross. At the same time Jupiter in Pisces by transit made a trine to Mars in the fourth house and went over Venus and Saturn in Pisces giving her a mother and a home. When Pluto came to square Mars in the fourth house her mother died. As Saturn moved through Gemini and was in the 12th house squaring Venus, Saturn and Neptune she was going through a karmic time that involved her father and her stepmother. In many ways this soul would be unable to be objective about circumstances in her life. This would be very true where any woman who filled the mother role was concerned. Venus, ruler of the 4th house, is conjunct Saturn and opposition Neptune. She would be a very difficult child to raise for she had a will of iron and would refuse to conform.

Certainly violence is shown for she gave it as well as took it. Her tieup with prostitution and the underworld would be connected with a love affair and an unwise choice of close partners. This is shown in two ways: Mars, ruler of the 5th house, co-ruler of Scorpio with Pluto, is afflicted to the 7th house Sun, ruler of the house of finances; and Sun opposition Pluto.

Her compassion is shown by the Cancer ascendant, and Venus and Saturn in Pisces, but there would be a lack of discrimination due to the opposition of Neptune in Virgo.

If this soul will use her Neptune, ruler of the house of the superconscious, trine to Mercury (consciousness) and Jupiter (understanding) she can purge herself of all she has brought upon herself and go free into a life of service. Here again is proof that Plutonian power can be used negatively or positively.)

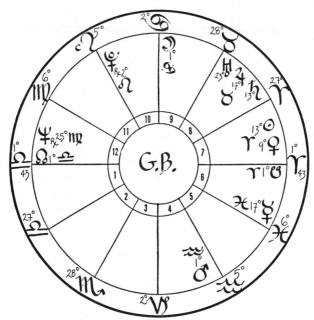

Commentary on the Chart of G.B.

"When Pluto transited 29 Virgo my son was hospitalized and I was told he had Cerebral Palsy or something similar to it. Pluto was in orb of conjunction to my Ascendant square natal Moon, trine Mars, and setting off the inconjunct aspect between Mars and the Moon in the natal chart.

(The karmic pattern is shown by the Moon, ruler of the 10th house, sixth house from the fifth, child's health, and by the inconjunct from the Moon to Mars with Mars posited in the 4th house, 12th house from the fifth.)

"From that time I became very introspective and anti-social. I stopped seeing my friends and spent all my time alone with my son. I became very preoccupied with death and thought my son was going to die." (The transit of Pluto trining Mars ruler of the 8th was protection and he didn't die. The natal Mars on the hidden side of the fifth house, opposition Pluto, would show the purging necessary through a child.)

"The extremes of my interest in death brings out what you say about the extremes of Pluto. During this time I read everything I could find regarding the life of Charles Manson. I was reading *Seth Speaks* by Jane Roberts also. Thus from the lowest to the highest. Isn't this Pluto?

"With the transiting Pluto square my Moon my first instinct was that the burden and blame were completely mine and to shield and protect my son from society. I know now that this I cannot do.

"This transit also caused a physical problem to my father. When Pluto conjuncted my Ascendant and squared the Moon, ruler of the house ruling my father, he was hospitalized." (At her birth Scorpio was in the third house, sixth house from the 10th having to do with her father's health.)

"Our charts show a very strong karmic tie and this has brought up a whole new set of problems I know I must face.

"Pluto has changed my life completely. I honestly feel as though I had been reborn. During this period I have changed my physical appearance, my mode of dress completely, and I think of my past as another incarnation, as though it were another person who lived it."

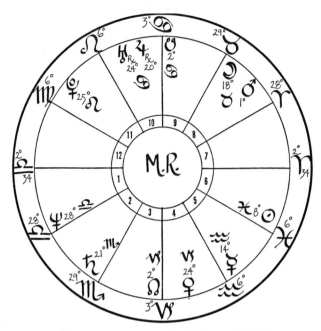

Commentary on the Chart of M.R.

This is the chart of a male, who was arrested May 10, 1973, on charges of kidnapping, rape, and robbery. He has been in and out of serious trouble off and on for about two years previous to this arrest.

He and two friends forced a young couple who were parked in a quiet lane to drive them back to the city and before letting them go, the three of them raped the girl. There was publicity about it in the local newspapers for three days. His mother is reexamining her values and praying for him while being supportive to him. His father can find no forgiveness and wants nothing to do with him.

Both parents have the Sun in Pisces; the mother has the Moon in Scorpio and the father, the Moon in Leo. Pluto was transiting the natal Ascendant. Note the Cosmic Cross at birth in the four fixed signs: Moon in 18 Taurus in the 8th house square Mercury in 14 Aquarius; Mercury square Saturn in 21 Scorpio; Saturn opposition Moon; and all three planets afflicted to Pluto in the 11th house in 25 Leo.

This man's downfall started with his wrong choice of friends. The combination of forces in his fixed signs show karma involving sex and sensuality through many lifetimes. This time the dues would be presented and have to be paid. With Neptune by transit so close to a square to the Sun in Pisces we believe there was psychic obsession due to drugs or alcohol. By progression the progressed Sun was in conjunction with the natal Moon and the progressed Moon in May was exactly square Neptune. With Uranus and Mars by transit square to Jupiter conjunct Uranus in the 10th house, the public indignation was great. There is a great possibility that full retribution will be demanded.

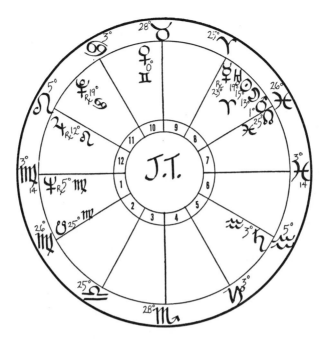

Commentary on the Chart of J.T.

In this chart that was sent to us the following information was shared. "When Pluto was conjunct my Ascendant my mother had a serious operation and was at home for several months of recuperation. (Scorpio was on the 4th house cusp of the Mother at birth.) She was a teacher in a nearby school. A teacher in her school came to visit her. This man proved to be my future husband. Pluto remained on my Ascendant until February, 1959. We were married May 2, 1959. It is not a particularly happy marriage."

(What a wonderful opportunity to accept the purging and go the higher way. Note the position of Neptune close to the Ascendant, ruler of the 7th house of marriage. No matter whom she would marry she would have to sacrifice her ego (Neptune in 1st house ruler of the 7th house) and give more to the marriage than she would receive. Venus square Neptune at birth is indicative of the necessity to learn the real meaning of love. The Pluto transit has given the opportunity to go the higher way.)

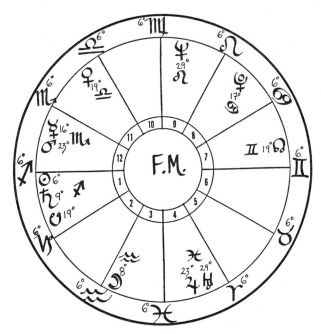

Commentary on the Chart of F.M.

"I don't know if what I have found regarding Pluto is relevant as it is not in conjunction but something is definitely going on. I wonder if the transit of Uranus over Venus, Neptune over the Sun, and Pluto in Libra doesn't affect the whole chart as my attitudes towards love are slowly changing but changing drastically.

"First of all, I was abandoned at birth and in an incubator for about two months. All my life has been spent in seeking a fulfilling love on a one-to-one basis. It seems to have been the main motivating force in my life. As a younger person I attempted suicide on two separate occasions. It was always with the feeling of being so terribly tired that death would mean at least rest and peace. It would be not so much an ending but a pause to try and regroup whatever it is I am. About three days ago I realized exactly what you talked about. I would have had to come back and go through it all again, and that I did have the strength to go on as long as I drew on strength from the greater power.

"I am a recovered alcoholic. I used alcohol to ease the pain of lack of self, lack of accepting people as people, etc. I was divorced August 9, 1972, and I thought my dream and hope of love and peace were ended. It was a terrible time as I am sure it is for anyone. I think I have learned a great deal from it. But what I am trying to get at, if I can even verbalize it, is that I am beginning to see that my perfect one-to-one love relationship is not my primary motivating force anymore. At least as of right now. It seems that it is greater and more than a one-to-one thing. I am no longer dependent upon another for the warmth I seek, or the love I seek. In a way I have even drawn away from

people to some extent. I question this, to some degree, but I suppose that time will show me if I am retreating or in reality finding the strength not to need the approval support and love from another in order for me to find happiness in life.

"I have become tuned again to a higher power. I meditate now. I ask to be shown the way, I say 'Thy will be done' even though I have no idea what that is. I wake up now and instead of feeling, 'why do I live?', I say, 'thank you for this day.' It is a bit of a shock to me. I don't know why this is happening but I really feel it has to do with Pluto and Uranus. I don't mean to imply that I don't want to have a good and loving relationship with another. I do very much, but the whole flavor has changed. If it does happen then I am blessed. On the other hand if it does not I am still blessed as I have found love is not dependent upon another person. Again I will say this is a direct antithesis to what I have always believed."

(A soul (solar) chart has been used for the exact time of birth is not known. With Venus square Pluto, the karma of this lifetime would have to do with no capital in her spiritual love bank. Saturn conjunct the Sun would mean selfishness brought over to be cleansed. She may have been in a male body and deserted her responsibilities as a parent. Therefore she had to be abandoned in this lifetime. Pluto trine Mercury conjunct Mars, trine to Jupiter-Uranus have helped her come to greater understanding and to the regeneration necessary in this life. Due to Saturn conjunct the Sun she has great strength. The changes she mentions in her letter are due to Neptune's transits over her Sun as well as Pluto's transit in Libra. Uranus transiting her Venus has given her a completely new concept of love. How wonderful! We wanted to share her letter with you because it is so indicative of the realization that comes when Pluto, Neptune, and Uranus are used positively.)

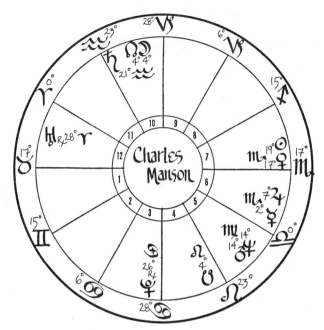

Commentary on the Chart of Charles Manson

Here is a powerful chart that could be used constructively or destructively. With the Taurus-Scorpio axis so highlighted there was the strength of the bull and the cunning of the serpent. Jupiter and Venus in his Sun sign gave great charm and charisma. With Venus and the Sun in the house of relationships he had attracting power and could (and did) use hypnotic powers to accomplish his goals and objectives.

At the time of his conception his parents were under very discordant conditions. Note the Sun conjunct Venus square to Saturn, and the Moon square the stellium in Scorpio. A subconscious hatred and resentment against women was very strong. This is further shown by the Moon square Mercury conjunct Jupiter and going on to square the Sun and conjunct Saturn. The Mars in such close conjunction to Neptune shows he was obsessed and the tool of a force he little understood. That conjunction is in the fifth house (esoteric karma) and undoubtedly he had indulged in black magic in other lifetimes as well as this one.

Would you expect Pluto, his own ruler, to be trine his Sun? Again and again in our research we found we couldn't judge how Pluto would operate by its trines or squares. The total chart had to be considered. Pluto on the dark side of the fourth house is square to Uranus in the 12th house of self undoing. Pluto is inconjunct to Saturn at birth.

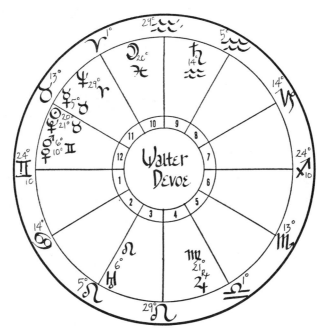

Commentary on the Chart of Walter Devoe

This man was one of the greatest healers in the United States for forty-two years of this century. He had a spiritual center in Boston and taught many souls how to become channels for healing. His ministry was aligned with the healing angels and in his presence even the most insensitive person could feel the magnetic force that emanated from him. He conducted his healing ministry and was of untold help to so many people. Isabel Hickey attended many of his meetings. He used a healing prayer given to him spiritually from higher planes of consciousness. Because this prayer is as powerful today as it was when it was conceived, we are passing it on. If it is used constantly it can be of untold value, not only to the person using it, but it enables him to be a healing channel to help others.

With Pluto conjunct the Sun in the 12th house there was tremendous power to help others. The Moon in Pisces in the house of the public shows the opportunity (Moon sextile Sun conjunct Pluto). The twelfth house is self-undoing or subjective sustainment. With four planets in that house, and the Moon (ruler of his house of resources) in Pisces in the 10th (house of the public), his subconscious was wide open as a channel to the inner planes. Saturn in Aquarius is powerful by sign. It is in the 9th house of the superconscious forces and square to the Sun-Pluto conjunction. The test for power would have to be faced. It came on the day when there was a solar eclipse on his Neptune. There was a large audience at his session that day. He stood up and said, "From now on you all pray to me, not to God. I am the Power." It was as though we saw an angel plunge from the heights of heaven into an abyss. All felt not only saddened but full of compassion. In the final analysis his brief

need for power could not erase the many years of service and the benefits to so many of his healing ministry. Within three weeks his Center was closed and nothing more was ever heard of him. Later while talking to a great teacher about the experience he said, "No one is ever safe from the test of power. From the earliest stages on the path of discipleship up to the highest heaven we can fail that test. When an angel falls it is as though a living nerve was torn out of the Cosmic body of God and all heaven mourns." The realization came that the higher we go in consciousness the greater the fall if the ego isn't cleansed. Walter Devoe served the highest aspect of Pluto for so many years and then fell into the depths of the negative aspect of Pluto. Power is forevermore the test of Pluto but always the choice is there. Will we be a channel of the power or use that power for self?

The Healing Prayer

BY WALTER DEVOE

Loving Father,
I recognize that my life is one with Thy unlimited life and power.

Thy constructive Mind is within me building my mind and body in strength and perfection.

I open my mind to the influx of Thy mighty Presence of health and peace.

Thou art within me a fountain of vitality flowing into every faculty and organ of my being.

Thou art God within my nature and Thy life and health have all power to regenerate and heal my body.

I am organizing Thy Life and strength into a mind and body of health and perfection.

Thy substance is feeding and restoring every part of my body to positive health.

I praise Thy healing life and intelligence in every organ, in every nerve, in every atom of my flesh.

I praise Thy glorious wisdom which is illuminating my soul and purifying my mind of every limiting thought.

I praise Thy healing tender Love which invigorates and upholds me and dissolves away all fear.

O Loving Father, this is thy holy temple. Make it a perfect dwelling place from which shall radiate Thy healing love and wisdom to all Thy children.

Father, glorify me with Thy healing power that I also may glorify Thee.

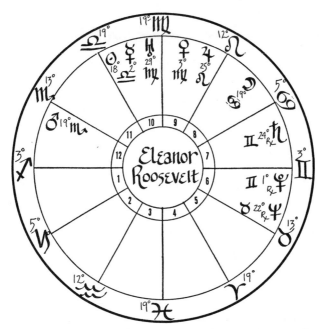

Commentary on the Chart of Eleanor Roosevelt

This is the chart of one of the great souls of this century. She was born in an atmosphere and in a family completely alien to her inner self. She had excessive pride (Jupiter square Mars and square Neptune; also, Mars was in opposition to Neptune) that had to be overcome. With Venus square the Ascendant and square Pluto the inferiority complex that would plague her all during her life played its part in the cleansing of the pride of other lifetimes.

Pluto on the hidden side of the house of marriage square to Venus, and Saturn in the 7th house, square to Uranus would mean that personal love would be denied her in this lifetime. Mercury, trine to Pluto from the 10th house, would bring in the higher aspect of Pluto in her public life. The public would appreciate her. The fixed T-square (with the 3rd house and Aquarius as the empty part of the t-square) would indicate that her younger years were very difficult. This is emphasized by Saturn (co-ruler of the 3rd house) square to Uranus, ruler of the third house cusp.

Any relationship of a personal nature would be a crucifixion to set her free to do the work she came to do where universal welfare was concerned. Pluto tied with the 7th house denies personal love and with its square to Venus there was no doubt she was not happy in her marriage.

With Mars, ruler of her house of children in the 12th house and heavily afflicted, her children would never give her the fulfillment and happiness that her mother heart (Moon in Cancer trine Mars) wanted. She would have the appreciation of the public, and her accomplishments were of such magnitude that her greatness would be recognized by the world long after she had left the body.

If she had what she had most yearned for — a loving husband and a happy home — perhaps the work she came to do for universal welfare would not have been accomplished.

The afflictions in the charts of those who have strength and are willing to suffer for the sake of principles are stepping stones to higher levels of consciousness. This life was a sacrificial life for Eleanor but she achieved what she came to do. The biography *Eleanor and Franklin* can be very enlightening to the astrological student making an in-depth study of her chart.

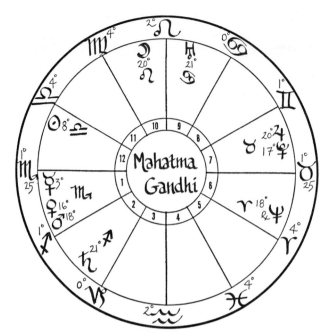

Commentary on the Chart of Mahatma Gandhi

We are including this chart to show how the higher side of Pluto can work under the most adverse squares and oppositions. If you didn't know this was Gandhi's chart would you be able to recognize one of the greatest souls of the last 200 years? It is doubtful. You would see great sensuality and lust. Scorpio is rising, Mars, Venus, and Mercury are in opposition Jupiter conjunct Pluto and square the Moon in Leo. You would not be wrong. Read his autobiography for it tells of his lust and sensuality and the battle he had to conquer them. That he would be involved with the public as a leader is shown by the Moon in Leo in the 10th house. Its square to Venus (ruler of the 12th and 7th houses) would put him in jail again and again but the Moon trine Neptune and Saturn would bring release, not only by help from without but help from inner forces. This is verified by Venus conjunct Mars trine to Uranus in the 9th house of the superconscious forces.

His tremendous magnetism and power is shown by Mars conjunct Venus trine Uranus. Winston Churchill watching him come up the steps of No. 10 Downing Street in London, turned to someone beside him and said, "That little skinny man clad in a loincloth is going to shake up the world and wreck our empire." He did.

The Moon, ruler of the 9th house, trine Saturn and trine Neptune gave him the power to change the destiny of India and lift those of the lowest caste to a sense of their own worth. With five planets in fixed signs he would never give up until he obtained his objectives.

Saturn trine Neptune trine the Moon is the indication of one who can be an illumined soul. An incandescent light burned in that little body. When he was

assassinated that light did not go out. It stayed in the hearts of all those who knew non-violence is the only way. Jupiter, the higher self, and Minerva, love and wisdom, working in conjunction for mankind. Those awake spiritually at the time of Gandhi's death knew that a new vibration was seeded on the planet during the three days after his death. It ignited a spark in Martin Luther King's heart as well as in the hearts of others who were of the light. It is a long time from seedtime to harvest but Gandhi's influence and his message live on. They will never die. Truth cannot be killed no matter what the unenlightened may do to the body.

The Forgotten One

"And there is the Forgotten One, betwixt heaven and earth; the Mediator, hitherto unspoken. I am the ingredient in the least and in the greatest, the Spark, where realized, to set the world alight with understanding. They who understand me mediate. Unrecognized I stand, for I am neither good nor evil, neither black nor white; an essence hitherto unrecognized by either one. A shade within a shade; the shadow's heart and yet the sunlight's joy. The scientists in laboratory play with Me and do not know Me. The high aspiring soul seeketh Me and hath Me in their hand and yet knoweth not of Me. The evil ones do clutch me in their grasp and use Me in destructive waywardness, yet know Me not as Saviour of their very selves.

"They lost me in the Cosmos, for I hindered their plan. I was withheld, for they wanted strife on your planet. They shut the gentle power of Love from earth and so unbalanced was the way.

"As pressure from the realms of Light is put upon the human-kind, all their viciousness doth upward seep into the Light which helpeth to quickly transmute it to a harmlessness with the Light. Ah! Well it is that man's intent be known in outwardness; and so new leavening is taking place.

"Hidden long between the conflict of the higher and lower realm so searing was the conflict that I integrated not to BE. I am not of paradox however. Retroactive be the workings of the plan. What be not recognized by humanity cannot be real to humanity, cannot be penetrating, cannot insinuate itself to mortalness. And yet I say that some of thee could be aware of Me if thou wilt recognize of my Being. Essential it is to know that a thing doth exist. It be not through a willfulness that I do come, but through a recognition. As surely may I be felt as thou dost feel of Earth things.

"I am the electron's very essentialness. I am the filament of Light; and only will I be perceived and understood after polarity; for I be the Center of polarity. Of no color am I, but of feeling; feeling of the higher sensibility: I speak to the highest in and of you.

"Around the glorious New which cometh down be Beings greater far than Masters, Mentors guided. In glorious justice They will help to integrate mankind with their Eternal Selves, the Pattern and prototype of Man."

Epilog

Isabel Hickey, or "Issie" as she was affectionately known, was — and continues to be — a source of tremendous inspiration and guidance for thousands of people. Isabel Hickey taught the use of astrology as a practical tool for Self-unfoldment and for understanding cosmic rhythms and cycles. In her early spiritual life, she had two teachers to whom she was eternally grateful. One was an Easterner on the path of devotion, the other an occultist on the path of knowledge and power. One of the most important principles she learned was that power, when divorced from love and service, can lead one into darkness, not light. She loved sharing the wisdom she gained through her studies, and her generous sharing of herself helped so many people toward a better life that her correspondence was filled with enthusiastic expressions of gratitude.

Isabel Hickey lived in Watertown, Massachusetts, for many years and was a renowned lecturer, counselor, healer, and metaphysical teacher. Sometimes known as "Boston's spiritual sparkplug," she was a Leo Sun in the ninth house, trine to Uranus in the first house, and inspired countless thousands of people to learn to allow the greater Self to live more dynamically through their personalities. She left this physical world in 1980, but, as one of her students stated, "Anyone who has been touched by Issie is never the same." Her essence burns brightly in the countless lives she touched during forty years of learning, sharing, loving, and caring.

After the publisher conceived the idea of combining Isabel Hickey's pamphlet *Pluto or Minerva: The Choice is Yours* with her large textbook *Astrology: A Cosmic Science* into a new paperback edition, Amy Shapiro was asked to help update and edit the combined work, in cooperation with Barbara McEnerney, long-time astrology editor at CRCS Publications. Isabel and Amy began their relationship as teacher and student when Amy was a teenager. Their professional activities grew to include founding astrological associations, joint lectures and seminars, radio and TV appearances, and promoting respect for astrology as a profession. Their mutual respect and appreciation is the main reason Amy was asked to help revise this new edition.

Therefore, Isabel's daughter Helen and the publisher both wish to acknowledge the contributions of Barbara McEnerney and Amy Shapiro and to thank them sincerely for their creative suggestions and faithfulness to the essence of Isabel Hickey's philosophy.

ALSO BY THE AUTHOR

It is All Right

This book may be obtained from:

Helen K. Hickey, Facilitator
New Pathways
103 Goldencrest Avenue
Waltham, Massachusetts 02154

It would be appreciated if inquiries are accompanied
by a stamped, self-addressed envelope. Thank you.

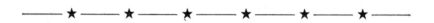

Large-size (31″ × 32″) fine art prints of the *Roundel of the Seasons*
used on the cover, signed by the artist, are available directly
from her:

Sheila Waters
20740 Warfield Ct.
Gaithersburg, MD 20879
USA

Unsigned large prints (28″ × 28″) with either gold, black, or white
background are also available from:

Celestial Arts
P.O. Box 7372
Berkeley, CA 94707
USA

Write for current prices & shipping information.

C·R·C·S BOOKS

THE ANCIENT SCIENCE OF GEOMANCY: Living in Harmony with the Earth by Nigel Pennick $14.95. The best and most accessible survey of this ancient wholistic art/science, superbly illustrated with 120 photos.

AN ASTROLOGICAL GUIDE TO SELF-AWARENESS by Donna Cunningham, M.S.W. $8.95. Written in a lively style, this book includes chapters on transits, houses, interpreting aspects, etc. A popular book translated into 5 languages.

THE ART OF CHART INTERPRETATION: A Step-by-Step Method of Analyzing, Synthesizing & Understanding the Birth Chart by Tracy Marks $7.95. A guide to determining the most important features of a birth chart. A must for students!

THE ASTROLOGER'S GUIDE TO COUNSELING: Astrology's Role in the Helping Professions by Bernard Rosenblum, M.D. $9.95. Establishes astrological counseling as a valid and legitimate helping profession. A break-through book!

THE ASTROLOGER'S MANUAL: Modern Insights into an Ancient Art by Landis Knight Green $12.95, 240 pages. A strikingly original work that includes extensive sections on relationships, aspects, and all the fundamentals in a lively new way.

THE ASTROLOGICAL HOUSES: The Spectrum of Individual Experience by Dane Rudhyar $9.95. A recognized classic of modern astrology that has sold over 100,000 copies, this book is required reading for every student of astrology seeking to understand the deeper meanings of the houses.

ASTROLOGY: The Classic Guide to Understanding Your Horoscope by Ronald C. Davison $8.95. The most popular book on astrology during the 1960s & 1970s is now back in print in a new edition, with an instructive new foreword that explains how the author's remarkable keyword system can be used by even the novice student of astrology.

ASTROLOGY FOR THE NEW AGE: An Intuitive Approach by Marcus Allen $7.95. Emphasizes self-acceptance and tuning in to your chart with a positive openness. Helps one create his or her own interpretation.

ASTROLOGY IN ACTION: How Astrology Works in Practice, Demonstrated by Transits, Progressions & Major Chart Themes in Famous People's Lives by Paul Wright $12.95. Penetrating exploration of astrological symbolism. Includes the charts of Woody Allen, Brando, Prince Charles, Sean Connery, Cezanne, Dylan, Lennon and many more.

ASTROLOGY IN MODERN LANGUAGE by Richard Vaughan $12.95, 336 pages. An in-depth interpretation of the birth chart focusing on the houses and their ruling planets — including the Ascendant and its ruler. A unique, strikingly original work.

ASTROLOGY, KARMA & TRANSFORMATION: The Inner Dimensions of the Birth Chart by Stephen Arroyo $12.95. An insightful book on the use of astrology for personal growth, seen in the light of the theory of karma and the urge toward self-transformation. International best-seller!

THE ASTROLOGY OF SELF-DISCOVERY: An In-Depth Exploration of the Potentials Revealed in Your Birth Chart by Tracy Marks $10.95, 288 pages. Emphasizes the Moon and its nodes, Neptune, Pluto, & the outer planet transits. An important and brilliantly original work!

ASTROLOGY, PSYCHOLOGY AND THE FOUR ELEMENTS: An Energy Approach to Astrology & Its Use in the Counseling Arts by Stephen Arroyo $9.95. An international best-seller. Clearly shows how to approach astrology with a real understanding of the energies involved. Awarded the British Astrological Assn's Astrology Prize. A classic translated into 8 languages!

STEPHEN ARROYO'S CHART INTERPRETATION HANDBOOK: Guidelines for Understanding the Essentials of the Birth Chart $9.95. Shows how to combine keywords, central concepts, and interpretive phrases in a way that illuminates the meanings of the planets, signs, houses, and aspects emphasized in any chart.

CYCLES OF BECOMING: The Planetary Pattern of Growth by Alexander Ruperti $15.95, 274 pages. The first complete treatment of transits from a humanistic and holistic perspective. All important planetary cycles are correlated with the essential phases of personal development. A pioneering work!

DYNAMICS OF ASPECT ANALYSIS: New Perceptions in Astrology by Bil Tierney $12.95, 288 pages. Ground-breaking work! The most in-depth treatment of aspects and aspect patterns available, including both major and minor configurations. Also includes retrogrades, unaspected planets & more!

A JOURNEY THROUGH THE BIRTH CHART: Using Astrology on Your Life Path by Joanne Wickenburg $7.95. Gives the reader the tools to put the pieces of the birth chart together for self-understanding and encourages creative interpretation by helping the reader to think through the endless combinations of astrological symbols.

NEW INSIGHTS IN MODERN ASTROLOGY: The Jupiter/Saturn Conference Lectures by Stephen Arroyo & Liz Greene $10.95. Deals with myth, chart synthesis, relationships, & Jungian psychology related to astrology. A wealth of original ideas!

THE LITERARY ZODIAC by Paul Wright $14.95, 240 pages. A pioneering work, based on extensive research, exploring the connection between astrology and literary creativity.

NUMBERS AS SYMBOLS FOR SELF-DISCOVERY: Exploring Character & Destiny with Numerology by Richard Vaughan $8.95, 336 pages. A how-to book on personal analysis and forecasting your future through Numerology. Examples include the number patterns of a thousand famous personalities.

THE OUTER PLANETS & THEIR CYCLES: The Astrology of the Collective by Liz Greene $12.95. Deals with the individual's attunement to the outer planets as well as with significant historical and generational trends that correlate to these planetary cycles.

PLANETARY ASPECTS – FROM CONFLICT TO COOPERATION: How to Make Your Stressful Aspects Work for You by Tracy Marks $11.95, 225 pages. This revised edition of HOW TO HANDLE YOUR T-SQUARE focuses on the creative understanding of the stressful aspects and focuses on the T-Square configuration both in natal charts and as formed by transits & progressions. The most thorough treatment of these subjects in print!

THE PLANETS AND HUMAN BEHAVIOR by Jeff Mayo $9.95. A pioneering exploration of the symbolism of the planets, blending their modern psychological significance with their ancient mythological meanings. Includes many tips on interpretation.

PRACTICAL PALMISTRY: A Positive Approach from a Modern Perspective by David Brandon-Jones $10.95, 268 pages. This easy-to-use book describes and illustrates all the basics of traditional palmistry and then builds upon that with more recent discoveries based upon the author's extensive experience and case studies. A discriminating approach to an ancient science that includes many original ideas!

THE PRACTICE AND PROFESSION OF ASTROLOGY: Rebuilding Our Lost Connections with the Cosmos by Stephen Arroyo $7.95. A challenging, often controversial treatment of astrology's place in modern society and of astrological counseling as both a legitimate profession and a healing process.

REINCARNATION THROUGH THE ZODIAC by Joan Hodgson $7.50. A study of the signs of the zodiac from a spiritual perspective, based upon the development of different phases of consciousness through reincarnation.

RELATIONSHIPS & LIFE CYCLES: Modern Dimensions of Astrology by Stephen Arroyo $8.95. Thorough discussion of natal chart indicators of one's capacity and need for relationship, techniques of chart comparison, & using transits practically.

SEX & THE ZODIAC: An Astrological Guide to Intimate Relationships by Helen Terrell $8.95, 256 pages. Goes into great detail in describing and analyzing the dominant traits and needs of women and men as indicated by their Zodiacal signs.

THE SPIRAL OF LIFE: Unlocking Your Potential with Astrology by Joanne Wickenburg & Virginia Meyer $7.95. Covering all astrological factors, this book shows how understanding the birth pattern is an exciting path toward increased self-awareness.

A SPIRITUAL APPROACH TO ASTROLOGY by Myrna Lofthus $14.95, 444 pages. A complete astrology textbook from a karmic viewpoint, with an especially valuable 130-page section on karmic interpretation of all aspects, including the Ascendant & MC.

YOUR SECRET SELF: Illuminating the Mysteries of the Twelfth House by Tracy Marks A Guide to Using Astrology & Your Dreams for Personal Growth. $12.95. This important book demonstrates how working with dreams is one of the most effective gateways into the hidden meanings of the Twelfth House.

CHINESE VEGETARIAN COOKERY by Jack Santa Maria $7.95. *VEGETARIAN* magazine called this "the best" of all the books on Chinese vegetarian cookery. It is by far the most accessible for Westerners and uses ingredients that are easily found anywhere.

THE FOOD ALLERGY PLAN: A Working Doctor's Self-Help Guide to New Medical Discoveries by Keith Mumby $7.95. A step-by-step guide that helps the reader identify and eliminate those foods which cause anxiety, irritation, or symptoms of illness.

HEALTH BUILDING: The Conscious Art of Living Well by Dr. Randolph Stone $9.95. A complete health program for people of all ages, based on vital energy currents. Includes instructions on vegetarian & purifying diets and energizing exercises for vitality & beauty.

HELPING YOURSELF WITH NATURAL REMEDIES: An Encyclopedic Guide to Herbal & Nutritional Treatment by Terry Willard, Ph.D. $12.95. This easily accessible book blends 20th century scientific & clinical experience with traditional methods of health maintenance. Allows you to select natural remedies for over 100 specific problems, all arranged in alphabetical order & with a complete index.

CATCHING GOOD HEALTH WITH HOMEOPATHIC MEDICINE: A Concise, Self-Help Introduction to Homeopathy by Raymond J. Garrett & TaRessa Stone $7.95. Includes dozens of fascinating personal stories of striking cures, as well as guidelines to choosing effective remedies for first-aid and sports injuries.

POLARITY THERAPY: VOL. I & II: The Complete Collected Works by Dr. Randolph Stone, D.O., D.C. $25.00 each. The original books on this revolutionary healing art, available for the first time in trade editions. Fully illustrated with charts & diagrams. Sewn binding.

PROTEIN-BALANCED VEGETARIAN COOKERY by David Scott $8.95, 184 pages. The only cookbook that focuses on the crucial issue of protein balance and protein-sufficiency.

TAI CHI: TEN MINUTES TO HEALTH: The Most Comprehensive Guide to Yang Tai Chi by Chia Siew Pang & Goh Ewe Hock $16.95, 132 pages. The most comprehensive manual on Yang style Tai Chi available, which breaks down the movements in more detail than any other book. Recommended by American Library Association's "Booklist."

YOGA FOR THE WEST: A Manual for Designing Your Own Practice by Ian Rawlinson $17.95. A large-size, profusely illustrated paperback with a sewn binding that opens flat for easy use, this pioneering book provides Western students of Yoga with a guide to adapting the ancient principles to the modern person's needs.

For more complete information on our books, a complete catalog, or to order any of the above publications, WRITE TO:

CRCS Publications
Post Office Box 1460
Sebastopol, California 95473
U.S.A.

1-900-370-6316